PAINTING IN FLORENCE AND SIENA

AFTER THE BLACK DEATH

PAINTING
IN FLORENCE AND SIENA

AFTER THE BLACK DEATH

BY MILLARD MEISS

PRINCETON, NEW JERSEY

PRINCETON UNIVERSITY PRESS

1951

———

PUBLICATION OF THIS BOOK HAS BEEN
AIDED BY A GRANT FROM
THE BOLLINGEN FOUNDATION

PRINTED IN THE UNITED STATES OF AMERICA
BY PRINCETON UNIVERSITY PRESS AT PRINCETON, NEW JERSEY

To
C. L. M.
and
M. L. M.

FOREWORD

THE present book deals with Florentine and Sienese painting from around 1350 to 1375. This is not one of the great periods in the history of these two remarkable schools, but it has seemed to me one of the most problematic. In it those aspects of reality and those problems of form that had occupied the leading masters of the first half of the century, and that were soon again to occupy the artists of the early Renaissance, were suddenly opposed by other values. The painters became engrossed with qualities which do not easily find a place in the evolution leading from Giotto to Masaccio, or from Simone and the Lorenzetti to Sassetta. The first part of the book endeavors to show that these qualities, however foreign to this evolution and to classical taste, are coherent and purposeful, and that the more important paintings of the time present a unique range of meaning and form. The subsequent chapters confront the problem of the emergence of this art, and they attempt to interpret it in the light of contemporary religious sentiment, contemporary literary thought, and a state of mind that was affected by a series of unusual events. In tracing these varied relationships I have not been unaware of the risks expressed by the old Tuscan proverb:

Chi due volpe caccia
L'una per l'altra perde.

One chapter, the Madonna of Humility, is not new. It was originally published as an article in the *Art Bulletin* in 1936. Part of this essay, particularly the account of the spread of the image in the northern countries, falls outside the scope of this book. But since much of the rest deals with the broader aspects of style and iconography in the first half of the fourteenth century, it extends and makes more concrete observations about the art of that period that are essential to the present study. To adjust the article to its new context I have revised the writing, but the content remains essentially unchanged. Two or three very brief additions have been made to the footnotes, a couple of attributions have been revised, and changes of ownership noted.

I have not found it desirable to be entirely consistent in the handling of quotations. Excerpts from poetry are usually included in the text, while the translations are placed in the footnotes. The reverse procedure is usually followed for prose. The original is always included, even in longer quotations, where the color and nuance of the language, which have mostly escaped translation, are as important as the ideas expressed. In a few instances, however, where published translations are quoted, the original has been omitted so as to limit the size of the notes.

I am deeply indebted to the Bollingen Foundation for a grant in aid of the publication of this book. My work has been greatly facilitated in many ways by the friendly assistance of members of the staff of the Frick Art Reference Library and its librarian, Mrs. Henry Howell, Jr. They have my warmest thanks. The librarians in charge of inter-library loan in the Columbia University Library, and Miss Mary Chamberlin

of the Fine Arts Library, have also been very helpful. A number of collectors, Conte Alessandro Contini-Bonacossi, Miss Tessie Jones, Mr. Robert Lehman, and M. Alphonse Stoclet have generously permitted me to reproduce paintings in their collections, and I owe several photographs to the kind intervention of Enzo Carli, W. G. Constable, Philip Hendy, and A. O. Quintavalle. I am very grateful for suggestions and criticism to several colleagues and friends: Hans Baron, Dino Bigongiari, Lucile Bush, Vittorio Gabrieli, Frederick Hartt, Paul Oskar Kristeller, Hanns Swarzenski, and, above all, Erwin Panofsky. To two good friends, Richard Krautheimer and Richard Offner, I feel a special gratitude. Richard Krautheimer read the manuscript and made many valuable observations. Richard Offner lent me several photographs for study or for reproduction, and he was unsparing of his own time in bringing to my hypotheses his incomparable knowledge of the painting of the time. My wife has been helpful in innumerable ways. Throughout the period of preparation and composition she maintained unfailingly just the right blend of enthusiasm and indifference.

MILLARD MEISS

New York City, June 1950

CONTENTS

ILLUSTRATIONS

PAINTING IN FLORENCE AND SIENA

AFTER THE BLACK DEATH

INTRODUCTION

IN ONE of his *Trecento novelle*, written around 1390 toward the end of his life, Franco Sacchetti relates the following incident:

"In the city of Florence, which has always been rich in talented men, there were once certain painters and other masters who were at a place outside the city called San Miniato al Monte for some painting and other work that had to be done in the church; after they had had a meal with the abbot and were well wined and dined, they began to converse; and among other questions, this was posed by one of them called Orcagna, who was head master of the noble oratory of Our Lady of Orto San Michele: 'Who was the greatest master of painting that we have had, who other than Giotto?' Some replied Cimabue, some Stefano, some Bernardo [Daddi], others Buffalmacco, and some named one master, and others another. Taddeo Gaddi, who was one of the company, said: 'Certainly there have been plenty of skillful painters, and they have painted in a manner that is impossible for human hand to equal; but this art has grown and continues to grow worse day by day.' "[1]

The story, which has come down to us incomplete, then takes a jocular turn in the remarks of the sculptor Alberto di Arnaldo. He belittles the opinions of the others, saying that excellent painters, the equals of Giotto, were working at that very moment—the Florentine women, whose skill in cosmetics corrects the defects of the greatest painter of them all, God.

The proposals for Giotto's nearest rival have an authentic ring, and it is generally agreed, though we cannot be certain, that the story reflects a conversation at a gathering at S. Miniato in the late 'fifties.[2] We know all the artists present and those mentioned in the discussion—one group, Taddeo Gaddi, Orcagna, Bernardo Daddi, Cimabue, Alberto di Arnaldo by their works, another, Stefano and Buffalmacco (the St. Cecilia Master?), by reputation. We should expect the assembled masters to accept the preeminence of Giotto without question. And as for the choices expressed by the group, they are remarkable, so far as we can judge, only for the omission of Maso, surely Giotto's greatest follower, and perhaps Nardo. Taddeo Gaddi himself was not

[1] "Nella città di Firenze, che sempre di nuovi uomini è stata doviziosa, furono già certi dipintori, e altri maestri, li quali essendo a un luogo fuori della città, che si chiama San Miniato a Monte, per alcuna dipintura e lavorio, che alla chiesa si dovea fare; quando ebbono desinato con l'Abate, e ben pasciuti e bene avvinazzati, cominciarono a questionare; e fra l'altre questione mosse uno, che avea nome l'Orcagna, il quale fu capo maestro dell'oratorio nobile di Nostra Donna d'Orto San Michele: qual fu il maggior maestro di dipignere, che altro, che sia stato da Giotto in fuori? Chi dicea, che fu Cimabue, chi Stefano, chi Bernardo, e chi Buffalmacco, e chi uno e chi un altro. Taddeo Gaddi, che era nella brigata disse: per certo assai valentri dipintori sono stati, e che hanno dipinto per forma, ch'è impossibile a natura umana poterlo fare; ma questa arte è venuta e viene mancando tutto dì" (*Novella* 136).

[2] Orcagna was capomaestro of Or S. Michele from 1355 to 1359, and both Taddeo Gaddi and Alberto di Arnaldo were in Florence at that time (see J. von Schlosser, *Quellenbuch für Kunstgeschichte*, XLVIII, Vienna, 1896, p. 349).

proposed, possibly because he was present; nor Orcagna, who was both present and the proponent of the question. Quite surprising, however, at least on first consideration, is the statement of Taddeo Gaddi. For it goes beyond an acceptance of the superiority of Giotto, already dead some twenty-three years, to assert a continuous decline of the art into the present moment.[3]

Though laments about the state of contemporary art are common enough in history, precisely in the fourteenth and fifteenth centuries they were exceedingly rare. Taddeo's pessimistic opinion is thus exceptional in its time, and it is all the more remarkable because of the occasion on which it was expressed. For it was spoken in the very presence of Orcagna, certainly the greatest Florentine Trecento painter after Giotto, excepting only Maso di Banco. And it ignores the stature not only of Orcagna but of his brother Nardo and of Andrea Bonaiuti, who were inferior to Maso but no less gifted than any of the other masters of the earlier part of the century, Bernardo Daddi and Taddeo Gaddi himself included.

The significance of this extraordinary judgment may be grasped, I believe, if we consider the historical position and the taste of its author. Taddeo Gaddi was the most devoted pupil of Giotto. He had worked with him, according to Cennino Cennini, for twenty-four years, and in the later 'fifties he was the only veteran of Giotto's circle still alive. His insights and his taste were those of an earlier time, and the utter failure to recognize the greatness of Orcagna, if we may trust Sacchetti, suggests an important truth—the profound difference of the art of this painter and his contemporaries from that of Giotto and his successors in the earlier part of the century.

This difference implies not only that people with a taste formed in the earlier Trecento might fail to understand Orcagna, but also that some members of Orcagna's generation might feel less enthusiastic than their elders about Giotto. Possibly we may find an intimation of this in a rather cryptic comment of a writer of the time. In the great chorus of approval of the painting of Giotto that begins with Dante and Riccobaldo and extends into the fifteenth century there was only one discordant note. It was introduced by a writer just a few years younger than Orcagna, Benvenuto da Imola. Though Benvenuto was not Florentine, he lived for a time in Florence[4] and he was quite familiar with Florentine critical and historical thought. In his commentary on the *Divine Comedy*, which he wrote ca. 1376, he upheld the reputation and the superiority of Giotto, but qualified it with what, in the light of earlier and later opinion, amounts to heresy. "Giotto," he said, "still holds the field because no one subtler than

[3] The story has been mentioned by previous writers simply as evidence of the pessimism, the "Epigonengefühl," of all the artists present. See J. v. Schlosser, in *Kunstgeschichtliches Jahrbuch der K. K. Zentralkommission*, IV, 1910, p. 126; P. Toesca, *Florentine Painting of the Trecento*, New York, n.d., p. 50 (the translation in part incorrect); W. R. Valentiner, in the *Art Quarterly*, XII, 1949, p. 48 (Taddeo's reply incorrectly read).

[4] From 1357 to 1360 and in 1373-1374 (see P. Toynbee, *Dante Studies*, London, 1902, pp. 218-222).

he has yet appeared, even though at times he made great errors in his paintings, as I have heard from men of outstanding talent in such matters."[5]

These are serious charges against the man who had been widely hailed as the founder of modern painting and the greatest master since the Greeks. They have been ignored by almost all later historians, and recently one scholar has attempted to dispel them by attributing their meaning exclusively to their context. Benvenuto's statement occurs in the course of his discussion of Dante's famous passage on the transitory nature of fame. The poet says that the renown of Oderisio the miniaturist was short-lived because he was immediately succeeded by Franco, just as Cimabue was eclipsed by Giotto.

> O vana gloria dell'umane posse,
> Com' poco verde in su la cima dura,
> Se non è giunta dall'etadi grosse!
> Credette Cimabue nella pittura
> Tener lo campo, ed ora ha Giotto il grido,
> Sì che la fama di colui è oscura.[6]

It has been suggested that Benvenuto's reference to the great errors of Giotto was simply contrived *ad hoc*, to extend to this painter also Dante's thought about the brevity of fame.[7] But neither the verses themselves nor Benvenuto's comments permit this interpretation. Dante was concerned first of all with reputation and renown, not with problems of criticism and value. Benvenuto himself understood this, devoting most of his commentary on the passage to a discussion of Dante's condition for the loss of fame. The glory of Plato, he says, was dimmed by Aristotle. But since Aristotle was not followed by a philosopher equally as subtle, his reputation survived to the present day.[8] Virgil enjoyed a similar good fortune, for similar reasons, while Cimabue was unlucky enough to find himself not "in aetatibus grossis" but "subtilioribus." Giotto on the other hand, Benvenuto says, *had* no equally subtle successor. Benvenuto would have been inconsistent then if he had supposed a necessary decline in Giotto's reputa-

[5] ". . . Giottus adhuc tenet campum, quia nondum venit alius eo subtilior, cum tamen fecerit aliquando magnos errores in picturis suis, ut audivi a magnis ingeniis" (*Comentum super Dantis Aldigherii Comoediam*, ed. Florence, 1887, III, p. 313).

[6] "O empty glory of human powers! How short the time its green endures at its peak, if it be not overtaken by crude ages! Cimabue thought to hold the field in painting, and now Giotto has the cry, so that the fame of the former is obscured." (*Purgatorio*, XI, 91-95.)

[7] R. Salvini, *Giotto*, Rome, 1938, p. iii.

A later Dante commentator, perhaps under the influence of Benvenuto, also imputed errors to Giotto, but in architecture, where they are far less significant. The Anonimo, writing about 1395, says that he made two errors in the Campanile, of which he was aware and which led him to die of a broken heart. "Composie et ordinò il campanile. . . . Commissevi due errori: l'uno, che non ebbe ceppo da piè, l'altro, che fu stretto: posesene tanto dolore al cuore, ch'egli si dice, ch'egli ne 'infermò e morrissene" (see Milanesi in Vasari, I, p. 371). Schlosser, *op.cit.*, p. 124, refers to changes in the design made by Giotto's successors as a possible source of the Anonimo's fable.

[8] ". . . fama Platonis non diu viguit in alto, quia Aristoteles subtilior diminuit et offuscavit gloriam eius; sed quia post Aristotelem non venit alius subtilior, ideo fama adhuc viget" (*Comentum cit.*, p. 311).

tion; and if he himself had for some personal reason felt called upon to detract from it, would he not have written simply and vaguely that nowadays "some people are no longer unqualified in their praise" rather than the careful statement "he made great errors, as I have heard from outstanding critics"? It seems indeed quite probable that Benvenuto's comment was not provoked by Dante's text alone, but reflected current criticism of Giotto's pictorial style.[9]

Whatever the real meaning of Benvenuto's remarks, a certain kind of adverse criticism of the work of Giotto and his followers was certainly common at this time in the paintings themselves. Every one of the younger masters after 1345-1350 rejected, at least in part, Giotto's most easily imitable accomplishment, linear perspective. None attempted to rival the equilibrium in his art between form and space, or his supple figures moving freely in a measured, easily traversible, receptive world. And which of these masters subscribed without equivocation to his conception of the divine immanent in an exalted and profoundly moral humanity? In all these respects Maso di Banco, of whose activity we do not hear after the early 'forties, was Giotto's last follower. It is striking that the influence of this major master was not dominant in the late 'forties and 'fifties. He had no real succession among the younger painters, who turned unanimously to Orcagna and Nardo.[10]

All of this is indicative of an important change in style and in taste around the middle of the fourteenth century. Variety and change there was of course in the preceding years, too, however dominant the figure of Giotto. The space with which he had surrounded his figures was extended and deepened, the environment made more specific and more familiar. In the hands of Taddeo Gaddi his massive forms became ponderous and rather assertive, in Bernardo Daddi refined and lyric. Maso introduced a marvelous subtlety of color, and gave to the ambience of the figures a wholly new intensity of form and meaning. Other painters, the S. Cecilia Master, Pacino, Jacopo del Casentino, the Biadaiolo Master, whose work has been defined in recent years chiefly by Richard Offner,[11] heeded Giotto's example relatively little, seeking an effect of greater animation and spontaneity, and a more fluid mode of expression. They avoided the grave and the monumental. Unlike Giotto and Taddeo and Maso they

[9] It is true that eulogies of Giotto were not lacking around this time. Petrarch spoke admiringly of him in a letter, and in his will of 1361 he referred to the praise of the "magistri artis" as Benvenuto had of the "ingenii." But Petrarch, living far from Florence, may not have been in close touch with the growth of Florentine opinion on the arts. Boccaccio's famous statement in the Decameron was written in 1350-1352, thus at the very beginning of a profound change of taste in Florence. (For the passages in Petrarch and Boccaccio, see Salvini, *op.cit.*, pp. 4-5.)

[10] This statement seems to me essentially correct even though some elements of Maso's style were assimilated by two or three younger masters, among them the author of the frescoes of the Nativity and Crucifixion in the Chiostrino of S. M. Novella (Van Marle, *The Development of the Italian Schools of Painting*, The Hague, 1924, III, fig. 241), and Orcagna himself.

[11] *Studies in Florentine Painting*, New York, 1927, pp. 3-42, and *Corpus of Florentine Painting*, New York, sec. III, vols. I, 1931, and II, 1930.

were more effective in smaller works—tabernacles, miniatures, little histories in altar-pieces—than in fresco. The departures of the mid-century from Giottesque style, however, are not connected with differences of scale or technique or the conditions of exhibition: they appear in large murals as well as in retables, tabernacles, and miniatures. And whereas some of the masters of the earlier part of the century are un-Giottesque, most of the later ones are, in a sense, anti-Giottesque.

There were similar changes in Siena, too, around the middle of the century. The great styles that succeeded one another during the preceding fifty years—those of Duccio, Simone Martini, Pietro and Ambrogio Lorenzetti—show despite their diversity many related qualities and a certain community of purpose. They constitute a rather orderly development, the younger painter in each instance developing one or another aspect of the older master's style. Around 1350 this continuity seems interrupted. Though the influence of the earlier tradition persists, many of its fundamental elements were rejected, and others were combined in a new and wholly different way. These transformations occurred despite the fact that only one of the painters active at this time, Barna, approximated in stature the great masters of the preceding years. He belonged to an earlier generation, however, and with all his originality he remained in many ways more fully within the tradition of the first half of the century. The younger painters, Bartolo di Fredi, Luca di Tommè, Andrea Vanni, were all less gifted, but they created distinctive forms nevertheless, very similar to one another and related to those of contemporary Florence without being dependent upon them.

Previous accounts of Sienese painting of this period have been devoted less to the analysis of its distinctive character than to its dependence upon the art of the earlier part of the century.[12] It has always, furthermore, been studied separately from Florentine. And when these studies have been part of a comprehensive account of Italian painting, they have emphasized the differences between the two schools rather than the similarities, although they have pointed to the influence upon the Florentines of the earlier art of Simone Martini and the Lorenzetti.[13] Without minimizing these differences, our present purpose is to consider those aspects of the form and content of the two schools that are related.

These similarities between the painting of the two towns are interesting in the light of the remarkably similar circumstances surrounding their appearance. Though the history of the two city-states had corresponded in many ways from the late twelfth century onward, the resemblances between them were especially numerous just before and after the middle of the fourteenth century. During this brief period, both the

[12] See for instance C. Weigelt, *Sienese Painting of the Trecento*, New York, 1930, pp. 56-57.

[13] Resemblances between Florentine painting of the period and Bartolo di Fredi have already been observed, however, by G. Gombosi (*Spinello Aretino*, Budapest, 1926, p. 14)
and F. Antal (*Florentine Painting and its Social Background*, London, 1947, p. 205). But I cannot agree with Antal's belief that Giovanni del Biondo and several contemporary Florentine painters were influenced by Fredi.

Sienese and Florentines lived through a series of deeply disturbing events, which provoked in each a social, moral, and cultural crisis. For what light it may throw on the similarities of their painting, therefore, we shall consider the history of the two people together—their common experience of economic failure, pestilence and social conflict, their fear, their sense of guilt, and the varieties of their religious response.

I

THE NEW FORM AND CONTENT

ORCAGNA'S ALTARPIECE

THE most impressive Florentine painting of the third quarter of the fourteenth century that has come down to us is the altarpiece in the Strozzi Chapel of S. M. Novella, painted by Andrea Orcagna between 1354 and 1357 (Fig. 1). A landmark in the history of style, it is also unprecedented in subject, at least among Florentine and Sienese retables of the great epoch in painting that began with Giotto and Duccio. Of the dozens of altarpieces that were painted by them and their successors during the first half of the fourteenth century, none so far as I know represents the full-length adult Christ in the central field. Nor does any of these earlier altarpieces show Christ in the act of disseminating doctrine and granting ecclesiastical authority. During this period of fifty years only one polyptych presents even the half-length Redeemer in its main field.[1] With this single exception Christ appeared in the central panels of altarpieces only as an infant, on the arm of his mother or in her lap. As an adult he was either banished from altarpieces entirely or relegated to a pinnacle or the predella; and even then he was often given the pathetic form of the wounded man, the Man of Sorrows, rather than the omnipotent King. Before 1300, however, the majestic Christ not infrequently occupied the main panel of altarpieces; in Tuscany he was usually but not always in half-length (Fig. 2),[2] in Rome and its environs quite commonly enthroned (Fig. 3).[3] Many of these earlier works, too, represent intercessors at the side of the impersonal transcendent Redeemer: the Virgin and John the Baptist, as in Orcagna's altarpiece, or, especially in Rome, the Virgin and John the Evangelist.[4]

[1] Polyptych from the workshop of Giotto, the central panel by the master himself, published by W. Suida, in the *Burlington Magazine*, LIX, 1931, p. 188. The half-length Redeemer appears between the Virgin and the Baptist. The polyptych, improperly reconstructed, has just entered the National Gallery in Washington.

[2] In addition to the altarpiece of 1271 by Meliore (Fig. 2), the half-length Redeemer appears in the Pisan polyptych of ca. 1275 in Pisa, Museo Civico, Room III, no. 3, and in the Cimabuesque polyptych in the National Gallery, Washington. The retable of 1215 in the Pinacoteca, Siena, shows a full-length Christ in a mandorla between the symbols of the evangelists.

[3] On the altarpieces of the enthroned Redeemer in Lazio, see J. Wilpert, *Die römische Mosaiken und Malereien*, Freiburg, i/B, 1917, II, pp. 1101ff., and W. F. Volbach in *Rendiconti della Pont. Accademia Romana di Archeologia*, XVII, 1940-41, pp. 97-126. The paintings are bound up with the cult of the Acheiropoieta or miraculous image of Christ in the pontifical oratory of the Sancta Sanctorum. The cult spread to the towns near Rome, each of which had a similar image painted during the twelfth, thirteenth, and subsequent centuries. The cult of the image in Rome was fostered by the popes, for whom it was a symbol of authority and power.

[4] In the fresco of the Last Judgment by Nardo di Cione on the wall behind the altarpiece, undoubtedly planned at the same time, Christ as judge is again accompanied by the Virgin and the Baptist as intercessors.

Orcagna's design is reminiscent then of an older religious outlook and an older artistic convention—a convention that was most strongly established and most persistent in the immediate vicinity of the Papacy.

Orcagna's majestic Redeemer, a major innovation just after the middle of the century, did not remain unique in its time. Shortly afterward Giovanni da Milano introduced a similar figure in the central field of a polyptych (Fig. 4). In this panel, now in the collection of the Conte Contini-Bonacossi in Florence, Christ is seated on a faldstool, adored, as in the Pala Strozzi, by four angels. We hear, too, of the figure of the Eternal in the main panel of a triptych that Boccaccio is said to have commissioned in 1366 for the church of SS. Michele e Jacopo in Certaldo. Though it and a companion altarpiece are lost, it seems probable that God was shown full-length and enthroned because Boccaccio, the donor, was represented kneeling on his right.[5]

While all these representations revive the earlier tradition of the Majesty, Orcagna's joins to it the Deësis and allots additional roles to Christ and the Virgin Mary that demonstrate the connection of the Church with the Deity. Mary acts as sponsor of Thomas Aquinas as well as intercessor for mankind, and Christ appears as the source of doctrine and the founder of the Church. With an effortless, seemingly unconscious though inexorable gesture, defined chiefly by falling diagonals that extend unbroken from his shoulders to his hands, Christ extends the book and the keys to the kneeling Thomas and Peter.[6] Though he is thus related to these two saints and to the four angels below he is at the same time isolated from them and the surrounding space by the mandorla in which he is suspended. The two rigid arcs formed by the cherubs cut his space decisively from that around. This exclusive space is snapped shut above and below by pairs of cherubic wings, pointed and crossed like the blades of a shears.

Orcagna's Christ, like those of the early Dugento, is a transcendent figure, superior to specific acts and functions. Frontal, elevated, and almost motionless, he looks directly outward with glowing but unfocused eyes. Looming before a yellow radiance intensified by the dark blue of his mantle, he is a visionary but massive figure, seated but without visible means of support. These paradoxes are continued in the definition of his position in space. He seems both near and far: near because his form is large, insistent, and linked with Thomas and Peter, more distant because the four kneeling

[5] The triptych represented the Eternal between the Baptist, Boccaccio's patron, and Mark. The second altarpiece represented the Madonna between St. Catherine of Alexandria and S. Miniato. Both triptychs were said to show Boccaccio's arms. See Florence, Biblioteca Nazionale, MS Cappugi 124, fol. 9 (early sixteenth century); O. Bacci, *Burle ed arti magiche di Gio. Boccaccio*, Castelfiorentino, 1904, p. 3 (Nozze D'Ancona—Cardoso); G. Bilanovich, *Restauri boccacceschi*, Rome, 1945, p. 168, and D. Tordi, *La chiesa dei SS. Michele e Jacopo di Certaldo*, Orvieto, 1913, pp. 24-25, 34.

A detail of the panel by Giovanni da Milano (Fig. 4) was published (as a work of this painter) by R. Longhi in *Critica d'arte*, v, 1940, p. 150, fig. 3.

[6] See H. Gronau, *Andrea Orcagna und Nardo di Cione*, Berlin, 1937, pp. 14-15, for the antecedents of this aspect of Orcagna's representation in the illumination of the Decretals.

angels, set away from the lower frame and much smaller in scale than the adjacent figures, press backward the mandorla that surrounds him. It is apparent that the qualities of Christ's form and of his exclusive space are partly incommensurate with those of the rest of the composition.

Thomas, the theologian, responds thoughtfully to Christ; Peter, the militant churchman, with intense fervor—the same fervor that he shows in the Navicella of the predella. There again Christ, though addressing him, does not return his gaze. The Baptist is a dour double of Christ, frontal, and, like him, encased in a mantle that binds and limits his gesture. The Virgin is more relaxed, and her brooding eyes and parted lips are not without a certain sensuousness. But this is countered by the tightly wound wimple that covers her throat, cheeks, and forehead. Very seldom worn by the Virgin, though recurring in the work of Orcagna and his circle, it gives her an ascetic and monastic look.[7] On her cheeks, as on those of Christ and the saints, there is a hot, unnatural blush.

The saints at the limits of the design, coupled as in the Parry altarpiece of Daddi's workshop (1348) although now within a more constricted space, are freer in movement and more varied in posture (Figs. 1, 6, 7). But the conflicts inherent in the figure of Christ are present in these areas of the composition also. Since Catherine, for instance, is overlapped by the melancholy Michael and his dusky dragon, she seems deeper in space. The forms of these two figures tend on the other hand to be unified, in a thoroughly un-Giottesque way: the diagonal sweep of Catherine's mantle parallels that of Michael's, her book and palm are the same green as his cuirass, and the pink vertical strip of the underlining of his mantle runs into the orange border of hers, eliminating any spatial interval between the two. The planes of his figure, turning independently of his action, glide backward, merging with hers. On the other hand, the beautifully patterned light yellow and gold mantle of Catherine tends to come forward alongside the gray-blue figure of Michael, an emergence that is deliberately enhanced by her slightly greater scale. At the opposite extremity of the polyptych Lawrence and Paul, though more differentiated in color, are similarly related in shape. Their outlines correspond, the grate and the sword are parallel, and the dark blue orphrey of Lawrence is equated with the dark blue vertical strip of the inner surface of Paul's mantle that extends downward from his shoulder. The light orange and white robe of Lawrence, like Catherine's in value and design,[8] starts forward in much the same way.

The predella shows similar tensions in spatial relations. Though in the scene at the left, the Mass of St. Thomas, Orcagna renounced the usual architectural setting and

[7] Orcagna gave the Virgin a wimple again in his relief of the Assumption in Or San Michele (Fig. 8) and she wears it in Nardo's frescoes of the Paradise and the Last Judgment in the Strozzi Chapel.

[8] The patterns of both contain a beautiful figure of a bird resembling a parakeet that must have been drawn from a cloth in the Cione workshop. A similar bird appears in textiles in other paintings of the circle, such as Nardo's Madonna in the New-York Historical Society (Fig. 11) and Jacopo di Cione's Madonna in the Accademia (Fig. 138).

11

placed the figures against the gold ground (Fig. 168), at the right, just below Peter (the most massive of the figures), he introduced a building that constructs an emphatic and rather abrupt cubic space.[9] But within the violet walls of this chamber the bed is tilted upward toward the picture plane, and the tall man at the right, larger than the soldier in front of him, tends to move forward, his emergence supported by the attraction between his scarlet cloak and the more saturated scarlet in the foremost figure at the left.

Within the figures there are tensions similar to those between them. They have a sort of dense substantiality, a mass that is confined, repressed, and even denied by outlines that obstruct the implied turning of the planes. The hair of the somber Baptist, instead of continuing, at its limits, to curve around the head, rises into five locks that fan out in the plane of the gold (Fig. 30). The ears are scarcely foreshortened. To enhance the assimilation of the volumes to the broad vertical plane, four of the nine large figures are shown either in perfect profile or in perfect frontality. The ground itself on which they stand is twisted around into the same plane by the gilt motifs strewn over it and by its intense orange-red color. Inasmuch as the motifs are unforeshortened, they deny recession. And, like the patterned background of Orcagna's relief of the Assumption (Fig. 8), they maintain the continuity of the vertical plane in the interstices between the figures.

The scarlet color of the ground recurs, though sometimes less saturated, throughout the upper areas of the composition and even in the frame. It appears in the lining of Peter's mantle, in the borders of the mantle of the Virgin, the Baptist, and St. Catherine, and on the Baptist's staff. Often it is set alongside a strong blue or a gray-blue. The cherubim, the spaces between the dentils of the frame, and the four angels above the arches alternate between those two colors. They are almost equally intense, one very warm, the other cool, and they compete and conflict. They compose the basic chord in the color sequences of the altarpiece.

The same artistic intention that shaped the composition of the figures is manifest in the frame. The altarpiece is a polyptych of five compartments. The exigencies, however, of the central subject and the desire to assert and to maintain the unity of the painted field led Orcagna to omit from the framework the four colonnettes that would normally divide the compartments. The colonnettes are not, however, wholly missing. They are implied by the capitals underneath the arches, by the shafts in the spandrels, and by the bases below, which define the compartments without interrupting the rhythmical movements of the composition. The ghosts of the colonnettes themselves are present. They are tooled into the gold—a remarkably ambiguous and ingenious solution.[10] The structure of the altarpiece is thus stated in part *forte* and in part *pianissimo*.

[9] Though Orcagna is not as concerned with tectonic qualities as Giotto and the Giotteschi, his placement of the building as a supporting member below St. Peter and below the base in the frame is notable. Below the base at the far left he set the lectern.

[10] Earlier altarpieces representing the Maestà or historical scenes sometimes omit the colon-

For similar purposes Orcagna has altered in other ways the traditional skeleton of the Gothic altarpiece. The flat fields above the pointed arches sparkle with gilt tendrils and flowers that are consistent with the patterns in the robes of Lawrence, Catherine, and the angels. They serve to extend the plane of the painted area into the frame and thus to counter the effect inherent in earlier altarpieces, and to some extent in this, of looking through a frame at a scene behind. Furthermore, the central field is enlarged by the addition of two lobes, which oppose the normal progression of the straight lines and the contraction of the space, and, incidentally, compose a shape that resembles the crown of Christ below. The predella is likewise of novel design. There are only three scenes, and they are not divided by the usual shafts. The corners of each are beveled, and there are large flat fields between them that are filled with the same pattern as the fields at the upper limits of the altarpiece.

Some peculiarities of the frame of the Strozzi altarpiece recur in other altarpieces of the period. In the triptych of the Trinity in the Accademia, dated 1365 and painted by a follower of Nardo (Fig. 9), the progression of the pinnacles is interrupted by quatrefoils which curve outward beyond their limits and which are filled with painted forms that create a divergent lateral movement. The pinnacles are completed above the quatrefoils, but on a different scale and angle. Similar shapes and displacements appear in Giovanni del Biondo's altarpiece of 1379 in the Rinuccini Chapel, S. Croce.[11] These recurrences of details of the frame of the Pala Strozzi are only symptoms, as we shall see, of its extensive relationships with the painting of the entire period.

The Strozzi altarpiece is, in my opinion, the only painting executed by Orcagana himself that has been preserved in its entirety. There are however a few other paintings, and some sculpture, for which this leading Florentine master was wholly or in part responsible. We first hear of him in 1343 or 1344, when he was registered in the guild of physicians and apothecaries. In 1352 he entered the masons' guild, and he directed during the following seven or eight years the greatest sculptural enterprise of the time, the elaborate marble tabernacle for Or San Michele, which was very nearly completed in 1359 (Figs. 5, 8, 28). In 1354 he undertook to paint for the chapel of the family of Tommaso Strozzi in S. M. Novella the altarpiece which we have already considered (Fig. 1). It is signed and dated 1357. From 1355 to 1359 he acted as *capomaestro* of Or San Michele, and from 1359 to 1362 he held a similar position at the cathedral of Orvieto. There he made, significantly enough, a mosaic. During the 'sixties in Florence his counsel on problems arising at the cathedral was frequently sought, and

nettes for the sake of a larger field, but I do not recall one which preserves the bases, or in which colonnettes are tooled in the gold background (see Simone Martini's Annunciation, Ambrogio Lorenzetti's *Maestà* and Presentation in the Temple, Pietro Lorenzetti's Ma-

donna at S. Ansano).

[11] Van Marle, *op.cit.*, III, fig. 294. Giovanni Bonsi's polyptych of 1371 in the Vatican also shows the influence of the structure of the Strozzi altarpiece.

he served on a commission that furnished a drawing for the construction of the building itself. He fell ill during the summer of 1368 while he had in hand an altarpiece of St. Matthew for the Arte del Cambio (Fig. 59), and he apparently died shortly thereafter.[12]

Along with this work as sculptor, architect, and administrator, Orcagna was busy with painting during most of his career. Of the many frescoes and panels of which there are documentary records and of which early writers speak, little besides the Strozzi altarpiece has survived. Nothing remains of the two chapels in the Annunziata which Ghiberti said he frescoed, nor of a chapel in S. Croce. The extant Crucifixion and Last Supper in S. Spirito, probably the paintings that Ghiberti listed as his, seem to me actually only the work of close followers.[13] In the nave of S. Croce fragments have been discovered of his "tre magnifiche istorie," the Triumph of Death, the Last Judgment, and Hell (Figs. 83, 84, 86), the latter executed in part by assistants. Just a few years ago a small part of his work in the choir of S. M. Novella came to light— figures of prophets in quatrefoils in the vaults. These paintings, largely the work of assistants, give us valuable intimations of Orcagna's early style.[14] The forms, still reminiscent of Maso, are not as tense or as severe as those in the Strozzi altarpiece of 1354-1357. The only definitely dated work from the late years is the altarpiece of St. Matthew, now in the Uffizi, for which he received the commission in 1367 (Fig. 59). Orcagna probably laid this work out but, as we know from a document, it was completed by his brother, Jacopo di Cione. The Strozzi altarpiece of 1354-1357 thus remains the only complete work actually painted by Orcagna himself.

THE MADONNA BY NARDO

The preceding analysis of the Strozzi altarpiece has not attempted to explore all the subtleties of Orcagna's art nor the full richness of form and color that make the altarpiece the greatest painting of its period. It has sought rather to disclose certain qualities of his style that are fundamental to the more advanced painting of the time. These qualities are to a considerable extent the creation of Orcagna himself, but very similar ones appear in the painting of Sienese masters who may not have known his work, and the paintings of his closest Florentine associates and followers show related forms that

[12] See the documents and records assembled by K. Steinweg, *Andrea Orcagna*, Strasbourg, 1929, pp. 53-59.

[13] These frescoes have recently been published as the work of Orcagna and Nardo by L. Becherucci, in *Bollettino d'arte*, XXXIII, 1948, pp. 24-33, 143-156. Becherucci also attributes to Orcagna, as early works, the Crucifixion and the Nativity in the Chiostrino of S. M. Novella mentioned in the Introduction, note 10, and a fresco (a very mediocre fresco) of the Disputà of St. Catherine in S. Trinita. None of

these attributions is convincing.

[14] The frescoes were published by Becherucci, *loc.cit*. On the basis of a document published in part by C. di Pierro in *Giornale storico della letteratura italiana*, XLVII, 1906, pp. 15-16, she dates the frescoes approximately between 1340 and 1348 (as does also J. Wood Brown, *The Dominican Church of S. M. Novella*, Edinburgh, 1902, p. 128). H. Gronau's plausible interpretation (*op.cit.*, p. 66) of this document places the beginning of the frescoes in 1348.

cannot be shown to derive directly from him. Orcagna was the leading figure of the new style, but not its sole creator.

The qualities of form and content that differentiate the painting of the middle of the century from preceding styles appear in varying measure and combination, of course, and always within the context of individual taste and creativity. Nardo, for instance, tends to be gentle where his brother Orcagna is severe, mild and sensuous where he is tense and ascetic. His beautiful large panel, perhaps of 1356,[15] in the New-York Historical Society (Fig. 11), shows nevertheless many basic relationships with the Strozzi altarpiece. Like Christ in Orcagna's painting, the Virgin is frontal, elevated, and almost motionless. Though she appears to be seated, what she sits on is not visible.[16] She is sustained by formal rather than by natural means, unlike earlier Florentine Madonnas, such as Giotto's (Fig. 10), in which a throne and a podium are prominent. She is closely identified with, almost embedded in, a perfectly flat, richly figured textile that has a very active outline above; it loops upward to a point, but is quiet below. This ascending movement helps to fix the Madonna high in the area. Less of the drapery, furthermore, is visible below; it and the lower part of the figure of the Virgin are constricted by the two Saint Johns. The corresponding area of Giotto's design, on the other hand, contains an expanding figure and architecture. For these and other reasons Nardo's Madonna, though quite massive, is without suggestions of weight.

The formality of the Madonna is enhanced by the repeated horizontals that cross her figure—her hand and Christ's arm, and the broad band of ermine. They are extended to the frame by the heads of the saints. The glances of the saints and of the Virgin tend to be horizontal, too: Zenobius and the Baptist look slightly upward toward the Child, but Reparata and John the Evangelist, though just below Christ, look off to the left. Their glances, moreover, are not clearly focused. Thus, as in the Strozzi altarpiece, there is little direct communication between the figures, and even less between the figures and the spectator. The Virgin as well as the saints seem aloof, self-absorbed, and their eyes are partly veiled by lowered lids.

Giotto's Madonna is very different. In it the glances of all the saints and angels are directed upward at the Virgin or the Child. These glances are expressive of the great potential activity of the figures, and they are counterparts of the dynamic structure of

[15] H. Gronau, *op.cit.*, p. 58, has suggested that because of its style and the presence of four patron saints of Florence—the two Saint Johns, and Saints Reparata and Zenobius—the painting may be identical with one signed by Nardo and dated 1356, once in the rooms of the Gabella de' Contratti in Florence.

For information about Nardo's career see Appendix II.

I am very grateful to Dr. R. W. G. Vail, director of the New-York Historical Society, for having Nardo's Madonna cleaned before it was photographed for this book. The work was skillfully done by Ingrid Marta Held.

[16] There are numerous examples of the seated Madonna without a throne in the painting of the third quarter of the century. See, for instance, a tabernacle by a follower of Nardo in the Parry collection, Gloucester, a Cionesque tabernacle in the Museum Meermanno-Westreenianum in The Hague, and one in the New-York Historical Society (B-11).

weight, thrust, and support. They enhance, too, the effect, created especially by the perspective of the throne, of a specific point of sight that brings the observer into an immediate and fixed relation with the entire group. The Madonna looks directly at him, and the open space below her provides for him a figurative path of access up a series of steps. The four angels are very near in this vivid, easily traversible space. Standing or kneeling in adoration of the Madonna, and offering flowers or a crown, they are equated with, just as they define, the attitude of the observer. All of this is very dissimilar from Nardo's painting, which in many ways is less like the Madonnas of Giotto or his followers than those of the mid-thirteenth century (Fig. 16).

FROM NARRATIVE TO RITUAL

The Strozzi altarpiece by Orcagna and the large Madonna in New York by Nardo have given us an insight into the character of mid-Trecento representations of cult images and dogma. For an understanding of historical painting we must turn to the work of other masters, because nothing of this kind by either of the brothers has been well preserved except the small panels of the predella of the Strozzi altarpiece. Let us consider a painting of the Presentation in the Temple in the Florentine Academy, the central panel of a triptych executed in 1364 (Fig. 13).[17] It is the earliest work, or rather the earliest definitely dated work, of Giovanni del Biondo, a Florentine master with a very indifferent reputation. The productions of the latter part of his career are, it is true, mock-intense, vapid, mechanical. The dreary impression of these later works has tended to obscure the fact that during his early years he painted several panels of real strength and beauty.

The painter of the Presentation had evidently studied very closely the style of Orcagna and of Nardo; perhaps he had been trained by them. We can in fact find him, I believe, among the assistants in the Strozzi Chapel, the frescoes of which were executed by Nardo, probably while Orcagna was painting the altarpiece. He seems to me the author of the lean, crisply painted St. Jerome on the soffit of the entrance arch of the chapel (Fig. 17),[18] and probably also of the St. Gregory opposite.

If we compare with Biondo's Presentation a painting of the same subject made around 1330 by Taddeo Gaddi (Fig. 12), we become aware of the profound differences of style that underlie Taddeo's pessimistic judgment of the state of painting after the middle of the century. In Taddeo's panel the poised, supple figures move freely through

[17] The altarpiece came to the Academy from the western cloister of the Convento degli Angioli (U. Procacci, *La galleria dell'Accademia*, Florence, 1936, pp. 27-28).

[18] Characteristic of Biondo, as we know him in later work, are the smooth drapery with very narrow folds, the wiry line, and the peculiar hand, bent back sharply at the wrist. The fingers are likewise bent at the joints, all of them at exactly the same angle. The palm of the hand is a prominent and regular square, set off from the wrist by a band of shadow. B. Berenson, *Italian Pictures of the Renaissance*, Oxford, 1932, p. 241, has already given to Biondo the adjacent figure of St. Augustine, but of this figure, and the St. Ambrose opposite, I am more uncertain.

an ample space. This space and their own position in it is defined by their roundness, by the calculated overlapping of figure and figure or figure and architecture, by the perspective of the temple and the altar, and by differences of color corresponding to differences of depth. The subject is ritualistic: the redemption of the Child, accompanied by the fulfillment of one prophecy and the utterance of another.[19] The figures are primarily concerned, however, either as actors or as sympathetic spectators with the touching behavior of the Child. He has become frightened by the gentle, but formidably bearded, old Simeon and reaches for the outstretched arms of his mother. The central incident is thus familiar, human, intimate, and the pantomime seems quite natural. Even the High Priest shows a warm benevolence. He watches with relaxed features, nodding his head informally. Though on the central axis of the composition, he is a secondary figure, standing farthest away and partly concealed by the Child.

In the cavernous apse of Biondo's panel the Child, swaddled in bands that bind his arms to his side, is set on the altar before the High Priest like some precious liturgical symbol. The action has the air of a grim and mysterious rite, performed around a large brightly-lighted altar. The figures are divided into two groups, those who offer and those who interpret or receive. The latter include Simeon, the prophetess Anna, and the priest, who is distinguished by his large white tiara, his black beard, and his scarlet cope. The Virgin and Joseph bow humbly before him, one presenting the Child, the other sacrificial doves. The association of the two is unmistakable, and it is not accidental that the bound, inactive Infant is held so close to the flames. The Presentation was often understood as a sacrificial act, prefigured by Abraham's sacrifice of Isaac. In Biondo's painting it seems to allude, at the same time, to the offering of the host in the mass.

The people are rapt and noncommunicative. Though they seem deeply stirred, their feelings smoulder behind rigid masks, lighting up only the eyes. Some of their movements and gestures are emphatic or even abrupt, but they are nevertheless highly self-contained. Simeon's hand is extended towards the Infant, but the fingers recoil, eliminating any sense of an imminent contact. Every movement is similarly arrested, and the figures seem frozen in their present attitudes.

Most of the participants appear in profile or a position very close to it, and they extend their arms or bend their bodies in one plane only, parallel to the picture plane. Though the figures are modeled, the folds of the drapery do not wind around them, but stop at the taut and wiry outlines. The forms are thus both massive and flat. The painter, like Orcagna, has developed qualities of dense substantiality and planar linearity so as to produce an acute tension between the two.

The entire space has the same character. The floor and the glaring altar table are tilted so that while they suggest extension inward they nevertheless tend to rise into place in a planar pattern. Similarly, the figures overlap each other and seem therefore

[19] See the illuminating article on the Presentation by D. C. Shorr in the *Art Bulletin,* XXVIII, 1946, pp. 17-32.

to extend back into space, but at the same time they are so closely interrelated rhythmically that they are drawn together into one plane. This telescoping of forms is enhanced by the color. The dark green of Joseph's mantle is repeated in the central bay of the church, so that the nearest plane is equated with the farthest. Similarly the scarlet on the lining of the Prophetess Anna's mantle reappears in the flame and in the mantle of Simeon. The glowing red of the Virgin's tunic starts forward above the dusky green of St. Joseph.

It is true that after the development of tridimensional space in the late thirteenth century pictorial compositions always have both planar and spatial aspects. But in the earlier fourteenth century these aspects were harmoniously coordinated where here they conflict. The oppositions in Biondo's panel between plane and space and between line and mass are accompanied by tensions between movement and rigidity and between abruptly juxtaposed areas of widely different value. As in Orcagna's altarpiece, red and orange colors, closely crowded in hue and value, compete and conflict. Rounded shapes are contrasted with acutely pointed ones: the inflexible outline of Joseph's back, for instance, with the sharp free-hanging folds of his drapery.[20] The broad figures and forms in the lower part of the composition, grouped in a horizontal rectangle, are surmounted by the slim pointed arches and vaults of the apse. These are the most active forms in the composition, comparable to the arcs of the drapery in Nardo's Madonna (Fig. 11). In both these paintings the setting tends to be active, the figures still. Just the opposite relation is apparent in Taddeo's Presentation and in other paintings of his period. The pointed arches in Biondo's panel dart upward like arrowheads, straining against the figures and the horizontal forms of the lower part of the design. The figures are, at the same time, squeezed between the altar and the frame, and the ponderous heads are pinched by the narrow, slight, but active arches behind them. The relation of the heads to these arches produces an effect of simultaneous opposed expansion and contraction, a sort of strained systole and diastole, that is characteristic of all the formal relationships in the painting.

The three other Florentine paintings of the Presentation that I know from this period are essentially similar to Biondo's in style and mood. One detail is especially significant. In two of the three paintings, as in Biondo's panel and Orcagna's relief on the tabernacle of Or San Michele,[21] Christ is tightly swaddled or wrapped in a cloth that binds and conceals his arms (Fig. 18).[22] He is unfree and inactive, precisely like the cherubim in the Strozzi altarpiece or the Or San Michele tabernacle, who are sheathed in rigid wings (Figs. 1, 5). Though during the early Trecento Christ is often

[20] A similar figure, which probably served as Biondo's model, appears in Orcagna's tabernacle: the apostle bending over the dead body of Mary in the entombment (Fig. 8). The long, taut, uninterrupted line of his back contrasts violently with the freer shapes and irregular planes adjacent to it.

[21] A. Venturi, *Storia dell'arte italiana*, IV, fig. 542.
[22] Cionesque predella (Fig. 18) in the Moll Sale, P. Cassirer, Berlin, 1917, no. 3; Florentine panel of about 1380 in the Dresden Pinakothek, no. 27.

swaddled in representations of the Birth and the Flight into Egypt, he appears in this way, so far as I know, in only two Presentations: Ambrogio Lorenzetti's and the Giottesque fresco in the lower church of Assisi.[23] Ambrogio's Infant, however, is loosely wrapped and very active; he puts his finger in his mouth and kicks his feet (Fig. 14). In some fourteen other paintings of the Presentation from the first half of the Trecento the arms of the Child are quite free, flung toward the Virgin or against old Simeon.[24] It is apparent then that he is bound in the representations of the third quarter of the century not simply as a sign of his infancy, but to conform to a fundamentally different conception of the event.

A few years later than Giovanni del Biondo a Sienese master, Bartolo di Fredi, painted a Presentation in the Temple that is now in the Louvre (Fig. 15). Bartolo's work is based on Ambrogio Lorenzetti's altarpiece of 1342 (Fig. 14). He transformed Ambrogio's design, however, much as Biondo transformed a composition like Taddeo Gaddi's. Ambrogio's deep space is curtailed, his system of perspective distorted. The inlaid floor that defined the recession and the position of the figures in space has been eliminated. The figures have been drawn into one or two shallow planes and knit tightly together by their more salient outlines and drapery folds. The light, unlike that in Ambrogio's panel, seems to have no source. As in Biondo, it enhances the spatial ambiguity, creates a dense relief but not roundness, and accents lines and shapes which compose a pattern. Instead of suggesting atmosphere, it produces, as in Biondo, conspicuous glints, and on the altar table a glare. Bartolo's colors, more saturated than Ambrogio's, exhibit stronger contrasts; and gilt ornament, reminiscent of Nardo, is used more extensively. A cloth spangled with golden elements is spread perfectly flat across the altar, replacing the massive arcuated structure in Ambrogio's painting.

In Bartolo's composition, as in Biondo's, the horizontal axis of the main block of figures is opposed by a strong vertical movement. This opposition of perpendicular axes, apparent also in Nardo's Madonna (Fig. 11), is accompanied by a dispersal of the narrative. Whereas in Ambrogio's concentrated design the figures are united in contemplation of Anna's prophecy, Bartolo has created three separate competitive centers—around the child, the priest, and the prophetess Anna. Even within these centers the figures are withdrawn from one another. Although the Virgin, the Child, and Simeon participate in a common action, none looks directly at the other. The priest and his attendant are similarly detached.

[23] O. Sirèn, *Giotto and Some of His Followers*, Cambridge, Mass., 1917, II, pl. 93. The Child is occasionally swaddled in representations of the Presentation before the fourteenth century. See, for example, the ivory of the ninth-tenth century in the Louvre (A. Goldschmidt, *Die Elfenbeinskulpturen*, Berlin, I, 1914, pl. XLI).

[24] I shall list only a few: Giotto, the Arena Chapel; Jacopo del Casentino, National Gallery, Washington, no. 359; Pacino, Tree of Life, Florence Academy and MS no. 643 in the Morgan Library; workshop of Giotto, Gardner Museum, Boston; follower of Taddeo Gaddi, Castello, Poppi (Sirèn, *op.cit.*, II, pl. 137); Master of the Dominican Effigies, Poppi, Bib. Com., MS no. 1. See also, from the late thirteenth century, Torriti's mosaic in S. M. Maggiore, Rome, and for the Sienese school, Duccio, panel of the *Maestà*.

Bartolo has introduced in the foreground the incident of the return of the Child from Simeon to Mary, which was not represented by Ambrogio. But at the same time he increased the importance of the altar, introducing a ceremony of inscription around it and elevating the High Priest to a position of dominance in the entire scene.[25] Several people look up toward him, even the Child, significantly enough, while he reaches for his mother.

When Bartolo di Fredi was at work on a fresco cycle in S. Agostino, S. Gimignano, representing the life of the Virgin, he again used as a model a Lorenzettian composition. His Birth of the Virgin (Fig. 20) undoubtedly was based on a fresco on the façade of the Ospedale della Scala, one of four paintings of the Life of the Virgin that were signed by Ambrogio and Pietro. The Birth itself was begun by Pietro in 1335. These frescoes have since been destroyed, but a semblance of the compositions has been preserved in numerous Sienese paintings.[26] The Birth of the Virgin is reflected fairly accurately in several works, among them a panel in Asciano by a master close to Sassetta (Fig. 19). We recognize as Lorenzettian the domesticity of setting and action. The people move quietly, with a grave and thoughtful air that transforms their homely duties into a momentous event. The space has a characteristic Lorenzettian perspective and depth, indexed, like Ambrogio's Presentation (Fig. 14), by the geometry of the inlaid floor. Both of the figures around whom the story revolves, St. Anne and the infant Mary, are reclining. It is characteristic of the art of the early Trecento that they, and they alone, are foreshortened. At this time the most important figures are commonly centers of the most vividly created space, just as they are vehicles of the maximum massiveness and motility.

In his own design Bartolo di Fredi has again reduced the space, diminishing the effect of one of the most easily imitable aspects of his model, the linear perspective, and eliminating another, the inlaid floor. His room is seen from an eccentric position near the left margin of the painting. The opposite side of the wall of the antechamber from the one in the Asciano panel thus becomes visible, and Bartolo has reversed the position of Joachim, his companion, and the young boy. In his model this area is part of a symmetrical composition determined by a central point of sight; both are normal for paintings of the first half of the century except when they constitute a unit in a series. Bartolo's modification disperses the glances and the gestures of the two old men toward the margin of the composition. The men become parallel, furthermore, to

[25] D. Shorr, *op.cit.*, p. 67, bearing in mind the passage from Malachi, III, 1, inscribed on the prophet's scroll in Ambrogio's Presentation, and pointing to its inclusion in the feast of the Purification in the Roman Missal, suggests that the act of inscription, unique in Bartolo's painting, is based on Malachi, III, 16: ". . . a book of remembrance was written before him for them that feared the Lord and thought upon his name and they shall be spared at the Day of Judgment." If this conjecture is correct, the eschatological reference would be entirely in accord with the ideas of advent, sacrifice, and redemption conveyed by Giovanni del Biondo's Presentation and other paintings of the period.

[26] See A. Peter, in *As Országos Magyar Szépmüveszéti Múzeum Evkönyvei*, Budapest, V, 1930, pp. 70-71.

Anna and to the woman holding the Virgin, repeating the diagonals of those figures. And together with the boy they add to the series of short movements in and out of a shallow space that are essential to the structure of the design. This zigzag pattern in depth is repeated in the vertical plane, and the woman in the doorway rises without intermediate forms high above the two women seated on the floor.

Bartolo has greatly diminished the overlapping of the figures, and he has twisted their movements and gestures into parallel planes.[27] Thus the farther figures tend to come forward and to coalesce with those in the foreground. The infant, who lies half-nude in the lap of a nurse in the earlier composition, is in Bartolo's wrapped in a cloth and held upright. Similarly St. Anne rises to an upright position and, seemingly trans-fixed, gazes at the attendant as she prepares, in this more formal and ritualistic way, to wash her hands.

Though the stature of Bartolo di Fredi does not approach that of either Ambrogio or Pietro Lorenzetti, the differences of his work from theirs are not simply the conse-quences of this inferiority. His departures from the two Lorenzettian compositions that we have considered are both consistent and purposive. At the same time they affiliate his painting with that of the Cioni and Giovanni del Biondo as well as several contemporary masters in Siena. When, for instance, Luca di Tommè, the subtlest Sienese painter of the 'sixties and 'seventies, undertook to paint the Assumption of the Virgin now in the Jarves Collection of Yale University (Fig. 21) he was certainly familiar with a composition of this scene that was created in Siena some forty years earlier. In this composition, whose renown is attested by a half-dozen or more extant copies (Fig. 22),[28] the ascending Virgin, seated on a cloud, is accompanied by a flock of angels who sing and play a variety of instruments. The angels fly in a circle, seen in perspective from above. Luca (Fig. 21) has compressed the angels into the plane of the Virgin, deliberately crowding them between her and the frame, as Biondo crowded his figures in the Presentation. The angels are at the same time separated decisively from her by the repeated arcs of the mandorla painted in several shades of blue. The

[27] In two contemporary Florentine repre-sentations of the Birth, the upper half of Anne's figure is turned around so as to be parallel to the main plane of the composition: Orcagna, relief on the tabernacle of Or San Michele; Cionesque predella, Ashmolean Mu-seum, Oxford (see H. Gronau, *op.cit.*, fig. 57).

[28] The style of this panel in the Alte Pina-kothek, Munich, is very close to that of the follower of Simone and Barna whose work (in-cluding a Madonna in the Houston Museum, a St. John Evangelist from the same polyptych at Yale, an Annunciation in the Kaiser-Fried-rich Museum, and a Crucifixion in the Ashmo-lean Museum, Oxford) has been identified by

R. Offner (*Art News*, XLIV, 1945, p. 17). For similar compositions of the Assumption see Bartolommeo Bulgarini, Pinacoteca, Siena (De Wald, in *Art Studies*, VII, 1929, fig. 68); fresco in S. M. del Carmine, Siena, by the mas-ter of the late fourteenth century frescoes in the sacristy of the cathedral (Berenson in *Dedalo*, XI, 1930, fig. on p. 334); panel, partly by Sassetta, in the Kaiser-Friedrich Museum (J. Pope-Hennessy, *Sassetta*, London, 1939, pl. 24); panel by Pietro di Giovanni in the archi-episcopal museum at Esztergom, by Giovanni di Paolo in the Collegiata, Asciano, and by Vecchietta, Duomo, Pienza.

sarcophagus, though related in outline to the two lowest angels, punctures abruptly the shallow space of the figural group.

Three other Sienese representations of the Assumption from the third quarter of the century are essentially similar to Luca's. Two of them were painted around 1355-1360 by Niccolò di Ser Sozzo Tegliacci, one in the Museo Civico at S. Gimignano,[29] the other a hitherto unidentified work by this master in the Museum of Fine Arts in Boston (Fig. 25).[30] He had, moreover, painted an Assumption of a similar compositional type, though of different style, some years earlier—certainly before the middle of the century, if not in 1334 as has been generally believed.[31] This miniature from the early part of his career carries into the second quarter of the century a late Dugento and early Trecento Sienese composition that shows the Virgin in a mandorla, accompanied by six or eight angels flying in one plane.[32] It is thus this older type with the angels in a plane, rather than the new composition of the second quarter of the century with the angels in a circle (Fig. 22), that is most closely related to the Assumptions of Luca and Niccolò (Figs. 21, 25). It is significant, too, that the circular composition (Fig. 22) appears only once during our period, in a painting by Bartolomeo Bulgarini or the so-called "Ugolino Lorenzetti,"[33] a master whose position in Siena at this time was similar to that of Taddeo Gaddi in Florence. And though this design was rejected by other painters during the third quarter of the century, it was revived shortly afterward and in the early Quattrocento. Its history is thus similar to that of other Simonesque and Lorenzettian compositions. As we have already seen in the instance of the Birth of the Virgin, the closest replicas were not made, paradoxically enough, by immediate successors of these masters but by painters active forty to a hundred years later.[34]

[29] C. Brandi, in *L'arte*, n.s. III, 1932, fig. 3.

[30] See Appendix II. The painting has been considerably damaged. Richard Offner has independently attributed it to the same master. Though its composition is related to the stylistic trend we have been describing, the representation of the Madonna on a smaller scale than the apostles, because of perspective diminution, reflects a point of view more characteristic of the early Trecento.

The third Assumption of this type is in the panel in the Siena Gallery, no. 163, by a painter close to Niccolò di Buonaccorso. This panel is discussed below on page 122.

Orcagna's relief of the Assumption on the tabernacle at Or San Michele (Fig. 8) is similar in many respects to these Sienese compositions.

[31] See Appendix II, p. 169.

[32] See the stained-glass window in the Duomo, Siena, designed under the influence of Duccio (E. Carli, *Una vetrata ducciesca*, Siena, 1946)

and the Ducciesque panel (cut down) in S. Lorenzo, Terenzano.

[33] Siena, Pinacoteca no. 61. See Van Marle, *op. cit.*, II, fig. 216. The Assumption in Girton College, Cambridge, by Francesco di Vannuccio (J. Pope-Hennessy, in *Burlington Magazine*, XC, 1948, fig. 13) is a rather flattened version of the type. This Sienese circular composition was copied by a Florentine master around 1385 in a panel in the Kaiser-Friedrich Museum, Berlin, no. 1089.

[34] For the revival of the circular Assumption, see the fresco in the Carmine, Siena, by the master of the Life of the Virgin in the sacristy of the Duomo, Siena, and the Quattrocento paintings mentioned in note 28. For the Lorenzettian Birth of the Virgin see, in addition to Fig. 19, the fresco in the sacristy of the Duomo, Siena, and the panel by Paolo di Giovanni Fei in the Pinacoteca, Siena (based on Pietro's Opera del Duomo composition). For the Lorenzettian Presentation of the Vir-

Luca di Tommè's Assumption exhibits, though in a limited way, a method of transforming earlier Trecento space that becomes common after the middle of the century. Space is compressed, as in the group of the Virgin and angels, but compressed areas are occasionally juxtaposed with forms, like his sarcophagus, that strike vehemently back into depth. The equilibrium characteristic of the earlier period between form and space, between solid and void, is thus supplanted by tension between the two. The fresco of the *Via Veritatis* by Andrea da Firenze in the Spanish Chapel (Fig. 94), usually described as flat, has yet a landscape that recedes farther than any preceding one in Florence, however ambiguous its depth. In several paintings by Niccolò di Buonaccorso, the tiled floor, derived from the Lorenzetti, carves out a space that the flattened figures do not really occupy.[35] In all these paintings the perspective serves to force apart forms that are unified otherwise in a plane, or to surround them with a deep space that is incommensurate with their planar character.

This conflict between the planar and spatial aspects of compositions is enhanced by the use of frontal and profile postures, which are exceptionally common, as we have seen, in the art of the time.[36] Figures that had never appeared in frontality in earlier Tuscan painting were now represented in this position: the Magdalen at the foot of the Cross,[37] or Christ in the manger in the Nativity.[38] In one painting of the Presentation the Infant stands, frontal, on the altar, as in the late twelfth century relief at Chartres.[39] He is turned toward frontality even in the representation of the *Madonna del Latte* (Fig. 24)[40] or the Madonna of Humility, and in one example of the latter subject he appears in perfect profile.[41] In many cult images of the Madonna, the Virgin

gin in the Temple, see below, note 58. For Simone Martini's Annunciation, the panel in S. Pietro Ovile, and for his Madonna of Humility, the paintings around 1400 by Andrea di Bartolo (especially the one in the National Gallery, Washington, Fig. 131).

[35] See his Madonna of Humility published by B. Berenson, *op.cit.*, fig. on p. 340; the Annunciation by a follower, *ibid.*, fig. on p. 342; the Marriage of St. Catherine, National Gallery, Washington. In this last panel the flight of the orthogonals is intensified by wide red bands that push the Virgin's throne back into space to a point where the Christ Child could scarcely reach the finger of St. Catherine on which he places a ring.

[36] As in the Strozzi altarpiece, both the central Madonna of the Orcagnesque polyptych in S. M. Maggiore and the adjacent Baptist are exactly frontal. Three of the four saints in the frame of Jacopo di Cione's Crucifixion in the National Gallery, London, are frontal, and the fourth very nearly so. In Andrea da Firenze's fresco of the death of St. Peter Martyr in the Spanish Chapel, the figure of the executioner is largely frontal.

[37] Fresco of the Crucifixion, cloister of S. M. Novella (Van Marle, *op.cit.*, III, fig. 241).

[38] Fresco in S. M. Novella by the painter of the Crucifixion mentioned in the previous note. In Orcagna's relief in Or San Michele the Infant is almost frontal. See also a predella of about 1380 in the Museo Bandini, Fiesole, Room II, no. 11.

[39] Predella, Museo Bandini, Fiesole, Room II, no. 12. Florentine about 1380.

[40] This Madonna, now cut down to an oval, was very probably the central panel of a large altarpiece that contained the Saints Peter and Paul in the Museum of Fine Arts, Boston (Fig. 127), a St. John Evangelist, whereabouts unknown, and perhaps also the Annunciation in the Fogg Museum, Cambridge, Mass. I shall discuss elsewhere the reintegration of this altarpiece.

[41] Master of the Fabriano Altarpiece, Dijon (Offner, *Corpus*, sec. III, vol. v, pl. 31).

is frontal, or the child, or sometimes both, as in the Byzantine Nikopoia (Figs. 11, 16).

In these paintings, as in earlier mediaeval art, frontality usually has a positive value and a specific connotation. It is generally associated with divinity or at least with the most important figure in a hierarchy. Two fourteenth century writers, whom we shall cite below, assign it this significance.[42] Frontal figures of this sort were occasionally employed also in the first half of the century. In Giotto's frescoes in the Arena Chapel, for instance, Justice is frontal while Injustice is in profile. In general, however, painters of this earlier period avoided both these positions as too fixed, static, unfree. The most exalted figures were, in fact, endowed with the most intense plasticity, the greatest potentialities of movement, and they appear in the most vividly created space—just the opposite qualities, therefore, of the corresponding figures in the third quarter of the century. Though figures such as the St. Matthew by Orcagna and Jacopo di Cione (Fig. 59) resemble the frontal saints of earlier western or Byzantine painting (Fig. 3), they possess important distinguishing qualities. They are organically articulated and physiognomically individualized—often indeed to a higher degree than figures of the earlier fourteenth century. They exhibit likewise a capacity for movement, or rather a tension in many parts of the body. We sense it in the taut ligaments of the neck of St. Matthew, in the pressure of his left arm against the book and against his body, in the firm grasp of the inkpot. Yet these potentialities are opposed by the perfectly erect and inflexibly frontal position, by the flattening of the mass, and by the adherence of the arms and hands to the torso. The right forearm and hand, it is true tend to move away from it, but they are restrained by the folds of drapery, especially prominent at this point, that wind across them. Both arms, in fact, and much of the body are tightly bound by the drapery. St. Matthew is in this respect like the Infant in the Presentation or in paintings of the Madonna (Fig. 138), and we have seen similar figures, encased in mantles as in a sheath, in the Strozzi altarpiece. They are common in the painting of the time.

The tension inherent in these figures may recall the dynamism of certain figures of the preceding period, but there are differences that enable us readily to distinguish the two. In a painting of the Madonna, for instance, by Ambrogio Lorenzetti in the Brera, Milan (Fig. 23),[43] the Child is almost entirely wrapped in a cloth—a rare form in a Tuscan painting of this subject. Unlike the bound Infants of the later period (Figs. 13, 18, 138), however, the activity of Ambrogio's Infant is felt throughout his body, in the turn of the head, the spreading fingers, and the curving outlines of the torso and legs.

[42] P. 107.

[43] The condition of this painting, usually attributed to Ambrogio, makes it difficult to be certain of its author. Parts of the surface have been badly rubbed, others repainted (particularly the mantle of the Madonna that now shows a pattern of poinsettas). This reworking may be partly responsible for the resemblance of the painting to Pietro (A. Peter, in La Diana, VIII, 1933, p. 169, has attributed the painting to him), but its color, suffused light, and supple form do seem to reflect the style of this painter. The Madonna seems to me an early work of Ambrogio, painted under the influence of Pietro.

The figures by Ambrogio's brother Pietro, likewise, are often no less tense than those of Orcagna. They seem restless, feverish, tormented by doubt. The Baptist in the Arezzo altarpiece, for instance, twists in two opposite directions at once.[44] But the tension of these figures, developed within organic terms, is capable of resolution. That of St. Matthew is not, arising as it does from an interpenetration of the natural and the unnatural, the physical and the abstract.

Qualities of bearing or behavior related to those of the frontal and bound figures are apparent almost everywhere in the narrative and cult painting of the third quarter of the century. In the works already described we have observed the inflexible masks, the dispersed glances, the halted action. The figures, exhibiting a more generalized intensity, are less responsive to their immediate situation. In Giovanni da Milano's Meeting at the Golden Gate, painted in 1365 (Fig. 27), Joachim and Anna avoid a familiar greeting. Anna lowers her head in humble contemplation of the miraculous conception, and Joachim, grasping her arm, gazes beyond her with a grave portentous look. These two figures constitute only one of three centers in the composition. At the left Joachim is preoccupied with the angel. The exceptionally prominent man at the very middle, though evidently aware of the meeting, turns an enigmatic melancholy face toward the left, and one at least of the two women under the gate, though close to the aged couple, likewise looks away from them. There are thus a dispersal of attention and an individual withdrawal that resemble Bartolo di Fredi's Presentation or Nardo's Madonna and that differentiate Giovanni's fresco from scenes of the Meeting painted in the earlier part of the century.

For Giotto the meeting was a joyful event (Fig. 26). Joachim's retainer and all but one of the attendant women watch the aged couple with curiosity and delight. Joachim and Anna kiss tenderly. The arch created by their embrace, the germinal form of the composition, is echoed in the city gate and the bridge. This warm and spontaneous greeting had been represented in earlier scenes of the Meeting;[45] it was suggested by the Apocryphal gospels, which tell that "Anna . . . saw Joachim coming, and ran and hung upon his neck."[46]

In paintings by the followers of Giotto, and occasionally already in the late thirteenth century,[47] Joachim and Anna embrace each other at the waist, crossing their

[44] C. Weigelt, *Sienese Painting of the Trecento*, New York, 1930, pl. 72.

[45] In the Homilies of the Monk James, Vat. grec. 1162, Joachim and Anna press their cheeks together (Stornaiuolo, *Miniature delle Omilie di Giacomo Monaco*, Rome, 1910, pl. 6); they embrace, their heads very close, in the Menologion of Basil II (*Menologio*, Turin, 1907, II, pl. 229), but both look upward to heaven; they kiss in the relief of the very end of the thirteenth century over the main door of the Duomo of Siena (recently attributed to Tino di Camaino by E. Carli, *Le sculture del*

Duomo di Siena, Turin, 1941, pl. XI).

[46] Proto-Evangelium of James, IV, 4 (see M. R. James, *The Apocryphal New Testament*, Oxford, 1924, p. 40). The description in the Pseudo-Matthew (III, 5) is the same, and the gospel of the Nativity of Mary says that the two met and rejoiced (see the Golden Legend, chap. 129).

[47] See the altarpiece in the Museo Civico of Pisa, Room II, no. 7, attributed to Raniero di Ugolino by Garrison, following Offner (E. B. Garrison, *Italian Romanesque Panel Painting*, Florence, 1949, pp. 26, 150).

arms. He peers intently at her. In Taddeo Gaddi's fresco (Fig. 33) she returns his glance, in a panel by Bernardo Daddi[48] she looks shyly downward. The greeting in these paintings is less intimate than in Giotto's, partly perhaps because in them the Meeting at the Golden Gate was more explicitly associated with the immaculate conception of the Virgin, a tenet that was widely disseminated by the Franciscans during the course of the fourteenth century. The angel who hovers over the aged couple in Daddi's panel is an explicit reference to this idea.[49] Nor is it improbable that Taddeo's decision to portray a less intimate embrace than Giotto was influenced by the moral injunctions of the Augustinian preacher Fra Simone Fidati, although he did not conform to them fully. Fra Simone, whom Taddeo knew while he was preaching and writing in Florence from 1333 to about 1338, included in his *L'ordine della vita cristiana* a brief guide to the marital behavior of the pious. "Married couples," he said, "should not touch one another, neither seductively nor playfully, because this puts the fire of desire in their flesh."[50] When describing the Nativity, Fra Simone asserted that no midwives were present because Christ was born without difficulty or pain.

These comments of Fra Simone disclose a point of view that did not, we surmise, welcome the growth of naturalism in art, and that was opposed to the increasingly familiar and human conception of sacred legend in the art of the late thirteenth century and the first half of the fourteenth. With Fra Simone Fidati this point of view appears in the course of the 'thirties. It became dominant some twenty years later. It is significant that none of the five scenes of the Meeting at the Golden Gate that I know from this period[51] revives the composition of the Arena Chapel.[52] They all represent a more formal greeting, like that of Daddi or Gaddi, and in some of them, Giovanni da Milano's fresco included (Fig. 27), the joyless Joachim and Anna are separated still further, bodily and in spirit.

[48] Predella of Daddi's altarpiece in the Uffizi (Offner, *Corpus*, sec. III, vol. III, pl. 14^{25}).

[49] F. Antal, *op.cit.*, p. 222 note 90, says that this reference gives the painting a "severely ecclesiastical" character. But the idea of the immaculate conception was certainly not limited to ecclesiastical circles—the Dominicans in fact rejected it. It was rooted in the intense veneration of the Virgin, and won great popular acclaim during the fourteenth century.

[50] "Gli sposi non debbono fare toccamenti l'uno all'altro, nè lusinghe, ne piacevolezze, le quali mettono fuoco di lussuria nelle carni loro" (*L'ordine della vita cristiana*, ed. F. Mattioli, Rome, p. 195). I. Maioni first called attention to this passage and to the relationship of Taddeo with Fidati in an interesting article in *L'arte*, XVII, 1914, pp. 107ff.

[51] In addition to the fresco by Giovanni da Milano, see the fresco in the cloisters of S. M. Novella by a follower of Nardo (Van Marle, *op.cit.*, III, fig. 272); Orcagnesque panel in the Museum of Fine Arts, Houston, Texas; Cionesque panel sold in the Chillingworth Sale, Lucerne, September 1922, no. 100 (incorrectly attributed by Van Marle, *op.cit.*, III, p. 506, to Jacopo di Cione); predella of the altarpiece of 1375 formerly at Impruneta, by Pietro Nelli and Tommaso del Mazza.

[52] I doubt that Giotto himself would have represented the couple kissing in paintings made during his later years. In the 'twenties his art tended toward greater formality and an expansive rhetoric.

THE EXALTATION OF GOD, THE CHURCH, AND THE PRIEST

The ritualistic character of paintings of sacred history in the third quarter of the fourteenth century is bound up with an expression of the authority of the enduring Church. When the representation involves a priest, he is given an exceptional prominence and formal intensity. We have seen him in Bartolo di Fredi's Presentation towering above all the other figures in the temple (Fig. 15). In a predella panel of unknown whereabouts by a follower of Orcagna (Fig. 18)[53] he stands behind a brightly lighted altar, frontal and dominant in the central bay of the church. In this panel the discreteness of the figures has been increased by enclosing them in separate compartments defined by the arches of the five-domed building.

In the related subject of the Presentation of the Virgin in the Temple, represented in relief on the tabernacle of Or San Michele (Fig. 28), Orcagna has given the High Priest an even greater supremacy. Framed by the arch of the temple, which repeats the outline of the upper part of his body, he looms up above the youthful Mary at the top of a long flight of steps, a formidable apparition, certainly, for a child. For the first time in Italian representations of this scene both he and the temple are frontal and they are closely identified, asserting together a superior principle of unshakeable stability and permanence. The priest raises both hands, one, covered by his mantle, suggesting his proximity to sacred things, the other in a generalized gesture of acceptance and blessing not directed specifically at the Virgin. Beyond this formal act, he takes no cognizance of her.

The emphatic axiality and symmetry of the upper part of the composition is extended below. The Virgin appears on the central axis below the priest, enveloped by him as the Christ Child is by the Madonna in the Dugento image of the Nikopoia (Fig. 16). Joachim and Anna kneel in profile, like Thomas Aquinas and Peter in the Strozzi altarpiece (Fig. 1); and like them, too, they comprise the two lower parts of an inflexible triangle that reaches its apex in the frontal high priest or, in the Strozzi altarpiece, in Christ.

Orcagna follows the Pseudo-Matthew and other apocrypha in representing fifteen steps leading to the temple.[54] He has also conveyed the exceptional nature of the ascent as described by the text: "She ascended quickly the fifteen steps, without looking back and without inquiring of her parents as children usually do, much to the astonishment of everyone; and the priests themselves wondered at her."[55] But, preferring a more formal and more static composition, Orcagna has shown her turned outward, gesturing with one arm toward the priest, while the upper part of her body, and, one judges, her face, are exactly frontal like his. In his famous fresco in the Baroncelli Chapel Taddeo Gaddi had already represented her turned outward, but with profound

[53] See note 22.

[54] Mary is placed exactly on the middle steps, the seventh and eighth.

[55] Pseudo-Matthew, IV (M. R. James, *op.cit.*, p. 73).

differences. In it the figure of Mary and the adjacent steps have been altered by later reworking, but Taddeo's drawing of the composition shows that her posture is more casual than in Orcagna's relief and she does not point to the priest (Fig. 32).[56] Most important of all, and quite characteristic of early Trecento narrative, she does what children in strange circumstances "usually do," and precisely what the apocryphal text states she did *not* do: she hesitates on the steps and glances inquiringly at her parents.

The spirit of Giotto's fresco in the Arena Chapel is even more remote from the miraculous event of the apocrypha (Fig. 29). He sees in the story the drama of the departure of a young child from her home, and he shows a wonderful sympathy for the human realities of the event. The final moment of separation itself is represented. The child stands at the portal of the temple before the priest. Anne has accompanied her part way up the steps, but stops short of the final ones and bends toward her daughter, looking intently at her with mixed feelings while she both supports her and presents her to the priest.[57] The little girl, crossing her arms over her breast, accepts the transfer quietly, reassured by the tender but firm intention of her mother and the understanding warmth of the priest, who bows his head and opens his arms in a gentle welcome. Her entry into the new world of the temple is made less trying also by the appearance near by of her future companions, the virgins. They crowd together, enveloping the child and the priest and peering over the wall with benevolent curiosity at the newcomer.

Like Giotto's fresco, all the scenes of the Presentation painted in the first half of the century dwell on familiar and universal human experience. We have already described Taddeo Gaddi's painting, and in a Lorenzettian fresco, known by later "copies," the Virgin likewise turns back to her mother while the priest bows to receive her (Fig. 165).[58] After the mid-century, on the other hand, these sentiments disappear; in accordance with the Apocrypha the moment is not that of departure from the family but of an unnaturally determined entry into the temple.[59] The Virgin stands

[56] The general belief that this drawing is by Taddeo himself (see Berenson, *Drawings of the Florentine Painters*, Chicago, 1938, III, fig. 1), seems to me correct. For the view that it is a later copy of the fresco, perhaps by the Rinuccini Master, see R. Oertel (*Mitteilungen des Kunsthistorischen Instituts in Florenz*, v, 1940, pp. 236-238).

[57] Giotto here develops a late thirteenth century composition of the Presentation such as the one in the altarpiece in the Museo Civico, Pisa (*Catalogo della Mostra Giottesca*, Florence, 1943, fig. 24a). See also the contemporary relief on the Duomo of Siena (E. Carli, *op.cit.*, pl. XIII), where the child stands at the top of the flight of steps, her head as high or higher than that of the welcoming priest. As we have observed previously, the compositions of this relief are exceptionally close to those in the Arena Chapel.

[58] This important panel (Fig. 165), 64 x 60 inches and unrecorded in the literature, belonged to H. M. Clark, London. The group in the lower left corner is taken from Taddeo's *Presentation* (Fig. 32). Other Sienese paintings, likewise dependent in part on the Lorenzettian composition and showing the Virgin looking at her parents, are: frescoes at S. Leonardo al Lago and in the sacristy, Duomo, Siena; panels by Giovanni di Paolo, Siena Gallery, and Sano, Vatican.

[59] See the Nardesque fresco in the cloisters

alone and, except in Orcagna's relief (Fig. 28), she faces the priest.[60] She faces him even in the fresco in the Rinuccini Chapel, S. Croce,[61] though in every other essential this work copies Taddeo's painting in the same church. Sometimes she signifies by an extended hand her eagerness to reach the temple precincts. In all these works the authority of the priest approximates Orcagna's relief. There is an increasing emphasis on the church, and the central act is the willful mounting of the steps, which signifies beyond doubt an ascent from worldly to religious life.

The temple of the Old Testament and its ministers were closely associated in the thought of the Middle Ages and the Renaissance with the Church and its clerics. On the scroll held by the prophet Malachi directly above the Christ Child in Ambrogio Lorenzetti's Presentation in the Temple (Fig. 14) is written: "And the Lord whom ye seek shall suddenly come to *his* Temple" (Malachi, III, 1). The most grandiose painting of the temple in the fourteenth century has a dual character (Fig. 36). Its style, Romanesque and therefore outmoded, probably designates the Synagogue,[62] while a cross appears in the arch above the nave. This remarkable building, Lombard in character, is the dominant form in one of Giovanni da Milano's frescoes in the Rinuccini Chapel of S. Croce, part of the same cycle of 1365 as the Meeting at the Golden Gate discussed above (Fig. 27). The painting represents the Expulsion of Joachim from the Temple. If the Presentation of the Virgin in the Temple may be a theme of religious dedication, of entry into the Church, the Expulsion of Joachim signifies rejection by it. The Expulsion is therefore a subject that we would expect to convey an uncommonly intense meaning in the art of the third quarter of the century.

For Giotto the Expulsion was, like the Presentation of the Virgin in the Temple, a moment of profound and complex personal relations (Fig. 35). Following a late thirteenth century tradition, exemplified again by the corresponding scene on the altarpiece in the Museo Civico of Pisa (Fig. 34) or by the relief of about the same time on the façade of the Sienese Cathedral,[63] he shows the priest pushing Joachim from the Temple. Unlike the earlier works, the priest has no attendants, and there are no

of S. M. Novella (Van Marle, *op.cit.*, III, fig. 273); pinnacle of the altarpiece of 1375 by Tommaso del Mazza and Pietro Nelli (*ibid.*, fig. 366); fresco in the Rinuccini Chapel of S. Croce (see note 61).

Similarly Niccolò di Buonaccorso's panel in the Uffizi, though dependent on the Lorenzettian fresco on the façade of the Scala, greatly reduces the welcoming movement of the priest, who stands almost erect, and minimizes the relative importance of the Virgin (G. Marchini, *Rivista d'arte*, x, 1938, fig. 3). The character of the narrative in the fresco by Bartolo di Fredi in S. Agostino, S. Gimignano, is, however, more closely related to representations of the first half of the century than to contempo-

rary ones, although in many formal qualities it resembles the latter.

[60] This posture of the Virgin appeared earlier in Daddi's predella in the Uffizi, and the church, too, is prominent, but the priest bows to greet the Virgin (Offner, *Corpus*, sec. III, vol. III, pl. 14[27]).

[61] A. Venturi, *Storia dell'arte italiana*, v, Milan, 1907, fig. 717.

[62] The temple in Fig. 18 shows five domes, perhaps expressive of its eastern character. For the use of the Romanesque to characterize the temple, see E. Panofsky, *Albrecht Dürer*, Princeton, 1943, I, p. 102.

[63] E. Carli, *op.cit.*, pl. XI.

witnesses. The two confront each other alone—the stern, perhaps angry but certainly not unsympathetic priest, who exhibits a fundamental humanity during the performance of his official duty, and the anguished old man, still clinging tightly to his rejected lamb as though it were the child that God had denied him. Giotto has suggested very discreetly the consequences of this fateful meeting. At the left, more than half hidden behind a wall, a second priest blesses a young father. At the right, where Joachim must go, there is now a void, an expressive but unique form whose authenticity has often been questioned.[64] In any event, the rejected old man is still retained within the structure of the composition and the temple, framed as he is by the pulpit, its columns, and the marble floor.

The tense and moving relationship of the two chief actors in the Arena fresco is preserved in paintings of this subject by Giotto's immediate followers: the fresco by Taddeo Gaddi in the Baroncelli Chapel[65] and the predella by Bernardo Daddi in the Uffizi,[66] although the priest, who now wears a tiara, becomes more aggressive, the church is larger, and numerous other figures are introduced. Radically different, however, is the representation by Giovanni da Milano (Fig. 36). In it the experience of Joachim has not an equally central significance, and the dramatic personal encounter has entirely disappeared. The action resembles in fact the account in the early Apocrypha or the Golden Legend, which tell simply that Joachim, learning that his offering was unacceptable, left the temple weeping.[67] In Giovanni's fresco, and in the painting ten years later that was formerly at Impruneta,[68] Joachim appears in front of the temple, the only person wholly outside it.[69] His exclusion is emphasized by the design of the arches opening into the building. The one behind him, though actually slightly wider than the others, seems to be much narrower. He casts a gloomy, furtive look back into the nave, where the high priest, ignoring him completely, receives the offerings of the fathers who are acceptable to him. The priest, as in Orcagna's relief (Fig. 28), is a grim figure, closely identified with the nave and the half-dome of the apse, and towering like a campanile above the kneeling worshippers. The five-aisled church rises in absolute frontality, filling the entire painted area and extending beyond the framing arch at the sides. It is massive, rigid, all-inclusive, and it assimilates to its tight structure the regular rows of worshippers within. This insistent fixity and order renders more poignant the exclusion of Joachim. The overwhelming weight and authority of

[64] See, for instance, Rintelen (*Giotto*, 2nd ed., Basel, 1923, p. 19) who suspects the loss of a figure in this area.

[65] See Sirèn, *op.cit.*, pl. 114.

[66] Offner, *Corpus*, sec. III, vol. III, pl. 14[23].

[67] See the Pseudo-Matthew, II, 1, and the Proto-Evangelium of James, I, 1 (James, *op.cit.*, pp. 73 and 39).

[68] Van Marle, *op.cit.*, III, fig. 366.

[69] This and other aspects of Giovanni's painting may reflect the Expulsion that Orcagna probably painted in the choir of S. M. Novella. Joachim has a similar position and posture in the fresco of the Expulsion that Ghirlandaio painted in his cycle that replaced Orcagna's frescoes after the latter had been badly damaged (Van Marle, *op.cit.*, XIII, fig. 40). In many respects Ghirlandaio's composition looks like a revised version of Giovanni's, or, more probably, of Orcagna's.

the Church is brought to bear on the old man. The rejection is institutional, rather than, as in earlier paintings, personal.

The composition of the fresco shows opposed axes and movements, more abrupt even than in other paintings of the time. The nave and the aisles, seen in perspective from an axial point of sight, sweep back into space, their extension duplicated by the parallel rows of sacrificants. All the latter, though units in receding rows, are in exact profile. They look intently at or move toward the similarly profile priests, creating a lateral movement perpendicular to that of the architecture and equally as strong.

The figures overlap each other with an extraordinary regularity, reminiscent of earlier mediaeval art. The nose of each of the standing men and women touches, or almost touches, the ear of the figure behind. In each row they are similarly dressed, and the women look very much alike. Despite therefore the more varied features of the men at the left—exceptions to the otherwise uniform character of these figures—all the sacrificants appear less as individuals than as undifferentiated members of a congregation.

This strict uniformity and regimentation of the figures involves a denial of the values of individuality—a denial that we have observed in other aspects of the painting of the time, and that is profoundly opposed to the art of the earlier fourteenth century. Though the regimentation of figures is most conspicuous in this representation of the pious, it is not peculiar to it nor to the painting of Giovanni da Milano. Along with a partially contrary interest in individualized physiognomy, it appears as a rather constant trend in the painting of the time. We find it, for example, in the fresco of Limbo by Andrea da Firenze (Fig. 98), in the wings of the Coronation of the Virgin in London by Jacopo di Cione,[70] in an Ascension of Christ by Andrea Vanni,[71] or in the shutters of a Cionesque tabernacle in Bayonne.[72] In the case of the angels in the Madonna of Humility in Washington from the workshop of Orcagna (Fig. 140) or the soldiers before Christ in the Way to Calvary by Andrea da Firenze (Fig. 38), it governs the appearance of figures which by their intrinsic character imply uniformity but which had not earlier been represented in so regular and unvaried an alignment.

In Giovanni da Milano's Expulsion, as in Orcagna's Presentation (Fig. 28) and many other works of the time, the priest is a central figure, elevated, often frontal and motionless. Similar qualities of decisive hierarchical superiority are attributed to Christ in contemporary cult images (Figs. 1, 4) and occasionally also in scenes of his miracles. In the numerous paintings of the Resurrection of Lazarus from the first half of the century, Christ stands at the left confronting the shrouded dead man, who appears at the right, held erect by bystanders or placed in an open vertical tomb cut in the rock.[73] Christ is attended by the apostles and all the figures stand on approximately

[70] Van Marle, op.cit., III, fig. 277.

[71] Formerly in the Stroganoff collection; reproduced, without a definite attribution, by Berenson in Dedalo, XI, 1930, p. 274.

[72] F. Antal, op.cit., pl. 44b.

[73] See the fresco by Giotto in the Arena Chapel or Duccio's panel from the Maestà (Van Marle, op.cit., II, fig. 20; III, fig. 43). In

the same level. Giovanni da Milano fundamentally altered this traditional composition in his scene of the Resurrection, another of the frescoes in the Rinuccini Chapel, unfortunately smeared here and there with repaint (Fig. 37). Christ stands at the center, as in some earlier mediaeval representations of the subject.[74] He looms above the other figures, his head rising into the sky. He is framed by dark hills that ripple and heave as though they were activated by the magnetism of his presence and his miraculous act. Lazarus himself, in an unusual position, turns away from Christ, though he casts a look backward as two apostles help him step from the tomb.[75] Here, as in other paintings of the time, a direct meeting of the glances of lesser figures with the Deity is avoided. Though Lazarus does not quite see Christ, Christ looks intensely toward him, his brow contracted and casting deep shadows over his eyes. His movement, moreover, is more limited than in earlier representations of the subject. Instead of the usual extension of an arm toward Lazarus, he raises one hand close to his body and parallel to its axis. His energy is expressed more by his eyes than by his gesture, and the miracle itself becomes the consequence of forces that are spiritual and ineffable rather than physical.

In view of the importance of the Church and the priest in the art of the third quarter of the Trecento it is not surprising that a subject connected with the reception and dissemination of ecclesiastical doctrine should have undergone a special development during this period. For the first time in the history of Tuscan painting, and so far as I know, the only time, the Pentecost was selected as the subject of an altarpiece (Fig. 39). The significance of its selection is not lessened by the fact that the painting, though now in the Badia, may have been made for the high altar of the church of the Apostles (SS. Apostoli) in Florence.[76] It was painted by a close follower of Orcagna, possibly in his workshop.[77] Though its iconography is similar to that of earlier representations of the event that were included in historical cycles, such as Taddeo Gaddi's in Berlin (Fig. 40), the composition is radically different. The active group in the earlier painting, with its variety of individual response, has been transformed into the most inflexible and schematic assembly of figures in the history of Tuscan art. Even the "cloven tongues of fire" have been congealed to a single flame and stilled to a tense quaver, and they are not too small to escape the almost exact symmetry that governs the whole.[78]

one of the medallions in Pacino's Tree of Life in the Academy, Florence, Lazarus is seated in a sarcophagus.

[74] For instance, S. Angelo in Formis (*ibid.*, I, fig. 64).

[75] His posture resembles that of Christ in certain representations of the Resurrection (see the Bible of the Duke of Berry, British Museum, Harley MS no. 4382, reproduced by H. Schrade *Die Auferstehung Christi*, Berlin,

1932, fig. 80), though the far leg of Christ is outside the sarcophagus.

[76] See W. Paatz, *Die Kirchen von Florenz*, Frankfurt, 1940, p. 259 note 47.

[77] H. Gronau, *op.cit.*, p. 40, suggests that the altarpiece was designed by Orcagna himself.

[78] They start abruptly from the heads as do the locks of hair of the Baptist in the Strozzi altarpiece (Fig. 30).

The insistence on hierarchy that we have observed in other paintings of the time is no less evident here. The Virgin emerges as the dominant person, placed at the apex of a triangle that embraces the entire triptych. As the superior figure, she shares with the Holy Ghost above her a position of exact frontality. The apostles seem to have dropped to their knees as much in adoration of her as of the Spirit that descends from heaven.

In other paintings of the Pentecost from the period, such as the fresco of 1366-1368 by Andrea da Firenze in the Spanish Chapel (Fig. 41), the figures are similarly transfixed by the mystical experience. They are passive, tense, and erect, the Virgin again is perfectly frontal, but the scene is now not limited to the moment of reception of the Spirit. It has been modified and enlarged to show the consequences for humanity of the divine influence. The apostles and the Virgin are seated in a chamber, a setting which had been eliminated in the Badia altarpiece but which enclosed the figures in representations of the early fourteenth century (Fig. 40). This chamber, however, has become the open second storey of a building. In front of the building, the main door of which is ajar, a multitude of men listen attentively or gesticulate with surprise and wonder. Differentiated ethnically and in costume, they are the people described in the Acts, people "out of every nation under heaven." They had learned of the ability of the apostles to speak their languages after the descent of the Spirit, and congregated to witness the miracle. They were amazed to hear their native tongues spoken, and they became suspicious, thinking that the apostles were drunk. But Peter rose to speak, as in the fresco, telling them the meaning of Christ's death and resurrection, and urging them to save themselves by repentance and baptism. Three thousand became Christians on that day.[79]

This painting illustrates then the beginning of the mission of the apostles and it celebrates their first success. Peter, furthermore, is glorified above the other apostles or even the Virgin, and through him the Papacy and the ecclesiastical hierarchy. Here once again is the familiar theme of the time, but with a more explicit reference to repentance, conversion, and the missionary zeal of the Church.

Although the people from all parts of the world are occasionally included in representations of the Pentecost of a much earlier period,[80] as in a mosaic in one of the domes of S. Marco in Venice, they are absent from the paintings of Duccio, Giotto, or Taddeo Gaddi (Fig. 40). In these works, moreover, St. Peter is seated with the other apostles. It is all the more significant therefore that the representatives of the diverse peoples reappear in several paintings of the latter part of the century. Two—a panel of 1370-1371 by Jacopo di Cione and a Cionesque miniature—clearly derive from the fresco by Andrea da Firenze.[81] Andrea was probably moved to include this group and

[79] Acts, I and II.

[80] See E. Sandberg-Vavalà, *La croce dipinta italiana*, Verona, 1929, p. 379.

[81] The panel by Jacopo di Cione, now in the National Gallery, London, is a pinnacle of an altarpiece made for S. Pier Maggiore (see H. Gronau in *Burlington Magazine*, LXXXVI, 1945, p. 139, and R. Offner in *Studies of the Museum of Art of the Rhode Island School of Design*, 1947, p. 43). The miniature is in the Victoria

the discourse of Peter by the context of the fresco in the Spanish Chapel. His Pente-
cost forms part of a monumental fresco cycle that is the most elaborate statement of
doctrine in the history of Tuscan painting. It is a kind of *summa* of the ideas of the
Church, of divinity, conversion, and redemption that are so prominent in the painting
of the third quarter of the century. The cycle, painted around 1366-1368, will be dis-
cussed in chapter IV, but it should be said here that, however great its influence, it was
clearly not the sole nor even the major source of these ideas; they are conveyed con-
sistently by the art of the preceding ten or fifteen years.

In view of the concern with doctrine and the exaltation of the Church and the
Deity, it is not surprising that the Trinity should suddenly have become prominent in
the iconography of the third quarter of the century. Represented only once, so far as
I know, in Italian altarpieces and tabernacles of the thirteenth and early fourteenth
centuries, and then in a subordinate field, examples of it multiply after 1350.[82] Earlier
Italian representations in frescoes or miniatures show a variety of forms: a three-
headed figure, three men identical in feature and dress, God the Father holding the
Christ Child on his knee, or God the Father holding a crucifix. It is the latter, the
more pathetic form created in the north in the twelfth century, that becomes com-
mon in Tuscan panels (Fig. 9).[83] The most interesting of these paintings, and the
earliest to have survived from Siena, is a hitherto unknown work now in the market
in New York by a contemporary, perhaps an associate, of Luca di Tommè (Fig. 50).[84]

and Albert Museum, London, no. 3045. See
also the Gerinesque fresco in the former Con-
vento di S. Birgitta, *Paradiso degli Alberti*
(Sirèn, in *L'arte*, XI, 1908, p. 186), and a late
fourteenth century Florentine miniature in
the Kupferstichkabinett, Berlin, no. 643. The
iconography of this group of paintings was
adopted by Ghiberti in his first pair of doors
for the Florentine Baptistery.

[82] I have referred to the emergence of the
Trinity in Tuscan panels in the *Art Bulletin*,
XXVIII, 1946, p. 6, listing examples of the sev-
eral types. To the works cited there should be
added the miniature by the shop of Pacino di
Bonaguida in the Morgan Library, MS 742,
which represents the Trinity in four forms:
God the Father holding the crucifix (also ap-
pearing in Morgan MS 716, Bolognese, toward
the middle of the century), three "identical"
men behind an altar, the three-headed figure,
and Abraham with the three angels (Offner,
Corpus, sec. III, vol. II, pt. II, add. pl. VIII);
miniature, Sienese around 1355 or at least
Tuscan under Sienese influence, collection of
Robert Lehman, New York, showing three
similar men seated side by side.

The only Trinity familiar to me in the panel

painting of the first half of the century appears
in a compartment of the right wing of a trip-
tych by Pacino now in the New York market
that will be published shortly by Richard
Offner.

[83] In addition to the altarpiece of 1365 by a
follower of Nardo (Fig. 9), see the panel by
Jacopo di Cione in the National Gallery, Lon-
don, and the Cionesque panel in the Gallery
of Fine Arts, Yale University (O. Sirèn, *Cata-
logue of the Jarves Collection*, New Haven,
1916, pl. opp. p. 46).

[84] Height, 22¼ inches; width, 21 inches. This
master also painted, I believe, the Conversion
of St. Paul in the National Gallery, Washing-
ton, no. 319, and two additional panels of the
same predella with other scenes of the legend
of St. Paul in the Pinacoteca, Siena, nos. 117
and 118. Longhi pointed to the relationship of
these predella panels, but attributed the three
to the Florentine Lorenzo di Bicci, whereas
Berenson ascribed the Washington panel to
Lippo Vanni (see the *National Gallery, Pre-
liminary Catalogue*, Washington, 1941, p. 206).
Brandi listed the two Siena panels as Spinello
Aretino, with question (*Catalogo della Pina-
coteca di Siena*, Siena, 1930, p. 365). The

The central panel of this tabernacle shows the Trinity together with the Crucifixion, a combination that reappears in later paintings by Luca himself in the Museum at Pisa (dated 1366), by Paolo di Giovanni Fei in the Duomo of Naples,[85] and by Andrea di Bartolo in the Castle at Konopiště.[86] But whereas in Luca's Pisa panel God the Father and the dove hover over the crucifix, and in the other two Sienese paintings God holds the crucifix, all three members of the Trinity appear behind it in the tabernacle. In this rather anomalous iconography the Crucifixion and the Trinity have not been completely fused, and the second member, Christ, appears twice.

Even more extraordinary, and indeed rather disturbing, is the form of the Trinity itself. The image of three almost identical men, well known in the Middle Ages, is startling enough when carried into the more naturalistic and humanistic art of the fourteenth century. But our painter has not only eliminated their individuality of feature and dress; he has reduced and compromised their separate physical existence. Within a mandorla, two of the figures are seated close together; the third is between and behind them in an otherwise nonexistent space. Only two hands and two feet are visible, and the mantles of the two outer figures merge at the center. The three men thus appear to be neither abnormal nor quite normal, and the painter has deliberately created an image of the greatest visual ambiguity.[87] Though expressive of the conception of the triune God, its relationship to the groups of impersonal, uniform figures in other paintings of the time cannot escape us.

The Trinity now in New York is painted in a small tabernacle. Apparently, then, in the third quarter of the century this image was the object of private devotion as well as of the more public and collective veneration occasioned by large altarpieces (Fig. 9). Similarly the Redeemer, whom we have seen reappear in the main field of two altarpieces (Figs. 1, 4), became the subject of a small panel (Fig. 42). This extraordinary painting, hitherto unpublished, was made around 1380, perhaps by a Pistoiese master. His style is deeply dependent upon the Cioni, and his novel subject may have derived from the same source. The panel represents the head of Christ, firmly based in

painter is very probably the author also of the Crucifixion, no. 33 in the Lindenau Museum, Altenburg.

The posture of Christ in the Resurrection derives from the fresco by Pietro Lorenzetti in S. Francesco, Siena (see E. DeWald, in *Art Studies*, VII, 1929, fig. 43).

[85] F. M. Perkins in *La Diana*, VI, 1931, pl. 18.

[86] Meiss, *op.cit.*, fig. 3. Masaccio's fresco in S. M. Novella belongs to this tradition, though God the Father is standing rather than seated. In this respect his Trinity is anticipated by a panel by Lorenzo di Niccolo now in the market in New York.

[87] There are images of the Trinity that re-

semble one or another aspect of the painting in New York. In a miniature in a missal in Toulouse (Bibliothèque Municipale, no. 91) of 1362 the three figures wear a common mantle and crown, but each figure has two arms (V. Leroquais, *Les Sacramentaires et les Missels*, Paris, 1924, pl. 59). In a twelfth century "binity" in a gospels in Pembroke College Library, no. 120, the bodies of God Father and Christ unite at the hips into one lower half (M. R. James, *A Descriptive Catalogue of the Manuscripts in the Library of Pembroke College, Cambridge*, Cambridge, 1905, pp. 123-124).

accordance with Tuscan taste upon a sort of plinth, formed by the shoulders and the inscription on the neck-band: PACEM MEAM DO VOBIS.[88] The qualities of the face are the now familiar ones attributed in the third quarter of the century to the Deity, to the priest, and to other hierarchically superior figures.

Organically articulated and solid, the head is also immovably frontal and rigid. Its tension is increased by the taut ligaments of the neck and by the relations of light and dark that show subtle and expressive variations of a generally symmetrical pattern. The contrasts of value culminate in the eyes, whose white corneas and dark, almost full-round, pupils emerge from the surrounding shadows. The glance is penetrating but unfocused and impersonal. The transcendence of the figure is suggested also by the abnormally high dome of the head. Though spiritually remote, the face seems also very near. It creates a peculiarly insistent and dramatic effect.

The head of Christ is reminiscent of earlier mediaeval images, and the resemblance may in this instance be the consequence not only of a generally related formal intention but of a more specific iconographic one as well. The painting may have been intended as a likeness of one of the miraculous images of the *sacra facies* that were venerated in Rome in the later Middle Ages.[89] The ornamented textile in the panel, held by two angels, may be a cloth of honor that falls behind the head. But it may, on the other hand, represent the sudarium, the kerchief of St. Veronica on which the likeness of Christ was impressed during the journey to Calvary. The sudarium was preserved in St. Peter's, and it became the object of a rapidly growing cult, fostered by the popes, in the thirteenth and fourteenth centuries.[90] Giovanni Villani saw it during his stay in Rome in the Jubilee year of 1300: "per consolatione de' Christiani peregrini," he wrote, "ogni venerdì, o dì solenne di festa, si mostrava in San Piero la Veronica del Sudario di Christo."[91] The sudarium was exhibited frequently also during the Jubilee of 1350, and over a period of several years special indulgences were granted by the pope for prayer before it.[92] Badges showing the image were distributed among the faithful. The pilgrim in the Spanish Chapel frescoes wears one pinned to his hat (Fig. 44).

Before the fourteenth century the sudarium was occasionally represented in northern illumination,[93] and although rare in Italy at that time, there is one surviving example in Trecento panel painting before our Cionesque specimen. This little-known work, one of thirty-six panels composing a retable in the Museo Civico, Trieste, painted in the Veneto around 1325, is a typical Veronica image (Fig. 45).[94] Our

[88] "My peace I give unto you" (John, XIV, 27).

[89] See J. Wilpert, *Die römischen Mosaiken und Malereien*, Freiburg i/B, 1917, II, pp. 1123-1127, and K. Künstle, *Ikonographie der christlichen Kunst*, Freiburg i/B, 1928, I, pp. 589-592.

[90] See the exhaustive study of the Veronica legend by E. von Dobschütz, *Christusbilder*, Leipzig, 1899, pp. 197-262; also Wilpert, *loc.cit.*

[91] Dobschütz, *op.cit.*, p. 310.

[92] *Ibid.*, pp. 310-312.

[93] See, for instance, the thirteenth century drawings by Matthew Paris (M. R. James, in *The Walpole Society*, XIV, 1925-26, pl. 29, nos. 140, 141); also H. Swarzenski, *Die deutsche Buchmalerei des XIII. Jahrhunderts*, Berlin, 1936, I, pp. 52, 128.

[94] See Garrison, *op.cit.*, p. 148. A second Venetian example on panel is in the collection

Tuscan painting departs from it in several respects. Its highly ornamented cloth is unlike the usual white kerchief, but there are a few examples similarly decorated.[95] Only the face is usually shown, but once again there are instances in which the neck and part of the shoulders are included.[96] Similarly the representation of angels holding the cloth, though rare in the fourteenth and fifteenth centuries, is not entirely exceptional.[97] If our panel is actually a Veronica, it is apparently the earliest one in Tuscany, apart from the pilgrim's badge in the Spanish Chapel, and the earliest surviving example from any part of Europe painted as an independent subject on a panel.[98]

The head is almost certainly not more than life-size, and very likely less, so that the panel probably measures at the most a foot or a foot and a half in height. This small size, together with the inscription PACEM MEAM DO VOBIS, suggests the possibility that the painting may have served as a pax, a tablet employed in the liturgy to transmit the kiss of peace from the celebrant to other clerics and to the laity.[99] Though the surviving examples are mostly in metal, a few tiny panels, such as Fra Filippo Lippi's Man of Sorrows in the Horne Museum, Florence,[100] have been identified as liturgical instruments of this kind.

Whatever its precise use and iconic connotation, this little panel is significant as an

of J. Pope-Hennessy, London, (G. Fiocco, in *Dedalo*, XI, 1930-31, p. 892 and fig., as Maestro Paolo). The panel is a quatrefoil, and must have been part of an altarpiece or some other large complex.

[95] See the drawing by Matthew Paris (no. 140) mentioned in note 93. The cloth in the Veronica in the collection of J. Pope-Hennessy mentioned in note 94 shows four or five horizontal stripes. A diaper pattern appears in the cloth in the tenth or eleventh century image in Vat. Ross. 251, fol. 12v (see C. Osieczkowska, in *Byzantion*, IX, 1934, p. 264 and pl. 16).

[96] In the Venetian Veronica in the Pope-Hennessy collection the neck and the neckband of the tunic are visible. See also the image in Vat. Ross. 251, fol. 12v, mentioned in note 95.

[97] K. H. Schweitzer, *Der Veronikameister und sein Kreis*, Würzburg, 1935, p. 15, says that this type appeared ca. 1350, but his evidence is not clear. Possibly he had in mind a miniature in a document of Pope Clement VI of 1350 which was mentioned by K. Pearson, *Die Fronika*, London, n.d., p. 97. Pearson took his information about this painting from W. Grimm, *Kleinere Schriften*, III, p. 159. I have not been able to consult this book nor to find any trace of the painting. C. Aldenhoven describes an early panel formerly in Helmstadt in which two flying angels hold the cloth (*Ge-*

schichte der Kölner Malerschule, Lübeck, 1902, p. 375 note 121). A similar representation appears also in a drawing, of the early fifteenth century, in British Museum MS Royal 17 A XXVII, fol. 72v (Pearson, *loc.cit.*). This composition occurs frequently in later painting, especially German (see the panel by Zeitblom in Berlin: A. Michel, *Histoire de l'art*, Paris, V, part 1, 1912, fig. 13). In a Guelders Book of Hours of 1415 a standing angel holds the cloth (Berlin, Staatsbibliothek, 4°.42, fol. 15v).

[98] Apart from the panel discussed above, the earliest Tuscan Veronica seems to be the one by Masolino above his Man of Sorrows in Empoli.

Both K. Pearson, *loc.cit.*, and C. Aldenhoven, *loc.cit.*, mention a painting in the Cathedral of Prague which was traditionally identified as a sudarium, and which Charles IV was believed to have brought from Rome in 1368. This panel, however, is neither a Veronica nor made before ca. 1400 (see A. Matejcek, *Gotische Malerei in Böhmen*, Prague, 1939, pp. 135-136, pl. 143).

[99] See F. X. Kraus, *Real-Encyklopädie der christlichen Alterthümer*, Freiburg i/B, 1886, p. 602.

[100] See *Catalogo della Mostra d'Arte Antica —Lorenzo il Magnifico e le arti*, Florence, 1949, p. 26 no. 5. The panel measures 13 by 22 cm.

independent image of the Redeemer in the painting of the later fourteenth century. Two similar images from the same period, though the very end of it, have come down to us. One, probably Sienese, in the Lanz collection, Amsterdam, is a Veronica (Fig. 46). The other, a small Florentine panel in the Horne Museum, Florence (Fig. 43), omits the cloth and is simply a *volto santo*.[101] The halo in this panel is ornamented with an arabesque like those that appear in the paintings of Coppo and the Magdalen Master in the latter part of the Dugento. It is our Cionesque panel however (Fig. 42) that shows the more pervasive resemblance to earlier art. Though in detail the style of the Venetian painter of the Trieste panel is much more Byzantine (Fig. 45), his Veronica appears bland alongside our Tuscan image, in which the exaltation and intense ardor of Near Eastern Pantocrators seem to appear before us again.

THE SUPERNATURAL

The representation in the later fourteenth century of subjects such as the Trinity and the majestic Christ rather than the Madonna and Child springs from an intention to magnify the realm of the divine while reducing that of the human. A similar intention is evident, as we have seen, in the painting of religious history, which accents the miraculous rather than the natural, the mysterious rather than the familiar and the human. Sometimes the more explicit representation of the supernatural led to a fundamental modification of the compositions of the earlier fourteenth century and to what are, in fact, striking iconographic innovations.

Before the late thirteenth century the Resurrection was not a frequent subject in Italian painting. As in Byzantine art, the event itself was alluded to by the representation of the three Marys at the empty tomb. This is the scene that appears in the cycles of the life of Christ by both Giotto and Duccio. In the paintings of the Resurrection made in the late thirteenth and early fourteenth centuries, Christ, erect and frontal, or nearly so, stands on the tomb[102] or inside it.[103] Sometimes he seems to rise, though one foot remains either within the tomb or touching it.[104] These closely related postures persist in Florentine painting of the first third of the Trecento,[105] although the

[101] In the Lanz panel (no. 448 in the collection) Christ is crowned with thorns. For the painting in Florence, see *Illustrated Catalogue of the Horne Museum*, Florence, 1926, no. 81, p. 40, as school of Siena. These panels, unpublished so far as I know, prove that the Quattrocento paintings of the sudarium and of Christ crowned with thorns, discussed some years ago by R. Longhi (*Pinacoteca*, 1928, pp. 156ff.) have Trecento prototypes.

[102] Crucifix, S. Frediano, Pisa (E. Sandberg-Vavalà, *op.cit.*, fig. 381); Cavallinesque fresco in S. M. di Donna Regina, Naples (H. Schrade, *op.cit.*, fig. 16).

[103] Bolognese miniature ca. 1300 (P. Toesca, *La collezione di U. Hoepli*, Milan, 1930, pl. 19).

[104] Fresco in S. M. in Vescovio (Van Marle, in *Bollettino d'arte*, 1927, fig. 16). Reminiscent of this early type is, too, the fresco fragment of the Resurrection by Pietro Lorenzetti in S. Francesco, Siena, and the Resurrection by Luca di Tommè (Fig. 50) which is derived from Pietro's design. In both, Christ stands in front of the tomb, but he is, on the other hand, very active.

[105] In a miniature in the Kupferstichkabinett, Berlin, by a follower of Pacino di Bonaguida,

levitation of Christ is developed until, in Taddeo Gaddi's panel in the Florentine Academy of around 1330, he glides sideways from the tomb.[106] At the same time, however, the form of the Resurrection that had earlier become conventional in the north was adopted in Tuscany, or at least in Siena and Pisa. In these paintings Christ mounts from the sarcophagus, placing one foot on its front rim (Fig. 48).[107]

This composition was quite familiar to the Florentine painters of the later fourteenth century, but they rejected it for a novel design which, like the new form of the Pentecost, seems to have appeared first around 1366 in the Spanish Chapel (Fig. 47).[108] In it Christ does not climb from the sarcophagus, an active figure impelled by a firm will. He hovers high above it, and in the panel by Jacopo di Cione (Fig. 49), painted just about five years after the fresco by Andrea da Firenze, as well as in later representations,[109] he is frontal and entirely passive. A weighty figure, he is sustained in mid-air or drawn upward by a force that transcends, as it violates, natural law. In the painting by Jacopo di Cione, moreover, the sarcophagus is covered by the lid, which is undisturbed, in accordance with the belief that when rising Christ passed miraculously through the closed tomb.[110]

The essential relationship of this new type of the Resurrection with other representations of the time is evident. And like them, it is reminiscent of an older art. For

Christ stands in the tomb (Offner, *Corpus*, sec. III, vol. II, part II, add. pl. XI). In a miniature by Pacino in the Fitzwilliam Museum, Cambridge, he is floating, though his feet seem to touch the front edge of the sarcophagus.

[106] For the painting by Taddeo Gaddi see *Catalogo della Mostra Giottesca*, fig. 137m. Outside Tuscany a similar posture appears in the Riminese painting in the Palazzo Venezia, Rome (Van Marle, *op.cit.*, IV, fig. 138).

[107] In the north Christ more commonly puts a foot over the sarcophagus.

In addition to the painting by Ugolino reproduced in Fig. 48, other Tuscan examples of this type are the fresco by a follower of Pietro Lorenzetti in S. Francesco, Assisi, the central panel of the Sienese altarpiece of around 1335 in the museum at Borgo Sansepolcro (F. M. Perkins, *La Diana*, V, 1930, pl. 11), a miniature (ca. 1350) by Niccolò di Ser Sozzo (Toesca, *op.cit.*, pl. 51), and the fresco in the Camposanto at Pisa executed by an assistant of Francesco Traini (Meiss, in the *Art Bulletin*, XV, 1933, fig. 29).

[108] Schrade (*op.cit.*, pp. 149-151) confuses the development by placing a Florentine panel showing the floating Christ (Sirèn, *op.cit.*, fig. 213) immediately after Taddeo Gaddi's painting, though actually it was made later than

the fresco in the Spanish Chapel, in fact at the end of the century. He also ignores distinctions between the several Italian schools. The Hamilton Bible, for instance, is Neapolitan.

[109] Niccolò di Pietro Gerini, fresco, sacristy of S. Croce (Van Marle, *op.cit.*, III, fig. 344); miniature by a Florentine painter influenced by Spinello Aretino in the Musée Condé, Chantilly (Giraudon photo no. 7389: in the border, the rare scene of Christ putting his arm around his mother in a meeting after the Resurrection); fresco by a Pistoiese master, ca. 1400, in the Capitolo of S. Francesco, Pistoia. In a miniature of the end of the Trecento in S. Croce, the floating Christ is turned to a three-quarter position and looks upward (P. d'Ancona, *La miniatura fiorentina*, Florence, 1914, pl. XXIII).

[110] Just as at birth he emerged from the body of the Virgin without destroying her virginity (see Y. Hirn, *The Sacred Shrine*, London, 1912, chap. XVII).

The miraculous passage through the closed tomb is represented also by Lippo Vanni in the Antiphonary in the Fogg Museum, and by those earlier paintings cited above (note 102) in which Christ stands on the covered sarcophagus.

although the levitation of Christ is anticipated to a degree by Pacino di Bonaguida and Taddeo Gaddi, the passive suspended figure recalls the paintings of the thirteenth and very early fourteenth century in which Christ, erect and frontal, stands on or in the tomb.[111] And this early form is itself revived in at least one instance, a predella panel of unknown whereabouts by Giovanni da Milano, which shows Christ poised majestically on the closed lid of the sarcophagus.[112]

At the end of the fourteenth century Agnolo Gaddi returned to the active Christ mounting the tomb in the Resurrection,[113] just as he revived other forms and compositions characteristic of the second quarter of the century.[114] Many of his successors followed him in this respect, but the new type of Andrea da Firenze reappeared frequently in later art, either in its original form, showing Christ suspended, or developed to suggest a more active rise to heaven.[115] Often its reappearance is associated with the style of a painter or a period that is related in one way or another to that of the third quarter of the Trecento, but its continued use is also a symptom of a general trend to distinguish, more explicitly than in the art of the first half of the fourteenth century, the supernatural from the ever-growing realm of the natural. For us it is significant that the beginnings of this historical movement lie in the third quarter of the Trecento. In this way, then—and we shall have further evidence of it—the painters of the third quarter of the fourteenth century made an important contribution to the evolution of later religious painting.

The fresco by Andrea da Firenze combines with the Resurrection the representation of the three Marys at the Tomb and the *Noli me tangere*. Despite variations in scale and the slight differences of depth at which the figures are placed, they are united in a single vertical plane. The two figures of Christ and the angels are frontal or nearly so, the Magdalen is in profile. They are linked with the other figures by the rhythmical sequences of their outlines and by their gestures, all of which remain within the dominant plane. In partial opposition to this the landscape is expansive and deep. Its overlapping and terraced planes, exhibiting a variety of flora and fauna, extend further

[111] Schrade (*loc.cit.*) suggested quite rightly that the new floating type in Florence was influenced by the Ascension. The Christ in Jacopo di Cione's Resurrection is, in fact, almost indistinguishable from the Christ in his Ascension. Schrade refers also to precedents in German Romanesque painting (see his fig. 20).

[112] Berenson, in *Dedalo*, XI, 1931, pl. opp. p. 1060.

[113] See his panel in S. Miniato (R. Salvini, *L'arte di Agnolo Gaddi*, Florence, 1936, pl. 37).

[114] See his fresco of the Meeting at the Golden Gate in the Duomo at Prato (*ibid.*, pl. 27a), in which the action of Joachim and Anna is reminiscent of Taddeo Gaddi's fresco (Fig. 33); and the Presentation of the Virgin,

also in Prato (*ibid.*, pl. 27b), in which the Virgin turns to look at her parents, and the priest, placed very little higher than Joachim and Anna, bends to welcome the child.

[115] See, for instance, the terracotta by Luca della Robbia in the sacristy of the Duomo, Florence; Ghiberti's relief on the Baptistery doors (though this is perhaps more closely related to Taddeo Gaddi's Resurrection in the Academy); Castagno's painting in the Frick Collection and Bellini's in the Kaiser-Friedrich Museum; Vecchietta's bronze in the Frick Collection; and, though Christ is more active, Gruenewald's altarpiece at Colmar, and Titian's in Brescia.

into space than in earlier Florentine paintings, but they tend at the same time to coalesce in the plane of the figures. This unification is abetted by the light. The radiant Christ hovering in the air is the main source of it. A bright aura surrounds him, lighting the horizontal streaks of clouds beneath his feet and striking into the dark landscape below. It falls with great intensity upon a few large forms—the angels, the tomb, the two hills, the city wall at the left corresponding to the figure of Christ in white at the right—creating a symmetrical pattern of light that strengthens the symmetry of the main forms in the composition. But the light is no longer limited to its usual function in the earlier Trecento of defining mass and space; it becomes essential to the drama and mystery of the scene. As a quality that is no less expressive than line, shape, and volume it recalls a late thirteenth century painting such as Coppo's Crucifix at San Gimignano while it anticipates the art of Lorenzo Monaco and of the later Quattrocento.

The new form of the Resurrection in the third quarter of the century was motivated by the desire to endow Christ with a more decisive hierarchical superiority and to accentuate the miraculous character of the event. In it the supernatural is represented explicitly by the unnatural. A similar intention and similar methods are evident in the novel forms given to other subjects at this period. In Andrea's fresco of Limbo Christ floats toward Adam, scarcely touching with his feet the fallen portal (Fig. 98). The Madonna of Humility, created in the second quarter of the century as an intimate image of the Virgin's sympathy and love (Fig. 128), was so drastically transformed after 1350 as to lose much of its original meaning.[116] Seated on a cushion, the Madonna is raised above the ground and suspended in the area of gold, becoming less the humble mother than an exalted celestial apparition (Fig. 145). Whereas the painters of the early Trecento brought the sacred figures down to earth, both figuratively and literally, those of the third quarter of the century projected them upward again.

The germ of this new celestial Madonna lay in the original image and its copies, which allude to an identification of the Madonna with the heavenly Woman of the Apocalypse. In these works she was therefore exalted in her humility. But whereas her heavenly aspect was suggested originally by symbols of the sun, the moon, and twelve stars, it is conveyed in the new celestial type by the elevation of the Madonna herself and her unnatural suspension in space. Hovering or ascending figures are of course not absent from the art of the earlier fourteenth century: the Madonna rises through space in the Assumption, Christ in the Ascension, St. John in his translation. Their number increased, however, in the third quarter of the century, and often, as in the "celestial Madonna" or in cult images (Figs. 1, 11), the supernatural effect is heightened by showing the suspended figures in seated postures.

Only a portion of the representations of the Madonna of Humility painted after the middle of the century belong to the "celestial type." But even those paintings that conform more closely to the original image show important and characteristic differ-

[116] For the history of the Madonna of Humility see chap. VI.

ences. In the panel now in Washington, probably designed by Orcagna and executed partly by Jacopo di Cione (Fig. 140), the Child is no longer suckling nor even close to the Virgin's breast. In other paintings he is seated upright on her knee.[117] In Jacopo di Cione's panel in the Academy (Fig. 138) he is wholly wrapped in a rich cloth, and though his head touches the Virgin's, the two impinge like stones. The peculiar discreteness of the two figures is enhanced by the characteristic contrasting colors—intense blue in the Madonna's mantle and orange-red in the wrap of Christ.

It was of course not only the Humble Madonna that was transformed after the middle of the century. In the traditional Madonna enthroned, the throne itself was often eliminated, as in Nardo's altarpiece (Fig. 11), and in a painting by the Master of the Fabriano Altarpiece, the Virgin together with her throne is suspended above the ground.[118] There is, too, in this period an exceptional group of paintings of the standing Madonna. Though common in free-standing sculpture, this representation was rare in Tuscan painting before the third quarter of the century, when Nardo and Jacopo di Cione and their followers executed a series of six examples.[119] In the panels by Nardo (probably the earliest, Fig. 51) and Jacopo (Fig. 53) the height of the Virgin is increased by the exceptional length of the lower half of her body. She holds the Child in a formal, diffident way, her own thought detached, veiled, and inscrutable. She towers above the spectator or the small kneeling saints and donors, more like a priestess than an affectionate intercessor or a mother.[120]

[117] See chap. VI, note 25.

[118] The panel, formerly in the collection of A. E. Street, London, was painted around 1365 (Offner, *Corpus*, sec. III, vol. v, pl. 50). It anticipates the Madonna by the Master of Flémalle at Aix.

[119] Madonnas by Nardo di Cione, collection of Tessie Jones, Newburgh, N.Y. (Fig. 51); Jacopo di Cione, partly repainted, SS. Apostoli, Florence (Fig. 53); Giovanni del Biondo, Vatican Gallery (Fig. 52); Master of the Fabriano Altarpiece, ca. 1365 (Offner, *Corpus*, sec. III, vol. v, pl. 44); follower of the Cioni, formerly in the Corsi collection, Florence; follower of the Cioni, Museo Civico, Arezzo. See also the tabernacle by Ceccarelli in the Walters Gallery, Baltimore.

Of the five standing Madonnas of the thirteenth or very early fourteenth century listed by Garrison, only one is definitely Tuscan—the panel at Peccioli (Garrison, *op.cit.*, no. 47; but see also no. 45). From the circle of the great masters of the first half of the fourteenth century I know only the standing Madonna by the Dijon Master in the collection of Bernard Berenson, and this may in fact have been painted after 1350.

[120] In two of the paintings there are allusions to the Apocalyptic Woman, as often in the Madonna of Humility. Stars are strewn over the ground plane of the panel by Jacopo di Cione (Fig. 53). Twelve stars appear above the head of Giovanni del Biondo's Madonna in the Vatican, and the crescent moon below her feet (Fig. 52). Above the Madonna an angel touches the lips of Isaiah with a coal of fire. Friar Philip, one of the first companions of St. Francis, had a similar experience (*Fioretti*, chap. I), and this fact may be relevant because Giovanni's panel is Franciscan. Another aspect of the extraordinary iconography of this panel, the corpse in the predella, will be discussed below (p. 74).

Apocalyptic symbols appear also in two Cionesque paintings that represent the *Madonna del Parto*, one in the Vatican (P. d'Acchiardi, *I quadri primitivi della Pinacoteca Vaticana*, Rome, 1929, pl. x), the other in the Museo Bandini, Fiesole, Room I, no. 6 (*Rivista d'arte*, XVI, 1934, p. 217). This image, which has been discussed by Offner (*Corpus*, sec. III, vol. v, p. 28), shows the pregnant Virgin standing, wearing a girdle and holding a book. There are two Florentine examples of around 1335,

The Coronation of the Virgin underwent a transformation in the third quarter of the century similar to that of the Resurrection and the Madonna of Humility. In the early Trecento the scene was set on a floor or platform. The throne of Christ and the Virgin was raised somewhat above it on a dais, and the witnesses were assembled at the sides (Fig. 58).[121] Shortly after the middle of the century a new composition was created. In Florence in 1360 and somewhat later in Siena the supernatural character and environment of the action was expressed by suspending Christ and the Virgin above the ground (Figs. 54, 56).[122] Though their throne is usually eliminated, they appear in seated postures, often before a figured drapery[123] or surrounded by cherubim,[124] and sometimes above a small cloudbank that symbolizes the natural heavens and provides a semblance of a supporting plane.[125] The attendant saints and angels, who in earlier representations stood alongside Christ and the Virgin, are now usually placed below, and occasionally they, too, are without a ground plane.[126] When they

but only the two Cionesque paintings contain the Apocalyptic symbols. In the Fiesole panel, the Virgin, labeled *Regina Coeli*, wears a crown, the moon is beneath her feet, and stars are strewn over her mantle as well as on the ground. In the Vatican panel twelve stars appear above the Virgin's halo, and the moon is at her feet.

[121] See for instance the Ducciesque paintings in the Pinacoteca, Siena, no. 35, and in the Metropolitan Museum, New York, no. 41.190.-31; panel by the Master of the St. George Codex, Musco Nazionale, Florence; fresco by a follower of Ambrogio Lorenzetti, S. Agostino, Montefalco; the Baroncelli altarpiece in S. Croce (Fig. 58), and the Daddesque panel in Altenburg, no. 13 (Offner, *Corpus*, sec. III, vol. IV, pl. 36).

A Coronation in the pinnacle of a Madonna in the Kaiser-Friedrich Museum (no. 1710), painted by a late follower of Duccio who was influenced by Simone Martini, shows Christ and the Virgin seated on cherubim (P. Hendy, in *Burlington Magazine*, LV, 1929, pl. IIB). This composition anticipates the type of the third quarter of the century. A ground plane is lacking also under the throne of Christ and the Virgin in Pacino's small medallion in the Tree of Life in the Academy, Florence. The omission, exceptional in its time, may have been suggested by the unusual shape of the frame.

[122] I described this innovation in the *Art Bulletin*, XVIII, 1936, p. 448, and XXVIII, 1946, p. 13. See also Offner, *Corpus*, sec. III, vol. V., 1947, p. 250. Offner suggests that the celestial type was anticipated by Torriti's mosaic, and

that the first Florentine example may have been Jacopo di Cione's panel of 1372-1373 in the Academy. While it is true that Jacopo's panel appears to be the first in which Christ and the Virgin, together with the drapery behind them, are separated from the figures and the ground below by a strip of gold, the two figures were supernaturally suspended as early as 1360 in the altarpiece by Matteo di Pacino, formerly in the Stroganoff collection, and dated in that year (Khvoshinsky and Salmi, *Pittori toscani*, Rome, 1914, II, fig. 38).

[123] Panels by the Master of the Fabriano altarpiece in Ghent and in the Cenami-Spada collection, Lucca (Offner, *ibid.*, pls. 39 and 42); Jacopo di Cione, altarpiece of 1372-1373 in the Academy, Florence (Fig. 56); Matteo di Pacino, altarpiece of 1360 (see preceding note); Giovanni del Biondo, altarpieces in the Musco Bandini, Fiesole and S. Ansano (near Florence), both of 1373, and in the Oratorio of S. Giovanni Valdarno (Van Marle, *op.cit.*, III, fig. 291).

[124] Bartolo di Fredi, Museum, Montalcino, dated 1388 (Fig. 54); Niccolò di Buonaccorso, collection of Philip Lehman, New York; follower of Bartolo di Fredi, Siena, Pinacoteca no. 580.

[125] Panel by a follower of Jacopo di Cione, Vatican (Van Marle, *op.cit.*, III, fig. 286) and Cionesque panel, Musée des Arts Décoratifs, Paris (Giraudon photo no. 26713). For additional examples, see Offner, *op.cit.*, p. 250.

[126] Coronations by Niccolò di Tommaso, Castle, Konopiště (Meiss, *Art Bulletin*, XXVIII, 1946, fig. 23) and Academy, Florence (Offner,

flank Christ and the Virgin they are decisively separated from them by a circle of cherubim or by a mandorla.

Thus in this composition, as in others of the time, the most important figures are isolated and remote. In this respect they resemble the corresponding figures of the thirteenth century more than those of the first half of the fourteenth. The essential aspect of the new Coronation, the heavenly locale of Christ and the Virgin, is itself reminiscent of Dugento painting. In the beautiful mosaic made by Jacopo Torriti in 1296 for the apse of S. M. Maggiore (Fig. 55), one of the earliest surviving Italian representations of the Coronation, the enthroned Virgin and Christ are placed in a round mandorla that hangs like a rising moon above the world. The moon itself and the sun appear just below the throne, and these elements of Torriti's Byzantinesque composition recur in representations of the Coronation painted during the 'fifties and probably earlier in that Italian center in which Byzantine form lingered longest in the Trecento: Venice.[127] In these paintings, too, a mandorla sometimes appears behind the throne (Fig. 57), and an ornamented cloth is spread behind Christ and the Virgin, adding to the luxurious effect of their garments. It is, in fact, not impossible that the Tuscan painters of our period were attracted by Venetian painting of the fourteenth century, as they certainly were by the earlier Byzantinesque art of the Dugento.

THE RECOVERY OF THE DUGENTO

The similarity of the heavenly type of the Coronation with Torriti's mosaic is only one of numerous resemblances that we have already observed between the painting of the third quarter of the fourteenth century and the Romanesque or Byzantine art of the Dugento. In the light of these resemblances, the conception current among the early Florentine writers and still surviving today, of Giotto as a sort of impassable continental divide in the history of Italian painting, clearly requires some qualification. This qualification is all the more important because certain forms of our period that seem to have been influenced by pre-Giottesque painting—qualities of expressive light and color as well as compositions such as the Resurrection or Coronation—per-

Studies, p. 112 and fig. 3); late fourteenth century Florentine panel in the University Gallery, Göttingen, no. 62.

[127] See the Coronation in the Frick Collection, New York, by Maestro Paolo and his son Giovanni, dated 1358 (Van Marle, *op.cit.,* IV, fig. 6); the earlier Coronation in the Brera (Fig. 57).

In Trecento Venetian paintings of the Coronation, as in Torriti's, Christ is seated majestically and often does not look at the Virgin while with one hand he places the crown on her head. The action is similar in the Paduan psalter, late thirteenth century and very By-

zantine, formerly in the Yates Thompson collection (*Illumination of One Hundred Manuscripts in the Library of Henry Yates Thompson,* London, v, 1915, pl. 65; here the sun and moon are missing, but the figures rest their feet on orblike baldachini). In Tuscan representations, on the other hand, Christ abandons this posture of dignified superiority. He becomes more fully involved in the action, and turning toward the Virgin, he bestows the crown with both hands. (In the earliest Tuscan example, the mosaic in the Duomo, Florence, Christ places the crown with one hand and blesses the Virgin with the other.)

sisted in later art. In this sense the "recovery" of certain aspects of Dugento form was a fateful historical accomplishment.

Relationships with the Romanesque or Byzantine traditions of the thirteenth century are of course not lacking in the painting of the first half of the Trecento. Giotto and Duccio, each in his way, was deeply indebted to them. Even while denying and transcending the older pictorial tradition, they absorbed and maintained a part of it. Among the followers of these masters, however, the connection diminished. A few Dugento forms, considerably modified, persisted—such as the type of altarpiece representing in the central panel a saint and in the wings scenes from his life.[128] Jacopo del Casentino, when designing an altarpiece for San Miniato,[129] not only adopted this kind of retable, but retained the earlier proportions and the older means of dividing the scenes. It is possible, however, as Offner has suggested, that the close dependence of this and a few similar works on thirteenth century precedent arises from an intention of the painter and the donor to replace an earlier miracle-working image.[130] Apart from such specially motivated instances, the relationships of the first half of the century with Dugento painting are neither so pervasive nor so central to style and content as those of our period. In the work of Giotto, Duccio, and the painters of their generation Dugento form persisted as a natural heritage; for the later Trecento it was the object of conscious interest and deliberate selection.

The similarities between Torriti's mosaic (Fig. 55) and the paintings of the Coronation of the Virgin by Bartolo di Fredi (Fig. 54), Jacopo di Cione (Fig. 56), and other masters of the period are not limited to the representation of a transcendental locale. In the mosaic Christ and the Virgin are clothed in rich garments, the large crown is set with jewels, and the cushions and throne are highly ornamented. This material opulence, characteristic of the Byzantine tradition, including its late phase in Venice (Fig. 57), is approximated in the painting of the third quarter of the Trecento. In the panels by both Fredi and Jacopo di Cione the Virgin and some of the saints and angels wear a figured mantle, and in Jacopo's painting Christ and the Virgin appear in front of a brocade woven with golden threads. A similar cloth is spread behind Nardo's Madonna (Fig. 11), laid over the throne of God in the altarpiece of the Trinity (Fig. 9) or over the altar in Bartolo di Fredi's Presentation (Fig. 15). It is worn as a tunic by the Virgin in the Pentecost (Fig. 39) or used to wrap the Child in Jacopo di Cione's Madonna of Humility (Fig. 138). Frequently the ground plane itself is ornamented and has the character of a textile, as in the Strozzi altarpiece (Fig. 1), where a larger

[128] For example, Simone Martini, altarpiece in S. Agostino, Siena (Van Marle, *op.cit.*, II, fig. 156).

[129] *Ibid.*, III, fig. 172.

[130] Offner, *Corpus*, sec. III, vol. V, p. 132 and note 3, cites the Crucifix in the Academy by the Assistant of Daddi; the shape of the altar-piece by Giovanni del Biondo in the Contini collection (Fig. 68), which in this respect is related to the retable of Jacopo del Casentino; and the Madonnas by Ambrogio Lorenzetti at Vico l'Abate and Bernardo Daddi in Or San Michele.

area of it, significantly enough, is visible just below Christ. Precious objects such as crowns are large and elaborately contrived (Figs. 1, 54, 56).

It is true that a related decorative richness may be found in several panels of Simone Martini. In the Giottesque and Lorenzettian traditions, on the other hand, the garments of the figures are generally plainer, and ornament is much less prominent. As has often been observed, the taste of Simone Martini and his technique of working the gold influenced greatly the painting of the later fourteenth century. But to his example must be added Byzantine and Byzantinesque paintings and mosaics of an earlier time. In later Trecento works the transcendent world of the Deity and the saints glows with gold and is filled with objects of luxurious and sparkling texture.[181] This material richness is concentrated on or around the superior beings, and the hierarchical distinctions that it implies are often augmented by clothing lesser religious figures as well as laymen in contemporary dress.

In color, too, the paintings of our period imply an attentiveness to the panels and mosaics of the Dugento. Single hues and their pattern, like other qualities of form, vary considerably of course from painter to painter. Among the Florentines, Niccolò di Tommaso inclines toward warm and relatively mild colors—rose, lilac, yellow-green, and pale orange, which he frequently uses in the hair. Giovanni da Milano shows a related taste, preferring especially a light apple green. The hues of Jacopo di Cione are more somber and sooty. Despite this diversity, however, the colors of the more advanced painters of the time show a certain similarity. They are more solid and saturated, and less transparent, than those of Giotto, Simone, the Lorenzetti and their followers. Their impact is more direct, less merged with impressions of roundness or space, and they compose a pattern that tends to be more independent of the design of the shapes. Among the Florentines this taste was inspired by the art of Maso di Banco, who had given to hue and value a basic structural function—in one fresco in S. Croce the ground plane moves from buff to olive green. His painting exhibited a new delight in the evocative power of color as such. But in its density and radiance the color of the later Trecento is equally reminiscent of the mosaic and panel painting of an earlier period, and these broad resemblances become quite explicit in the swarthy flesh tones. As in Byzantinesque works of the thirteenth century, the flesh colors tend to be dark red-brown, and the *terra verde* underpainting is more telling in the finished surface. These somber colors, alternately warm and cool, contribute to the intense expressiveness of the faces, stark, dour, grim, and often anguished (Figs. 30, 31, 42, 60-62).

The Dugento provided, however, no historical precedent for the intensity of the color contrasts in the third quarter of the fourteenth century. Extraordinarily strong blue alongside scarlet, which we have observed in the Strozzi altarpiece, recur con-

[181] Bartolo di Fredi, in his *Adoration of the Magi* in Siena (Van Marle, *op.cit.*, II, fig. 318) uses gold in the large, prominently displayed hats of the Magi and on the harnesses of their horses as well as on their gifts, their clothes and their crown. The tunic of the Virgin, the wide border of Joseph's mantle, and the architecture contain gilt motifs. Very little gold, of course, was used in frescoes.

stantly in the painting of Florence and frequently, too, in Siena. Closely crowded shades of red are juxtaposed, and a brilliant yellow alongside gold. These clashing colors, bright and dark, warm and cool, are set side by side to create a tense pattern of repeated abrupt change.

One painting of the period exhibits such broad resemblances to Dugento dossals that at first glance it might almost seem a thirteenth century work (Fig. 63). Now in the National Gallery, London,[132] the hitherto unpublished, it is one of the rare tempera paintings by Andrea da Firenze. Though many works have been attributed to this master, only the altarpiece in the Carmine in Florence (Fig. 64), and two panels in the storeroom of the Accademia are in my opinion by him.[133] The design of the Madonna and Child in the London panel recurs in the Carmine altarpiece and also in the center panel of the triptych that stands on the altar before which S. Ranieri kneels in Andrea's fresco in the Camposanto at Pisa.[134] The polyptych in London is clearly connected with the Dominicans of S. M. Novella, for whom Andrea executed a great fresco cycle, and it shows a special relationship with the Gondi Chapel in their church.[135]

The painting in London belongs to a type of low retable with a higher, projecting central field that was current in Florence in the second half of the thirteenth century. Only a few examples have survived.[136] It is probably significant that the best of them is an altarpiece dated as early as 1271 (Fig. 2). Toward the end of the century the type seems to have become outmoded in Florence, and though in the early Trecento it continued in occasional use in provincial regions, I am aware of only one example in Tuscany—a painting from the conservative circle of Pacino di Bonaguida.[137] Andrea da Firenze reverted then to a form of the second half of the thirteenth century. And the division of the entire field by colonnettes that support round arches (except in the center) draws his work closer to the earliest example of the type, the altarpiece of 1271 by Meliore (Fig. 2). The later ones employ pointed arches or a painted framework or, as in the late Dugento altarpiece at Yale[138] or the one by the school of Pacino mentioned above, eliminate the divisive framework entirely.

It is possible that the adoption of this long outmoded form was motivated less by the artistic intention of the painter than by the wish of his patron to possess a sort of replica of a Dugento painting made memorable for religious or other reasons. In weighing such a possibility we should have to bear in mind Andrea's consistent interest in the painting of the earlier period, and his use of a Dugento convention in the

[132] No. 5115. The surface is dirty and somewhat damaged. The painting came to the Gallery in 1940 from the collection of Mrs. F. W. Myers.

[133] Deposito, Academy, Florence, no. 3145. See B. Berenson, *Italian Pictures*, p. 11. Close to Andrea are Saints Agnes, Bartholomew, Nicholas, and Elizabeth in the Museum at Houston, and eight saints, perhaps the left

section of a triptych of the Coronation, formerly in the market at Brussels.

[134] A. Venturi, *Storia, cit.*, v, fig. 653.

[135] See Appendix IV.

[136] Garrison, *op.cit.*, pp. 159-161.

[137] In a private collection in Dublin. Cited *ibid.*, p. 159.

[138] O. Sirèn, *op.cit.*, p. 17 and Garrison, *loc.cit.*

Carmine Madonna, where it was almost certainly not dictated by the patron nor by a special function of the work. In this panel (Fig. 64), as in numerous Tuscan Madonnas of the late thirteenth century,[139] the busts of two angels appear above the back of the throne, their heads nearly frontal and inclined gently toward the Virgin. But even if Andrea had been asked, when undertaking the London panel, to produce the semblance of a thirteenth century painting, the significant thing is the extraordinary sympathy for his model that he displayed in executing the commission. For in addition to retaining the shape and design of the older altarpiece, he has given most of the saints a Dugento impersonality and rigidity, and five of them are represented frontal. He has even inserted in each spandrel a colored stone, four of them blue and four pinkish orange—the favorite colors of the time. This means of enhancing the glitter and preciousness of a painting is unique, so far as I know, in the Tuscan Trecento. It was common enough, however, in the thirteenth century, and similar colored stones might have been visible in the spandrels of Meliore's altarpiece (Fig. 2) had they not later been replaced by seraphim.

However much the shape of the polyptych in London resembles Dugento dossals, in one respect it differs conspicuously from them and at the same time from polyptychs of the earlier fourteenth century. Along with the Madonna there are not the usual four or six saints, but ten. It is improbable that this exceptional number appeared in Andrea's model, if indeed he had one; and even if the patron had insisted that all these saints be represented, Andrea was still free to vary the proportions of his polyptych as he included them. To an eye familiar with the shapes of thirteenth and earlier fourteenth century Tuscan polyptychs (Fig. 2), Andrea's central panel would seem much too small. Its size, including the leafy projections from the frame, would be normal in relation to two or at most three saints at each side, but not five. It rises abruptly from the long blank horizontals of the lateral sections, without attaining sufficient size to maintain a quiet dominance over them. These unusual relations are neither accidental nor unique. They recur in Andrea's fresco of the Pentecost (Fig. 41), where Peter rises starkly above the eleven apostles and the Virgin, who compose an isocephalic group like the saints in the polyptych. In the same painter's Way to Calvary (Fig. 38) the long, only slightly varied horizontal of the central part of the procession is broken by the emergence of two soldiers, framed by turrets, just above and behind Christ. A similar unmediated emergence from a horizontal group occurs in Bartolo di Fredi's Presentation (Fig. 15), and to a degree in Nardo's Madonna (Fig. 11), as we have already seen. And in Giovanni da Milano's Expulsion of Joachim (Fig. 36), the relationship of the priest and the relatively small central bay of the church to the long row of sacrificants and the aisles is likewise reminiscent of Andrea's polyptych.

The tendency of this period to distinguish Christ and other superior figures by eleva-

[139] See the altarpiece of St. Anne and the Virgin, Museo Civico, Pisa (Van Marle, *op.cit.*, I, fig. 149); the Madonnas at Rovezzano, Stia, and S. M. dei Servi, Bologna (*Catalogo della Mostra Giottesca*, figs. 69, 84a, 95a).

tion, immobility, isolation, and frontality, is manifest not only in cult images and scenes of ritual and the supernatural; it shows itself also in narrative subjects that in the earlier part of the century had been the occasion for the expression of warm, spontaneous and intimate feelings. In the Deposition from the Cross by Duccio (Fig. 67) the mourners press with desperate affection around the dead body of Christ. The Virgin, Mary Magdalen, and St. John kiss the limp figure, helping at the same time to support it. All the representations of the Deposition in the first half of the century are related to this in the quality of their action and emotion. Though in the panel by Simone Martini in Antwerp[140] Christ and the cross are higher, the figures below unite in a frantic movement toward him. His slumped body is surrounded by their clutching hands and by Joseph of Arimathea and Nicodemus, who are very close to him on the cross. In Bartolo di Fredi's deeply-felt Deposition of 1382 in Montalcino (Fig. 66), on the other hand, Christ is comparatively alone, with larger, less active spaces around him. His unsupported, stiffly suspended head and the slightly divergent planes of his torso create the maximum tension in a very tense design. Unlike earlier Trecento representations (Fig. 67), he is very nearly frontal,[141] and his entire body forms a rather rigid, unnatural arch that is the dominant shape in the composition. In all these respects Bartolo di Fredi's panel resembles the Deposition in Dugento painting (Fig. 65).

The trend toward symbolism in later Trecento painting and its method of expressing values by the relative position of the figures in the picture space unite in the work of one painter of the period to produce images of a very exceptional kind. In three of his large panels Giovanni del Biondo represented one figure trampling upon another. In his altarpiece in the Contini collection in Florence (Fig. 68), which preserves a thirteenth century convention in its general design and the absolute frontality of the central figure, the grim, aggressive Baptist stands on a recumbent figure of Herod, pinning him down with his talon-like feet and long, predacious toenails. In Biondo's panel in the cathedral of Florence, the enthroned St. Zenobius puts his feet on personifications of pride and cruelty (Fig. 70). Three vices lie beneath the enthroned St. John Evangelist in the same painter's panel in the Uffizi (Fig. 69), a work which was probably commissioned by the Arte della Seta, perhaps for a pier in Or San Michele.[142]

[140] Van Marle, *op.cit.*, II, fig. 162.

[141] The torso of Christ is frontal in the Deposition in the Sienese altarpiece, ca. 1335, in Borgo San Sepolcro (F. M. Perkins, *La Diana*, v, 1930, pl. 16), but in other respects this composition shows the form and qualities of mood and action of Duccio and the Lorenzetti.

[142] Now no. 444 in the Uffizi, the panel came to the Gallery from the Camera di Commercio, an institution founded in 1770. The paintings in its possession were inherited from the guilds, several of them from the guild church of Or San Michele. (For this information about the Camera I am indebted to a notice given by Dr. Ugo Procacci to Professor Richard Offner, who kindly communicated it to me.) The panel has in the past been associated with a predella, no. 446 in the Uffizi, which represents the Ascension of the Evangelist and which bears the stemma of the Arte della Seta (Alinari photo no. 990). This predella, conforming in subject and place of origin to Biondo's panel of St. John, was probably made for it, but it was painted by a different hand (a related

These compositions revive an old mediaeval convention in which Christianity demonstrates its victory over its enemies, or the virtues their conquest of the vices, by the simple physical act of trampling them underfoot.[143] The famous passage in Psalm xc about the asp and the basilisk was commonly referred to Christ, who was represented standing on these creatures, or seated, like Biondo's saints, with his feet upon them.[144] When in 1376 the French Pope Gregory XI set out for Italy his aged father attempted to restrain him by throwing himself at his son's feet. The pope, saying "it is written that thou shalt trample upon the asp and the basilisk," passed over the prostrate body of his father and boarded his ship.[145] The image, referred to Christ, appears in Giovanni Pisano's pulpit in Pisa. And in two frescoes in the Arena Chapel Giotto employed the related device of the virtues, personified as female figures, treading on the vices. In adopting this traditional representation, however, Giotto modified it in an essential and significant way. He did not place underfoot the traditional personifications of the vices, as they appear for instance on Strasbourg Cathedral,[146] but only symbols of them. Caritas stands on bags of money and grain that signify avarice (Fig. 72), and Faith treads upon pagan writings while pinning down an idol with her cross (Fig. 73), just as the lances of the Virtues pinned the Vices in the traditional compositions. The exchange in these two frescoes of personifications for symbols was motivated in part perhaps by the painter's desire to avoid repetition, for personifications of infidelity and other vices (though not avarice)[147] actually appear on the opposite wall of the chapel. But it seems probable in any event that Giotto's conception of the human being as the source and the emblem of moral and aesthetic values would lead him to avoid, if he could, casting figures on the ground, to be trodden ignominiously underfoot. When he must subject them to this or similar mistreatment, as in the Inferno, he greatly reduces their scale, giving them a miniature-like unreality. And though two of the personified vices are partly deformed, he will not deny most of them a certain shapeliness and grace and even dignity, while the greatest violence he does

Orcagnesque Master) and it is wider than Biondo's painting. The latter measures 2.34 x 1.04 meters, the predella, 0.55 x 1.15.

[143] See A. Katzenellenbogen, *Allegories of the Virtues and the Vices*, London, 1939, pp. 14ff.

[144] Twelfth century relief, Porta dei Mesi, Duomo, Ferrara. For this and earlier examples, see Trude Krautheimer-Hess, in the *Art Bulletin*, XXVI, 1944, pp. 156, 171.

[145] E. G. Gardner, *St. Catherine of Siena*, London, 1907, p. 194.

[146] Katzenellenbogen, *op.cit.*, fig. 19.

[147] Giotto did not include Avarice among the personifications of the vices. He placed Envy opposite Caritas, but he alluded to Avarice twice in this opposed pair. Caritas stands on moneybags, as we have seen, and Envy holds one. By representing Envy instead of Avarice, and giving her this form, Giotto's thought is related to that of his Florentine contemporary, Giovanni Villani. Though Villani classified avarice as one of the capital sins, he asserted that it arises from envy (see his *Chronicle*, book XI, chap. 2).

Giotto's Envy, furthermore, with her tightly clutched treasure and her grasping hand, is not unlike Ambrogio Lorenzetti's Avarice in the Palazzo Pubblico, Siena (Fig. 74). Avarice here is an old woman who holds a grappling-hook and a closed chest. Giotto's figure is clearly an avaricious Envy.

to Folly, Inconstancy, and Infidelity is to throw them off balance—for him a momentous step and a particularly poignant means of expressing evil.

Though such conceptions in their full range of meaning are peculiarly Giotto's, they were shared to some extent by all the painters of the *stil nuovo* of the first half of the fourteenth century. Inanimate symbols might be trampled, as the weapons of war by Ambrogio Lorenzetti's Peace, but personifications, whether of evil or of a defeated good, were simply placed upon the ground (Fig. 74).[148] It was, so far as I know, only in the 'sixties and 'seventies, in the painting of Giovanni del Biondo, that the old device of human figures underfoot was revived.

In Giovanni del Biondo's panel in the Duomo (Fig. 70) the drapery behind St. Zenobius is held by the winged Virtues, Humilitas and Caritas, and his feet rest on the corresponding Vices, Superbia and Crudelitas. Crudelitas appears here as the opposite of the latter of the two aspects of Caritas—*amor dei* and *amor proximi*.[149] And just as *amor proximi*, or love of one's fellowmen, is represented in Italy by a woman caring for a child (Nicola Pisano's pulpit in Pisa), Cruelty in Biondo's painting assumes the form of a vicious person attacking a child. This motif is especially appropriate in a representation of St. Zenobius, who was revered for having revived a child—a miracle which in fact is represented in the predella.[150] Ambrogio Lorenzetti in his fresco of Bad Government had earlier shown Cruelty brandishing a serpent in one hand and choking an infant with the other (Fig. 74).[151] In the more strenuous times of the later Trecento, when the tortures of conscience and of Hell became more intense (Fig. 83),[152] Giovanni del Biondo turned Cruelty into a cannibal who sinks fanglike teeth into the writhing child.

Below the feet of John the Evangelist in Biondo's panel in the Uffizi lie Pride, Avarice, and Vainglory (Fig. 71). These vices largely coincide with the great sinful trio of the late Middle Ages, pride, avarice, and unchastity.[153] This trio is supreme in the scheme of evil of Thomas Aquinas. It is prominent in Franciscan thought also, as is implied by its emphasis upon the virtues of poverty, chastity, and obedience.[154] Though

[148] For the figure of Peace, see Weigelt, *op.cit.*, pl. 99. See also Eve lying in front of the enthroned Madonna (Lorenzettian fresco at Monte Siepi—G. Rowley in *Art Studies*, VII, 1929, fig. 1—and several later examples) or Averroes lying before St. Thomas (panel by the Master of the Dominican Effigies in the Philip Lehman collection in New York, and, after the middle of the century, fresco by Andrea da Firenze in the Spanish Chapel, or panel in S. Catarina, Pisa).

[149] For these aspects of Caritas, see R. Freyhan, in the *Warburg Journal*, XI, 1948, pp. 68-69.

[150] The predella, like the child and the head of St. Crescentius, is repainted.

[151] This image of Cruelty choking an infant

persists into the sixteenth century. Ripa says the vice is represented in this way "perchè grandissimo effetto di crudeltà è l'occidere chi non nuoce altrui" (*Iconologia*, s.v. crudeltà).

[152] See chap. III, pp. 75ff.

[153] See M. Gothein, in *Archiv für Religionswissenschaft*, X, 1907, pp. 416ff., and M. Schapiro, in the *Art Bulletin*, XXI, 1939, pp. 325-328.

[154] Biondo's composition precedes, and may well be the source of the image of St. Francis standing upon the same three vices, which appears in Taddeo di Bartolo's altarpiece of 1403 in the Gallery at Perugia (B. Berenson, *A Sienese Painter of the Franciscan Legend*, London, 1910, pl. 21) and in the panel by Sassetta in the collection of Mr. Berenson (*ibid.*, pl. 20). In both these paintings Avarice is a Bene-

pride was usually considered the greatest of the three, and represented therefore in the center between the other two, Biondo has given this position to Avarice. However, the avaricious old woman—Avarice commonly took the form of an old woman—who squeezes the mouth of a bag of money already firmly and conspicuously tied by a heavy cord, is less intensely conceived and thus less prominent than her neighbors.

Instead of Unchastity (luxuria) Biondo has represented Vainglory. In general, and especially in this instance, the two vices are closely related. Biondo has designed for her, not without perhaps a touch of humor, a fantastic headdress combining a crown and peacock's plumes. As usual she holds a mirror before her. Unlike the other two Vices, who sprawl on the floor, she reclines indolently, her supple, low-necked dress revealing the sensuous form of her body.

Despite these evident allusions to luxuria in Biondo's Vanagloria, it is primarily the latter that is represented. This reflects a shift in the relative condemnation of two evil pleasures associated, iconographically at least, with women—the pleasure of personal adornment now preceding the physical pleasure of sex. In this respect Biondo's thought resembles that of Ambrogio Lorenzetti, who had earlier represented vainglory along with pride and avarice as the three supreme vices of bad government and a bad society (Fig. 74). Similarly Giovanni Villani, enumerating the sins of the Florentines that had provoked the disastrous flood of 1333, named *vanagloria* after *superbia* and *avarizia*, defining it as "vanagloria delle donne e di disordinate spese e ornamenti."[155] To him and to other burghers of the time a delight in elaborate personal adornment, associated with the older nobility, appeared to be disturbing to family and social relations, and incompatible with industriousness. The expenditures which it entailed seemed wasteful and uneconomic, draining capital from productive investment. Thus vainglory could become a real threat to the commune, and efforts were made to control it by sumptuary laws that set precise limits on the kind of finery in which the Florentines could indulge.[156]

dictine nun. (Pope-Hennessy, *Sassetta*, London, 1939, p. 123 note 16, suggests that the symbolism of Taddeo's and Sassetta's panels may originate in the *Sacrum commercium*. He is not specific, and I do not see the connection.)

[155] *Cronaca*, book XI, chap. 2.

[156] In 1327, six years before he had written the condemnation of vainglory quoted above, Giovanni Villani and his brother Filippo were fined for violations committed by their wives (see E. Mehl, *Die Weltanschauung des Giovanni Villani*, Leipzig, 1927, p. 2). This event may imply a discrepancy between professed belief and practice, a discrepancy that is hardly uncommon. The event also demonstrates that the regulations were enforced against the well-to-do.

F. Antal, however, holds that the sumptuary laws were instruments of class conflict and class oppression. He maintains that they were aimed at the lower classes, and that the rich garments in paintings of the "democratic period" reflect the struggle of these classes for the right to wear the same clothes as the upper class (*op.cit.*, pp. 19, 207). But if the petty bourgeoisie, as he says (p. 33 note 43, and p. 34 note 59), sought the repeal of the laws, how is it that the government which he believes was dominated by this class did not abolish these laws but in 1355 actually instituted more stringent restrictions? (For the sumptuary laws of 1355, see F. T. Perrens, *Histoire de Florence*, Paris, 1888-90, IV, pp. 357-358.)

Villani conceived of the other vices, too, in terms of the welfare, largely the economic welfare, of the bourgeois republic. He associated avarice with fraudulent trade and highly venturesome loans. These ill-gotten riches involved great risks and thus shook the stability as well as the reputation of Florentine business. And pride connotes for him the desire of an oligarchy or a tyrant to govern—that is, to violate and despoil— the citizenry.[157] In the light of such views, doubtless widespread at the time, it is not surprising that Biondo's Superbia, an aggressive warrior from whose helmet project two horns, and Ambrogio Lorenzetti's Tirannia (Fig. 74) should be very much alike.

BARNA. CONCLUSION

All the paintings that we have linked together as manifestations of a distinctive phase of Tuscan painting were made within a period of twenty-five or thirty years. None of them can be dated before 1350, and only one, Bartolo di Fredi's Deposition, was made as late as 1382. Almost all these works, furthermore, were produced by painters who had become independent masters within a period of about fifteen years. Andrea and Nardo di Cione, who entered the guild in 1343-1344, were probably the earliest of the group. We possess no works by them from the beginning of their career, but the newly discovered prophets in the choir of S. M. Novella, mostly by assistants of Orcagna,[158] and paintings such as the Baronci triptych of 1350 now in the collection of Mrs. Kijzer-Lanz, Amsterdam,[159] or the retables of 1353 and 1354 by the Master of the Fabriano Altarpiece[160] show that during the late 'forties Orcagna had begun to transform the style of Daddi and of Maso, and to evolve the new forms that appear, highly developed, in the Strozzi altarpiece (1354-1357).

Andrea da Firenze matriculated in the guild around the same time as the Cioni, and he is mentioned in Florence from 1351 on, but the first dated work that we know is the cycle in the Spanish Chapel, ca. 1366-1368. During the 'fifties we first hear of the Florentine Giovanni del Biondo, of Giovanni da Milano who had come from the north, and of the Sienese Bartolo di Fredi, Andrea Vanni, Giacomo di Mino, and

[157] ". . . la infinita avarizia e mali guadagni di comune, di fare frodolenti mercatanzie e usure, recati da tutte parti dalla ardente invidia l'uno fratello e vicino coll'altro. . . . Superbia, l'uno vicino coll'altro in volere signoreggiare e tiraneggiare e rapire." Similarly ingratitude: "lo pessimo peccato della ingratitudine di non conoscere da Dio i nostri grandi beneficii e il nostro potente stato . . ." (book XI, chap. 2).

[158] See note 14 above. For the career of Nardo and other painters mentioned in this and subsequent paragraphs see Appendix II.

[159] See H. Gronau, *op.cit.*, pp. 34-38, fig. 23. Gronau believes, incorrectly in my opinion, that this triptych was designed, though not

executed, by Orcagna himself. I believe it may be an early work of the Rinuccini Master.

[160] In the museum at Fabriano and the National Gallery, Washington (Offner, *Corpus*, sec. III, vol. v, pls. 36 and 37). In the panel of 1353 at Fabriano the central figure of St. Anthony is tense and frontal; all his worshippers are in profile. The ornamental richness of the altarpiece in Washington, the prevalence of gold, orange, and intense blue, are Cionesque, and the motif of confronted birds, common in the Cioni workshop, appears in two of the textiles. The figure of St. Anthony Abbot in this altarpiece, painted by Allegretto Nuzi, shows a similar influence.

Luca di Tommè. The activity of Jacopo di Cione and of Francesco di Vannuccio is first recorded in the 'sixties.

Along with these masters there were numerous painters now anonymous—followers of the Cioni in Florence, the Master of the Pietà in Siena[161]—who likewise began to work during the 'fifties or 'sixties in a closely related style. There were, furthermore, one or two painters whose later work exhibits many of the characteristic forms of the third quarter of the century but whose beginnings go back to the 'thirties, so that their earlier paintings belong to the preceding stylistic phase. One of these masters was Niccolò di Ser Sozzo Tegliacci. All his known panel paintings are, I believe, from the latter part of his career—he died, probably of the plague, in June 1363. One of these, a polyptych made in collaboration with Luca di Tommè, is dated 1362. We know his early work only in illuminations. The style of the most important of these, the miniature of the Assumption of the Virgin in the Caleffo dell'Assunta, always dated between 1332 and 1336 but perhaps not quite so early as this, resembles Simone Martini, Pietro Lorenzetti, and Lippo Vanni whereas the style of the panels is more closely related to Bartolo di Fredi and Luca di Tommè.

One master has been conspicuously absent from our discussion of painting in the third quarter of the Trecento. We have not hitherto mentioned Barna, by far the most gifted painter active in Siena around the middle of the century. Though not one of his paintings is dated, and we know nothing of his career, there is general agreement that his major surviving work, the New Testament cycle in the Collegiata at S. Gimignano, was made around 1350-1355.[162] Unlike most of the other masters whom we have considered, his beginnings go back to the 'thirties. His early work, such as the Madonna in S. Francesco at Asciano,[163] is essentially in the tradition of Simone Martini, though it contains intimations of the tragic character of the S. Gimignano frescoes. The frescoes themselves are still reminiscent of Simone, especially of his late work (Figs. 75, 76), and they also disclose a new interest in Duccio. Despite these continuing and profound relationships with the art of the earlier part of the century, and despite the exceptional and highly personal nature of Barna's later style, it shows some similarities with the characteristic art of its time. The raking diagonals of the Way to Calvary (Fig. 76), the free flow of the forms in space, the physical and emotional impact of one figure upon another, are unparalleled in painting after 1350. But they convey a terrible intensity that is related, in a special way, to the art that we have considered. We feel

[161] See Meiss in the *Art Bulletin*, XXVIII, 1946, pp. 6-12.

[162] In a careful study of the date of the frescoes in the *Art Bulletin*, XIV, 1932, pp. 285-315, Lane Faison argued that they were painted before the Old Testament cycle by Bartolo di Fredi and assistants, dated according to Vasari 1356. Though Faison is not convincing on all points, his thesis seems to me correct. However, the discovery of the actual date, 1367, of

Bartolo's frescoes (E. Carli, in *Critica d'arte*, VIII, 1949, pp. 75-76) would permit, from this point of view, a later date for Barna's paintings—later than I should be inclined to place them for stylistic reasons.

Faison speaks of Barna's "strange, dark state of mind" influenced by the Black Death (p. 285).

[163] Van Marle, *op.cit.*, II, fig. 196.

that the grim tension of these Florentine and Sienese works, their inner conflict and repressed excitement, have in Barna erupted violently. The bobbing, twisting helmets, the piercing glances, the lances shooting up at different angles, create a turbulence that breaks against the order—not really stable—of the cross and the ladder. Just behind the haunted Christ, who is brutally pushed on one side and pulled on the other, is a dark, menacing soldier, his face startlingly close. He walks parallel to Christ, the two moving together like Adam and Eve in the Brancacci Chapel, and he looks like the evil alter ego of Jesus, or the devil. With one hand he brandishes a long sharp claw-hammer, with the other a bundle of enormous spikes—actions that are unprecedented in Italian painting. The Virgin, more decisively separated from Christ than in earlier representations (Fig. 75), does not even reach for him. In preceding paintings her access to Christ is often blocked by an upraised arm or shield. Here a sword is driven by a vicious soldier straight at her cheek. She, the Magdalen, and their companions are less able to redeem by their affection the brutality and pain of the scene. Even more than in other paintings of the time Christ is alone.

The Pact of Judas (Fig. 78) is a quieter, more orderly composition, but it, too, contains elements of conflict and strain. As in the late paintings of Botticelli, with which Barna's art has so extraordinary a resemblance, the intent figures are bent together, forming a taut, indissoluble group. Instead of the three or four casually arranged priests of Duccio's painting (Fig. 77), one is clearly distinguished as a High Priest. He stands in the middle, disengaged from the action but craftily eyeing Judas and unable to refrain from exulting as he sees his plot progress. He is the central figure of the active trio in the foreground, but not of the entire group of figures, and he stands a little to the right of the central opening in the building, so that there is an oscillation between the axis of the architecture and the axis of the figures. This sort of displacement, so foreign to Duccio's Pact or to other compositions of the first half of the century (Fig. 14), occurs frequently in our period.

In Barna's fresco the tense conflict is continued in the design of the building and its relation to the figures. The figures form a round arch, but the gable, the only central architectural form of comparable size, is pointed. Furthermore, the gable encloses highly diverse shapes, which become progressively *smaller* as they approach the large arc of the figures. The narrow pointed arch moves upward and away from the dramatic center, like the vaults in Biondo's Presentation (Fig. 13). Within it there is a rectangular door, surmounted by a round arch—the only shape that corresponds to the figural pattern, but also the smallest. While this nest of dissimilar forms conflicts in several ways with the figures, it at the same time intensifies, by repeating, their contraction into dense and ever smaller groups.

There is a similar counterpoint between figures and architecture in the Last Supper (Fig. 79). Barna's composition again resembles Duccio's, but he has increased the importance of Christ, as of the High Priest in the Pact. Christ rises a little above the apostles at the far side of the table, so that he appears larger than they. His apparent

size is increased by his frontality and the coalescence of his figure with the reclining St. John. The central arch behind him, however, is no larger than the two at the sides; indeed, like the central bay of the church in Giovanni da Milano's Expulsion of Joachim (Fig. 36), it appears even to be smaller. Large areas of the lateral openings are visible; the apostles are not framed by the arches, but distributed irregularly in front of them. The close conformity of figures and architecture in earlier Trecento painting is replaced by contrast and conflict. And this new relation often entails, as in Barna's painting, an oscillation between a formal, accented, yet contracted middle and freer, more open and more active sides.

In the fresco of the Presentation in the Temple, probably designed by Barna but executed by an associate, the swaddled Child is set on the altar, as in Giovanni del Biondo's panel (Fig. 13). Just as the grave Infant is unaware of his mother, the young Christ teaching in the temple seems little concerned with the arrival of his parents (Fig. 81). He does not, as in Duccio's representation of this subject, turn gladly toward them.[164] Frontal and erect, he continues his discourse and acknowledges their presence only by the turn of his eyes and the tilt of his head. In this composition, and also in the paintings of Christ before Caiaphas, the Massacre of the Innocents, and the Miracle at Cana, Barna renounced the architectural setting that his Trecento predecessors had used. Relatively indifferent in these scenes to depth and to quantitative space, he tilts the planes of the floor and the furniture sharply upward, so that the figures—the farthest of them very high—fill a great part of the picture area. He accomplishes this extension, at once inward and upward, without the tension inherent in contemporary compositions, because the rounded single forms and the freely moving figures imply unequivocally a tridimensional space. The mode of composing these frescoes, how-ever, without an architectural framework, allowing the figures to be set before a neutral ground that throws into relief their lively shapes and gestures, recurs in other paintings of the time. The most impressive example is Orcagna's Mass of St. Thomas in the Strozzi altarpiece (Fig. 168).

If the frescoes of Barna thus exhibit a special relationship to the artistic trend that we have defined, the work of several masters active in the 'fifties or 'sixties stands almost wholly outside it. The paintings of Taddeo Gaddi in Florence, of Lippo Vanni, Bartolommeo Bulgarini ("Ugolino Lorenzetti"), or the Dijon Master in Siena, show at most a limited and often superficial connection.[165] Most of these masters belonged

[164] Christ faces his parents also in Taddeo Gaddi's quatrefoil in the Accademia (*Catalogo della Mostra Giottesca*, fig. 137f), but in other Florentine paintings of the early Trecento, Giotto's fresco in Padua and the Giottesque fresco in the lower church at Assisi, he is no more concerned with them than in Barna's painting. In this respect all these works continue the mediaeval tradition, but it is significant that Mary and Joseph are present in all these Tuscan Trecento representations, whereas they are frequently omitted in earlier mediaeval works. They are also absent in the works of essentially non-Tuscan Trecento painters, such as Giusto (fresco, Baptistery, Padua).

[165] The late altarpieces by Taddeo Gaddi in S. Felicita and in the Uffizi (dated 1355) are richer in ornament, and along with the Pietà at Yale, show a much graver mood than his earlier work.

to an older generation; they formed their styles in the 'twenties or the 'thirties and they continued to paint without essential change of purpose after the middle of the century. In the same way certain painters, notably those in the Gerini workshop, carried on into the early Quattrocento the characteristic forms of the third quarter of the century, though in the 'eighties and 'nineties Agnolo Gaddi, Spinello Aretino, and above all Antonio Veneziano had given a fundamental redirection to Florentine painting.

The painting of the third quarter of the century in Florence and Siena presents then a considerable variety. Beyond the diversity of trends and of individual styles, there were continuing differences between the two schools. These differences persisted despite the recognized influence of Simone Martini upon the Florentine painters, and the probable but unacknowledged influence of the Cioni upon the Sienese. Sienese art remained more linear, more mercurial, more lyrical, Florentine more massive, more geometric, and intellectual. There were no Sienese paintings comparable in the structure of their thought to the Strozzi altarpiece, the Spanish Chapel, or the frescoes by Orcagna in S. Croce—there were indeed few mural paintings of any kind in Siena at the time, and nothing of importance has survived. The Sienese masters were less concerned with dogma, system, and the institutional aspects of religion. Their painting shows a more spontaneous sentiment and a greater immediacy of religious experience.

But we have found in Sienese paintings, too, a greater emphasis upon the Church and the priest than in the first half of the century. The traditional histories, which the earlier period had understood more as narratives of the familiar, recurring events of human life, assumed in them also the character of formal ritual, enactments of ineffable mysteries. This transformation was not accomplished either in Siena or Florence without a conflict and a persistent ambiguity. We have seen these in the relation of pattern and space, or line and mass, or color and form. We have seen them also in the tension between the human, the ecclesiastical, and the divine, between secular commitments and a more compelling religious aspiration. The humanity of the figures is only partially suppressed. Many naturalistic qualities of the preceding period are maintained or even developed, so that a relatively inorganic figure in a rigid unnatural posture is yet given considerable anatomic and physiognomic detail—often more, indeed, than in the first half of the century (Figs. 6, 7, 30). Even where this detailed articulation serves, as it often does, to intensify the religious rapture, so that there is no conflict in final purpose, there remains a tension arising from highly diverse or even contradictory means.

How are we to understand these profound changes in Tuscan painting around the middle of the fourteenth century? Understand them, that is, within the limits imposed by the nature of art, whether of our own time or of six hundred years ago. Whatever the elucidation, by the critic, the historian, or the artist himself, there remains at the core of creation an impenetrable mystery. Shall this ultimate obscurity lead us to refrain from enquiry? Shall we dismiss the redirection of Trecento painting as the con-

sequence simply of an inevitable reaction against the art of the preceding years? That would be to assert an undeniably relevant psychological fact, but it leaves us wondering why the reaction did not set in earlier or later, and it tells us little about the art that we did not already know. We have also the possibility of inquiring whether these new qualities are related to circumstances and events of the time, and whether the state of mind that they disclose is discernible in other areas of contemporary culture. Without denying that each art has a certain rationale and momentum of its own, this is what we propose to do.

II

THE TWO CITIES AT MID-CENTURY

For both Florence and Siena the first forty years of the fourteenth century had been generally years of great prosperity and of political stability. Already at the beginning of this period the two cities had risen to European prominence as centers of finance and manufacture. Just before 1300 the contest between the rising middle class and the long-established noble landholders had ended in a victory for the former. The middle class acquired complete control of the state. Though many noble families, particularly in Florence, had entered trade or banking and had merged to a great extent with the business groups, they were, like all the members of their class, excluded from communal offices.

As in other late mediaeval towns, Florentine and Sienese society was organized for political and economic purposes in a series of guilds. Citizenship depended upon membership in one of them. The thousands of workers in the chief industry, the manufacture or refinement of woolen cloth, were forbidden to form or to join guilds, and they thus had no political rights whatever. The guilds of the great merchants, bankers, industrialists, and professional men (jurists and physicians) formed the Greater Guilds, or *Arti Maggiori*. The shopkeepers and artisans were members of the more numerous *Arti Minori*. The state, which shortly before 1300 had assumed the form of a bourgeois republic, was actually administered by a wealthy oligarchy centered within the *Maggiori*. Their rule, as well as the guild structure which supported it, lasted in both cities for about half a century.

The great entrepreneurs were engaged in production for foreign more than for local consumption, and with their large accumulation of capital they financed the Papacy as well as many princes throughout Europe. Seeking wider markets in their own regions, they pursued a policy of local "imperialism." During their rule almost all of Tuscany was brought under the domination of one or another of the two cities. As long as the oligarchy succeeded in maintaining a high level of prosperity, it was not seriously challenged in either Florence or Siena.

Though political power was thus highly concentrated, the form of the state reflected a libertarian ideal. The oligarchy sought to maintain the approval of the entire middle class, which believed it had the right to determine the policy of the government, and at times of crisis, as in Florence in 1343, exercised it. The republican principle, which implied the evolution of a nonhierarchical, more horizontal social order, was apparent also in other forms of association—in the guilds, for instance, with their elected captains. It was apparent also, within the sphere of religion, in the confraternities. These societies, formed by laymen for purposes of worship and mutual aid, grew rapidly from the late thirteenth century on. Their members, though subject to canon law, lived in the world without taking vows or adhering to a fixed rule. They were drawn from all classes; priests and friars were admitted too, but they had no special rights or privileges.

The fraternities were governed, and their religious services conducted, by lay rectors elected for short periods of time. On the altar of the chapel that each of these societies possessed there stood almost invariably a retable that was the visible center of the cult. There the members assembled periodically, singing hymns to the Virgin before her painted image. No phenomenon of town life was more expressive of its democratic and lay tendencies, and none impinged more directly upon the art of painting.

As in other advanced European centers, but nowhere more than in Florence and Siena, the new competitive economy fostered (as well as it implied) independent individual inquiry and action in all fields of endeavor, and it stimulated a greater measure of individual self-consciousness. The middle class, concerned with the techniques of manufacture and the kinds of calculation required by production and banking on an unprecedented scale, developed increasingly empirical, inductive, and quantitative modes of thought. The burghers emphasized family and civic responsibilities and they valued circumspection, moderation, and, above all, industriousness.[1] Though they remained deeply pious, they believed with increasing assurance that they could enjoy themselves in this world without jeopardizing their chances in the next. Their optimism seemed to be confirmed by the prosperity and the comparative peace of the first forty years of the century.

The arts flowered as at few other moments in history. The painters and sculptors, developing a more naturalistic style, created an image of an orderly world, substantial, extended, traversable. They endowed the people in it with a new range of intellectual and emotional awareness, and great moral strength. The realm of human values was immeasurably enlarged, the relation of man to man becoming as important as the relation of man to God. It is no accident that the most memorable episodes in the Arena Chapel include the return of Joachim to his sheep, his meeting with Anna at the Golden Gate (Fig. 26), and the lament over the dead body of Christ. These are scenes that had held only a subordinate meaning in earlier Christian art or had only recently been represented at all. In the early Trecento cycle they seem more congenial to the painter and more deeply felt than the episodes involving the prophetic and the symbolical (Last Supper), or the supernatural (Wedding at Cana, Ascension, Pentecost—the last executed by an assistant). Giotto's human sympathy and insight reach an astonishing profundity in the wonderful soldier standing at the left in the Massacre of the Innocents, a wholly unprecedented figure who, though traditionally on the side of brutality and evil, now withdraws in anguish from the bloody work of his men.

Such novel accents and reinterpretations of traditional themes are not uncommon at the time. The life of the Virgin attains a new prominence, along with the Infancy cycle, and the mother of Christ is given a much greater role in the sequence of the Passion. Entirely new subjects, such as the Madonna of Humility or the *Madonna della Culla* (Madonna with the cradle) were introduced.[2] In one of his panels Simone

[1] See, for instance, a collection of middle class precepts such as that of Paolo di Messer Pace, *Il libro di buoni costumi*, ed. by S. Morpurgo, Florence, 1921. For burgher modes of thought, see also the comments below on the Villani chronicles (note 27 and p. 80).

[2] See the *Madonna della Culla* by Bernardo Daddi and an assistant in the Museum at Berne (Offner, *Corpus*, sec. III, vol. IV, add. pl. I). For the Madonna of Humility, see chap. VI.

Martini represented Mary and Joseph admonishing Christ after he had strayed from them and tarried in the temple at Jerusalem—a scene that is as rich in human significance as it is weak in religious or dogmatic.[3] The theme of the Holy Family appears for the first time,[4] and the Virgin's father, Joachim, not previously present at her birth, waits in an antechamber in Sienese paintings of the scene.[5] Sometimes Christ brings together and embraces St. John and the Virgin, recommending them to one another as son and mother.[6] A variety of marriages are represented, most of them novel.[7] These themes are all expressive of family sentiments, of the emotional bond between mother and child, mother and son, or husband and wife. They reflect burgher values and many of the paintings were commissioned by a married couple for their own private devotion. It is not surprising then that children should have become especially prominent. Scenes of the resurrection of a child by St. Francis and St. Nicholas were represented more frequently. In the representation of Caritas, the woman personifying love of man (*amor proximi*) is accompanied, not by a beggar as in earlier French sculpture, but by a nude child.[8] Similarly, Amor is transformed from a man into a boy.[9] In this predilection for youth we sense also an ebullience and an optimism similar to that conveyed a century later by the putti of the early Renaissance.

Though some of these forms were carried into the art of the third quarter of the century, their expressive meaning was modified. The playfulness of the Christ Child and the glad affection of his mother, prominent especially in the panels of Daddi's circle, were subdued, and no new types or motifs expressing similar sentiments were introduced. The inventiveness and the creative power of the age manifested itself in a darker realm of fearful, strenuous yet often uncertain piety, brightened only by mystical transports and visions of supernatural splendor.

THE ECONOMIC CRISIS

From about 1340 on, the whole of Florentine and Sienese society was shaken by a series of increasingly disastrous events. The persistent and costly attempt of Florence to add Lucca to its domain was frustrated in 1341 by the capture of that city by the Pisans. The expansion of Milan under the Visconti began to present a serious threat,[10]

[3] The panel, which is in the Walker Art Gallery, Liverpool, is based on Luke, II, 48.

[4] See the panel close to Ambrogio Lorenzetti, and probably reflecting a composition by him, in the Abegg collection, Zurich.

[5] Altarpiece by Pietro Lorenzetti, Opera del Duomo, Siena, and numerous later Sienese paintings.

[6] The representations are based on John, XIX, 26-27. See the triptych of 1334 by Taddeo Gaddi in the Kaiser-Friedrich Museum, Berlin (Van Marle, *op.cit.*, III, fig. 181). Also a panel by a Sienese painter influenced by Barna (*Fogg Art Museum, Collection of Medieval and Renaissance Paintings*, Cambridge, 1927, no.

18B and fig.). As B. Berenson has pointed out, the same painter made a Lamentation in the Stoclet collection, but he is certainly not, as Berenson maintains, Andrea di Bartolo (*International Studio*, 1931, p. 34, fig. 10).

[7] See below, p. 109.

[8] Beginning, apparently, with Nicola Pisano's figure on the pulpit of the Baptistery in Pisa (see R. Freyhan, in the *Warburg Journal*, XI, 1948, p. 72).

[9] See E. Panofsky, *Studies in Iconology*, New York, 1939, pp. 114-115.

[10] The growth of the power of Milan weighed so heavily upon the minds of the Florentines that a large part of Matteo Villani's chronicle

and the burden of meeting this, together with the failure of the English branches of two of the largest Florentine banks, provoked an economic and then a political crisis. In 1343 the great house of the Peruzzi declared bankruptcy, and it was followed by the Accaiuoli, the Bardi (1345) and almost every other bank and mercantile company in Florence.[11] Many of the Sienese houses were brought down also. Throughout the cities workshops and stores closed because commissions were lacking and funds were not available for the purchase of materials or the payment of wages.[12] The crash plunged the towns into an unprecedented depression. Long after it had passed it continued to weigh upon the spirit of enterprise, engendering a more cautious and conservative attitude. For many years, fear of comparable loss tended to divert investment from trade and manufacture to farms and land. The merchant and chronicler Giovanni Villani, who himself suffered severe reverses and who was even thrown into the Stinche for inability to pay his debts, reported that by 1346 the Florentine companies had lost around 1,700,000 florins. No such calamity, he said, had ever overtaken the commune.[13] He wrote this judgment on the eve of a far greater one, in which he lost not his fortune but his life.

POLITICAL AND SOCIAL CHANGE

The ruling merchants and bankers in Florence tried to meet the mounting crisis by the usual method of the Italian communes in time of distress—transference of municipal authority to a dictator. In 1342 the Duke of Athens was called to Florence and given supreme power in the state. But this expedient, which in many other cities had resulted in the permanent loss of republican government, proved unsatisfactory to all sections of the Florentine middle class. Rallying to the cry of liberty, they united to expel the Duke in 1343. The republic was restored, but with new provisions that curtailed the power of the great merchants, industrialists, and bankers who had controlled the state almost uninterruptedly since the end of the thirteenth century. Weakened by the failure in the Lucchese war, the financial collapse, and the necessity of relying upon other groups to expel the *signore* whom they had installed, they were obliged to admit to the priorate representatives of sections of the middle class that had not previously had a voice in its councils. Of the eight seats in the priorate only two were retained by this old oligarchic faction, which consisted of the wealthier members of the "great" guilds of the Lana, Calimala, and Cambio. Three or four seats were given to the *mezzana gente*, whose identity is disputed. The old belief that they belonged to five "middle guilds" which were commonly grouped with the fourteen Lesser Guilds has recently been opposed by evidence that they, too, were members of the

from 1351 on (book II) is devoted to it. For the consequences of the Milanese threat see H. Baron, in *Annual Report of the American Historical Association for 1942*, Washington, 1944, pp. 123-138.

[11] See A. Sapori, *La crisi delle compagnie mercantili dei Bardi e dei Peruzzi*, Florence,

1926; also A. Doren, *Italienische Wirtschaftsgeschichte*, Jena, 1934, pp. 464ff.

[12] Sapori, *op.cit.*, p. 140.

[13] "Maggiore ruina e sconfitta che nulla che mai avesse il nostro comune" (book XII, chap. 55). Villani was a *socius* of the Buonaccorsi Company.

Greater Guilds, but distinct from the oligarchic party, less wealthy and the owners of smaller business enterprises.[14] Two or three seats finally were allocated to the fourteen Lesser Guilds of shopkeepers and craftsmen, in other words to the lower middle class. This distribution of power was maintained until 1378, when the famous revolt of the *ciompi* won a brief control of the state for the disenfranchised workers of the woolen guilds. They were quickly succeeded by the Lesser Guilds, and in 1382 the old oligarchy reestablished its power.

If the smaller entrepreneurs and the professional men, the *mezzani* of the Greater Guilds, were actually dominant in the government of Florence from 1343 to 1378, this era was not quite so "democratic" as many historians have maintained.[15] But in any event the oligarchy was overthrown, the new priorate was more widely representative, and the lower middle class did acquire a share in the regime. There were, moreover, corresponding readjustments of power within the guilds themselves, so that the consequences of the revolution were felt through Florentine society.[16] The rise to power of the *mezzani* and the necessity for the political recognition of the lower middle class shattered the confidence of the very wealthy, which had already been shaken by the crash. They and all those in the city who depended upon, or sympathized with, the old oligarchy bitterly opposed the new government. In 1345 Giovanni Villani ridiculed the rulers of Florence as "artisans and manual workers and simpletons."[17]

[14] The character of the several Florentine parties and the nature of the complex conflict between them need further clarification. Party alignments often cut across the guild structure, and within the guild groups there were fundamental differences of interest—within the seven Greater Guilds, for instance, between those producing for export (free-traders) and for the local market (protectionists). Furthermore, the financial position of the producer and the scale of his production did not always correspond to the rank of his guild. In fact some of the *sottoposti* of the cloth guilds (such as the dyers) who were not permitted to form their own guild conducted larger enterprises than some members of the Lesser or even the Greater Guilds.

For the identification of the *mediani* with a section of the *Arti Maggiori*, see G. Scaramella, *Firenze allo scoppio del Tumulto dei Ciompi*, Pisa, 1914. For the older interpretation of the events of this period, still maintained by most historians, see F. T. Perrens, *Histoire de Florence*, Paris, 1888-90, IV, pp. 342ff.; F. Schevill, *A History of Florence*, New York, 1936, pp. 259-283; N. Rodolico, *I ciompi*, Florence, 1945.

[15] This government, furthermore, suppressed as firmly as the oligarchic one preceding it the *sottoposti* of the woolen guilds, who comprised the great majority of the working population of Florence (see G. Capponi, *Storia della Repubblica di Firenze*, Florence, I, 1875, p. 245).

[16] See, for instance, the changes within the guild of the physicians and apothecaries to which the painters belonged, described by R. Ciasca, *L'arte dei medici e speziali*, Florence, 1927, pp. 86ff., and A. Doren, *Entwicklung und Organization der florentiner Zünfte*, Leipzig, 1897, pp. 51-59.

During these years the painters acquired greater independence and influence within the guild, but this was in part the consequence of special factors, chiefly the greater public esteem won by this craft during the course of the fourteenth century. The painters entered the guild in 1314 as dependents of the *membrum* of the apothecaries, classified simply as men who buy, sell, and work colors. In the guild lists of the 'forties or 'fifties painters of panels and frescoes are called *dipintori*, and differentiated from painters of chests and furniture. Not long afterward the *dipintori* became dependents of the physicians, the only professional group in the guild. Finally, in 1378 the group of painters was authorized to form an independent *membrum* because, as the record states, "aveva conseguito una grande importanza nella vita dello stato, ed appariva già

In Siena during these years there was a corresponding series of revolutions, though they occurred at different intervals of time and on the whole the swing to the left extended farther than in Florence.[18] The *Nove*, the counterpart of the oligarchic party in Florence, was thrown from power in 1355, after having been the sole ruler of the city since the end of the thirteenth century. Weakened by the economic consequences of the Florentine bank failures and by the plague of 1348, the *Noveschi* were excluded by law from the new government of the so-called *Dodicini*. It consisted of a coalition between the nobles and the smaller entrepreneurs, shopkeepers and craftsmen. These groups, except for the nobility, corresponded exactly to the Florentine *mezzani* and *minuti* who had won a share in political power in 1343. A second revolution, precipitated again by the nobility, brought down the *Dodicini* in 1368 and led, after some rapid changes, to the most widely representative government in the history of the Tuscan communes. It included the nobility and all sections of the middle class, omitting only the workers in the woolen industry, whose riotous demands for citizenship in 1371 were suppressed by the expulsion of thousands from the city.[19] The several parties were represented in proportion to their number in the population, so that the lower middle class held a majority in the supreme council. Whereas the rule of this class lasted in Florence only from 1378 to 1382, in Siena it persisted from 1368 to 1385. During the years of lower middle class participation and ascendancy, several Sienese painters—Andrea Vanni, Bartolo di Fredi, Luca di Tommè, Giacomo di Mino—were active in the political parties and in the government, occupying a variety of offices and serving as municipal envoys.

THE BLACK DEATH

During the 'forties, just after the fall of the oligarchy in Florence and several years before it was overthrown in Siena, both cities suffered seriously from lack of grain.[20] The bankruptcies reduced the financial resources of the cities and weakened the influence of the great Florentine houses of the Accaiuoli and the Bardi in Naples, so that normal imports from that region were not forthcoming.[21] On top of this, crops failed throughout Tuscany in 1346, and they were badly damaged in 1347 by exceptionally heavy hailstorms. Weakened and terrified by these deprivations, which they attributed to divine displeasure, the Florentines and Sienese attempted to appease God. They engaged in collective prayer and public displays of repentance. Giovanni

maturo per la vita dello stato" (Ciasca, *op.cit.*, p. 131).

[17] "Signori artefici e gente manovali e idioti" (book XII, chap. 43). In 1340, before the revolution, Villani had advocated a government representative of all classes (book XI, chap. 118).

[18] See G. Luchaire, *Documenti per la storia dei rivolgimenti politici del comune di Siena dal 1354 al 1369*, Lyons, 1906; P. L. Sbaragli, "I mercanti di mezzana gente al potere in Siena," in *Bullettino senese di storia patria*, VIII, 1947, pp. 35ff.; F. Schevill, *Siena*, London, 1909, pp. 213-228; L. Douglas, *A History of Siena*, New York, 1902, pp. 149ff.

[19] Rodolico, *op.cit.*, p. 24.

[20] See N. Rodolico, *Il popolo minuto*, Bologna, 1899, p. 51. See also chap. III, note 5 below.

[21] See Doren, *Italienische Wirtschaftsgeschichte*, p. 391.

Villani tells of great processions, in one of which, continuing for three days, he marched himself.[22] These had scarcely disbanded when an unimaginable catastrophe struck both towns.

Suddenly during the summer months of 1348 more than half the inhabitants of Florence and Siena died of the bubonic plague.[23] By September only some 45,000 of the 90,000 people within the walls of Florence were still living; Siena was reduced from around 42,000 to 15,000.[24] Never before or since has any calamity taken so great a proportion of human life. The plague struck again in 1363 and once more in 1374, though it carried off far fewer people than in the terrible months of 1348.[25]

The survivors were stunned. The Sienese chronicler Agnolo di Tura tells of burying his five children with his own hands. "No one wept for the dead," he says, "because every one expected death himself."[26] All of Florence, according to Boccaccio, was a sepulcher. At the beginning of the Decameron he wrote: ". . . they dug for each grave-yard a huge trench, in which they laid the corpses as they arrived by hundreds at a time, piling them up tier upon tier as merchandise is stowed in a ship. . ."—sights not unfamiliar to modern eyes. For years the witnesses were haunted by memories of bodies stacked high in the streets and the unforgettable stench of flesh putrefying in the hot summer sun. Those fortunate few who were able to escape these horrible scenes by fleeing to isolated places were, like Petrarch, overwhelmed by the loss of family and friends.

The momentous nature of the experience is suggested by the words of Matteo Villani as he undertook after a few years to continue the chronicle of his dead brother:

"The author of the chronicle called the Chronicle of Giovanni Villani, citizen of Florence and a man to whom I was closely tied by blood and by affection, having rendered his soul to God in the plague, I decided, after many grave misfortunes and with a greater awareness of the dire state of mankind than the period of its prosperity had revealed to me, to make a beginning with our varied and calamitous material at this

[22] Book XI, chap. 21.

[23] In a previous epidemic, during the spring of 1340, 15,000 Florentines died, according to Giovanni Villani (book XI, chap. 114).

[24] These estimates of Doren (*op.cit.*, pp. 634-635) are conservative. Others suppose a higher rate of mortality. N. Rodolico, *La democrazia fiorentina nel suo tramonto*, Bologna, 1905, pp. 7, 32, 35, gives an over-all figure for Florence in 1347 of 120,000; after the plague 25,000 to 30,000, a death rate of four-fifths. Boccaccio in the Decameron said that 100,000 Florentines died, and the Chronicle of Stefani puts the figure at 96,000. Matteo Villani gives a general death rate of three-fifths (see note 27).

Agnolo di Tura seems to say that 80,000 Sienese died, leaving only 10,000 alive (*Rerum Italicarum scriptores*, XV, part VI, ed. by A. Lisini and F. Iacometti, Bologna, 1932, p. 555) and an anonymous chronicler (*ibid.*, p. 148) asserts that the "grande morìa" carried off three-fourths of the people. A. Lisini, commenting on this statement (*ibid.*, p. 148 note 2), says that if three-fourths did not die, at least a half did. Lisini estimates as many as 70,000 people in Siena before the plague. Commenting on Siena, Matteo Villani (book I, chap. 4) says "non pareva che fusse persona."

[25] See for Siena, W. Heywood, *"Ensamples"* of Fra Filippo, Siena, 1901, pp. 8ff., and for Florence, Perrens, *op.cit.*, IV, pp. 379ff. The plague of course became endemic, reappearing in 1400, 1411, 1424, and thereafter, but with a greatly diminished rate of mortality.

[26] *Rerum Italicarum scriptores*, XV, part 6, pp. 555-556.

juncture, as at a time of renewal of the world. . . . Having to commence our treatise by recounting the extermination of mankind . . . my mind is stupefied as it approaches the task of recording the sentence that divine justice mercifully delivered upon men, who deserve, because they have been corrupted by sin, a last judgment."[27]

Though the rate of mortality was doubtless somewhat greater among the poor, about half of the upper classes succumbed. Agnolo di Tura's comments about Siena are significant: four of the nine members of the oligarchic priorate died, together with two of the four officers of the *Biccherna*, the *podestà*, and the *capitano di guerra*.[28] The painters were not spared. The plague carried off Bernardo Daddi, the most active and influential master in Florence, and perhaps also his associate whom Offner has called the "Assistant of Daddi."[29] It is generally assumed that the disappearance of all references around this time to Ambrogio and Pietro Lorenzetti signifies their death in the epidemic.[30] Undoubtedly a great many minor painters suffered a similar fate. This sudden removal at one stroke of the two great Sienese masters and of Daddi along with numerous lesser painters produced a more than ordinary interruption in pictorial tradition. It gave to the surviving masters, especially the younger ones, a sudden, exceptional independence and a special freedom for the development of new styles.

[27] "Nella quale mortalità avendo renduta l'anima a Dio l'autore della cronica nominata la *Cronaca di Giovanni Villani* cittadino di Firenze, al quale per sangue e per dilezione fui strettamente congiunto, dopo molte gravi fortune, con più conoscimento della calamità del mondo che la prosperità di quello non m 'avea dimostrato, propuosi nell'animo mio fare alla nostra varia e calamitosa materia cominciamento a questo tempo, come a uno rinnovellamento di tempo e secolo, . . . Avendo per cominciamento nel nostro trattato a raccontare la sterminio della generazione umana . . . stupidisce la mente appressandosi a scrivere la sentenzia, che la divina giustizia con molta misericordia mandò sopra gli uomini, degni per la corruzione del peccato di final giudizio" (book I, end of chap. 1 and beginning of chap. 2).

The entire passage is interesting for its careful, precise account of the spread of the plague through Italy and Europe. Villani is assiduous in the collection of facts and opinions but cautious in accepting them, and he frequently records them with scepticism or with contrary argument. Thus he tells about the reports of a great fire in Asia, and the belief that the plague originated in areas ravaged by it, but adds, "ma questo non possiamo accertare." To the assertion of the astrologers that the plague resulted from the conjunction of three superior planets in the sign of Aquarius, he replies that a similar conjunction had occurred in the past without producing such dire results. He is quick to calculate, and to propose laws and principles: on the basis of reports from many countries, he says that the pestilence may be said usually to last five months in a given region. It normally carried away three out of every five persons.

[28] Agnolo di Tura, *op.cit.*, pp. 555-556. One hundred and thirteen of the friars in S. M. Novella in Florence died (C. di Pierro, in *Giornale storico della letteratura italiana*, XLVII, 1906, p. 14), and in Avignon nine cardinals and seventy prelates, despite the great fires which were maintained in the papal palace to purify the air (P. Schaff, *History of the Christian Church*, New York, V, part 2, 1910, p. 100).

[29] *Corpus*, sec. III, vol. V, p. 119.

[30] Their names are lacking not only in all documents, but in the list of the best Sienese painters compiled around 1349 for the *operaii* of S. Giovanni, Pistoia (C. von Fabriczy, *Repertorium für Kunstwissenschaft*, XXIII, 1900, pp. 496-497).

ECONOMIC AND SOCIAL CONSEQUENCES
OF THE PLAGUE

In the immediate wake of the Black Death we hear of an unparalleled abundance of food and goods, and of a wild, irresponsible life of pleasure. Agnolo di Tura writes that in Siena "everyone tended to enjoy eating and drinking, hunting, hawking, and gaming,"[31] and Matteo Villani laments similar behavior in Florence:

"Those few sensible people who remained alive expected many things, all of which, by reason of the corruption of sin, failed to occur among mankind and actually followed marvelously in the contrary direction. They believed that those whom God's grace had reserved for life, having beheld the extermination of their neighbors, and having heard the same tidings from all the nations of the world, would become better men, humble, virtuous, and Catholic; that they would guard themselves from iniquity and sins; and would be full of love and charity for one another. But no sooner had the plague ceased than we saw the contrary; for since men were few, and since by hereditary sucession they abounded in earthly goods, they forgot the past as though it had never been and gave themselves up to a more shameful and disordered life than they had led before. . . . And the common people (*popolo minuto*), both men and women, by reason of the abundance and superfluity that they found, would no longer work at their accustomed trades; they wanted the dearest and most delicate foods for their sustenance; and they married at their will, while children and common women clad themselves in all the fair and costly garments of the illustrious ladies who had died."[32]

This extraordinary condition of plenty did not, of course, last very long. For most people the frenzied search for immediate gratification, characteristic of the survivors of calamities, was likewise short-lived. Throughout the subsequent decades, however, we continue to hear of an exceptional indifference to accepted patterns of behavior and to institutional regulations, especially among the mendicant friars. It seems, as we shall see, that the plague tended to promote an unconventional, irresponsible, or self-indulgent life, on the one hand, and a more intense piety or religious excitement, on the other. Villani tells us, in his very next sentences, of the more lasting consequences of the epidemic:

"Men thought that, through the death of so many people, there would be abundance of all produce of the land; yet, on the contrary, by reason of men's ingratitude, everything came to unwonted scarcity and remained long thus; . . . most commodities were more costly, by twice or more, than before the plague. And the price of labor, and the products of every trade and craft, rose in disorderly fashion beyond the double. Lawsuits and disputes and quarrels and riots arose everywhere among citizens in every land, by reason of legacies and successions; . . . Wars and divers scandals arose throughout the world, contrary to men's expectation."[33]

Conditions were similar in Siena. Prices rose to unprecedented levels.[34] The econ-

[31] Agnolo di Tura, *op.cit.*, p. 560.
[32] Book I, chap. 4. A translation of the entire chapter—upon which the above is based—may be found in G. C. Coulton, *The Black Death,* London, 1929, pp. 66-67.
[33] Book I, chap. 5.
[34] Chronicle of Neri di Donato, *op.cit.*, pp. 633-636. On the inflation throughout Europe

omy of both Florence and Siena was further disrupted during these years by the defection of almost all the dependent towns within the little empire of each city. These towns seized as an opportunity for revolt the fall of the powerful Florentine oligarchy in 1343, and the Sienese in 1355. The two cities, greatly weakened, and governed by groups that pursued a less aggressive foreign policy, made little attempt to win them back.

The small towns and the countryside around the two cities were not decimated so severely by the epidemic, but the people in these regions felt the consequences of it in another way. Several armies of mercenaries of the sort that all the large states had come to employ in the fourteenth century took advantage of the weakness of the cities. Sometimes in connivance with the great enemy of the north, the Duke of Milan, they invaded, or threatened to invade, the territory of Florence and Siena. These large marauding bands—the companies of the Conte Lando, of John Hawkwood, and of Fra Moriale, the Company of the Hat and the Company of St. George—hovered in the neighborhood throughout the 'fifties and 'sixties, a continual threat to the peace of the *contado* and a serious drain on the already shrunken communal treasuries. Florence, the stronger of the two cities, was less troubled by them. Siena paid out huge ransoms,[35] in twenty years some 275,000 florins, but even then its lands were pillaged and the people on the farms and in the villages lived in constant terror. For them the story of Job, an old paradigm of trial and affliction, acquired a specially poignant meaning. Not only did Job suffer from a disease whose outward symptoms were like those of the plague; his cattle were driven off and his children killed. It is not surprising that his history, rarely if ever represented in earlier Tuscan panels and frescoes, should now have been portrayed several times. In a triptych dated 1365 by a follower of Nardo in S. Croce he appears as a cult figure at the left of the Madonna, and the entire predella is devoted to his trials.[36] Bartolo di Fredi appended five, or probably originally six, scenes of Job's misfortunes to his Old Testament cycle of 1367 in the Collegiata, S. Gimignano (Fig. 82).[37] Another of Bartolo's Biblical stories must likewise have evoked an intense response, stirring bitter memories of dislocated families even while it held out a measure of hope: the scene of the Jews fleeing from Egypt and of the pursuing Egyptian army drowned in the Red Sea (Fig. 80). In 1362, just a few years before the painting of these frescoes, Bartolo himself had written a report for the Signoria of Siena describing the movement of marauding troops in the countryside.[38]

after the Black Death see J. W. Thompson, in *American Journal of Sociology*, XXVI, 1920-21, p. 565, and Kovalevsky in *Zeitschrift für Sozial- und Wirtschaftsgeschichte*, III, 1895, pp. 406-423.

[35] Twenty thousand florins, for instance, to Lando in 1356 (see Neri di Donato, *op.cit.*, p. 585). On the merchant companies and Florence, see especially Perrens, *op.cit.*, IV, pp. 424, 457-470.

[36] Van Marle, *op.cit.*, III, fig. 289.

[37] In a study of these frescoes to be published

soon, Professor Lucile Bush has already suggested a connection between the Job sequence and the ravages of the merchant companies.

A third cycle of the Job story is in the Camposanto, Pisa (Van Marle, *op.cit.*, V, pp. 264-266 and figs. 173-174). It was begun by Taddeo Gaddi (in the 'fifties?) and completed some years later by another painter.

[38] G. Milanesi, *Documenti per la storia dell'arte senese*, Siena, 1854, I, p. 260.

The ravages of the merchant companies accelerated a great wave of immigration from the smaller towns and farms into the cities that had been initiated by the Black Death. Most of the newcomers were recruits for the woolen industry, who were attracted by relatively high wages. But the mortality offered exceptional opportunities also for notaries, jurists, physicians, and craftsmen. In both Florence and Siena the laws controlling immigration were relaxed, and special privileges, a rapid grant of citizenship, or exemption from taxes were offered to badly needed artisans or professional men, such as physicians.[39] Throughout the earlier history of Florence and Siena there had been, it is true, a steady influx of people from the *contadi*. Dante complained of a population swollen with rustics from places such as Signa and—ironically enough—Certaldo, Boccaccio's town.[40] But the magnitude of the immigration into Florence after the Black Death was unprecedented. Those historians who estimate the population of the city as 25,000 or 30,000 just after the Black Death postulate 45,000 in 1351,[41] and others state that, despite the successive epidemics, there were 60,000 people by 1375[42] and 70,000 by 1380.[43] Siena, on the other hand, grew comparatively little.[44]

In addition to bringing into the city great numbers of people from the surrounding towns and country, the Black Death affected the character of Florentine society in still another way. Through irregular inheritance and other exceptional circumstances, a class of *nouveaux riches* arose in the town and also in decimated Siena.[45] Their wealth was accentuated by the impoverishment of many of the older families, such as the Bardi and the Peruzzi, who had lost their fortunes in the financial collapse. In both cities, too, many tradesmen and artisans were enriched to a degree unusual for the *popolo minuto*. Scaramella sees as one of the major conflicts of the time the struggle between the old families and this *gente nuova*.[46] Outcries against both foreigners and the newly rich, never lacking in the two cities, increased in volume and violence. Antagonism to "the aliens and the ignorant" coalesced with antagonism to the new municipal regime; the government, it was said, had been captured by them. Filippo Villani wrote in his chronicle for the year 1363:

"In those days the administration and government of the city of Florence . . . had

[39] See R. Ciasca, *op.cit.*, p. 291. Despite these inducements the number of physicians did not increase as rapidly as the shopkeepers and tradesmen in the same guild (*ibid.*, p. 117). For immigration into Florence see also N. Rodolico, *I ciompi*, pp. 40-42, and *idem, Democrazia fiorentina*, pp. 36ff. For Siena, see Kovalevsky, *op.cit.*, p. 421 and L. Douglas, *op.cit.*, pp. 155-156. All these writers comment only very briefly on the immigration. The entire phenomenon, and its consequences for contemporary society and culture, has not hitherto been given adequate attention.

[40] *Paradiso*, XVI, 46. Cited by N. Rubinstein, in the *Warburg Journal*, V, 1942, p. 222.

[41] N. Rodolico, *Democrazia fiorentina*, p. 35, and Ciasca, *op.cit.*, p. 106. Ciasca points out that this figure includes refugees from the plague who returned to the city.

[42] The chronicler Stefani, quoted by Rodolico, *op.cit.*, p. 39.

[43] A. Doren, *Italienische Wirtschaftsgeschichte*, pp. 634-635.

[44] Doren, *loc.cit.*

[45] Agnolo di Tura (*op.cit.*, p. 560) wrote that "tutti li denari erano venuti a le mani di gente nuova." See also Matteo Villani (book III, chap. 56); Perrens, *op.cit.*, IV, p. 391.

[46] *Op.cit.*, p. 34. Though Scaramella does not observe it, all references that he cites to the *homines novi* are from the period after the plague (Matteo and Filippo Villani, Giovanni di Paolo Morelli, etc.).

passed in part—and not a small part—to people newly arrived from the territory of Florence who had little experience in civic affairs, and to people from more distant lands who had settled in the city. Finding themselves after a time enriched with money gotten in the crafts, in trade, and in money-lending, they married into any family that pleased them; and with gifts, feasts, secret and open maneuvers they put themselves forward so much that they were drawn into public offices and were added to the list of those eligible for election to the priorate.''[47]

In the *Corbaccio*, written in 1354-1355, Boccaccio compared the rulers of the city to a person lacking liberal studies,[48] and in a letter of about ten years later he said that the reins of government had been given to people who had come, as we would say, from Kalamazoo—"venuti chi da Capalle e quale da Cilicciavole, e quale da Sugame o da Viminiccio"—and who had been "taken from the mason's shop or from the plow and elevated to the highest office in the state."[49]

THE EFFECT UPON CULTURE AND ART

The painting of the third quarter of the century, more religious in a traditional sense, more ecclesiastical, and more akin to the art of an earlier time, may reflect these profound social changes in Florence and Siena, or rather the taste and the quality of piety that they brought into prominence. For these *homines novi*, the immigrants, the newly rich and the newly powerful, had not on the whole been closely identified with the growth of the new culture in the first half of the fourteenth century. They adhered to more traditional patterns of thought and feeling, and it may well be that their ideal of a religious art was still the art of the later thirteenth century—an art that was still visible almost everywhere in the cities, and even more in the churches of the *contado*. At other times, less educated, provincial people have clung to an art that had been supplanted for as long as fifty years, and we are given hints that this was so around the middle of the fourteenth century. Writing in 1361 in his will about a

[47] ". . . il reggimento e governo della città di Firenze in que' tempi, . . . era venuto in parte, e non piccola, in uomini novellamente venuti del contado e distretto di Firenze, poco pratichi delle bisogne civili, e di gente venuta assai più da lunga, i quale nella città s'erano alloggiati, e colle richezze fatte d'arti e di mercanzie e d'usure, in dilazione di tempo trovandosi grassi di denari, ogni parentado faceano che a loro fosse di piacere; e con doni, mangiari, preghiere occulte e palesi tanto si mettavano innanzi, ch'erano tirati agli uffici e messi allo squittinio" (chap. 65). See also Matteo Villani, book x, chap. 74, and, with emphasis upon the lower middle class, Stefani (quoted by Rodolico, *I ciompi*, p. 42). Already in 1345 Giovanni Villani, speaking of the new government, had accused the minuti of being "foreigners" (book XII, chap. 43).

[48] "Zoppa del piè diritto come quella cui mancavano liberi studi." See F. Macrì-Leone, in *Giornale storico della letteratura italiana*, XV, 1890, p. 109.

[49] The trouble with these people, Boccaccio adds, is not their place of origin nor their occupation, but their greed and stupidity. In the ancient world, he says, Roman farmers and workers had accomplished important things for the state. But elsewhere in the letter he wavers on this point. See F. Corazzini, *Le lettere edite e inedite di Messer Giovanni Boccaccio*, Florence, 1877, p. 74.

I suppose that the names of the towns invoked by Boccaccio are the inventions of his wit.

Madonna by the "outstanding" painter Giotto, Petrarch says that though its beauty is a source of wonder to the masters of the art, the ignorant do not understand it.[50] Boccaccio wrote that, as a poet and a student of classical antiquity, he was regarded as a sorcerer in the town of Certaldo.[51] Elsewhere he attacked the noisy adversaries of poetry (primarily ancient poetry) who, ignorant of its character and its true meaning, constantly opposed religion to it.[52] There is no reason to suppose that these ready "theologians" or the friars and other groups whom he excoriates for similar reasons were any less antagonistic to certain aspects of the more advanced style of the Trecento in the figure arts. We cannot expect them to have proved anything but hostile to Ambrogio Lorenzetti's fascination with ancient sculpture. One of the known objects of his fascination, a newly discovered statue by Lysippus, was broken into bits by frightened members of the Sienese public. It may be that these same groups were unsympathetic also to the assimilation of ancient forms in the work of Ambrogio or Cavallini or Nicola Pisano. We cannot then suppose them to have been much more friendly to all those dispositions and qualities of the new style that lie behind such assimilations—in other words, to the essence of the new style itself. Because known comments on painting and sculpture in the fourteenth century are few, and limited mostly to scholars, writers, and the artists themselves, such attitudes are difficult to ascertain. It is notable, however, that Fra Simone Fidati seems to disapprove, by implication at least, the warm relationship between man and wife in paintings such as Giotto's.[53] And in the *Meditations on the Life of Christ,* oddly enough in the very treatise that exercised so great an influence on painting, we find the old antagonism to the arts themselves reasserted. Except for their employment in the cult, they are, the Franciscan writer says, stimulants of a "concupiscenza degli occhi."[54]

Whether or not conservative tastes of this sort were felt by the painters at the moment of decisive change and innovation around the middle of the century, their wider diffusion and their prevalence among people who had acquired wealth and influence as patrons at least broadened the acceptance of the new styles and helped to maintain them. A painting such as Giovanni del Biondo's St. John the Evangelist trampling on Avarice, Pride, and Vainglory (Fig. 69)[55] may thus have struck an immediate response

[50] ". . . tabulam meam sive iconam beatae Virginis Mariae . . . cuius pulchritudinem ignorantes non intelligunt, magistri autem artis stupent." See R. Salvini, *Giotto (Bibliografia),* Rome, 1938, p. 5.

[51] H. Hauvette, *Boccace,* Paris, 1914, p. 464.

[52] See books xiv and xv of the *Genealogia degli dei* (trans. by C. G. Osgood, *Boccaccio on Poetry,* Princeton, 1930).

[53] See p. 26.

[54] *Meditations,* chap. xii (see the edition of the Italian text by A. Levasti, Florence, 1931, pp. 46-47): "Cotali cose [i.e. lavorìo curioso, bello, . . . delicato] sono concupiscenza degli occhi, lo quale vizio è uno de' tre peccati, ai quali tutti gli altri si riducono." The author condemns works of craft and of art also because they waste time, promote vanity, and are contrary to poverty.

The passage in the *Meditations* is based on ideas about the *concupiscentia oculorum* expressed by St. John (First Epistle, ii, 16) and developed by St. Augustine (*Confessions,* book x, esp. chap. 34), after whom they became part of the mediaeval tradition. The latter speaks of the "attractions" that men, with the aid of the arts, have added to paintings and other things.

[55] The association of these vices with St. John is probably connected with the passage

because of its older symbolic pattern and the austere frontality of its chief figure. The panel was doubtless widely approved for its subject, too, particularly the representation of the conquest of avarice. At this time avarice was, as we have mentioned, associated especially with the unlimited desire for profit and accumulation that had already become characteristic of early capitalism. Neither this motive nor the new economic system had been accepted by a considerable part of society. They were often opposed, it seems safe to assume, by the same people who were conservative in other spheres also, particularly religion and the arts. These people clung to the mediaeval belief in a just price and the limitation of wealth to the amounts needed for a livelihood by persons in the several stations of life.[56] Their antagonism to the new system and its values was certainly more assured after the bankruptcies and other events of the 'forties. Segre states that in 1354 twenty-one Florentine bankers were fined for usury, and in tracing the fluctuating policy of Florence on the lending of money at interest, he implies a greater opposition to loans in the second half of the fourteenth century.[57] At this time many people undoubtedly took a special pleasure in the sight of a defeated Avarice sprawled on the ground and ignominiously trodden underfoot.

Though the *gente nuova* was doubtless pleased by this portrayal of the triumph of St. John, it is questionable whether any of them played a leading part in the selection of the painter or the determination of the subject. The work was actually commissioned, as we have seen, by the *Arte della Seta*, one of the seven greater Florentine guilds. Though within it, as in all the other guilds, there were during this period certain shifts of responsibility and power, it was still dominated by established merchants and industrial entrepreneurs.[58] These were, in fact, the chief patrons of painting at the time, just as they had been earlier in the century. It was the Tornaquinci who commissioned the frescoes by Orcagna in the choir of S. M. Novella, the Strozzi who employed Orcagna and Nardo for the altarpiece and murals of their chapel, one of the Guidalotti who provided the funds for the frescoes in the Spanish Chapel, though they were executed after his death. But, as we shall see clearly in the instance of Giovanni Colombini,[59] these wealthy patricians were deeply affected, too, by the events of the 'forties and 'fifties. They had never freed themselves of doubt as to the legitimacy of their occupation. The Church had not explicitly sanctioned either their activities or their profits, and "manifest" usury it strongly condemned. The distinctions between usury of this kind and permissible interest, while precise, were very fine, and in advanced age merchants and bankers quite commonly sought to quiet their conscience and assure their salvation by making regular provision for corporate charity and by a voluntary restitution of wealth that they judged was improperly

from this saint cited in the previous note and later interpretations of it.

[56] See Paolo di Messer Pace da Certaldo, *Il libro di buoni costumi*, ed. by S. Morpurgo, Florence, 1921, p. CL (Paolo is mentioned in documents from 1347 to 1370). The writer, son of a jurist, recounts the perils of avarice, and then concludes: "Sia temperato in se, e non disiderare più che'l tuo stato richegha."

[57] A. Segre, *Storia del commercio*, Turin,

1923, p. 223.

[58] A. Doren, *Entwicklung und Organization der florentiner Zünfte*, Leipzig, 1897, p. 71, pointed to the greater recognition given at this time to silk weavers and dyers in a guild that continued to be dominated by silk merchants. See also *idem, Florentiner Zunftwesen*, Stuttgart and Berlin, 1908, p. 199.

[59] See below, pp. 86ff.

acquired. As the most eminent living student of Florentine economic history has written: "Reading the last wills of the members of the Company of the Bardi . . . there becomes evident and dramatic the contrast between the practical life of these bold and tenacious men, the builders of immense fortunes, and their terror of eternal punishment for having accumulated wealth by rather unscrupulous methods."[60]

The guilt of the entrepreneurs and bankers was greatly quickened around the middle of the century. The bankruptcies and the depression struck just as hard at their conscience as at their purse. The loss of exclusive control of the state and the terror of the Black Death seemed further punishments for dubious practices. Giovanni Villani attributed the failure of the companies of the Bardi and the Peruzzi, in the second of which he himself had invested money before he joined the Buonaccorsi, to the "avarizia di guadagnare," and his strictures imply a condemnation not so much of poor judgment in this single instance as of all financial practices that involve great risks. Since few large ventures of the time could be undertaken without such risks, Villani comes close to turning his back on capitalism itself, and he had earlier signified that money-lending was a disreputable occupation.[61]

In the wake of the disasters of the 'forties and 'fifties, then, the established wealthy families of Florence very probably welcomed a less worldly and less humanistic art than that of the earlier years of the century. Their own position seriously threatened, they felt sustained by the assertion in art of the authority of the Church and the representation of a stable, enduring hierarchy. Their taste would have tended to converge, then, with that of the *gente nuova*, who emerged from circles that still clung to a pre-Giottesque art in which very similar qualities inhered.

All sections of the middle class were, in any event, clearly united in their desire for a more intensely religious art. It was not only great merchants such as Giovanni Colombini, with their own special reasons for remorse, who vilified and abandoned their former mode of life. Masses of people, interpreting the calamities as punishments of their worldliness and their sin, were stirred by repentance and religious yearning. Some of them joined groups that cultivated mystical experiences or an extreme asceticism; many more sought salvation through the traditional methods offered by the Church. Several painters—Orcagna, Luca di Tommè, Andrea da Firenze—were, as we have seen, moved to a greater piety or a mystical rapture. Others who were less deeply stirred saw fit nevertheless, as the craftsmen of images for the cult, to adopt many of the new values and the new artistic forms, though in a more conventional way. For the painting of the time this religious excitement, and the conflict of values which it entailed, was a crucial cultural event. Hitherto little studied, it will be discussed at some length in the following chapter.

[60] "Nel leggere le ultime voluntà dei membri della compagnia dei Bardi . . . appare evidente e drammatico il contrasto della pratica della vita di quegli uomini audaci e tenaci, costruttori di fortune immense, e il terrore della punizione eterna per aver creato la loro richezza con mezzi poco scrupolosi" (A. Sapori, in *Archivio storico italiano*, III, 1925, p. 250). On the subject of voluntary restitution, see B. N. Nelson, in *Tasks of Economic History*, supplement VII, 1947, to the *Journal of Economic History*. Even in the fifteenth century, Cosimo dei Medici sought the advice of Pope Eugene IV on the restitution of money that he confessed had been illegitimately gotten.

[61] Book VII, chap. 147.

III

GUILT, PENANCE, AND RELIGIOUS RAPTURE

I

THE years following the Black Death were the most gloomy in the history of Florence and Siena, and perhaps of all Europe. The writing of the period, like the painting, was pervaded by a profound pessimism and sometimes a renunciation of life.[1] "Seldom in the course of the Middle Ages has so much been written," Hans Baron has said recently, "concerning the 'miseria' of human beings and human life."[2] Though religious thought throughout the Middle Ages had dwelt on the brevity of life and the certainty of death, no age was more acutely aware of it than this. It was preached from the pulpits, most vividly by Jacopo Passavanti, and set forth in paintings, both altarpieces and murals. In the predella below the Madonna by Giovanni del Biondo in the Vatican (Fig. 52) there is a representation entirely unprecedented in Tuscan art: a decayed corpse, consumed by snakes and toads. A bearded old hermit points to it with an admonishing gesture while a man and his dog recoil in terror. In the great fresco in the Camposanto at Pisa, painted probably around 1350, Francesco Traini[3] portrayed with intense feeling the suffering of the sick, the horror of rotting flesh, and the sudden, unpredictable coming of death (Fig. 85). In part this fresco raises to a monumental scale the theme of the meeting of the quick and the dead which had already been represented in the thirteenth and earlier fourteenth centuries. To this it joins an apparently unprecedented scene of death swooping in like a bird of prey upon its victims. The same scene was painted shortly afterward by Orcagna in S. Croce, Florence, as part of a cycle containing, as at Pisa, the Last Judgment and the tortures

[1] See, for instance, the beginning of Sacchetti's *Trecento novelle*: "Considerando al presente tempo, ed alla condizione dell'umana vita, la quale con pestilenziose infirmità, e con oscure morti, è spesso vicitata; e veggendo quante rovine, con quante guerre civili e campestre in esse dimorano; e pensando quante populi e famiglie per questo son venute in povero ed infelice stato, e con quanto amaro sudore conviene che comportino la miseria, là dove sentono la lor vita esser trascorsa; e ancora immaginando, come la gente è vaga d'udire cose nuove, e spezialmente di quelle letture che sono agevoli a intendere, e massimamente quando danno conforto, per lo quale tra molti dolori si mescolini alcune risa; . . ."

(Franco Sacchetti, *Proemio del Trecento novelle*).

[2] *Speculum*, XIII, 1938, p. 12. Baron discusses the diffusion of stoicism and the ideal of poverty in the period following the epidemic.

For the preoccupation with death, see A. M. Campbell, *The Black Death and Men of Learning*, New York, 1931, pp. 172ff.

[3] For comment on a question raised recently about the identity of Traini, see Appendix II, p. 171. The fresco has usually been dated around 1350 or a little later, though without any conclusive evidence (but see note 16 below). W. R. Valentiner (*Art Quarterly*, XII, 1949, p. 68) suggested that it may reflect the epidemic of 1340 rather than the Black Death.

of Hell.[4] Only a fragment of Orcagna's scene survives, showing several corpses and a few miserable creatures half alive who vainly implore Death to end their suffering (Fig. 86). The cripples fix their eyes upon Death with a marvelously rapt attention, and even the blind man senses its presence.

The style of Traini is essentially unrelated to that of Orcagna and his period, associating itself rather with the art of the earlier fourteenth century. But at this time he, like Orcagna, was engrossed with the actuality of suffering and death in the world, and although he added to his fresco an idyllic scene of the eremitic life, the *vita contemplativa* that banishes the fear of death and secures a triumph over it, it is the triumph of death that is painted with the greater urgency and hence gave its name, borrowed from Petrarch, to the entire composition.

The incidence of the plague, an undeniable triumph of death, was interpreted in diverse ways. Some writers attributed it to astrological influences (the conjunction of the planets), others to climatic conditions (the corruption of the air).[5] But far more common was the belief that, like the Biblical flood, the Black Death was caused by the moral corruption of man and the ensuing wrath of God. This was the opinion, transcending all others, of the chroniclers,[6] of poets and scholars such as Petrarch and Bartolus,[7] of the physicians who wrote treatises on the disease,[8] and of course of the

[4] For other representations of the Triumph of Death of the same period, see Meiss, *Art Bulletin*, XV, 1933, pp. 168-171, and R. Offner, *Corpus*, sec. III, vol. V, 1947, pp. 261-263.

A mound of dead, to which a hermit points, appears also in one section of a badly faded painting in the Siena Gallery (E. DeWald, in *Art Studies*, VII, 1929, figs. 90-93). The condition of this work makes precise attribution and dating very difficult. It is undeniably very close to Pietro Lorenzetti. Its general conception suggests this master himself, but what is visible of the execution seems rather the work of a follower.

[5] Around 1420, Lionardo Bruni offered a naturalistic explanation. Writing of the Black Death in his *Istoria fiorentina* (ed. Florence, 1857, II, p. 332) he traced its ravages to the effects of the years of famine on the health of the Florentines. Modern opinion tends to hold that the severity of the epidemic was due to the concurrence of bubonic and pneumonic plague (See *Encyclopedia of the Social Sciences*, s.v. Black Death).

Precautions and remedies for the disease were as varied as explanations of it, and they disclose equally diverse modes of thought. The Florentine physician Tommaso del Garbo, for instance, advised as preventives good food, proper quarantine, and a procedure that to-day we would call psychosomatic—the maintenance of a gay, relaxed frame of mind (see his *Consiglio contro la pistolenza*, in *Scelta di curiosità letterarie*, LXXIV, 1866). More interesting to art historians is the fact that gold, the substance used in paintings of the period for its beauty as well as its talismanic value, was also believed to be a potent weapon against the plague. It was made into an emulsion to be imbibed (according to the prescription of the eminent physician Gentile da Foligno) or it was used in the form of a pestle to stir the medicinal potions (see A. M. Campbell, *op.cit.*, p. 91). Its use in these ways was apparently dictated by the belief that it was an inherently good substance, i.e. good for anything.

[6] See, for instance, Matteo Villani, book I, chap. 2, quoted in part above, p. 66. Earlier, Giovanni Villani had given an interesting account of the astrological and supernatural interpretations of the flood of 1333 (book XI, chap. 2).

[7] A. T. Sheedy, *Bartolus on Social Conditions of the Fourteenth Century*, New York, 1942, p. 25; Petrarch, *Lett. sen.*, III, 1 (ed. G. Fracassetti, Florence, 1892, I, p. 150). In this letter, written after the plague of 1363, Petrarch attacks the astrological explanation.

[8] See A. M. Campbell, *op.cit.*

very devout.[9] It is reflected in several novel scenes of the Last Judgment painted in the wake of the epidemic.

In Tuscan representations of the Last Judgment in the late thirteenth century and the first half of the fourteenth, Christ addresses both the blessed and the damned, welcoming one group and rejecting the other. Sometimes he proclaims his will simply by the relative height of his hands—the right higher for the blessed, the left lower for the damned.[10] In other works, however, including Giotto's fresco in Padua (Fig. 88), this symbolism of position is disregarded, and he lowers an open hand toward the blessed while extending an averted one toward the damned.[11] His lowered hand expresses acceptance or welcome, and it is often so close to the blessed that it seems to suggest an active assistance. In most of these representations Christ manifests a special concern for the blessed by turning his eyes toward them,[12] or, as in Giotto's fresco and one or two other works, his head or even his body.[13]

In several compositions after the middle of the century, probably beginning once again with the fresco cycle in Pisa (Fig. 87), the attitude of Christ is radically different. For the first time in the representation of the Last Judgment he addresses the damned alone, turning on them with an angry mien, his arm upraised in a powerful gesture of denunciation. The Virgin alongside him is also wholly preoccupied, though more compassionately, with the damned, and the apostles do not sit as tense and impartial witnesses, but are moved to pity and to fear by the awesome sentence.[14] One of the archangels at the center of the composition expresses the inevitability and impartiality of the judgment, another cringes, terror-struck with a more human consternation.

Christ appears as a similar angry, denouncing figure in other paintings of the period: a miniature in a Laudario in the Biblioteca Nazionale, Florence, probably painted during the 'fifties (Fig. 90),[15] a panel by Niccolò di Tommaso in the Larderel collec-

[9] For instance, St. Bridget (*American Catholic Quarterly Review*, XLII, 1917, p. 116). She miraculously cured one of the Roman Orsini of the disease.

[10] Nicola Pisano's pulpit, Duomo, Siena; panel by a follower of Segna, Musée des Tapisseries, Angers. In Nicola's earlier pulpit in Pisa, Christ (now damaged) apparently raised both arms, as in French Gothic sculpture. On the gestures of Christ in the Last Judgment, see E. Panofsky, in *Festschrift für Max Friedländer*, Leipzig, 1927, pp. 307-308, and Offner, *Corpus*, sec. III, vol. v, 1947, p. 252 note 6.

[11] Pulpit by Giovanni Pisano, S. Andrea, Pistoia; mosaic, Baptistery, Florence.

[12] Follower of Segna in the Musée des Tapisseries, Angers; triptych by a Paduan follower of Giotto in the Frick Art Reference Library; panel by the Biadaiuolo Master, collection of Philip Lehman, New York (Offner, *Corpus*, sec. III, vol. II, part 1, pl. 19).

[13] Panel very close to Guido da Siena in the Museum at Grosseto. The right foot of Giotto's Christ is extended part way across the mandorla toward the blessed. Though he addresses primarily the blessed, his face, as Offner has pointed out (*loc.cit.*), seems to express anger, and thus anticipates the mood, but not the action, of Christ in the later representations discussed above. Already in the thirteenth century Jacopone da Todi had referred to the "faccia dura" of Christ at the Judgment (F. De Sanctis, *Storia della letteratura italiana*, Naples, 1870, I, p. 35).

[14] The apostles are similarly stirred in the representations of the Last Judgment by an earlier Pisan master, Giovanni Pisano, but their concern with the damned is not as explicit.

[15] Magl. II.I.212, fol. 64v.

tion, Livorno, and Nardo di Cione's fresco in the Strozzi Chapel, S. M. Novella (Fig. 89), though in the latter he permits himself also a rather mild gesture of benediction.[16] In some paintings of a later period, too, Christ is moved to denunciation alone: several panels by Fra Angelico, Giovanni di Paolo's predella in the Siena Gallery, and Michelangelo's fresco in the Sistine Chapel. But these later works do not diminish the significance of the appearance of the action around the middle of the fourteenth century. Like several other novel forms of this period, once created it survives into a later time, retaining in varying degrees its original expressive purpose.

In Italian and northern art of the fifteenth century the conception of an aroused God punishing mankind by pestilence often assumed the form of Christ hurling arrows at the world, like the thunderbolts of Jove.[17] Already at the end of the thirteenth century Jacopo da Voragine had related that when St. Dominic was in Rome he saw Christ in the heavens brandishing three lances against mankind, fully resolved to destroy it because of the prevalence of pride, avarice, and lust.[18] Though this image of the Saviour directing weapons at the world did not, so far as I know, appear in Tuscan art of the Trecento, arrows as symbols of pestilence appear in representations of St. Sebastian. This saint, who had been martyred with arrows, was invoked as an intercessor against plague as early as the seventh century. His cult was unimportant, however, at least in Tuscany, until after 1348. A few years later a relic was brought to Florence from Rome, and his figure began to appear frequently in Florentine painting.[19] His martyrdom was painted also, first perhaps in panels by Giovanni del Biondo (Fig. 91) and Andrea Vanni.[20] Giovanni's conception is unique. In representations painted later, at the very end of the fourteenth or in the fifteenth century, from three to around fifteen arrows puncture the body of the saint. In Biondo's painting, however,

[16] Offner, *Corpus*, sec. III, vol. v, p. 254. Offner surmises that the posture of Christ in the paintings by Traini and Niccolò di Tommaso may have been influenced by Orcagna's lost Last Judgment in S. Croce. Niccolò di Tommaso's Last Judgment, however, is clearly dependent in many details on the one in the Camposanto. Furthermore, Nardo di Cione's introduction of the wrathful Christ seems to me one more indication of the influence of the Pisan cycle on the Cioni. The implications of Christ's act of damnation are much more extensively developed in Pisa than in the Strozzi Chapel, or indeed anywhere else.

[17] See B. Kleinschmidt, *Maria und Franziskus von Assisi*, Düsseldorf, 1926, pp. 93-101.

[18] The Golden Legend, August 4. This legend is illustrated in a panel by the school of Fra Angelico in the Kaiser-Friedrich Museum (*Fra Angelico*, Klassiker der Kunst, pl. 173).

[19] Nardo's Paradise, altarpiece by the Master of the Fabriano Altarpiece ca. 1360, etc. See the list in Offner, *Corpus*, sec. III, vol. v, p. 162 note 1 (to which may be added the Rinuccini Master's altarpiece in the Academy).

For the importation of the relic, see D. von Hadeln, *Die Wichtigsten Darstellungen des heiligen Sebastian in der italienischen Malerei bis zum Ausgang der Quattrocento*, Strasbourg, 1906, pp. 8-9.

[20] Biondo's panel is now in the Opera del Duomo, Florence. Von Hadeln rightly suggests that this was probably the altarpiece mentioned by Sacchetti (*Novella* 171) as having been commissioned by the bishop of Florence for the altar dedicated to St. Sebastian in the Duomo, where the relic was preserved. For the lost painting of this subject made by Andrea Vanni in 1379, see G. de Nicola, in Thieme-Becker, I, 1908, p. 465.

the saint is riddled by dozens of them. He is a relentlessly tortured figure, blood dripping from more than thirty wounds.[21]

II

In the years following 1348, Florence and Siena were swept by reports of the imminence of a new disaster or the appearance of Anti-Christ. Dire prophecies were uttered. A Franciscan Tertiary, Tommasino da Foligno, proclaimed that new calamities would be wrought by an angry, unappeased God.[22] The pseudo Jacopone da Todi foretold the beginning in 1361 of the "duro male."[23] One Daniele, a Minorite, predicted in 1368 that ten years later there would be "great fears and horrors," that the "little people" would kill all tyrants, that Anti-Christ would appear, that the Turks, Saracens, and other infidels would ravage Italy, and that men would be assailed by tempests and floods, hunger and death.[24] We are not surprised to learn that, in these circumstances, such prophecies were widely believed. Doubtless their primary audience was the uneducated and the poor, to whom the words of Daniele, referring to an uprising of the workers, would even give some hope. But many who in less frightening times would have scoffed listened with heightened anxiety.[25] In any event, the number of sceptics was very shortly reduced, for the plague struck again in 1363 and once more in 1374.

Churches and religious societies were showered with bequests willed to them by people dying, or expecting to die, of the plague. Some of these funds would of course have come to them over the years in any event, but the unusual size of the donations and their concentration all at one time resulted, at least in Florence, in an unprecedented accumulation. Villani estimates that the Company of Or San Michele, a society with religious, social, and philanthropic functions, received the huge sum of 350,000 florins,[26] attaining such spectacular wealth that memory of it was still alive in Vasari's day; he refers to it in his Life of Orcagna. A considerable part of this money was, in fact, given to Orcagna for the splendid marble tabernacle that he made for the church of the fraternity (Fig. 8). Ghiberti, who otherwise does not speak of costs in his biog-

[21] A Florentine fresco of about the same time in the Oratorio di S. Lorenzo, Signa (Alinari 31179), is very similar in this respect to Biondo's panel. A second angel appears, bearing a palm. In the early fifteenth century Gaddesque fresco in S. Ambrogio, Florence, there are on the other hand only seven arrows. For later examples, see Von Hadeln, op.cit.

A gruesome violence to the body is represented in another painting of this time, a panel by the shop of Giovanni del Biondo in S. Agata in the Mugello, portraying in an exceptionally bloody manner the cutting of the breasts of the saint.

[22] H. C. Lea, History of the Inquisition, II, New York, 1909, p. 282.

[23] See N. Rodolico, I ciompi, Florence, 1945, pp. 59-62; idem, La democrazia fiorentina, Bologna, 1905, pp. 73ff.

[24] See Diario d'anonimo fiorentino in Documenti di storia italiana, Florence, VI, 1876, p. 389; Davidsohn, Geschichte von Florenz, Berlin, IV, 3, 1927, p. 107.

[25] Boccaccio himself was deeply moved by a related prophecy. See below, p. 161.

[26] M. Villani, book I, chap. 7. Most of the bequests were intended as alms, to be distributed by the captains of the Company. But, as Villani says, the very poor and needy were dead, and the captains used much of the money themselves, precipitating a great public scandal.

raphies of the Trecento masters, says that the company paid 86,000 florins for this work.[27] Some of the funds held by the company may have been applied to the frescoes in S. Croce by Giovanni da Milano and the Rinuccini Master (Figs. 27, 36, 37).[28] During the height of the epidemic S. M. Novella received from Turino Baldesi the large sum of 1,000 lire (or florins) for the painting of the "story of the entire Old Testament from beginning to end."[29] It was perhaps at this time, too, that the Tornaquinci gave to the same church funds for the painting of the choir, undertaken shortly afterward by Orcagna.[30] Like the Company of Or San Michele, the Company of the Bigallo was greatly enriched by the epidemic and in 1352 it undertook to build a new home, the Oratorio that still stands.[31] New hospitals were founded with gifts from wealthy individuals—S. Caterina dei Talani, for instance, in 1349.[32]

Despite the ensuing economic stagnation and the inflation, such gifts did not cease. In the years immediately following the Black Death Buonamico di Lapo Guidalotti, a Florentine merchant, whose wife had died of the plague, gave a considerable portion of his fortune to the Dominicans of S. M. Novella for the construction of a new chapter-house (the "Spanish Chapel"), an unusually costly enterprise for one man. Just before his death in 1355 he added 325 florins, and then 92, for the covering of its walls with frescoes.[33] These were, as we have seen, executed in 1366-1367 by Andrea da Firenze.

In Siena the bequests of the stricken were smaller, and they apparently were not

[27] Schlosser and other scholars do not question the size of this sum, but it seems fabulously large.

[28] See G. Milanesi in his edition of Vasari (I, p. 572 note 2).

[29] Shortly afterward the donor added a codicil to his will, bequeathing 270 florins for the construction of the main portal. See C. di Pierro, *Giornale storico della letteratura italiana*, XLVII, 1906, p. 15. The original bequest is given as 1,000 *lire* in *Delizie degli eruditi Toscani*, IX, 1777, p. 116. For another gift to several provincial churches, see *ibid.*, X, 1778, p. 268.

The use to which the 1,000 florins (or lire) were put is perhaps mentioned in manuscripts on the church which I have been unable to consult. In the west aisle of the church there was, according to J. Wood Brown (*The Dominican Church of S. M. Novella*, Edinburgh, 1902, p. 118) a cycle of New Testament scenes, and the Old Testament series may originally have been planned to complement this. However, construction of the Chiostro Verde was undertaken in the 'fifties (*ibid.*, p. 83) and the cycle of Old Testament frescoes which was begun there several decades later, and which still

exists, may have been financed, at least in part, by Turino's gift.

[30] See C. di Pierro, *loc.cit.*, and H. Gronau, *Andrea Orcagna und Nardo di Cione*, Berlin, 1937, p. 66.

[31] W. Paatz, *Die Kirchen von Florenz*, Frankfort a/M, 1940, pp. 378ff. The vaults of the building, now destroyed, and "altre cose" were painted by Nardo di Cione in 1363 (*ibid.*, p. 384).

[32] *Ibid.*, p. 440. K. Frey, commenting on the formation by the painters of the Company of St. Luke in 1349, said that the plague led to the foundation of many similar fraternities with a combined pious and social purpose (*Loggia dei Lanzi*, Berlin, 1885, p. 102). This is plausible enough, but Frey cites neither examples nor sources for his statement. The date of the foundation of the Company of St. Luke has in fact been controversial, but R. Ciasca has recently adduced new evidence for 1349 (*L'arte dei medici e speziali*, Florence, 1927, p. 88).

[33] Wood Brown, *op.cit.*, pp. 145-146, and I. Taurisano, in *Il rosario*, ser. III, vol. III, 1916, pp. 80-93, 217-230. Taurisano refers to many other bequests to the Church in 1348.

followed by large donations in subsequent years. The city was impoverished to a greater extent than Florence and its economy recovered very slowly, if ever, from the calamity. Barna and Bartolo di Fredi, the chief mural painters of the period, found work outside Siena, in S. Gimignano and Volterra. Construction of the great new cathedral was halted abruptly, never to be resumed. The *operaii* and most of the masters employed on the work had died in the epidemic, and as Agnolo di Tura tells us, there was no wish to begin again "because of the few people that remained in Siena, and also because of their melancholy and grief."[34] Though this fantastically ambitious project had to be abandoned, the fervor of the populace expressed itself in more modest construction. Agnolo di Tura says that the survivors began the Cappella del Campo as an offering to the Virgin and that they constructed the churches of S. M. delle Grazie and S. Onofrio as well as "molti altri oratori e luoghi divoti" throughout the town.[35]

III

The general feeling of fear, guilt, and sorrow sought expression in other ways also. The pope was besieged with requests from all stricken countries for a "perdono generale" and for the designation of 1350 as a Holy Year.[36] Though in 1300, when the jubilee was instituted, a holy year every hundred years was envisaged, Clement VI decided to proclaim one in 1350, and special indulgences were granted pilgrims to Rome. The number of these was extraordinary. Matteo Villani wrote that on holy days there were in the city as many as a million visitors. This figure is not idly speculative, for Matteo shared with his brother Giovanni the characteristic Florentine interest in quantities and precise calculation. In this instance he goes on to report the number of visitors at various times during the year as well as their places of origin, and he records regretfully the excessive prices of food and lodging, chiding the Romans for cheating the pilgrims at every turn.[37]

The throngs of pilgrims were preceded and accompanied by great congregations of Flagellants. These zealots were addicted to a form of self-chastisement which, from

[34] *Op.cit.*, p. 557.

[35] *Op.cit.*, p. 558.

[36] Matteo Villani, book 1, chap. 29. Villani connects these requests with the proclamation of the jubilee, but, according to A. C. Flick (*Decline of the Medieval Church*, New York, 1930, I, p. 71), the papal decision precedes 1348.

Inasmuch as no adequate history of religious life in Italy in the fourteenth century exists, the account that follows above is more extended than it would otherwise have been. The book by Charles Dejob, *La foi religieuse en Italie au quatorzième siècle*, Paris, 1906, has little value, and the discursive treatise of G.

Volpe, *Movimenti religiosi e sette ereticali nella società medievale italiana*, Florence, 1922, makes only a few references to the Trecento. The religious leaders and the various movements have attracted little attention, apart of course from St. Catherine, who has been studied intensively, though almost always as an isolated phenomenon.

[37] Book 1, chap. 56. Similarly when Matteo compared the mortality in the plague with that in the Biblical flood he estimated the approximate number of people living in that remote period and concluded that the flood took a smaller toll of human life (book 1, chap. 1).

the mid-thirteenth century on, had occasionally swept through the Italian towns.[38] On this occasion they attracted unusually large numbers of adherents not only because self-punishment offered a very tangible kind of penance, an immediate release from an oppressive guilt, but because they claimed a special heavenly intervention in their favor. They possessed a letter which they said was delivered by an angel on Christmas day, 1348, shortly after the pestilence had subsided. It was addressed to the Flagellants by the Virgin Mary, and in it she stated that she had obtained from Christ a pardon of all their sins.[39] Fortified with this document, groups of them set out for Rome, gathering converts along the way as they engaged in their frenzied but methodical practice of whipping themselves, all of them together, twice a day and once during the night for periods of thirty-three days on end.[40]

These violent exhibitions often led to public disorders, accompanied by a display of bitter anticlerical feeling. The town councils tried to control them, and in October 1349, Pope Clement VI issued a bull prohibiting the Flagellants from assembling.[41] By 1351 they were dispersed. Their practices persisted, however, though on a less spectacular scale. In Florence societies of *battuti*, the first of which had been founded around 1330, multiplied during the latter part of the century,[42] and religious leaders, such as St. Catherine, scourged themselves privately.[43]

A second group of zealots, confronting the Church with a far more serious and lasting challenge, likewise increased in numbers and influence from the 'forties on. These were the Fraticelli, dissident Franciscans who descended from the Spirituals of the thirteenth and early fourteenth centuries. The Spirituals were committed to a strict interpretation of the ideas of St. Francis, especially with relation to property. They maintained that Christ and the apostles had had no possessions either individually or in common, and that therefore a denial of poverty was a denial of Christ. Though in the early fourteenth century this doctrine was advocated, with qualifications, by the general of the Franciscan Order, Michael of Cesena, and by other Franciscan leaders such as William Occam, Pope John XXII declared it heretical in a bold and decisive series of bulls issued from 1318 to 1324. Thereupon most of the Spirituals, including those of Tuscany, fled to regions where they would be less accessible to papal authority. But their ideas persisted—even Fra Simone Fidati, preaching in S. Croce in the 'thirties, showed sympathy with them. The extremist friars, now called Fraticelli, increased greatly in number from the 'forties on, especially in Florence. This city, in fact, became a center of the sect in the third quarter of the century.[44]

[38] The gates of the city of Florence were always closed against them, except in 1335. See Davidsohn, *op.cit.*, IV, 3, p. 76.

[39] See *Dictionnaire de théologie catholique*, s.v. Flagellants.

[40] One day for each of Christ's years on earth. See *Enciclopedia italiana*, s.v. Flagellanti; G. Biagi, *Men and Manners of Old Florence*, London, 1909, pp. 119-121; Lea,

op.cit., II, p. 381, and G. Volpe, *op.cit.*, pp. 232ff.

[41] I. F. C. Hecker, *The Black Death*, London, 1833, p. 100, and Lea, *loc.cit.*

[42] Davidsohn, *op.cit.*, IV, 3, p. 78.

[43] E. G. Gardner, *St. Catherine of Siena*, London, 1907, p. 13.

[44] F. Tocco, "I Fraticelli," *Archivio storico italiano*, ser. 5, XXXV, 1905, pp. 331-368

The rise of the Fraticelli was facilitated by the "Babylonian Captivity." The residence of the popes in Avignon, together with the corruption of the Curia, weakened ecclesiastical control in Italy. The authority of the Papacy and the Church, along with that of all institutions, was shaken also by the Black Death and the developing social conflicts. The Fraticelli, preaching a doctrine that had been declared heretical, now boldly claimed that Pope John XXII and his successors were heretics themselves.[45] They rejected the sacraments offered by priests other than their own. Under the influence of the urban social and economic crisis, their original conception of the sinfulness of property tended to shift to a belief in the sinfulness of the rich and the justice of taking from them to give to the poor.[46] These ideas were especially attractive to the oppressed woolworkers and the poorer artisans and shopkeepers; they provided a religious stimulus and sanction for their struggle for political rights and economic betterment. It is not surprising therefore that the great merchants, bankers, and industrialists, once again in complete control of the government of Florence in 1382 and eager to please the pope, who protected their commerce abroad, immediately had the old laws against heresy reenacted. And in 1389 one of the Fraticelli, Michele da Calci, was burnt at the stake.

The ideas of an extremist group such as the Fraticelli were not likely to have affected directly an art so closely connected as that of the fourteenth century with the Church. Their own houses were poor and impermanent, and they did not, so far as we know, commission altarpieces and frescoes. On the other hand, their zeal undoubtedly quickened the religious life of the age, and I believe that we can discern their influence upon painting, no less important because it is indirect and in a sense even negative. The challenge which they, and to a lesser extent the Flagellants, presented to the ecclesiastical institutions provided one more stimulus for that affirmation of the authority of the Church which we have discovered in the painting of the time, and of which we shall speak again later.

IV

These heretical or heterodoxical movements represent only one—and a secondary—

cima L. Douie, *The Nature and Effect of the Heresy of the Fraticelli*, Manchester, 1932, p. 226; A. T. Sheedy, *Bartolus on Social Conditions in the Fourteenth Century*, New York, 1942, p. 193, quoting Wadding (*Annales minorum*, VIII, 98). See also L. Oliger, "Beiträge zur Geschichte der Spiritualen, Fratizellen und Clarener," *Zeitschrift für Kirchengeschichte*, XLV, 1926, pp. 215ff.

[45] See the public letter explaining their position published in *Scelta di curiosità letterarie*, Bologna, LV, 1865. The editor, G. Vanzolini, suggests 1336 as the date of the letter, but it was probably written later.

[46] Rodolico, *I Ciompi*, pp. 53-59. Rodolico had already claimed, in his *Democrazia fiorentina nel suo tramonto*, Bologna, 1905, an influence of the Fraticelli on the rise of the *popolo minuto*. This was contested by Tocco, "L'eresia dei Fraticelli," in *Rendiconti della R. Accademia dei Lincei, Classe di scienze morali, storiche, e filologiche*, ser. 5, XV, 1906, pp. 3-20. Tocco insisted that the Fraticelli movement was purely ascetic, but he ended up by admitting an alliance between the Fraticelli and the proletariat. See also F. Antal, *Florentine Painting and its Social Background*, London, 1947, pp. 71-72.

aspect of the religious life of the time. The majority of the people expressed their devotion within the traditional patterns established by the Church. In Florence they were inspired chiefly by the great Dominican preacher, Jacopo Passavanti. Passavanti, who was born in Florence at the beginning of the century, became a preacher at S. M. Novella in 1340 after a period of study and teaching in Paris and Rome. From the late 'forties on he was in charge of maintenance and construction, and from 1354 to his death in 1357 he served as prior.[47] During this period the new church was completed, the Spanish Chapel was built, and funds were received for its frescoes. Orcagna, further-more, painted the altarpiece of the Strozzi Chapel and Nardo its walls, and the former may also have undertaken the mural cycle in the choir. Much of this activity was due to Passavanti's influence, and all of it was under his supervision. The existence of iconographic similarities between the paintings in the Strozzi and Spanish Chapels is therefore not surprising, even though the latter were not executed until some years after his death.

Passavanti's thought has been preserved in a treatise called "Lo Specchio di Vera Penitenza."[48] In it he brought together in a systematic way ideas expressed in his sermons, especially those delivered in 1354. They center on the necessity, or rather the urgency, of penitence, for which he accumulates evidence among the writers of the past, and which he makes vivid for his contemporaries by numerous "esempi," brief but highly colored images or stories interspersed through his more formal discourse. His thought and his mood are closely related to contemporary painting. Man appears a perpetual sinner, hovering in the shadow of death and judgment. His only hope lies in penitence, a mordant contrition that continually torments the spirit (Figs. 30, 60-62). Recalling the common experiences of 1348, Passavanti describes for his audi-ence the frightful decay of human flesh, more odorous, he insists, than that of putrefy-ing dogs or asses (Figs. 52, 85).[49] He tells of sceptics who, uttering words of doubt, were struck by lightning and immediately reduced to ashes.[50] He follows them to hell, lingering with their tortures and listening for their anguished shrieks, as though he were under the spell of Orcagna's fresco in S. Croce, where the faces of the dammed are torn by the claws and teeth of wildly sadistic devils (Fig. 83). Passavanti tries to convey by calculation the incalculable endlessness of their doom. "One day," he says "a French nobleman wondered if the damned in hell would be freed after a thousand years, and his reason told him no; he wondered again if after a hundred thousand years, if after

[47] C. di Pierro, "Contributo alla biografia di Fra Jacopo Passavanti," *Giornale storico della letteratura italiana,* XLVII, 1906, pp. 1-24.

[48] Ed. by M. Lenardon, Florence, 1925. See also N. Sapegno, *Storia letteraria d'Italia, Il trecento,* Milan, 1942, pp. 505-510; A. Levasti, *I mistici del duecento e del trecento,* Rome, 1935, pp. 64ff.; A. Monteverdi, "Gli esempi di Jacopo Passavanti," *Giornale storico della let-*

teratura italiana, LXI, 1913, pp. 266ff., and LXIII, 1914, pp. 240ff.

[49] *Specchio, cit.,* pp. 307-308.

[50] See A. Monteverdi, *op.cit.,* 1914, pp. 249, 287. The monastery of S. M. Novella itself was struck by lightning several times during the priorate of Passavanti. In 1358 the choir was hit and the frescoes of Orcagna damaged (see Matteo Villani, book VIII, chap. 46).

a million years, if after as many thousands of years as there are drops of water in the sea, and once again his reason told him no."[51]

To Passavanti sin is a daemonic power and life a relentless struggle against it, grimly maintained because of fear of something worse. And in many paintings of the time, devils, the embodiments of guilt, become more prominent, more aggressive and more vengeful, attacking the lost souls in Orcagna's Hell, menacing the patriarchs in Andrea's Limbo (Fig. 98)[52] and the unrepentant thief in Barna's Crucifixion, the most intense image of guilt and fear in the art of the fourteenth century (Fig. 92). In the fresco of Limbo one devil munches ecstatically on a human head, and in Orcagna's Hell a group of them lacerate the faces and bodies of their victims. For Giotto, on the other hand, hell is a place more of disorder than of excruciating pain (Fig. 88). The damned and all the devils except Satan are reduced in scale. Hell is more remote and less substantial than heaven. Indeed Giotto's outlook, serene and assured, differs from that of these later masters in much the same way as Giotto's Dominican contemporary Domenico Cavalca (ca. 1270-1342) differs from Jacopo Passavanti. Of these two preachers De Sanctis wrote: "Cavalca's muse is love, and his material is Paradise, of which we get a foretaste in that spirit of charity and gentleness which gives his prose so much softness and color. But Passavanti's muse is terror, and his material is vice and hell, pictured less from their grotesque and mythological sides than in their human aspects, as in remorse and the cry of conscience. . . ."[53] Can we avoid thinking of Giotto and Orcagna?

<div align="center">V</div>

Many of Passavanti's "esempi" are drawn from the eremitic life, a life that was actually exemplified in Florence at this time by the Beato Giovanni dalle Celle.[54] Born of a noble Tuscan family around 1310, Giovanni entered the monastery of Vallombrosa before 1347, became abbot of S. Trinita in Florence in 1351, and shortly afterward retired to the "eremo delle celle" above Vallombrosa. Here numerous disciples gathered around him, among them Agnolo Torini, author of a treatise on human misery.[55]

Giovanni dalle Celle extended his influence beyond the circle of Vallombrosa to all of Tuscany by an indefatigable correspondence. His letters were preserved and copied, and his reputation became so great that they continued to be read in the Quattrocento as models of sanctity and pious asceticism. He addressed these letters, moral and hortatory in character, to friends and acquaintances, some of whom were members of the Florentine government, and he communicated with all the Tuscan religious leaders

[51] Monteverdi, op.cit., 1913, p. 305.

[52] Antal, op.cit., p. 202, has pointed to the prominence of the devils in this scene, connecting them with "popular taste."

[53] F. De Sanctis, History of Italian Literature, trans. by J. Redfern, New York, 1931, I,

p. 123.

[54] Sapegno, op.cit., p. 259; Levasti, op.cit., pp. 1010-1011.

[55] Breve raccoglimento della miseria umana, written between 1363 and 1374. See Levasti, op.cit., pp. 909-948, 1014-1015.

of the time—Colombini, St. Catherine, William Fleet, St. Bridget (in Rome), and even the Fraticelli. He tried to induce the latter to confess to their presumptuousness and to renounce their heretical convictions.[56]

As far as his own life was concerned, Giovanni was uncompromising—"we enter the world," he said, "by dying."[57] Although he was also a firm supporter of the Church, he was tolerant and discreet in judging others. His ardor was tempered by rational analysis and by consideration of the practical consequences of religious beliefs and acts. He was wary of ecstasy and visions, attributing them to pride. On the other hand, he showed sympathy if not enthusiasm for Colombini and his followers, counseling them to ignore the scorn of their opponents and assuring them in the words of the Gospels, Job, and Seneca, as well as in eloquent phrases of his own that poverty is the only way to salvation.[58] He admired St. Catherine and attacked her opponents; occasionally, however, his views differed sharply from hers. At the time of the War of the Eight Saints (1374-1378) Catherine declared that the Florentines were sinful to take arms against the pope, but Giovanni felt they were justified in defending their "patria" against oppression, as he put it, and he did not insist on strict observance of the papal interdict, holding that such decrees were applicable only to mortal sin.[59] On one occasion he even countered Catherine's advice. She had urged a young Florentine follower, Suora Domitilla, to join a crusade. Hearing of this, Giovanni wrote a letter and cautioned her from undertaking the journey, pointing to the constant temptation to which travel with young men would expose her.[60] He added: "If you have Christ in the sacrament of the altar . . . why would you abandon him to go see a stone?"[61]

These differences between Giovanni and Catherine arise from dissimilar personalities and religious conceptions. In the relationship of these two figures as well as of the Florentine Passavanti with the Sienese Bianco and Colombini we sense differences in the religious culture of the two cities that correspond to those in the realm of art, at this time as well as others. It is true that Giovanni dalle Celle had a sort of lesser counterpart in the region of Siena, but he was an Englishman, William Fleet, a hermit who settled at Lecceto apparently in 1362 and who acquired a great reputation for piety and learning. He held a degree from Cambridge, and was respectfully known as "il Baccelliere." Like Giovanni, with whom he corresponded, Fleet took an active part in the religious movements of the time, and became a disciple of St. Catherine.[62]

[56] Decima L. Douie, *The Nature and the Effect of the Heresy of the Fraticelli*, Manchester, 1932, pp. 232-240.

[57] See the letter published by Levasti, *op.cit.*, p. 793.

[58] See the letter to "i poverelli di Dio" (*ibid.*, p. 800).

[59] See Giovanni's letter of 1375-1377 to Guido di Neri, in *Archivio storico italiano*, ser. v, xxxv, 1905, p. 348; also P. Cividali, in *Atti della R. Accademia dei Lincei*, ser. 5,

Memorie della classe di scienze morali, storiche e filologiche, XII, 1906, pp. 366ff.

[60] Cividali, *op.cit.*, pp. 366, 367, 391, and R. Fawtier, *Sainte Catherine de Sienne*, Paris, 1921, p. 54.

[61] Gardner, *op.cit.*, pp. 174-175. The letter was written ca. 1373-1375. Giovanni probably refers to the famous stone of unction.

[62] Fawtier, *op.cit.*, pp. 53ff., and Cividali, *op.cit.*, p. 366.

The two never met, but they felt they knew each other "per istinto di Spirito Santo." It is noteworthy that when Catherine's opinions were contradicted by Giovanni dalle Celle, Fleet immediately sided with her, and made angry protests to Giovanni.

At Lecceto, too, another voice was raised a few years later which was reminiscent of Passavanti—that of the Augustinian Fra Filippo.[63] It is true also that the devotion of all the leaders of the time, in Siena as well as Florence, was distinguished by strenuousness, excitement, and a sense of urgency. But there remains nevertheless a significant difference between the stern, terrifying but logical preacher of S. M. Novella or the discreet speculative hermit of Vallombrosa and the impulsive, ecstatic and more essentially mystical figures of Siena. The Florentines exhibit self-denial, the Sienese, self-abandon. In religion as in art the Florentines inclined toward rationality and speculation, the Sienese toward an immediacy of sentiment and emotion.

VI

Historians, even of religion, have paid little attention to the Beato Giovanni Colombini. He has remained in the shadow of his far greater and rather like-minded Sienese contemporary, Catherine, but his life gives us an uncommonly clear insight into many aspects of the religious sentiment of this troubled time. Colombini was a wealthy Sienese merchant.[64] He held high political office, probably that of prior of the commune. In 1355, apparently in July[65] and thus just two months after the fall of the government of the great merchants and bankers, Colombini suddenly dedicated himself to a different life. Haunted by guilt, he gave all his possessions to the poor, to the convent of Santa Bonda, and to the Hospital of the Scala. His wife, eminently pious but not, in the salty words of his Quattrocento Florentine biographer, Feo Belcari, "equally in love with poverty," reproved him for his abandon. When Colombini remonstrated that she had always prayed for a greater charitableness on his part, she replied with a burgher's pungent sense of the proper and practical mean: "io pregavo che piovesse, ma non che venisse il diluvio" (I prayed for rain, but not for the flood).[66]

Colombini, wishing to demean his former mode of life and to humiliate himself publicly, undertook manual labor in the Town Hall where formerly he had sat with the rulers. Together with the first of his followers, fellow members of the oligarchic party of the *Nove*, he carried wood and water, cleaned the stairs, and helped in the priors' kitchen. He had himself whipped in front of the Town Hall, and he sought to

[63] Sapegno, *op.cit.*, p. 548, and William Heywood, *The "Ensamples" of Fra Filippo*, Siena, 1901. Fra Filippo's treatise was written toward the end of the century, but as Sapegno observes, it seems earlier in character. Fra Filippo was born in 1339 and died, after a long life, in 1442.

[64] See Feo Belcari, *La vita del Beato Giovanni Colombini*, Verona, 1817 (Belcari, an excellent prose writer, composed this biog-

raphy in 1448, utilizing a life written in the early fifteenth century by Giovanni Tavelli da Tossignano; see L. Albertazzi in *Propugnatore*, XVIII, part 2, 1885, pp. 225-248). See also Sapegno, *op.cit.*, pp. 510-513; Levasti, *op.cit.*, pp. 1008-1009; G. Pardi, *Bulletino senese di storia patria*, II, 1895, pp. 1-50, 202.

[65] *Acta sanctorum*, July, VII, p. 352.

[66] Feo Belcari, *op.cit.*, p. 32.

expiate his sense of guilt about his former business practices by asking his companions to shout accusations at him in the great piazza that he had sold poor grain high and bought good grain low.[67] To growing audiences, who watched him riding about the city on an ass, he advocated democracy and, like the Fraticelli, the elimination of the privileges of the wealthy. Neither the Church nor the ruling council of Siena, though now dominated by the smaller merchants and bankers together with shopkeepers and artisans, were sympathetic to these views. The government soon condemned him to perpetual exile as "a dangerous innovator, who might ruin the peace of families and cause a rebellion among the populace."[68] Colombini went to Arezzo, where one of his followers was hung as a heretic. When the plague appeared for the second time, however, in 1363, so many Sienese interpreted it as a sign of God's displeasure with the ban that it was hastily lifted and Colombini was recalled to the city.

Colombini continued to be opposed by both civil and ecclesiastical authorities, but the number of his followers increased in Siena and in the other Tuscan towns, Florence among them, where he preached. They all lived in a state of exaltation, identifying themselves with Christ and St. Francis, and praying God to grant death and martyrdom. They urged the populace to shoulder the Cross of Christ—"prendiamo la croce di Cristo," Colombini wrote in his letters.[69] This is the exhortation of Christ himself in a unique group of contemporary paintings. In them the Child holds a cross and sometimes a scroll on which is inscribed the passage from the Gospels: "If any man will come after me, let him deny himself, and take up his cross, and follow me" (Fig. 119).[70]

As Colombini and his followers moved about they sang mystical *laudi*. Some of the songs were composed by members of the band, and those of Bianco da Siena, who was the most ardent and the most eloquent of the disciples, have taken a place in the religious literature of the century.[71] Though the group prayed for long hours, Colombini rejected the mass, citing as predecessors in this respect Mark, Anthony, and Paul. He was intolerant of intermediation and of formal worship. Like the extreme Spirituals and the Fraticelli, he was opposed to books and learning. A certain Domenico, to whom he had written of mystical love, replied: "I understand clearly by your letter that all sciences, natural, ethical, political, metaphysical, economic, liberal, mechanical . . . are merely a dark cloud over the soul. . . ."[72] Colombini said that he was "burning with the love of the Holy Spirit"; the core of his faith was the conviction that the "fire of love" would renew the world. The wide acceptance of these views finally reversed the position of the Church. In 1367, a few days before Colombini died, his activity was approved by Pope Urban V, despite the hostility of members of the Curia. He was wel-

[67] P. Misciatelli, *The Mystics of Siena*, Cambridge, 1929, p. 80.

[68] *Ibid.*, p. 81.

[69] Sapegno, *op.cit.*, p. 513.

[70] For a discussion of these paintings, see Meiss, in the *Art Bulletin*, XXVIII, 1946, pp. 6-7.

When St. Francis, seeking guidance shortly after his conversion to a religious life, asked a priest to open the missal three times, the passage disclosed on the third opening was the one quoted above. In many respects Colombini was a close follower of Francis.

[71] Sapegno, *op.cit.*, pp. 515-517.

[72] Misciatelli, *op.cit.*, p. 96.

comed as the founder of a new lay congregation, called the Gesuati, and his followers became its first members.

VII

Colombini's life was to some extent a model for the youthful Catherine Benincasa, the last and the greatest religious figure of the period, and the only one, too, who is generally known, so that our account may be proportionately brief.[73] Like Colombini and the other leaders whom we have discussed, her religious impulses were stimulated by an acute sense of personal and human misery, deepened by the plague, inflation, and poverty, the devastation of the countryside by marauding condottieri, and social and political conflicts in the commune. Born the youngest of the twenty-five children of a Sienese dyer, she was only an infant at the time of the Black Death, but we know that at least one of her brothers died of the "mortalità" in 1363, two others in 1374, together with a sister and with eight of the eleven grandchildren in her mother's house. She buried all the latter herself.[74] During the epidemics she was one of the few who moved about the city, helping to bury the dead, comfort the stricken, and on one occasion she was said to have cured a dying victim—the rector of the Hospital of the Scala.[75] Her family acquired political influence and a measure of prosperity in 1355 by the victory of the *Dodicini,* the political party to which her brothers belonged; but this party was driven from power thirteen years later, her brothers became the objects of attack, and Catherine, who by then had become an inviolable person, had to conduct them through those parts of the city where their enemies were concentrated.[76]

Catherine devoted herself at an early age to strenuous ascetic practices. At six or seven she began to have visions, and she showed so much independence and so firm a conviction of her religious insight and her mission that, like Colombini, she incurred the hostility of several ecclesiastical authorities in Siena.[77] Though she became a Dominican tertiary in 1363-1364, she wanted to live outside any fixed rule. Like Colombini she formed a *cenacolo* or lay society, one member of which, Cristofano Guidini, wrote the first biography of Colombini. The rule of her group, she said, came straight from God.[78]

Catherine's devotion, especially during these early years, assumed an intensity

[73] For a recent topical listing of the writing on St. Catherine, see Sapegno, *op.cit.,* p. 564 note 6. The first critical biography, still very useful, was written by R. Fawtier, *op.cit.* There are several books in English: E. G. Gardner, London, 1907; A. T. Drane, London, 1899; A. Curtayne, London, 1929. The monograph by Gardner is very good biographically but not equally valuable for an analysis of her thought. The best recent study I am familiar with is G. Getto, *Saggio letterario su Santa Caterina,* Florence, 1939. Many of Catherine's writings, or rather the letters and treatises which she dictated, have been translated into English. See the *Letters,* translated by V. Scudder, New York, 1906, and the *Dialogue,* translated by A. Thorold, London, 1925.

[74] See *I miracoli* (the earliest surviving biography, written in 1374), ed. Fawtier, *op.cit.,* pp. 229-230. Also Gardner, *op.cit.,* p. 122.

[75] *Miracoli,* pp. 230-231. At this time she also restored two friars.

[76] *Miracoli,* p. 225.

[77] Getto, *op.cit.,* p. 20; Gardner, *op.cit.,* p. 92.

[78] Misciatelli, *op.cit.,* p. 103.

greater even than Colombini's. To Andrea of Lucca she wrote: "Drown you in the Blood of Christ, and may our own will die in all things."[79] The Blood was an obsessive symbol for her, and almost every letter begins: "I write thee in the precious blood of Jesus Christ." She enjoined her friends and followers to sacrifice themselves for the sins of humanity, and indeed one of the accusations of her opponents was that she had undertaken to do penance for others. Though she believed, with Passavanti, that sin had to be overcome by strenuous striving, it was not, as for him, a constant, oppressive, tormenting threat. She thought that knowledge of self, which everyone could gain by assiduous introspection, would reveal love.[80] And love rather than penitence was essential to perfection.

Some of the ideas which Catherine advanced in her youth made her, as we have mentioned, a controversial figure. Her visions were mistrusted, and she was openly attacked by several friars and clerics in positions of authority. In 1374 she was called to S. M. Novella in Florence for interrogation by the provincial chapter of the Dominican Order. After an examination, the record of which has been lost, she was assigned a spiritual director, Raymond of Capua, a learned Dominican, who remained with her till her death.[81] From about this time on, Catherine's career became more public, and her activities reached beyond Siena to Rome, Avignon, and the whole of Italy. Opposed now to mere asceticism and contemplation, and preaching a militant Christianity, she advocated a crusade in the east, and attempted to persuade the condottiere John Hawkwood to abandon his free-booting for generalship of the Christian forces. She tried to end the war between Florence and the pope, and her persistent attempt to induce the latter to quit Avignon for Rome is a familiar chapter in European history.

VIII

St. Catherine, Giovanni dalle Celle, Colombini, Passavanti and several of their more inspired adherents compose an exceptional group of religious leaders. There was no comparable group in Tuscany at any other period within the fourteenth century; indeed, they made the two decades immediately after the plague one of the most important moments in the religious history of central Italy. They communicated their ardor to a people that had already been made fervent by the trials and disasters of the time. We feel their influence in the spiritual intensity of contemporary painting, in its reversion, not without ambivalence and conflict, from the natural and the human to

[79] See the entire letter in Scudder, *op.cit.*, p. 312. For an equal intensity later in her career, see the letter to Raimondo of Capua (Scudder, *op.cit.*, p. 329).

[80] See Getto, *op.cit.*, pp. 104-105. Getto suggests that this psychological trend in Catherine relates her to the Renaissance.

[81] See R. P. Mortier, *Histoire des maîtres généraux de l'ordre des Frères Prêcheurs*, Paris, 1907, III, pp. 460-461. The appointment was confirmed by a bull of Gregory XI in 1376 (see *Fontes vitae S. Catharinae Senensis*, I, ed. by M. H. Laurent and F. Valli, Siena, 1936, p. 38).

Before 1374 Catherine had been given instruction and advice by Fra Tommaso della Fonte.

the unnatural and the divine. The mystical rapture of Colombini and Catherine is more evident in the painting of Siena; in Florentine art there is more of Passavanti's grim penance, of his insistence upon the curative power of good works and participation in the rites of the Church.

The zeal of these religious figures affected the Church and the orders as well as the laity, and it embodied itself in a series of lasting institutional innovations and reforms. We have already seen that the movement led by Giovanni Colombini, similar to the Spiritual Franciscans in character, was eventually recognized by the Church and in 1367 established as the Order of the Gesuati. St. Catherine provided the initial and the major stimulus for the reform of the Preaching Friars. In the later fourteenth century many Dominican as well as Franciscan houses had become lax, partly because of the plague, which promoted an indifference to religion and to ecclesiastical authority among some people at the same time that it stimulated a more intense devotion in others.[82] Catherine induced her order to commit several monasteries to strict observance. Their number was greatly increased by a formal program of reform launched shortly afterward by her spiritual director, Raymond of Capua, whom she had deeply influenced and who became general of the order in 1390. He was aided in this work by Giovanni Dominici, who began his novitiate at S. M. Novella the year Catherine was in Florence.

Among the Minorites a similar movement of reform gained momentum and led to an equally important institutional innovation. Since their suppression by Bonaventura in the late thirteenth century, the Spirituals had been striving for recognition and for the grant of houses where they might live according to their own beliefs. In 1334 one group was permitted to live apart, and in 1352 four additional hermitages were granted, into which even a few of the Fraticelli came. In 1368 some of the more moderate under Paolo da Trinci were formally recognized by the Franciscan general as a separate section of the order and they founded the first monastery of the Observants or Osservanti at Brugliano in Umbria. There they adhered more closely to the original rule of St. Francis, without reference to subsequent papal interpretations and dispensations. In 1374 the general permitted them to form communities outside Umbria, and their houses multiplied rapidly during the later fourteenth and fifteenth centuries.[83]

During the period when they lived as marginal members of the Franciscan order the Spirituals maintained close relationship with the very numerous devout laity existing within the Third Order, and with the anticlerical and antipapal Fraticelli. After the recognition of the Osservanti in 1368, the Fraticelli began to lose their influence. Some of them compromised their views and joined the new sect; the rest were persecuted as heretics by the Osservanti themselves.[84]

[82] See below, note 95.

[83] See D. Muzzey, *The Spiritual Franciscans,* New York, 1908, p. 55; H. E. Goad, *Franciscan Italy,* New York, 1926, p. 254; R. M. Huber, *A Documented History of the Franciscan Order,* Washington, 1944, pp. 255ff.

[84] See Douie, *op.cit.,* pp. 240-241.

It is evident that this broad movement of reform was not caused simply by laxity in the orders and the desire of their leaders for a stricter observance. In the 'sixties and 'seventies the Church and the mendicant orders felt the necessity of redirecting and absorbing the intense religious impulses of the time, many of which had assumed forms independent of, or hostile to, ecclesiastical institutions. Thus in 1367 Pope Urban V, against the advice of several cardinals, transformed Colombini's group into the Gesuati. The moderate Spirituals were accepted as the Osservanti in 1368. In 1370 the pope confirmed another new order, likewise with a strict rule—that of St. Bridget, the Swedish mystic who had been living in Rome since the end of the 'forties.[85] And a few years later Catherine began the reform of the Preaching Friars. These institutional innovations and changes are in themselves ample proof of the scope and intensity of the religious movements of the preceding years.[86]

The role of the mendicant orders in the religious movements of the time was greater than that of any other branch of the Church. They were much more active than the secular clergy, especially during this period of the Babylonian Captivity of the popes, and they were in closer touch with the people, as indeed they had been for over a hundred years. The Dominicans, moreover, were more prominent than the Franciscans. They provided two of the leaders, Catherine and Passavanti. But it would be erroneous to understand the quickening of religious life as exclusively, or even primarily, a Dominican phenomenon. It was more broadly rooted, stimulated by the economic collapse, the plague, and the general feeling of guilt and despair. It is clear, too, that Colombini and the Gesuati were inspired by Franciscan patterns of devotion, and that the dissident Franciscans, the Spirituals and the Fraticelli, attracted widespread sympathy. Furthermore, Giovanni dalle Celle was Vallombrosan, William Fleet Augustinian, and within the *cenacolo* of Catherine, at first only loosely connected with the Dominican Order, there were two Franciscans and an Augustinian.[87]

Similarly the more important paintings of the period were neither commissioned nor inspired by any one order or institution. Again the Dominicans are most conspicuous—three of the best surviving works are in the Strozzi and Spanish Chapels of S. M. Novella. But Franciscan S. Croce can show a chapel frescoed by Giovanni da Milano and a collaborator (Figs. 27, 36, 37) and fragments of a large cycle by Orcagna—the

[85] See S. M. Gronberger, in *American Catholic Quarterly Review*, XLII, 1917, pp. 97ff.

[86] Antal, *op.cit.*, pointed to the influence of the reformist movement on painting, but only its later, more conventional phase in the early fifteenth century. He overlooked both the more intense stage described above and the religious excitement of the third quarter of the Trecento from which it sprang. Thus what peculiar religious content he perceived in the painting of this period he attributed to the more emotional piety of the rising lower classes and to the calculated attempt of the upper middle class or the orders to control them by giving them a suitably devout art.

[87] The Augustinian was Fra Felice da Massa, author of *La fanciullezza di Gesù*, a rhymed version of part of the Franciscan *Meditationes vitae Christ* (see below, p. 125). For the influence of Catherine among the Augustinians, see Gardner, *op.cit.*, p. 95.

Triumph of Death, Last Judgment, and Hell (Figs. 83, 86). Orcagna, it is true, painted the choir of S. M. Novella, too, but he also painted, according to Ghiberti, a chapel in S. Croce, two chapels in the Church of the Servites, and the refectory of the Augustinian church of S. Spirito, all but the last now lost.[88] His great sculptured tabernacle was made for the company of Or San Michele. In Siena itself nothing comparable to these Florentine works has come down to us, and indeed little monumental painting was originally undertaken. The large cycles by Barna and Bartolo di Fredi are in S. Gimignano, in the Collegiata and the church of S. Agostino.[89] The lesser Florentine and Sienese paintings of the period show an equally wide distribution.

In one form or another the religious revival of the third quarter of the century pervaded the various levels of society and the numerous orders or lay bodies existing within, or on the margins of, the organized Church. What we hear of the size of these religious groups proves that the masses of the people were included. The participation of the well-to-do is indicated by the social status of the leaders and their closest followers. St. Catherine, the daughter of a dyer, belonged to a lower middle class family. In her immediate circle of some fifteen or twenty disciples there were nine members of the most prominent Sienese noble families and two of the greater guild of the judges and notaries.[90] Many of them joined her *cenacolo* during her early independent, preecclesiastical years. Another of her adherents was the painter Andrea Vanni; three letters that she wrote to him while he held communal offices have been preserved.[91] In Florence she won followers in all classes; the center of her group was Francesco di Pippino, a tailor and a recent immigrant from S. Miniato al Tedesco.[92] Jacopo Passavanti came from an old and eminent Florentine family, Giovanni dalle Celle from the nobility. Colombini was a merchant and banker, one of the Sienese oligarchy. His first companion, Francesco di Mino Vincenti, and a later follower, Tommaso di Guelfaccio, had likewise been leading Noveschi,[93] and three "grandi" of the noble Piccolomini family joined his group. Of the identity of the leading Flagellanti and Fraticelli we know almost nothing, but it seems probable that more of them originated in the lower middle class or among the workers in the woolen industry.

Not all the populace responded to the events of the 'forties and 'fifties with increased devotion. That "unexpected" and "marvelously contrary direction" described by Matteo Villani—religious indifference, and what to him seemed immorality and irresponsibility[94]—persisted for many years. Within the religious orders themselves we hear

[88] On the surviving paintings by followers of Orcagna in S. Spirito, see p. 14 note 13.

[89] Fredi also executed a large mural cycle in the Duomo at Volterra, now lost. See Milanesi, *Documenti per la storia dell'arte senese*, I, p. 285.

[90] Getto, *op.cit.*, p. 25, and Gardner, *op.cit.*, p. 212. The nobles included Alessa Saracini,

Matteo Tolomei, Biancina Salimbeni, Gabriele Piccolomini, and Francesco Malavolti.

[91] *Le lettere di S. Caterina agli artisti e ai professionisti*, Rome, 1939, pp. 102ff.

[92] Gardner, *op.cit.*, pp. 171-172.

[93] Gardner, *op.cit.*, p. 43.

[94] See page 67.

of considerable laxity.[95] The plague, joined by the other disturbances, tended in fact to polarize society toward strenuous religiosity on the one hand and moral and religious dissidence on the other. The culture of the time is characterized by a heightened tension between the two. They constitute a kind of dialectic that is reflected in the conflicts of contemporary painting, and they gave a more highly charged polemical and evangelical meaning to its celebration of the Church, the ritual, and the priest.

[95] See R. P. Mortier, *op.cit.*, III, pp. 274ff., 291-319. For the encyclicals of the generals of the order (Simon de Langres, 1359, and Elie Raymond de Toulouse, 1368) on the failure of the observance, see *Monumenta ordinis Fratrum Praedicatorum historica*, v, pp. 299, 306.

See also F. A. Gasquet, *The Black Death of 1348 and 1349*, London, 1908, p. 216, who quotes Wadding, *Annales minorum*, VIII, p. 22; and Carlo Denina, *Delle rivoluzioni d'Italia*, Milan, 1820, pp. 588-590.

IV

THE SPANISH CHAPEL

I

THE chapter-hall of S. M. Novella and the paintings by Andrea da Firenze that cover its walls were both undertaken, as we have seen, with funds given to the Dominicans by Buonamico di Lapo Guidalotti under the impact of the Black Death. The frescoes, actually executed only ca. 1366-1368, were the largest and most unusual pictorial enterprise of the time (Fig. 93).[1] Their principle of unity is not so much narrative as systematic. In this respect they are comparable to the reliefs on the campanile of the cathedral of Florence and perhaps also to Ambrogio's frescoes of Good and Bad Government in the Palazzo Pubblico, Siena, both works of the second quarter of the century. It is not accidental that in this earlier period the foremost doctrinal or encyclopaedic statements were made in the town hall or on the bell tower of the cathedral under direct communal and guild supervision, whereas in the third quarter of the century they were set forth in a church, or rather the chapter-hall of a religious order. This difference of locale is partly the consequence of altered financial resources, for in the third quarter of the century those of the municipality were relatively reduced whereas numerous churches and societies, including S. M. Novella, were greatly enriched. It reflects also a shift of communal interest, and it shows us where at this time the greater energy and conviction were centered.

All the surfaces of the building, the four walls and the four webs of the cross-vaults, are covered with frescoes. The small chapel opposite the entrance, repainted after the building had been given to the Spanish colony in Florence, may originally have had scenes of the Corpus Christi, and on the altar was placed the still extant retable by the Assistant of Daddi containing numerous allusions to the eucharist.[2] On the wall around the chapel is represented the Crucifixion, the Way to Calvary, and the Descent into Limbo (Figs. 96, 38, 98). The entrance wall contains six scenes from the legend of Peter Martyr, and on the side walls appear elaborate representations of Christian

[1] In the execution of the cycle Andrea of course had assistance. The hands of followers are apparent especially in the group of saints in Paradise and in the Ascension, a fresco painted entirely by an assistant, though Andrea very probably provided the design. Numerous figures in the Apotheosis of St. Thomas, and parts of the background, have been repainted.

[2] J. Wood Brown, *The Dominican Church of S. M. Novella*, Edinburgh, 1902, p. 151. The retable (reproduced in Offner, *Corpus*, sec. III, vol. v, pl. 17) is dated 1344, and was made originally for another site. After centuries in the cloister, it has recently been replaced on the altar of the Spanish Chapel. A. Chiappelli, *Arte del rinascimento*, Rome, 1925, p. 262, questions Wood Brown's identification of the scenes in the small chapel.

The feast of the Lord's Supper was celebrated annually in the chapel.

Learning (Fig. 95) and the Way to Salvation (Fig. 94). In the vaults are the Resurrection (Fig. 47), the Ascension, the Pentecost (Fig. 41) and the Navicella (Fig. 97).

The effect of this ensemble of paintings is unusual (Fig. 93). Much more than in any painted interior of the earlier half of the century one has the impression that the walls are clothed with frescoes, as with a figured vestment that is bound by wide bright ornamented bands that seem like orphreys. The sources of this effect are various. There are not, for one thing, large areas empty of form and of uniform color, as in the Arena Chapel. In each of Andrea's frescoes the forms are distributed with almost equal density over the entire painted field, and there is an uninterrupted continuity of color, texture, and movement throughout. This even distribution extends into the vaults, which carry painted scenes instead of the more usual single figures set on a blue starry sky. The webs of the vaults are unusually large, and the decision to fill these curving spaces overhead with stories is clearly indicative of a certain kind of taste that appears more exceptional perhaps in Florence, with its tectonic tradition, than it would anywhere else. It is noticeable, at the same time, that three of the four scenes selected for the vaults are heavenly, or at least "airy," in form. The Resurrection is given the new design that we have discussed above (Fig. 47), and in it, as in the Ascension, Christ, the main figure, floats above the world. In the Navicella (Fig. 97) the great billowing sail seems almost to lift the ship from the water. The Pentecost (Fig. 41) is the most earthbound of the four, but like the Ascension and the Resurrection it exhibits an unearthly yellowish light high in its field (in the chamber of the apostles), and the figures are tied by rays to the Holy Ghost in the sky above. And while we are considering the distribution of the scenes, it is worth noting that the subterranean Limbo is placed at the bottom of a wall.

The large surfaces of the walls are not subdivided by frames, even where, as around the chapel, there are three separate historical events. This aspect of the layout was already noted by Vasari. Thinking of the huge frescoes of the sixteenth century, some of which he had made himself, he speaks approvingly of the design of the chapel, and criticizes those masters, old and modern, who "put the earth above the air four or five times."[3] In scale Andrea's frescoes were actually preceded by numerous paintings of the Last Judgment or by Traini's cycle in Pisa that includes this subject (Fig. 87). Representations of the Last Judgment, however, were commonly accompanied by smaller historical scenes framed singly, and similar small scenes appear on both sides of Traini's large frescoes in the Camposanto, though they were not executed by him. None of these earlier cycles has then the monumental uniformity of scale of the Spanish Chapel.

Though two of Andrea's frescoes are, as Vasari said, laid on a hill, the effect of this

[3] Referring to the painter of the Spanish Chapel, Vasari says: ". . . pigliando le facciate intere, con diligentissima osservazione fa in ciascuna diverse storie su per un monte; e non divide con ornamenti tra storia e storia, come usarono di fare i vecchi e molti moderni, che fanno la terra sopra l'aria quattro o cinque volte; . . ." (ed. Milanesi, I, pp. 551-552).

device is not, as he implies, more naturalistic. The terrain recedes very deeply in the *Via Veritatis* (Fig. 94), but apart from it there is not a single movement into depth anywhere in the chapel—nothing comparable, for example, to the curved platform upon which the apostles sit in Giotto's Last Judgment (Fig. 88). The painter, furthermore, tilts the ground planes sharply, tends to avoid overlapping, and usually rejects diminution—very strikingly in the procession of the Way to Calvary (Fig. 37). Thus the forms placed at deeper and also higher levels tend to come forward and coalesce in a single plane, though not without ambiguity and tension. These effects are enhanced by the choice and distribution of color. On the whole the figures are lighter than the ambient, so that there is not the same equilibrium between the two as in Giotto, Maso, and the Lorenzetti. The color is much colder than in the murals of these earlier masters. The reds are bluish, the yellows mustard, and rather closely crowded russets and maroons are set side by side. There are many changeable colors, especially red-yellow and green-blue. The more intense colors, moreover, are frequently used for the underlinings of garments. Similarly, the faces of the actual ribs of the building, painted a dull red, tend to recede behind the splayed sides, which are ornamented with an active white pattern.

The unity of pattern, so highly developed within each fresco on the walls, sometimes extends beyond them to include the adjacent composition in the vault. Though the relation of the vault paintings to those below was certainly governed primarily by their subjects, the Resurrection, with Christ suspended high in the air, is similar to the Crucifixion below it, and the Pentecost, with its frontal, axial figure of the Virgin, its horizontal bands, and its two rows of figures, the lower of which shows a greater variety of posture, bears a striking resemblance to the Apotheosis of St. Thomas underneath.

Each of the paintings, at the same time, is bound by the borders to one of the architectural spaces. The paintings seem bent and curved to fit these spaces, especially in the vaults. While these aspects of the design carry into the frescoes the structure of the building, others tend to deny it. The ribs themselves are weakened by the method of painting their faces that we have mentioned above. Furthermore, the borders in which they are imbedded are unusually wide, flat, and insubstantial. Ornamented with delicate, crisply cut patterns, they create a sort of filigree alongside the ribs, and where the borders meet, at the springing of the vaults, they are punctured by curiously elastic, gabled quatrefoils, very similar to the shapes in contemporary altarpieces (Fig. 9). This simultaneous assertion and masking of structure is reminiscent of the Strozzi altarpiece.[4] Like the altarpiece, too, with its undivided panels, is the omission of borders between the smaller scenes, and the unification of the entire painted surface. A similar aesthetic reveals itself here on a monumental scale.

[4] See above, p. 12.

The Christian order which is exhibited in the chapel begins with several historical scenes: the Way to Calvary and the Death of Christ on the chapel wall—the latter just above the lost scenes of the Corpus Christi—and the Resurrection and Ascension in the vaults. For Andrea da Firenze the Crucifixion (Fig. 96) is much less than in the first half of the century an occasion for the display of grief at the death of Christ, at his loss of humanity. In the great throng no one responds simply with sorrow,[5] and even the Virgin looks up at her son in a mood of composed contemplation. It is a moment rather of revelation, of sudden awareness of the divinity of Christ and the reality of redemption. Many of the figures signify their understanding by uplifted arms, others clasp their hands or cross their arms in adoration, and a few discuss gravely the meaning of the event. Toward the left margin a small knot of men assembled at the foot of the cross considers the serenity of the repentant thief and the journey of his soul to heaven, while a corresponding group on the right looks with consternation at his unregenerate companion, who writhes almost as painfully as in Barna's fresco (Fig.92), while devils sport with his body and his soul. The similarity of this new content of the Crucifixion with other representations of the time is evident.

The theme of salvation is continued below, on the same wall, in the Descent into Limbo (Fig. 98). This scene portrays a miracle of special redemption, affecting the Baptist, the patriarchs, and other ancestral figures who preceded Christ. The large adjoining fresco at the right (Fig. 94) is devoted to the institutions appointed by Christ as the ministers of redemption. It poses also, though not always very clearly, the problem of human choice, the acceptance or rejection of their ministry. Below, on the right or "good" side of Christ, is a large and imposing image of the Church, symbolized for the Florentine audience by the model of their own partly constructed cathedral. In 1366 and 1367, while Andrea was working on the frescoes, he was a member of the commission that prepared a working drawing for the building.[6] Arrayed before the Church are pope and emperor, cardinal and king, bishop and knight, grim, militant figures who guard the Church as the *domini canes* below them do the pious sheep. Around these formidable authorities cluster other representatives of the Church, the religious orders, the civil power, secular learning, and the faithful (the women always

[5] Except for the flying angels, who, as in the earlier Trecento, lament the death of Christ.

[6] See C. Guasti, *S. M. del Fiore*, Florence, 1887, pp. 167-169, 177-178. On the relationship of the fresco to the history of the cathedral and to the several models made in the fourteenth century see W. Paatz, *Werden und Wesen der Trecento-Architektur in Toskana*, Burg, 1937, p. 178 note 376.

In connection with the representation of the Church as the Florentine Duomo in a Dominican fresco, it may be worth mentioning that the bishop of Florence for many years, from 1342 to 1355, was a Dominican, Angelo Acciaiuoli (see G. Cappelletti, *Le chiese d'Italia*, Venice, 1861, XVI, p. 555). Acciaiuoli was thus bishop at the time of the gift of the money for the frescoes but not during their execution, and from about 1348 on he was continually in Naples as the chancellor of King Louis. The bishop during the years of the execution of the frescoes was Pietro Corsini, who was not a Dominican.

at the outer margins). Within the group, as in other paintings of the time, there are insistent distinctions of rank. The pope is frontal, his gesture emblematic, his figure motionless and, like Orcagna's Christ, wrapped with perfect symmetry in his mantle. He is seated slightly higher, too, than any of the others, and he is most closely identified with the Church by presenting a sort of flat façade precisely centered in one of the bays. In his case alone the moldings of the window behind project forward to suggest the wings of a throne. The emperor is seated slightly lower and not quite centered in his bay, but still higher and more centered than the king. Thus through the group the qualities that inhere most perfectly in the pope diminish in regular progression, giving way to greater physiognomic individuality, more varied postures, and, at the lowest levels, genuflection and worship.

On the sinister side, beyond the Church and without any comparable shelter or emblem of unity and stability are the unbelievers and the heretics. Peter Martyr confronts one group, Thomas Aquinas another. Two Jews whom Thomas converted at Molaria kneel before him,[7] and in the forefront of the confounded heretics an oriental tears up his writings. This Dominican conquest is represented again symbolically. Toward the left St. Dominic, Dante's "santo atleta," urges the *domini canes* to attack the wolves that are making off with the sheep.[8] Above, but still on the sinister side, men, women, and youths are enjoying the pleasures of the world, dancing, playing music or listening to it, and eating fruit, all in a remarkably grave and subdued manner.[9] Toward the center of the composition a group of men manifest penitence, and one, confessed by a Dominican friar, is grimly shown the way to heaven by Dominic himself. Cured in this way the souls, in the form of children, move toward the heavenly gate located above the Church. As they approach it, wide-eyed and expectant, two angels place garlands of flowers on their heads and they are given a rather back-handed welcome by St. Peter, whose towering form very nearly blocks the entrance. Far from bending to lend a helping hand, as he had done already a century earlier in the Last Judgment at Grosseto by Guido da Siena, he turns upon the childlike figures a stern countenance and stiffly indicates the way.

[7] See J. A. Endres in *Zeitschrift für christliche Kunst*, 1909, XXII, pp. 323-327.

[8] The wolf was a current symbol not only of heresy but of corruption within the Church. Alvaro Pelayo, a papal aide at Avignon, wrote: "Lupi sunt dominantes in ecclesia" (see L. Pastor, *History of the Popes*, I, p. 67).

H. Hettner, *Italienische Studien*, Brunswick, 1879, p. 118, identified the predators as foxes.

[9] Along with the similar figures in the Triumph of Death in Pisa they have, in fact, been interpreted as representatives of the spiritual life (H. Hettner, *op. cit.*, p. 120). For some of the difficulties of this view see my comments in the *Art Bulletin*, XV, 1933, p 170. See also the representation of a woman holding a white dog similar to the one in the Spanish Chapel, and also a mirror, in a miniature by the Master of the Dominican Effigies (Offner, *Corpus*, sec. III, vol. II, part II, pl. XVII[3]). She is labeled *Bellezza Corporale*.

Chiappelli, *op.cit.*, p. 268, attempts to distinguish between the seated figures and those among the trees behind them. The former are, he agrees, "gaudenti mondani," but the latter are in the "orto cattolico" tended by St. Dominic that is described by Dante (*Paradiso* XII). Chiapelli says nothing about the group below the bench, which, too, includes boys eating fruit.

Within paradise none of the little souls are visible; there are only Old Testament figures—Moses, Noah, David—and saints, all of them, like St. Peter, twice the size of the souls. Only these figures in paradise, furthermore, are vouchsafed a view of Christ.[10] He is seated in a mandorla at the apex of the composition, accompanied by the mystic lamb, the symbols of the four evangelists, a host of angels, and the Virgin. Though a dominant figure, he remains wholly detached from the scene below. He appears as the divine source of salvation, the ministry of which he leaves entirely to his appointed agents, the Church and the Dominican Order. He bears thus in his outstretched hands the symbols of these appointments: the keys which Peter, founder of the Church, exhibits below, and the book, which in this context alludes not so much to the Gospels as to Dominican doctrine. The symbols of the evangelists do not hold books, but St. Thomas displays an open one in the lower part of this composition and at the very center of the fresco on the opposite wall (Fig. 95).

The germ of this elaborate representation is in the Strozzi altarpiece (Fig. 1). There Christ gives the keys to Peter and the book to Thomas Aquinas; and the Navicella, represented in the predella, appears in the vault just above the fresco in the Spanish Chapel.[11] In both the altarpiece and the fresco this miracle of a rescued ship and of Peter's approach to Christ on the water, which had been given a prominent place in the papal church in Rome (Giotto's mosaic), symbolizes once again the designation of the Church and St. Peter as ministers of salvation. In the chapel, as in the mosaic in St. Peter's, it is accompanied by an image of the fisher of souls.[12] There is at the same time one interesting difference between the altarpiece and the large fresco in the chapel. In the altarpiece the Virgin and the Baptist stand alongside Christ, gesturing toward him as advocates. Christ extends his hands across the limits of his exclusive sphere toward the two kneeling saints. In the fresco even these links with a lower order of being are eliminated. Christ is entirely contained within his mandorla, the Virgin stands quietly at the side among the angels, and the Baptist finds a place far below at the head of the saints in paradise. Thus not only has humanity no direct access to a remote Divinity; it is deprived to an unusual extent also of its familiar advocates.[13] The only road to salvation leads through the Church and the Dominican Order. This alone is the *via veritatis*.

This essential meaning of the fresco is developed by the paintings on the two remaining walls. The one opposite is a schematic presentation of Christian doctrine

[10] Some fifty years earlier the aggressive Pope John XXII had precipitated a controversy by asserting that human souls do not see God until after the Last Judgment. The Franciscans Michael of Cesena, William Occam, and others accused him of a heretical denial of the beatific vision after death.

[11] The mass of St. Thomas, represented in the predella, may have appeared among the frescoes, now lost, in the chapel of the chapter-house.

[12] The general of the Dominican Order at this time, Simon de Langres, was commonly called the "fisher of men" (see R. P. Mortier, *Histoire des maîtres généraux de l'ordre des Frères Prêcheurs*, Paris, 1907, III, p. 289).

[13] The view of A. Venturi (*Storia*, v, p. 801) that the Virgin advances toward Christ as an advocate seems to me incorrect.

(Fig. 95). Thomas Aquinas again appears as its major source, and like Christ on the opposite wall, he is accompanied by the four evangelists. Beyond them are St. Paul and five Old Testament prophets and kings. Seven Virtues soar above, and below are seven theological Sciences and the seven traditional Liberal Arts, each with its historical representative.[14] None of the "mechanical" arts so intensely practiced in Florence and represented a generation earlier on the Campanile is included in the scheme.[15] In the vault above appears the Pentecost, in the new form discussed above that makes more explicit the mission of the apostles as disseminators of doctrine.[16]

St. Thomas is presented at the center of the painting on the wall not only as the foremost theologian but as the conqueror of heresy. Sabellius, Averroes, and Arius crouch at his feet. Thus the theme of the defeat of heresy is included in both the large frescoes in the chapel, and it is continued on the entrance wall. There it is given a greater concreteness and a local setting. Just as the Church assumed the form of the cathedral of Florence, the antiheretical struggle is conducted by St. Peter Martyr—the most militant and most effective expunger of heresy in the history of Florence. There are six scenes from his life: his investiture as a Dominican, his public sermon attacking an heretical bishop, three miracles of healing and resurrection, and his martyrdom. While only one scene portrays him in the fight for orthodoxy, his very presence evoked memories of his attack on the Patarines and his formation of the most active antiheretical society in Florence, the *Compagnia Maggiore della Vergine*, later called the *Compagnia del Bigallo*.[17] The six scenes of his legend exhibit a basic relationship between strict orthodoxy, militant opposition to heresy on the one hand and miraculous power and sainthood on the other.

III

The fresco cycle in the Spanish Chapel is a kind of *summa* of ideas and attitudes

[14] For the identity of the theological sciences, see J. v. Schlosser, in *Jahrbuch der Kunsthistorischen Sammlungen des Allerhöchsten Kaiserhauses*, XVII, 1896, pp. 44-52.

[15] Antal, *op.cit.*, pp. 247-250, does not deal with this aspect of the representation when arguing for its "popular" or lower middle class character. It is true, as he points out, that Tubal-cain is dressed as a smith and wields his hammer vigorously, but he is at the same time withdrawn from his action and quite visibly stirred by musical inspiration. He is not simply a "real plebeian artisan." I am equally doubtful about the other evidence he finds in the frescoes of "concessions" to the lower sections of the middle class. His identification of the costume in several paintings as the dress of these sections is not convincing, and certainly no artisan or shopkeeper, clearly distinguished as such, is being shown the way to heaven.

Furthermore, the notion of a direct relation between the symbolic or allegorical character of the frescoes and a desire to appeal particularly to these lower sections of the middle class and to the masses seems untenable. Surely the complex structure and symbolism of these paintings was not immediately intelligible to a large, poorly educated audience, nor could it have been easily explained to them. Would they, in fact, even have had access to the chapter-room in which the frescoes are painted?

[16] Page 33.

[17] He founded the society in 1244. See Davidsohn, *Forschungen zur Geschichte von Florenz*, Berlin, IV, 1908, pp. 426, 429. An Orcagnesque panel in the Bigallo represents St. Peter giving standards to the company (Antal, *op.cit.*, pl. 45b). Every figure in this painting is shown either in profile or full-face.

that were current in the art of the time. We have seen in numerous Florentine paint-
ings, and some Sienese, an exaltation of God and the Church, an emphasis upon the
divinity rather than the humanity of Christ, and an insistence upon the essential role
in salvation of the Church and its rites. In the chapel the Dominican Order emerges as
an agent alongside the Church, and St. Thomas Aquinas as the doctrinal authority
and the destroyer of heresy. These conceptions are all familiar Dominican ones. From
the time of the foundation of the order the Dominicans had considered themselves the
promoters and defenders of the faith, the *pugiles fidei*. Since they had recreated in the
late Middle Ages the type of apostolic preacher, they felt a special affinity with St.
Peter. Well established though these conceptions were, it is nevertheless true that
there is nothing quite like the frescoes in Tuscan Dominican art, nor indeed in Do-
minican art anywhere else, either earlier or later. It seems very probable therefore
that the impetus to display these ideas on so large a scale was affected by more im-
mediate conditions, which gave them, too, their specific form and accent. In part
these are the same conditions that exerted an influence upon other paintings of the
period. But the peculiarities of the Spanish Chapel are bound up with a special locale
and function.

Adolfo Venturi has claimed a close relationship between the frescoes and Jacopo
Passavanti's *Specchio di vera penitenza*—a relationship accepted by subsequent
writers.[18] Some similarities there are: the confessional, important in Jacopo's thought,
is represented in one painting in the chapel, and the image of the Navicella, of which
he was very fond, appears in the vault. But the Navicella in the chapel is not so much
the mystic ship of penitence of which he speaks as the ship of the Church, and the few
additional conceptions that Venturi cites are neither peculiar to, nor prominent in,
the *Specchio*. This compilation of sermons has in fact a different character than the
frescoes. It deals with the difficulties, the moral requirements, and above all the ur-
gency of penitence. Like Orcagna's frescoes in the nave of S. Croce, Traini's in the
cemetery at Pisa, or even Nardo's in the Strozzi Chapel it is addressed to a large, hetero-
geneous audience. These paintings, like the sermons, contrast the penalties of worldli-
ness and the reward of faith and good works; they are essentially "admonitions to
penitence," the title which Venturi himself has given to the cycle in Pisa.[19] These
fresco cycles, like Passavanti's *esempi*, dwell on sudden death and the horrors of hell,
describing them in vivid detail and giving them a frightening imminence and actu-
ality. The struggle for salvation is presented as a great human drama that includes
Christ himself. In Pisa (Fig. 87), at the moment of condemnation, Christ draws aside
his mantle to exhibit the wound in his side—a reminder of his humanity and his pain.
Even his rage, in this fresco and in Nardo's, has a human connotation.

In the *Via Veritatis*, on the other hand, Christ is a more remote and isolated being.
He is not accessible to humanity nor to pleas for mercy by its advocates—none of them,

[18] A. Venturi, *Storia dell'arte*, v, pp. 778-782;
Van Marle, *op.cit.*, iii, p. 427; F. Antal, *op.cit.*,
p. 248.
[19] *Op.cit.*, v, p. 727.

in fact, acts to compromise the sacraments of the Church and the ministry of the Dominican Order. The paintings are much more concerned, furthermore, with the ignorant, the sceptics, and the heretics than with the moral weakness of the ordinary sinner, whose fate is exhibited nowhere in the chapel. They concentrate less on penitence or the contemplative life as such than on the *true* penitence and the *true* contemplation—confession and absolution by a Dominican, conformity to Dominican thought, and acceptance of the authority of the order and the Church.[20]

The distinctive content of the frescoes in the Spanish Chapel must surely be related to their site and their primary audience. Whereas Passavanti's sermons were preached in the church of S. M. Novella to predominantly lay groups, and the related paintings by Traini in the Camposanto, by Orcagna in S. Croce, and even by Nardo in the Strozzi Chapel were designed for a more or less large public, again chiefly lay, the frescoes of Andrea da Firenze were made for the chapter-house of the foremost Dominican monastery in Tuscany, the meeting place of the provincial councils.[21] Their program was undoubtedly worked out in the *studium generale* of S. M. Novella, probably in consultation with the painter. Passavanti, though he died in 1357, may have formulated the initial scheme. In any event, the frescoes were addressed by the local authorities primarily to the Dominicans of Florence and Tuscany; they are an affirmation of Dominican convictions and at the same time an imposing charge to the order.

Around the time of the painting of the frescoes the Dominicans of S. M. Novella were challenged by a variety of difficulties and issues, some affecting the Church or the order as a whole, others of more local significance. The Black Death had had its usual consequences in S. M. Novella: decimation of the friars (325 had died), rapid admission of new members, an increased devotion in some groups together with laxity of observance in others. Similar conditions throughout the mendicant orders provided an opportunity for their old rivals, the secular clergy, to carry to the pope a formal attack and a demand for the suppression of their rights. The Irish and the English bishops, led by Richard Fitz-Ralph, Archbishop of Armagh, declared that the orders were corrupt and that their authority to beg, to preach, and to give confession—wrong at any rate in principle—should be revoked. They addressed their case first to Clement VI, and then, after his death in 1352, to Innocent VI, who finally reaffirmed the privileges granted the orders by Boniface VIII in the early thirteenth century.[22]

During these years the prestige of the popes themselves was greatly lessened in Italy by their continued residence in Avignon and by the notorious corruption of the Curia, especially under Clement VI (1342-1352). Antagonism to the papal incumbent, however, did not necessarily imply antagonism to the papal office itself. The two were

[20] Thus the fresco which I have called the *Via Veritatis* seems less a "Triumph of Penitence" (Venturi, *op.cit.*, v, p. 792) than a triumph of the Church and the Dominican Order.

[21] H. Brockhaus, in *Mitteilungen des Kunst-historischen Instituts in Florenz*, I, 1908-11, pp. 241-245, relates the frescoes, not to the chapter-house in which they were painted, but to the adjoining cemetery, and finds their content similar to that of the prayers for the dead.

[22] See Mortier, *op.cit.*, III, pp. 352-357.

often clearly distinguished—notably by the majority of Florentines during the period of papal interdict and the war of Florence against Pope Gregory XI (1375-1378). The Papacy as an institution, on the other hand, had still to contend with the effectiveness of a bold attack launched against it and the ecclesiastical hierarchy by Marsilio of Padua a generation earlier. Around the same time similar, though less radical, views were advanced by William of Occam and others. In the famous *Defensor pacis*, probably written in collaboration with Jean de Jandun, Marsilio asserted that the foundation of faith and of the Church is Scripture, that the ultimate power lay with the faithful represented in councils, that the pope, elected by them, is bound by law, and that the hierarchy was not necessary to the survival of the Church. He insisted on religious toleration, particularly of heretics. Marsilio's view of heresy, as of other ecclesiastical matters, was nowhere more strenuously rejected than by the Dominican Order.[23]

This major challenge to the Church strengthened several dissident or openly heretical sects, with whose rapid growth the Dominicans of S. M. Novella were confronted locally from the 'forties on. The Flagellants in 1348-1349, however anticlerical, presented only a rather ephemeral threat, but Florence became around that time, as we have seen, a center for the heretical Fraticelli, and Tuscany was full of them.[24] Around 1365, just when the painting of the Spanish Chapel was begun, Pope Urban V issued a bull urging inquisitors to be more active against heresy.[25]

While both these sects as well as Marsilio of Padua attacked primarily the institution of the Church, another group, consisting of followers of Averroes, was accused of rejecting essential tenets of Christian belief. The prominence of Averroes in the Spanish Chapel is not only a tribute to the growth of his influence generally among philosophers, but a reflection of a conflict that extended into the religious bodies themselves. In the thirteenth century this Arabic writer was widely respected for his commentaries on Aristotle, and Dante put him among the good heathens in Limbo (*Inferno*, IV, 143). On the other hand, St. Thomas and other theologians strenuously opposed some of his ideas, understanding them as a denial of creation and of personal immortality, and he emerged in Dominican circles in the fourteenth century as the arch-heretic.[26] His influence, however, continued to grow in Italy, especially in Padua, and, as Grabmann has shown recently, in the University of Bologna.[27] Even within the religious orders he was honored during the third quarter of the century. In the frescoes by Giusto formerly in the Augustinian church of the Eremitani in Padua he was given a place among the prominent theologians of the order. And he was defended by Richard Fitz-Ralph, the primate of Ireland and the great antagonist of the mendicant orders around 1350, as we have mentioned above.[28] The humiliation of Averroes in frescoes

[23] See L. Pastor, *op.cit.*, I, pp. 75ff.

[24] See p. 81; also Lea, *History of the Inquisition*, III, 1911, pp. 161-163.

[25] *Ibid.*, p. 163.

[26] See P. Mandonnet, *Siger de Brabant et l'averroïsme latin au XIIIe siècle*, Louvain,

1908-11, and E. Renan, *Averroès et l'averroïsme*, Paris, 1822.

[27] M. Grabmann, *Mittelalterliches Geistesleben*, Munich, 1936, II, pp. 239ff.

[28] J. v. Schlosser, *Jahrbuch der Kunsthistorischen Sammlungen*, XVI, 1896, p. 18. E. Gilson,

painted about 1365 in the meeting hall of Dominican scholars was thus quite topical and pointed.[29]

The defeat of Averroes in the Spanish Chapel very probably alludes to other unorthodox, if not actually heretical, religious trends of the time, and the persistent theme in the frescoes of the authority of the Church and of Dominican doctrine is undoubtedly directed at them. Partly because of the plague and other disturbances, the period witnessed, as we have seen, a revival of mystical religion. The essential conviction of mysticism that the soul was capable of a direct experience of God was only one short but fateful step from the belief that the soul could attain so high a degree of spirituality that it might dispense with the intermediation of the Church and its orders. The distinction between an acceptable and an heretical mysticism often involved indeed a very subtle discrimination. The great mystical leaders of the time, Colombini and Catherine, were both accused of heresy during the period of the painting of the Spanish Chapel. Opponents of Catherine within the Church, many of them jealous of her growing influence, attacked as sheer vanity her assertions of direct knowledge of God, her visions, and her consequent assurance of an evangelical mission. They excoriated her for promising to do penance for others.[30] When Giovanni dalle Celle decided to join her group, he wrote to William Fleet: "It will be glorious for me to be called a heretic with her."[31]

In 1374, as we have seen, Catherine was summoned by the general of the Dominican Order, Elie Raymond of Toulouse, to a chapter convened in the Spanish Chapel. There, surrounded by the great paintings of the *Via Veritatis* and the Glorification of Thomas Aquinas, she was closely examined by the assembled scholars. What actually transpired we do not know, since the acts of the chapter have been lost, but we may surmise the course of the interrogation from the one known result. She emerged with a doctrinal adviser who remained with her the rest of her life. Perhaps if she had had an earlier opportunity for extended contemplation of the frescoes, such an appointment would have seemed less urgent.

La philosophie au moyen âge, Paris, 2nd ed., 1944, p. 687, characterizes the thought of Fitz-Ralph as Averroizing Augustinianism.

[29] Averroes is placed in hell in the great fresco in the Camposanto, Pisa, and he is vanquished by St. Thomas, as in the Spanish Chapel, in the famous panel in S. Caterina, Pisa (Van Marle, *op.cit.*, v, p. 204). At the same time we hear of adversaries of St. Thomas in Pisa. The chronicle of the important Dominican house of S. Caterina in this town speaks of Bartolomeo da S. Concordia, who died in 1347, as follows: "Recollegit auctoritates Bibliae et philosophorum, et beato Thoma expositas per omnia opera sua. Doctrinam dicti Doctoris, quam totam quasi mente tenebat, defendit ab impugnantibus magna cura" (quoted by G. Paccagnini, in *Critica d'arte*, VIII, 1949, p. 199).

[30] See P. Cividali, in *Atti della R. Accademia dei Lincei*, ser. 5, *Memorie della classe di scienze morali, storiche, e filologiche*, XII, 1906, pp. 366-367.

[31] See E. Gardner, *Saint Catherine of Siena*, London, 1907, p. 175. One of the opponents of St. Catherine was Fra Gabriele da Volterra, provincial of the Minorites and inquisitor for Siena (G. Getto, *Saggio letterario su S. Caterina*, Florence, 1939, p. 20).

V

TEXTS AND IMAGES

THE personality of Catherine Benincasa was so extraordinary, and her religious ardor so compelling, that some members of her *cenacolo* were moved to write biographical accounts even during the earlier years of her life, before she became an international figure active in papal policy. The text of the first notices, written between 1370 and 1374 by Tommaso della Fonte and Bartolommeo Dominici, has been lost, but the second has come down to us. Called "I miracoli della Beata Caterina," it was composed in, or very shortly after, 1374 by an anonymous Florentine, possibly Giannozzo Sacchetti, brother of Franco.[1] The writer joined her circle during May and June of that year when she came to Florence for interrogation by the chapter of the Dominican Order. He tells of Catherine's early family life, her austerities, her visions, her conversion, and her miraculous deeds through the plague of 1374.

Her first vision, according to the *Miracoli*, occurred at the age of seven, when she was walking with one of her brothers along a lonely road. "Raising her eyes toward heaven, she saw in the air, not very high above the ground, a loggia, rather small and full of light, in which Christ appeared clothed in a pure white garment like a bishop in his cope, with a crozier in his hand; and he smiled at the young girl; and there issued from him, as from the sun, a ray, which was directed at her; and behind Christ (there were) several men in white, all saints, among whom appeared St. Peter and St. Paul and St. John, just as she had seen them painted in the churches."[2] The influence of paintings upon Catherine's imagination is asserted again when she beheld St. Dominic—a vision that led her to seek admission to the Dominican Tertiaries, who, according to the official legend, at first refused her application because she was young and pretty, but relented after she had been disfigured by illness.[3] In this vision, accord-

[1] The text was published by R. Fawtier, *Sainte Catherine de Sienne*, Paris, 1921, Appendix I, pp. 218-233, and in 1936, in a volume I have not seen, edited by F. Valli. For the authorship, see I. Taurisano, in his appendix to A. Curtayne, *St. Catherine*, London, 1929, p. 229.

The later life of St. Catherine, the *Legenda maior*, utilized the biographical notices of Tommaso della Fonte (Jorgenson, *op.cit.*, p. 406), without of course acknowledging specific borrowing, so that the content of this earliest account is for the most part unknown.

[2] ". . . levando gli occhi in verso il cielo, vidde nell'aria, non troppo alto di terra, una loggia di non troppo grandezza piena di sprendore, nella quale le parea vedere Cristo vestito di vestimento bianchissimo in modo et forma di vescovo parato, col pastorale in mano, et rideva guatando la fanciulla; et usciva di lui uno razzo a modo di quello del sole, il quale si dirizzava verso lei, et dietro a Cristo parecchi uomini bianchi, tutti quanti santi, tra quali le parea Santo Pietro et Santo Paolo et Santo Giovanni, secondo che veduti gli avea per le chiese dipinti" (Fawtier, *op.cit.*, p. 218).

[3] See the summary of the legend written by Raymond of Capua in Fawtier, *op.cit.*, p. 5.

ing to the *Miracoli*, she saw St. Dominic "in a certain place outside this world . . . in that form in which she had seen him painted in the church."[4]

This assertion of a formative role of the painted image has been dismissed by an eminent historian of literature as a naïve fiction of Catherine's Florentine biographer.[5] It is probably not, however, the Trecento biographer who is naïve, but the twentieth century historian. Whether the conception was that of Catherine herself or was simply added by her biographer, the kind of relationship which it suggests is not in the least improbable.[6] With rare exceptions, historians, responsive to the predominantly verbal character of modern culture and to the prestige of philology and literary scholarship, conceive of painting and sculpture as secondary arts, dependent at all times upon literature and other forms of thought communicated by the word. Within the sphere of religious art they have no quarrel with the view of Gregory the Great, persistent through the centuries and turning up in the Trecento even in the preamble of the statutes of the Sienese painters' guild, that the function of images was simply the instruction of those who could not read—as, incidentally, Catherine could not. They seldom envisage the possibility that the religious imagination may on occasion have been shaped by existing works of art, nor do they allow that painting such as Orcagna's, just as well as the preaching and writing of Jacopo Passavanti, may have stimulated and guided the religious impulses of an age. It is nevertheless true that, apart from the more profound but also more elusive effect of painted or carved images upon the general character of religious thought, history abounds in instances of their specific effect upon the imagination, the will, and the actions of individuals. They were often the ostensible instruments of religious dedication. St. Francis was converted while contemplating a crucifix in S. Damiano, S. Giovanni Gualberto before a crucifix in S. Miniato. Both these events, like similar ones that we shall discuss shortly, were judged crucial in the lives of these figures and were frequently represented in Trecento painting. Though such occurrences cannot be considered the norms of response to art in the Middle Ages, they do constitute one important category, and they tell us something at least about the more common effects of painting at the time.

I

It is apparent from the recorded thought of Catherine of Siena and the writing of her friends that she was sensitive to religious images throughout her life. Shortly after praying before a crucifix in S. Cristina, Pisa, during a visit to that city in 1375, she felt in her own body the pains of the stigmata. During her last days in Rome we hear of her

[4] ". . . in un certo luogo fuori di questo mondo . . . in quella forma che veduto l'avea dipinto nella chiesa" (Fawtier, *op.cit.*, p. 222).

[5] See Natalino Sapegno, *Storia letteraria d'Italia, Il trecento*, Milan, 1942, p. 518.

[6] The vision of the Nativity, for instance, which St. Bridget had in Rome in 1370 was influenced by Italian paintings of this scene (see the forthcoming book by Erwin Panofsky on early Netherlandish painting). For another example of the effect of works of art upon religious imagery see my account of the simile of the incarnation in *Art Bulletin*, XXVII, 1945, p. 177. See also below, note 75.

in St. Peter's, contemplating Giotto's Navicella, a composition with which she already had some familiarity through Andrea's version of it in the Spanish Chapel (Fig. 97). Praying before the mosaic on the third Sunday in Lent, 1380, she suddenly felt the ship transferred to her shoulders, and she collapsed on the floor, crushed by the unbearable weight. The lower part of her body remained paralyzed to her death.[7]

By her responsiveness to images, the religious development of Catherine resembles that of St. Francis and of her namesake, Catherine of Alexandria, both of whom, as we shall see, she consciously emulated. The legend of Catherine of Alexandria[8] tells us that when the young girl, who aspired to Christianity, asked a holy hermit how she might see the mother and son of whom he had spoken, the old man gave her an image of the Virgin with the Christ Child in her arms.[9] This gift is represented in the series of reliefs of the legend of Catherine in S. Chiara, Naples, made around 1345 (Fig. 103).[10] The hermit asked Catherine to contemplate the image, to pray before it, and to ask Mary to show her her son. When night fell Catherine's desire was partly fulfilled: the Virgin and Child appeared before her—looking, without doubt, as they had in the image. But only the back of the Child was visible.[11] When Catherine tried to catch a glimpse of his face by shifting her position, the Child turned also, always keeping his back to her. Both she and the Virgin begged him to face her, but Christ said that she was unworthy to see the splendor of his countenance until she had prepared herself further. Catherine returned to the hermit, who spoke to her of the Christian mysteries, and on the following night the Christ Child, reappearing, "turned sweetly toward her his glorious countenance." All of this is interesting evidence, in a fourteenth century text, of the significance of the frontal position, which we have discussed above.[12] In this respect it is similar to the observations of another Trecento writer, Francesco da Barberino. In his comments on the image of Amore, which for him represents the *mater virtutum* and which he himself had painted for his *Documenti d'amore*,

[7] The fullest account of this incident is given in an unpublished letter of William Fleet (Siena, Bibl. Com. T.II.7, fol. 17). It is briefly reported in the *Legenda minore*, book III, chap. II (ed. F. Grottanelli, Bologna, 1868, p. 156). See also J. Jorgenson, *St. Catherine of Siena*, New York, 1939, p. 370.

[8] The account that follows is based on a Latin text of the legend written in 1337 and published by H. Varnhagen, *Zur Geschichte der Legende der Katharina von Alexandrien*, Erlangen, 1891, pp. 20ff.

[9] In a rhymed legend of St. Catherine of the late thirteenth century this image is described in an interesting passage that conveys the delicacy and buoyancy of French art of the time:

Dedanz sa capella est assise
Sor un alter de marbre bisse
Un ymage estrainiement fine
E a forme d'un raine
Qui en ses braiz teint un enfant,
Colore vermeil et riant. . . .

(See H. Knust, *Geschichte der Legenden der h. Katharina von Alexandria und der h. Maria Aegyptica*, Halle, 1890, p. 27.)

[10] Here the image is in relief, while in the painting of the scene by a follower of the St. Cecilia Master it is a panel (Offner, *Corpus*, sec. III, vol. I, pl. XVIII).

[11] This scene is represented in the altarpiece by the follower of the St. Cecilia Master (see note 10).

[12] See pp. 23-24.

he said that the figure was frontal, or rather that the posterior part of the figure was not visible, so as to suggest divinity.[13]

While Catherine was praying before Christ, Mary questioned him about her progress as a Christian. He replied that he was pleased with it and that he was prepared to accept her as his perpetual spouse. Whereupon the Virgin took Catherine's right hand, extended it to him, and he placed on her finger the ring of his faith, set with a very precious stone.[14]

This passage in a manuscript dated 1337 is the earliest known account of the mystic marriage of Catherine of Alexandria. Earlier versions of the legend speak of Catherine as the bride of Christ,[15] but not of a wedding.[16] On the other hand two of the many Trecento paintings of the subject must be dated before 1337: a scene in the retable by a follower of the St. Cecilia Master in the Hearst collection (Fig. 100), which can scarcely have been painted after 1325, and a small miniature on a portable cross in the treasury of S. Francesco, Assisi, painted probably around 1330.[17] A thoroughly repainted fresco of the Marriage in S. Sernin, Toulouse, was probably made before 1337 also.[18] In all these representations, as in the text, Catherine is wedded to the *infant* Christ. Though the paintings are earlier, their distribution indicates that an older version of the legend describing the marriage existed, but has been lost.[19]

[13] See F. Egidi, "I Documenti d'amore," in *L'arte*, v, 1902, p. 15.

[14] "Ubi cum nocte sequenti se in cubicolo oracioni dedisset, in extasi facta virginem vidit gloriosam ad se iterum venire et filium bajolantem, qui faciem suam gloriosam ad se dulciter convertebat. . . . Et Christus: . . . 'Paratus sum michi eam assumere in perpetuam sponsam.' . . . Tunc virgo beata extendens manum, ut sibi videbatur, apprehendit dexteram eius et filio suo porrigebat dicens: 'Anulo fidei tue, dilecte mi, subarra eam et in perpetuam sponsam tibi eam assume.' Quo dicto Christus subarravit eam anulo in quo erat gemma preciosissima dicens: 'Ecce ego accipio te in perpetuam sponsam et idcirco diligenter attende ne amodo carnalem maritum admittas.' Et his peractis Katherina de extasi ad se est reversa in digito anulato" (Varnhagen, *op.cit.*, pp. 22-23; Varnhagen did not localize the Munich manuscript containing this text).

[15] See H. Knust, *op.cit.*, pp. 29-30, 58. J. Sauer (*Studien aus Kunst und Geschichte, Friedrich Schneider zum 70. Geburtstage*, Freiburg i/B, 1906, pp. 337ff.) has discussed the relation of the idea of the marriage to the earlier mediaeval conception of the soul as the bride of Christ. For this latter conception see Jacopone da Todi, *Lauda* 71 in the Florentine edition of 1490 (ed. G. Ferri, Bari, 1915, p.

167).

[16] There is, for instance, no reference to a marriage in the rhymed Italian legend, written in 1330 by Buccio di Ranallo of Aquila (see *Scelta di curiosità letterarie*, Bologna, vol. 211, 1885, pp. 49-132), nor in the Golden Legend, though it appears in the English translation of 1438 by Jean de Bungay (see U. Gnoli, in *Revue de l'art chrétien*, LXI, 1911, p. 338).

[17] *Dedalo*, II, 1921, fig. on p. 588. A third example, around 1340-1345, is in the Museo Civico at Verona, no. 356 (Van Marle, *op.cit.*, IV, fig. 100).

In a repainted fresco in the crypt of Notre Dame, Montmorillon, perhaps of the thirteenth century, Christ places a crown on the head of St. Catherine, who holds a disproportionately large ring (see A. Peraté in *Les arts*, xv, 1918, p. 6).

[18] In this fresco Catherine is seated in a faldstool, asleep, and Mary and the Child appear before her in a cloud (A. Auriol, in *Bulletin de la Société Archéologique du Midi*, 2nd ser., nos. 44-45, 1919, p. 248).

[19] This is indicated also by the representation in the painting by a follower of the St. Cecilia Master of the first appearance of the Christ Child with his back turned to St. Catherine, a representation which is earlier than the text of 1337.

Whatever the history of the texts themselves, it is evident that the introduction of a subject of this sort by early Trecento Tuscan painters is quite consistent with the general character of their imagery. For at this time painters as well as poets tended to transform the metaphors by which the Middle Ages expressed spiritual qualities or relations into more concrete, though still symbolic, scenes of familiar human circumstances and events—birth, marriage, motherhood, death. The creation of the Madonna of Humility involved a process of this sort, and there appeared at the same time other novel scenes of marriage—St. Francis to Poverty, for instance. This is represented for the first time in the Giottesque fresco in the lower church in Assisi (Fig. 102). Though some of the early legends of the saint speak of Poverty as the bride of St. Francis, none describes the wedding.[20] The form of the composition was doubtless influenced by a similar scene of marriage, very popular in the late thirteenth and fourteenth centuries, the betrothal of Mary and Joseph (Fig. 101). Christ extends the hand of Poverty to Francis as the High Priest extends the hand of Mary to Joseph, or indeed, the Virgin the hand of Catherine to Christ.

The image of marriage, in which burgher domesticity and French courtly ceremonial, very influential in Italy, tend to converge, invaded also the representation of Christ and the Virgin in heaven. In an exceptional scene in the gable of a panel in the Museum of Fine Arts in Boston, by a Florentine painter influenced by Jacopo del Casentino, the Virgin and Christ are seated together in heaven, surrounded by seraphim, angels blowing trumpets, and the symbols of the evangelists (Fig. 99).[21] Where, however, we would expect to find the usual regal spectacle of the Coronation, the right hands of the two are clasped in a *dextrarum junctio*, an action that commonly symbolizes marriage.[22] However anomalous such a union may appear to us, the conception of Mary as the bride of Christ (in addition to being his mother and his daughter) was current in the late Middle Ages. In this role she was identified with the Church, and associated with the *Sponsa* of the Song of Solomon.[23]

A second group of representations of the marriage of St. Catherine of Alexandria, peculiar to the Sienese and Florentine schools, resembles still more closely the scenes

[20] H. Thode, *St. François d'Assise*, Paris, n.d., II, pp. 206-208, does not observe this difference when citing the legends and a poem by Jacopone. See also B. Kleinschmidt, *Sankt Franziskus von Assisi*, M. Gladbach, 1926, p. 16.

[21] The Madonna enthroned and the Crucifixion are represented in the two fields below. The painting was published as a work close to Giotto by R. Tatlock in the *Burlington Magazine*, LVI, 1930, p. 225.

[22] See E. Panofsky, in *Burlington Magazine*, LXIV, 1934, pp. 118-124. Occasionally Christ clasps both hands of Mary with his left hand while with his right

he places a crown on her head (Simone dei Crocefissi, Gallery, Bologna; Van Marle, *op. cit.*, IV, fig. 223). This, however, is an actual Coronation combined with a demonstration of affection and acceptance.

[23] See especially the *Speculum humanae salvationis*, chaps. 35, 36, 40 (ed. Lutz and Perdrizet, Mulhouse, 1907, I, p. 228; II, pls. 99, 111, 112). Also H. Cornell, *Biblia pauperum*, Stockholm, 1925, p. 289, and H. Swarzenski, *Die Deutsche Buchmalerei des XIII Jahrhunderts*, Berlin, 1936, I, pp. 91-92; II, fig. 120. In none of these works, however, is the *dextrarum junctio* represented.

of the Marriage of St. Francis to Poverty and of Mary to Joseph. In this group Catherine is no longer wedded to the infant Christ. We are presented with a normal marriage: the groom has become a man (Figs. 105, 106). This type seems to have appeared in both Florence and Siena about 1350, and it occurs almost exclusively in the third quarter of the century.[24] Though the earlier type showing a wedding to the Child may convey more effectively the metaphysical character of the act, the later one is more narrowly connected with the art of its time. Christ, for one thing, appears as an adult. Furthermore, he, the Virgin and, sometimes, Catherine are standing. As in the peculiar contemporary group of images of the standing Madonna, they rise high in the field, above the donor as well as the spectator. The elimination of the Virgin's seated posture and of her throne permits a greater two-dimensionality, and the axiality and symmetry of the composition are more insistent.

In the imaginative painting in Boston (Fig. 107), the only one in which the Virgin is absent, the spiritual meaning of the marriage is expressed by the almost Byzantine restraint of the couple and their physical separation.[25] Standing as far apart as possible, they extend their arms across the wide area of gold, giving and receiving the ring with their fingertips. This painting was evidently made to commemorate a reconciliation of two feuding enemies. They appear in the central field of the predella, immediately below a representation of the infant Christ, curate of souls, standing between his mother and grandmother, who seem to act as intercessors. Thus this painting combines with the marriage of Catherine one of the equally new, and related, "family" subjects, St. Anne with the Virgin and Child.[26] Guided by an archangel, the two men embrace fervently, their weapons thrown to the ground. The conquest of violence and evil is portrayed in the outer areas of the predella, where Margaret and Michael subdue demons. The vehement animation of these scenes is contrasted with the serenity of

[24] The Sienese examples are the panel in Boston (Fig. 107), painted in the later 'fifties or 'sixties, and the damaged and retouched panel in the Ringling Museum, Sarasota (Fig. 105), by a follower of Pietro Lorenzetti (the Dijon Master) around 1350 (W. Suida, *A Catalogue of Paintings in the John and Mabel Ringling Museum of Art*, Sarasota, 1949, p. 8, as Sienese, close to Barna).

For the Florentine paintings see Offner, *Corpus*, sec. III, vol. V, pp. 148, 207, 228. They are: panel by Biondo (Fig. 106); Cionesque, Johnson collection, Philadelphia, no. 6 (Berenson, *Catalogue of the J. G. Johnson Collection*, Philadelphia, 1913, I, p. 228); Master of the Fabriano Altarpiece, collection of Lord Methuen (Offner, *Corpus*, sec. III, vol. V, pl. 47). In most of these Florentine paintings St. Catherine is kneeling. In a relief representing the marriage in S. Chiara, Naples, attributed to Giovanni and Pacio da Firenze, the adult Christ approaches the saint to place the ring on her finger (Venturi, *Storia*, IV, fig. 206).

The representation of the marriage to the infant Christ persists in the third quarter of the century (and of course later), and is especially common in Siena. See the panels mentioned in note 30.

[25] There is a similar composition by Giovanni dal Ponte in the Museum at Budapest, but the Virgin is introduced between Catherine and Christ.

[26] There is a second Sienese painting of this subject from about the same time—a panel by a follower of Pietro Lorenzetti now in the market in New York.

In the Boston painting Anne offers Christ what seems, at least from its color, to be an orange.

Catherine, and Christ and the two reconciled opponents. Their renunciation of conflict is, like every other act in the Middle Ages, charged with ramifying religious meanings. It involves, like the marriage of Catherine to Christ with which it is represented, a dedication to a higher moral and religious life.

The several representations of the Marriage of Catherine to the adult Christ that we have just considered were made at intervals in the period 1345 to 1375, but the earliest legend in which the event assumes this form has been dated late in the fourteenth century, and even as late as 1400, though not on convincing grounds.[27] This text, the so-called *Nova legenda*, was written by a Franciscan, Fra Pietro. This friar, interestingly enough, had spent some time in Assisi and therefore certainly knew the Giottesque fresco of the Marriage of St. Francis to Poverty (Fig. 102). He may well have been guided by it when giving the legend its new form.

Presumably before the *Nova legenda* with its account of the marriage was written, another event occurred which may have influenced it. Catherine of Siena, probably inspired by her Alexandrian namesake, had a vision of marriage which is described with significant differences in the two successive biographies. In the *Miracoli*, written in 1374, it is related as follows:

"One day she suddenly went out of the house and out of Siena by the Porta di Sant' Ansano to a region where she thought there were certain dells and caves almost hidden from the eyes of men; there she entered into one, and finding herself in a place where she could neither be seen nor heard, she kneeled on the ground, and in a transport of overwhelming love called the mother of Christ, and with a childlike simplicity asked her to give to her in marriage her son Jesus; and praying thus she felt herself raised somewhat from the ground into the air, and presently there appeared to her the Virgin Mary with her son in her arms, and giving the young girl a ring he took her as his spouse and then suddenly disappeared; and she found herself set back on earth and she returned to Siena and to her home."[28]

The writer of the *Miracoli* says that Catherine revealed this vision to her confessor, and from the sequence of events we can place it between her seventh and her

[27] See H. Knust, *op.cit.*, pp. 58ff. The text describes Christ as "iuvenis pulcherrimus quasi viginti quinque annorum."

Christ appears as an adult (a young king) likewise in an early fifteenth century English version: *Life and Martyrdom of St. Catherine of Alexandria*, ed. by H. Gibbs, London, 1884, p. 19.

[28] "Uno dì subito s'uscì di casa et di Siena per la porta di Santo Sano dove pensò di fuori sono certe vallicelle et grotte guasi nascoste dagli occhi delle genti, et ivi entrò nell'una, dove veggendosi così il luogo che non poteva esser veduta nè udita, inginocchiosi in terra et

con uno fervore di smisurato amore chiama la madre di Cristo, et con una puerile simplicità le chiede che ella le dia per suo sposo il suo figliuolo Gesù: et così orando si sentì levare da terra alquanto in aria, et di presente l'apparì la vergine Maria col suo figliuolo in braccio, il quale con uno anello isposò la fanciulla et subito sparì, et ella si ritrovò risposta in terra et tornossi in Siena e a casa sua" (Fawtier, *op.cit.*, p. 219).

"Nella confessione revelò al frate tutta quella visione che abbiamo detta di sopra" (Fawtier, *op.cit.*, p. 220).

fifteenth year, that is between 1354 and 1362.[29] The author does not point to the parallel between this marriage and that of Catherine of Alexandria, though the later *Legenda maior* establishes it. Nor does he add here, as he did in recounting two other youthful visions of Catherine, that the visionary figures were "as she had seen them painted in the churches." But it is quite probable that Catherine was familiar with one of the Sienese paintings of the marriage of Catherine of Alexandria to the infant Christ.[30] She might also, of course, have heard a reading—she herself could neither read nor write until later in life—of the story of the marriage as described in the version of 1337, but there is nothing in her vision which relates it more closely to the text than to the paintings. Her sense of elevation above the earth is found in neither.

The *Legenda maior* of Catherine of Siena expands and modifies the vision described in the *Miracoli*. It was written between 1385 and 1395, after her death, by Raymond of Capua, who had been appointed her spiritual counsellor by the Dominican chapter of 1374, and it was "published," as an authoritative life, in 1398. The description of the marriage differs in one essential respect from the *Miracoli*: Catherine is wedded to the adult rather than the infant Christ.[31] Thus the ceremony resembles, and may depend upon, the second group of images of the marriage of Catherine of Alexandria that had appeared in the third quarter of the century (Figs. 105-107). It resembles, too, the wedding in the *Legenda nova* of Catherine of Alexandria, written around the same time or a little later, and not impossibly influenced by it.[32]

In view of the uncertain date of two of the texts, and the probability of losses among the written legends and among the works of art, we cannot attain to the full truth about these intricate relationships between the texts and the images connected with the two Saint Catherines. But it is at least highly probable that the paintings and sculpture played a formative role in the growth of the two legends.

[29] The reliability of the author of the *Miracoli* may be gauged by the fact that he reports quite correctly certain facts which can be controlled by documents, such as the age of Catherine. Gardner, *op.cit.*, p. 24, and Levasti, *op.cit.*, p. 1012, date the marriage in 1366 or 1367, following the much later *Legenda maior*.

[30] See the panel by a follower of Simone Martini, Siena, Pinacoteca no. 108; tabernacle by Giacomo di Mino in the Perugia Gallery (Meiss, *Art Bulletin*, XXVIII, 1946, fig. 13); Luca di Tommè, Siena, Pinacoteca no. 594; Master of the Pietà, Siena, Pinacoteca no. 156 (*ibid.*, fig. 10). In addition to the Florentine examples of this type already cited, see the Cionesque panels in S. Lorenzo, Vicchio di Rimaggio, and in the Louvre (Archives photo 11664).

[31] The text of the *Legenda maior* follows very closely the action in paintings of the Biondo type (Fig. 106): "Virgo Dei genetrix, virginis dexteram sacratissima tua coepit manu, digitosque illius extendens ad Filium, postulabat ut eam sibi desponsare dignaretur in fide. Quod Dei unigenitus gratissime annuens, annulum protulit aureum . . ." (*Acta sanctorum*, April, III, p. 891).

[32] Knust, *loc.cit.*, dates the *Legenda nova* at the very end of the fourteenth century, after the *Legenda maior*, partly because the ring of Catherine of Siena is said in the *Legenda maior* to have been invisible, whereas the *Legenda nova* describes it as being visible on certain occasions, invisible on others. Knust judges the latter to be a later, derivative conception.

The strength and independence of the pictorial tradition is shown by the fact, pointed out by Sauer (*loc.cit.*), that even in illustrations of the *Legenda nova*, Christ appears as a child.

The earliest representations in the arts of the marriage of Catherine of Siena derive from the *Legenda maior.* In this legend Catherine prays in a cell instead of the cave described in the *Miracoli,* and several figures accompany Christ and the Virgin: John the Evangelist, Paul, Dominic, and David, playing a psaltery as he does in Sienese representations of the Assumption of the Virgin (Fig. 22). Dominic and possibly Paul, as well as Peter and the Virgin, appear in a Pisan painting of the last years of the fourteenth century (Fig. 111).[33] In this composition, however, Christ and the attendant saints no longer stand alongside Catherine. Surrounded by cherubim, they float down toward the young girl, who kneels before an oratory, and they are thus decisively distinguished, in accordance with late fourteenth and fifteenth century artistic conventions, as supernatural beings.[34]

Giovanni di Paolo's panel in the Stoclet collection, one of a series representing the legend of Catherine, shows a very similar composition, which now includes David and his psaltery (Fig. 104). Some later painters, however, recreate the ceremony by analogy with one or another of the types of the marriage of Catherine of Alexandria, showing the saint receiving the ring either from the infant Christ seated in his mother's lap,[35] or from the adult Christ, the Virgin standing between them, as in the panels of the third quarter of the Trecento (Fig. 106).[36]

II

The marriage to Christ is only one of many metaphors by which Catherine of Siena sought to express what for her was the central mystery—the relation of the soul to God. A number of others that she employed may likewise reveal the quickening of her imagination by works of art in the churches and public buildings of Siena and Tuscany. In one vision, for instance, Christ appeared and took her heart, which she had frequently offered him during her childhood. The following day he reappeared and

[33] E. Lavagnino, in *L'Arte,* XXVI, 1923, p. 85, has dated this painting in the middle of the fifteenth century, which seems to me much too late. G. Kaftal, following the opinion of R. Offner, dates it ca. 1385 (*St. Catherine in Tuscan Painting,* Oxford, 1949, p. 48, fig. XII).

The painting in Pisa has a certain historical importance because it is one of the earliest extant paintings of Catherine—another is the fresco by her disciple Andrea Vanni in S. Domenico, Siena—and the earliest showing an event from her legend, painted long before her canonization in 1461 by Pius II. Her halo is distinguished from those of Christ and the saints by painted rays and by a black outer border (I judge that these are original, but I have been unable to examine the painting itself).

[34] Exactly the same transformation occurs in the representation, for instance, of Sts. Peter and Paul giving St. Dominic a staff and a book. Compare Traini's painting in S. Caterina, Pisa, 1344-1345, with that by an assistant of Fra Angelico in the predella of the Coronation of the Virgin in the Louvre. See also my remarks on similar compositions in the *Art Bulletin,* XXVIII, 1946, pp. 13-14.

[35] See the panel by Benvenuto di Giovanni in the collection of Mme. M. van Gelder, Brussels (*Bollettino d'arte,* XXVIII, 1935, p. 301), or the painting by Michele di Ridolfo Ghirlandaio, Uffizi.

[36] See the painting of the early sixteenth century in the Academy, Florence (Venturi, *Storia,* IX, part 1, fig. 387). Here angels are dropping roses, as in contemporary representations of the Immaculate Conception by Crivelli and Signorelli.

inserted his own heart in its place.[37] A painting by Giovanni di Paolo in the Stoclet collection, Brussels, represents one phase of this vision (Fig. 112). Catherine kneels, suspended several feet above the ground in a characteristic state of levitation and ecstasy. She holds a heart in her right hand, and looks up at Christ, who appears over the chapel of the Dominican Sisters mentioned in the text.

The gift of the heart to God had been described in earlier theological literature,[38] but there seems no good reason to believe that Catherine's vision was inspired by these writings rather than by images in Siena that she undoubtedly saw. In Ambrogio Lorenzetti's frescoes in the Palazzo Pubblico, Caritas or Divine Love offers her heart to God, holding it aloft in her right hand (Fig. 109). A second similar Sienese Trecento figure has come down to us, again by Ambrogio, in his altarpiece at Massa Marittima, and there may of course have been others, perhaps still closer to the archetype of all these works, Giotto's fresco in the Arena Chapel. Here, as in Catherine's vision, the recipient of the heart, Christ himself, is present (Fig. 72).[39] Appearing above Caritas, he grasps the heart which she proffers him. This act, novel in the figure arts though with precedents in secular poetic imagery, recurs in a somewhat different form in an interesting panel that has just recently come to light (Fig. 169).

This painting, hitherto unpublished, is a valuable addition to the group of surviving panels from the immediate circle of Giotto. It is quite evidently, I believe, the work of the Master of the Stefaneschi Altarpiece, a painter who was for some time a prominent member of Giotto's workshop. Two of his altarpieces, in Bologna and in S. Croce, Florence (Fig. 58), bear Giotto's name, and a third, the polyptych now in the Vatican, seems to be the altarpiece for which Cardinal Stefaneschi paid Giotto himself. In the panel now in New York[39a] the enthroned Madonna is accompanied by six saints, including the Baptist and a Franciscan, probably Anthony of Padua. Below the saints are seven female figures, two standing, the rest seated, all wearing hexagonal haloes, and obviously virtues. On the Madonna's right stands Hope, clad in white, raising

[37] "Videbatur siquidem ei, quod Sponsus aeternus ad eam solito more veniret, ejusque latus sinistrum aperiens, cor inde abstraheret et discederet, sicque ipsa sine corde penitus remaneret. . . .

"Quadem autem die, dum esset in capella ecclesiae Fratrum Praedicatorum de Senis, in qua solent congregari Sorores de poenitentia B. Dominici supradictae, et post omnes remansisset orans; . . . subito circumfulsit eam lux de coelo, et in luce apparuit ei Dominus, habens in sacris suis manibus cor quoddam humanum, rubicundum et lucidum. Cumque ad adventum auctoris et lucis tremebunda cecidisset in terram: appropians Dominus, latus eius sinistrum aperuit iterum; ipsumque cor, quod in manibus gestabat, intromittens, inquit: Ecce, carissima filia, sicut pridie tibi abstuli cor tuum, sic in praesentiarum trado tibi cor meum, quo semper vivas. Et his dictis, aperturam, quam in carne fecerat, clausit et solidavit . . ." (*Legenda maior*, part II, chap. VI, in *Acta sanctorum*, April, III, p. 907).

[38] Passages from the writing of Balduinus of Ford and Thomas Aquinas are cited by R. Freyhan, in the *Warburg Journal*, XI, 1948, p. 79 note 2. Catherine's conception of an exchange with Christ seems to be anticipated by Balduinus: "Si autem . . . cor tuum Deo offeras, dans Deo, tuum facis."

[39] See Freyhan, *op.cit.*, p. 79.

[39a] 14 x 10 inches. For the Stefaneschi Master, reconstructed chiefly by R. Offner, see *Catalogo della Mostra Giottesca*, Florence, 1943, pp. 350, 354, 367, 585. Prof. Offner has independently given the new panel to him.

her arms and swaying gently, as though in a dance. The posture, unusual for this virtue, shows some resemblance to one of the floating angels in the Ascension in the Arena Chapel. The action of the central figure below the Madonna recalls one of the Paduan personifications, Infidelity, who holds aloft in one hand the small figure of a young, seductive girl (Fig. 166). But the Stefaneschi Master has made a virtue of one of Giotto's vices. The little girl is transformed into an angel holding a cross, and her possessor, crowned and dressed in red, undoubtedly represents Faith. The third cardinal virtue, Caritas, stands opposite Hope. She is very similar to the corresponding figure in the Arena Chapel (Fig. 72). She holds in her left hand, as a symbol of profane love, a bouquet of flowers (rather than a bowl of flowers and fruit), and with her right she puts into the outstretched hands of the Child a red object whose exact form is no longer distinguishable, but which can only be the symbol of divine love, her heart. Though derived from Giotto's Caritas, this is so far as I know a unique representation. Christ is an infant rather than an adult, and nowhere else is the Caritas group merged with the Madonna.

One might expect the remaining four figures, all seated, to represent the four theological virtues. One of them, Fortitude, is indeed present, a robust woman with a shield, a sword, and what the painter probably intended to be a lion's skin, all as in the Arena Chapel. A second may be the figure seated to the left of Faith. Clad in green, she apparently once held in each hand a small object, perhaps the scales of justice or the jugs of water and wine that frequently distinguish Temperance. Neither of the kneeling profile figures at the extremities, however, belong to the theological group. The heavily wrapped woman at the left, who bows her head, personifies the virtue that became so prominent in the fourteenth century—humility. Holding a taper, she may be identified by the very similar figure, kneeling also, in the Giottesque frescoes in the vaults of the lower church of St. Francis at Assisi, where she is conveniently labeled HUMILITAS (Fig. 167). There she appears alongside Obedience, and this may be the other virtue that is represented in the panel, in the guise of a woman modestly clad in dark green, her arms apparently folded over her breast, and looking meekly up at the Madonna. Her appearance directly below the Franciscan saint would seem to support this identification, because obedience was one of the three great Franciscan virtues. She is beautifully conceived, and she may, like the equally impressive Humility, reflect a lost figure by Giotto.

The ensemble of this extraordinary panel is no less interesting than the single figures. Hitherto Ambrogio Lorenzetti's *Maestà* at Massa Marittima seemed the first painting to show virtues on the base of the Madonna's throne, and thus to inaugurate the long tradition of representing other figures too, such as angels, seated in this place. The Stefaneschi Master's panel is however earlier than Ambrogio's. It seems not improbable therefore that this motif, so popular in the Quattrocento, originated in the work of Giotto himself.

Catherine of Siena, then, expressed her love for Christ by the gift of her heart, an

image common in Tuscan Trecento painting and sculpture. She may have been influenced by the same sources when she described the relationship of the priests and of the devout to the Church by the figure of a mother suckling her children. In the *Dialogo della Divina Providenza,* which she dictated in 1378, Christ speaks to her as follows: "What I say of the universal body and the mystical body of the Holy Church . . . I say also of my ministers, who stand and feed at the breasts of Holy Church; and not only should they feed themselves, but it is also their duty to feed and hold to those breasts the universal body of Christian people. . . ."[40]

This image has a long Christian history.[41] At the same time it is remarkably similar to the magnificent figure in Giovanni Pisano's pulpit in Pisa, which is often considered to represent *Ecclesia,* and which Catherine doubtless saw during her visit to that city in 1375 (Fig. 108).

The same figure of the mother suckling two infants appeared also in fourteenth century sculpture as the personification of Caritas. Two of the surviving examples are in Florence, one by Tino di Camaino for the porch of the Baptistery (Fig. 110), the other (with only one child) by Orcagna on the tabernacle in Or San Michele. Catherine probably saw both during her stay in Florence in 1374, and it is interesting, in any event, that in one of her letters dealing with Caritas and written during the later 'seventies she should say: "O Charity full of joy, you are the mother who nourishes the children of the virtues at your breast."[42]

III

Whether these several visions and metaphors of Catherine of Siena were influenced by works of art she had seen, by theological texts read to her by her disciples, by sermons she had heard, or by religious poetry recited in public, is not now, and probably cannot ever be, entirely clear. Attempts to discriminate between these various expressions of a highly unified and homogeneous culture are seriously limited by the accidents of loss and survival. That works of art played an important part in shaping

[40] Chap. xiv of *The Dialogue,* translated by A. Thorold, London, 1896, p. 49. The representation of the *Madonna del Latte* may also have a similar connotation (see especially those paintings of the Madonna of Humility inscribed *Mater omnium* mentioned below, p. 151).

[41] See St. Paul, I *Corinthians,* iii, 2; Augustine, *De quantitate animae,* 33.76 and *Sermo* 216.7 (kindly called to my attention by Dino Bigongiari). See also the Commentary by Honorius of Autun on Salomon's Song, cited by E. Panofsky, *Studies in Iconology,* New York, 1939, p. 157 note 97.

[42] "O Carità piena di letizia, tu se' quella madre che nutrichi i figliuoli delle virtù al petto tuo" (P. M. L. Ferretti, *Le lettere di S. Caterina da Siena,* Siena, 1922, ii, p. 206). Catherine goes on to say: "Tu se' ricca sopra ogni richezza, in tanto che l'anima, che si veste di te, non può essere povera." This sounds like a divination of an allegorical meaning in that French type of Caritas, appearing on the south porch of Chartres, in which she gives a cloak to a nude man. No Italian examples of this type have yet been cited, the nearest thing to it being the Caritas on Nicola Pisano's Pisa pulpit, where the woman is accompanied by a nude child.

her religious imagination is established, however, by the fact that some aspects of one vision can be shown, beyond doubt, to have been inspired by paintings.

One Sunday in 1375 Catherine went to the church of S. Cristina in Pisa, where she prayed before the still extant crucifix.[43] After communion she fell into a trance. Suddenly she raised herself from a prone position to her knees, extended her arms and hands, and remained thus for a time entirely fixed and rigid, her eyes closed. Then she called Raimondo of Capua, who was standing nearby, and told him secretly what had happened:

"I saw the Lord fixed to a cross descend toward me in a great light: wherefore under the impetus of my mind eager to meet its Creator, my body was constrained to rise. Then from the five marks of his most sacred wounds I saw coming down to me blood-red rays that were directed toward my hands and feet and heart; perceiving the mystery, I immediately exclaimed: Oh Lord my God, I beseech Thee, let not the marks appear outwardly on my body. Then, while I was still speaking, before the rays reached me, their blood-red color changed to bright light; and in the form of pure light they came to the five places of my body, that is, my hands, feet, and heart."[44]

The model for this vision was, of course, the stigmatization of St. Francis, but the fact is that it resembles the paintings of this subject far more than the texts. Several essential elements, such as the kneeling position, the arms extended to form a cross, and, most important of all, the rays that issue from the wounds of Christ, are not mentioned at all in any of the numerous written accounts of the stigmatization of St. Francis.[45] In order to clarify the relation of Catherine's vision to these texts and representations, we shall have to consider certain aspects of the history of the stigmatization of St. Francis which have not hitherto, so far as I know, been closely studied.[46]

In the earliest painting of the subject, made by Bonaventura Berlinghieri and dated 1235, Francis is shown kneeling. His hands are extended, like those of Christ in the

[43] The crucifix is preserved in Catherine's chapel in Siena.

[44] "Dominum . . . vidi cruci affixum, super me magno cum lumine descendentem: propter quod ex impetu mentis, volentis suo creatori occurrere, corpusculum coactum est se erigere. Tunc ex sacratissimorum ejus vulnerum cicatricibus quinque; in me radios sanguineos vidi descendere, qui ad manus et pedes et cor mei tendebant corpusculi; quapropter advertens mysterium, continuo exclamavi: Ha, Domine Deus meus, non appareant obsecro cicatrices in corpore meo exterius. Tunc adhuc me loquente antequam dicti radii pervenissent ad me, colorem sanguineum mutaverunt in splendidum; et in forma purae lucis venerunt ad quinque loca corporis mei, manus scilicet, et pedes, et cor" (*Legenda maior*, in *Acta sanctorum*, April, III, p. 901).

[45] After Bonaventura had completed his life of St. Francis, the chapter-general of the order, meeting in 1266 under his presidency, decreed the destruction of all earlier legends of the saint. Since this decree was rigorously enforced, it is improbable that these earlier legends were known to St. Catherine, or to painters of the late thirteenth and fourteenth centuries.

[46] The texts of the stigmatization have been discussed by Karl Hase, *Franz von Assisi*, Leipzig, 1856, and P. Sabatier, *Vie de St. François*, Paris, 1894, pp. 330ff., 404ff.; additional texts have since been discovered. For the representations see H. Thode, *Franz von Assisi*, Berlin, 1885.

garden of Gethsemane, toward the heavenly apparition (Fig. 113).[47] The visionary figure has two aspects: it is a seraph, but from the wings there project the hands and feet of a crucified man. In the only description of the stigmatization which precedes the painting—the *First Life* of Tommaso da Celano written in 1228-1229—the figure is described as "a man like a seraph, having six wings, with hands outstretched and feet joined together, fixed to a cross. Two wings are raised above his head, two spread for flight, and two veil the entire body."[48] This dual figure provokes in Francis a dual, ambivalent, response. He is delighted by the appearance of the seraph, symbol of the immortal spirit, but frightened and grieved by the suffering of the man on the cross.[49]

The account of the stigmatization in the *Legend of the Three Companions*, written almost twenty years later, resolves the merged figure of seraph-man into "a seraph, within the wings of which was the form of a beautiful, crucified man."[50] Bonaventura, whose Life was completed ca. 1262, describes the figure in about the same way as the *Three Companions*, but goes on to speak of "Christus sub specie Seraph."[51] Thus there is in these descriptions an increasing distinction between the seraph and the crucified man, who in Bonaventura is explicitly identified with Christ. This trend is carried much farther in painting, as we shall see.

In Bonaventura Berlinghieri's painting of 1235 the cross, already mentioned by Tommaso da Celano, does not appear (Fig. 113). The youthful head of the supernatural figure is, as in all immediately subsequent paintings, that of an angel rather than a man. To express the communion of Francis with the seraph, the hills are rolled back, like the waters of the Red Sea, leaving a path of gold that extends down to the

[47] This posture appears in the later thirteenth century in France. See the miniatures cited in note 54.

[48] "Vidit in visione Dei virum unum, quasi Seraphim, sex alas habentem, stantem supra, manibus extensis, ac pedibus conjunctis, cruci affixum. Duae alae supra caput elevabantur, duae ad volandum extendebantur, duae denique totum velabant corpus" (*Acta sanctorum*, October, II, p. 648).

The description of the figure is similar in both Celano's *Second Life*, written between 1244 and 1247 (*ibid.*, p. 649), and in his *Tractatus de miraculis*, written between 1250 and 1253 (*Analecta Bollandiana*, XVIII, 1899, p. 115). Where I have not specified otherwise, the dates given for the Franciscan texts are those of J. R. H. Moorman, *The Sources for the Life of St. Francis of Assisi*, Manchester, 1940.

[49] "Cumque ista videret beatus Servus Altissimi, admiratione permaxima replebatur; sed, quid sibi vellet haec visio, advertere nesciebat. Guadabatque quam plurimum et vehemen-

tius laetabatur in benigno et gratioso respectu, quod Seraphim videbat; quia pulchritudo inaestimabilis erat nimis; sed omnino ipsum crucis affixio et passionis ipsius acerbitas deterrebat. Sicque surrexit (ut ita dicam) tristis et laetus; et gaudium atque moeror suas in ipso alternabant vices" (*Acta sanctorum*, October, II, p. 648).

[50] ". . . apparuit ei Seraph unus, sex alas habens, et inter alas gerens formam pulcherrimi hominis crucifixi, manus quidem et pedes extensos habentis in modum crucis, effigiemque Domini Jesu clarissime praetendentis. Duabus enim alis velabat caput, et duabus reliquum corpus usque ad pedes; duae vero ad volandum extendebantur" (*Acta sanctorum*, October, II, p. 649).

[51] *Ibid.*, p. 650. Bonaventura's formulation persists in the *Actus Beati Francisci et sociorum eius* (Sabatier ed., Paris, 1902, p. 39) ca. 1325, and in the mid-fourteenth century *Sacre sante istimate*, a frequent appendix to the *Fioretti* (see, for example, the edition by F. Casolini, Milan, 1926, p. 232).

halo of the saint.[52] Rays as such are absent. They are lacking likewise in other Dugento Italian paintings, including the fresco of ca. 1265 in the nave of the lower church of Assisi,[53] as well as in thirteenth century representations outside Italy, in France, Germany, and England. These northern representations usually omit the cross, too, and Francis appears in a variety of postures, kneeling,[54] reclining,[55] or standing.[56]

In Italian painting of the later thirteenth century rays began to appear, doubtless by analogy with other scenes, such as the Pentecost, in which they express an emanation of the spirit. At first, in two Florentine panels painted around the middle of the century, one in the Uffizi (Fig. 114), the other in the Bardi Chapel of S. Croce,[57] the single path of gold in the Pescia altarpiece is tripled. Then, in a panel of the school of Guido da Siena around 1275, three rays extend from the mouth of the seraph to the head of Francis (Fig. 115).[58] The three paths or rays may refer to the Trinity, though there is

[52] A painting in a private collection in London published by E. Garrison *(Index of Italian Romanesque Panels*, Florence, 1949, no. 322A by the Magdalen Master) may show a similar cleft in the rocks; the reproduction is too poor to afford a clear reading.

[53] By the Master of St. Francis. See also the window in the nave of the upper church (B. Kleinschmidt, *Die Basilika San Francesco in Assisi*, Berlin, 1915, I, fig. 218); the ruinous painting in S. Costanza, Rome (J. Wilpert, *Die römischen Mosaiken und Malereien*, Freiburg, 1917, I, p. 314; two late thirteenth century miniatures, one in S. Francesco, Zara, MS no. 6, fol. 38 *(Beschreibendes Verzeichnis der illuminierten Handschriften in Oesterreich*, Leipzig, 1917, VI, fig. 44), the other in Bologna, Museo Civico MS no. 17, fol. 208v *(Tesori delle biblioteche d'Italia, Emilia e Romagna*, Milan, 1932, pl. 8a).

[54] Stained glass, late thirteenth century, in the Barfüsserkirche, Erfurt (E. Haetze, *Die Stadt Erfurt*, Burg, 1931, fig. 221); miniature in the *Regensburger Legendar*, German, late thirteenth century (H. Swarzenski, *Deutsche Buchmalerei des dreizehnten Jahrhunderts*, Berlin, 1936, I, p. 66 and II, fig. 377); Psalter, probably of Isabelle of France, Fitzwilliam Museum, Cambridge, before 1270 (ed. by S. Cockerell, London, 1905, pl. XVI); thirteenth century textile, Musée St. Raymond, Toulouse; Paris, Arsenal, MS 280, ca. 1280 (H. Martin, *Les principaux manuscrits à peintures de la Bibliothèque de l'Arsenal à Paris*, Paris, 1929, pl. 18). In the first and last examples cited, Francis kneels before an altar, a form that is strictly non-Italian and probably French in origin, as is also the representation of the seraph in clouds.

[55] Drawing in Matthew Paris, *Chronica maiora*, MS XVI in Corpus Christi College, Cambridge (A. G. Little, *Franciscan History and Legend in English Medieval Art*, Manchester, 1937, chap. IV, pl. 8). The seraph is here combined with the cross. The posture of Francis does not derive from Matthew Paris' text, which does not describe the stigmatization in detail (see *Acta sanctorum*, October, II, p. 653). It offers an interpretation, however, of each of the five feathers in the six wings of the seraph.

[56] Painting in the church at Doddington, Kent, English late thirteenth century (Little, *op.cit.*, chap. I, pl. IV); an enamel in the Louvre and one in a private collection, French or Spanish, thirteenth century (E. Rupin, *L'Oeuvre de Limoges*, Paris, 1890, figs. 545, 546, and W. Hildburgh, *Medieval Spanish Enamels*, London, 1936, p. 127). The standing posture in the enamels may have been suggested by their quatrefoil shape.

[57] *Catalogo della Mostra Giottesca*, Florence, 1943, pl. 55a.

[58] Siena, Pinacoteca no. 4. The stigmatization in the closely related no. 5 in this gallery is quite similar, but the rays are lacking. In both these panels St. Francis flings his arms above his head, and this posture reappears in the Bolognese miniature cited in note 53 and in the early Ducciesque tabernacle in the Fogg Museum (no. 132), which follows Siena no. 5 in omitting the rays. (This ruinous but historically important tabernacle, painted probably around 1300, shows a Guidesque type of Christ in the Crucifixion, and the throne of the Madonna still adheres to the design of the Rucellai Madonna.)

The stigmatization in the altarpiece of St.

no textual source for this meaning. More likely they signify the three spiritual gifts—divine love (*caritas*), mercy (*amor proximi*), and innocence of sin—which are symbolized, according to Tommaso da Celano, by the three pairs of seraphic wings.[59]

Thus the early paintings of the stigmatization in Italy and the north express the spiritual relation of Francis to God rather than his physical likeness to Christ incarnate. In these representations the import of the seraph, symbol of the eternal being, is greater than that of the crucified man, and the outer marks of Francis' resemblance to Christ—the wounds—are not emphasized.[60] Toward the end of the thirteenth century or in the early years of the fourteenth, a new conception, anticipated to some extent by the early texts, appeared in central Italian painting. To judge from surviving examples, the new form appeared first in the upper church at Assisi, or in the circle of Duccio or Giotto. In the Assisi fresco (Fig. 116) the supernatural figure has become preeminently the crucified Christ, who is borne and clothed by the wings of a seraph. The face is not red, as in some earlier paintings (Fig. 114), and the head is Christ's, not an angel's. The wings which in earlier representations had covered the body are lowered to the point where they disclose the wound in Christ's side. Most important of all, the rays, now five in number, pass from the wounds of Christ to the wounds of Francis.[61] Both Giotto's fresco in S. Croce and the Ducciesque panel in Buckingham Palace[62] are essentially similar, but it is significant that the wings are parted to disclose more of the body, and Christ is fixed to the cross, as indeed he is in almost all later representations of the subject.

This new form of the stigmatization became the characteristic one throughout the

Francis in the Museo Civico, Pistoia, painted around 1270, shows three red rays extending from the hands and feet of the seraph to the cupped hands of the saint—a unique and suspicious design. This painting is in fact damaged and repainted, and the rays are almost certainly the work of the restorer, as has already been claimed by P. Benvenuto Bughetti, in *Archivum Franciscanum historicum*, XIX, 1926, p. 35.

[59] *First Life*, paragraph 114. The two upper wings symbolize "love of the merciful Father" and fear of the "terrible Judge." The flight wings symbolize two kinds of charity to men, the one refreshing his soul, the other his body. These wings, unlike the upper two, are rarely joined because scarcely anyone is able to fulfill both these duties. The final pair of wings serves to cover the body, which has been stripped by sin, and is clothed with innocence through contrition and confession.

[60] A similar interpretation of the event reappears in Giovanni Bellini's beautiful and enigmatic painting in the Frick Collection, which I shall discuss elsewhere.

[61] In the Assisi fresco, and again in the Louvre panel bearing Giotto's name, the rays are multiple as they issue from Christ, and then become single.

The stigmatization in Giuliano da Rimini's altarpiece, dated 1307, in the Gardner Museum, Boston, shows Christ on the cross, the wound in his side visible, but the rays have not been introduced, possibly because Francis is placed close to Christ. The rays, however, are often lacking in Trecento representations.

[62] In this painting the rays do not pass from one figure to the other, but extend only a short distance from the wounds of each (Mr. Oliver Millar kindly verified this fact for me).

Elements of the new form have not been adopted in the Ducciesque triptych in Christ Church (see E. Garrison, in *Burlington Magazine*, LXXXIII, 1946, pl. 1). The rays are lacking, and the head of the heavenly figure is seraphic. Rays are likewise not visible in the badly damaged Sienese tabernacle of the early fourteenth century in the Budapest Museum, no. 34.

fourteenth and fifteenth centuries. It apparently was created around the turn of the century in the Roman-Tuscan ambient, in other words at a decisive historical moment and in those circles which transformed numerous other traditional representations. And certainly the shift of emphasis from the seraph, emblem of the ineffable being, to the humanity of Christ, and from spiritual similarity to bodily likeness, is one of the most revealing transformations effected at that moment of crucial artistic change.

Although the mid-fourteenth century Tuscan account of the stigmatization of St. Francis in the *Sacre sante stimmate,* an appendix of the *Fioretti,* does not reflect the creation of this new type in painting,[63] the vision of Catherine of Siena was undoubtedly inspired by it. For Catherine, kneeling with arms extended, saw only the Lord fixed to the cross—the seraph has disappeared completely—and from his wounds issued five rays. At first these rays appeared to be blood-red, as they occasionally are in paintings.[64] Then, following her request that her wounds be invisible, they changed to bright light (*color splendidus*), the usual form in painting, where they are executed in gold.

Paintings and sculpture representing the stigmatization of St. Catherine conform to the written account of her vision. They show the altar, the Crucifix, and usually also the rays.[65] Curiously enough, however, the rays are lacking in the earliest paintings of the subject, a Sienese panel of ca. 1400 in the Museo Civico Vetrario, Murano, and one by Giovanni di Paolo in the Robert Lehman Collection (Fig. 117).[66] Their omission is probably due to the influence of the texts of the Franciscan legend or, more likely, those representations of the stigmatization of St. Francis in which the rays are likewise absent.

I V

In the damaged and now very dirty predella of a Cionesque panel of the Madonna in the Museo dell'Opera of S. Croce, there is a representation of the Man of Sorrows between the Virgin, the Magdalen, Saints Dominic, and Catherine of Alexandria that shows an unusual inscription—unusual because of both its place and its content (Fig. 121).[67] Written across the gold above the extended arms of Christ, it reads:

[63] This text was based on the *Actus* (see note 51), compiled around 1325 from earlier sources.

[64] The rays are red in the Riminese Trecento panel no. 980 at Munich, according to Thode (*op.cit.,* I, p. 161—with an erroneous attribution to a contemporary of Cimabue) and in the early fourteenth century Taymouth *Hours* (see Little, *op.cit.,* p. 76).

[65] Fungai and also Pacchia, Casa di S. Caterina, Siena; Balducci, Pinacoteca, Siena, no. 406; Andrea di Niccolò, Coll. A. Pope-Hennessy, London (*Art in America,* XXXI, 1943,

p. 63); drawing in Bologna, Bibl. Univ. MS 1574 (Frati, in *Bibliofilia,* XXV, 1923, fig. 25). See also Kaftal, *op.cit.,* figs. 22, 23.

[66] For the panel by Giovanni di Paolo see M. Salinger, in *Bulletin of the Metropolitan Museum,* N.S. I, 1942, p. 21, and for the predella in Murano Kaftal, *op.cit.,* fig. 21.

[67] No. 18 in the Museum; attributed to Giovanni da Milano or his workshop by E. Sandberg-Vavalà, in *Art in America,* XV, 1927, p. 279, and to a follower of this painter by B. Berenson, *Italian Pictures of the Renaissance,* Oxford, 1932, p. 244.

O VOI TUTTI CHE PASSATE CONSIDERATE E VEDETE S[E] E DOLORE SIMILE AL DOLORE MIO E PER VOI LO PORTAI (Oh all ye that pass by, behold and see if there be any sorrow like unto my sorrow, and for ye I bore it). The same inscription is written again within the painted field of a Lamentation in the Congregazione della Carità, Parma, by another follower of the Cioni, Niccolò di Tommaso (Fig. 123).[68] The apostrophe evidently enjoyed a certain currency in Siena as well as among the Cionesque painters in Florence, for it appears on a panel of around the same time from the circle of Niccolò di Buonaccorso (Fig. 124).[69] Here it is in Latin and comprises part of a longer inscription that occupies a separate field below a Crucifixion:

CUR HOMO . MIRARIS .

MORIAR . NE TU MORIARIS .

MORTEM MORTE DOMO .

NE MORIATUR HOMO

O VOS . QUI TRANSITIS PER VIAM ADTENDETE E[T] VIDETE .

SI EST . DOLOR SICUT DOLOR MEUS VERE LANGORES . IP[S]E

TULIT . E[T] DOLORES . NOSTROS . IP[S]E PORTAVIT .

CUIUS LIVOR[E] SANATI SUMUS .[70]

The verse preceding the apostrophe may be translated:

Why O man do you wonder?
I die lest you die,
I master death by dying,
Lest mankind die.

The following lines are from Isaiah, LIII, 4-5: "Surely he hath borne our griefs, and carried our sorrows . . . and with his stripes we are healed."

Italian paintings of the fourteenth century, influenced as they were by French Gothic, often include writings of various kinds, but the inscription common to our three panels is not quite like any one of them. There are first of all the *tituli*, written usually in the frame below a narrative painting. They state concisely the subject, and begin with *Hic, Sic, Come,* or *Qualiter.* Closely related are the expanded labels that

[68] The first "O" of the inscription is not visible, but the painting is damaged and may have been cut down a little at both sides.

[69] Siena, Pinacoteca no. 163; according to Brandi (*Catalogo della R. Pinacoteca di Siena,* Rome, 1933, p. 60) by the same hand as the fresco fragments in a chapel adjoining the Cappella del Manto in the Ospedale, which are dated 1370 and signed by Cristofano di Bindoccio and Meo di Pietro. These frescoes are unpublished and I have not seen them. The other paintings attributed by Brandi to the same painters, the frescoes in the choir of S. Francesco, Pienza, seem to me very different in style.

A Crucifixion very similar in style to the one in Siena is in the Rheinisches Museum, Cologne, inv. no. 619.

[70] I have divided the first four lines in accordance with their poetic character. The inscription is not read quite correctly by Brandi, *loc.cit.* He reads IPE[R]TULIT instead of IP[S]E TULIT and the "I" in his DIOLOR is nothing more than an accidental streak.

are frequently set alongside figures, whose character or action they describe, as in the Triumph of Death, in Pisa.[71] Then there are the words spoken by one figure to another, usually written on scrolls, common in northern Gothic paintings and occasionally present in Italian (Fig. 85). Occasionally words spoken by someone who is not represented are addressed to the figures or to the spectator. Finally, apart from the names of saints, donors, and painters, there are the declarative statements of the figures themselves, such as the Baptist's ECCE AGNUS DEI or Christ's EGO SUM LUX MUNDI. Sometimes these statements are directed by implication at a specific audience, as the Virgin's remarks about justice in Simone Martini's *Maestà* in the Palazzo Pubblico in Siena. Occasionally they are hortatory, enjoining the audience to action, as in the panels discussed above containing the words on Christ's scroll: "If any man will come after me, let him deny himself, and take up his cross, and follow me" (Fig. 119). These last, which become frequent around the same time as our inscription, are also closest to it in character. But in our inscription the colloquium with the spectators is intensified by specifying them (*O Voi tutti che passate*), by the imperative, and by posing a question which implies a silent answer.

The inscription is thus an active invitation to contemplate the image, to share Christ's suffering and to evaluate its quality. It is another manifestation of that general tendency of the fourteenth and fifteenth centuries to draw more closely together the human and the divine, the spectator and the image, a tendency which continues to show itself in certain areas of the art of the third quarter of the century despite the counter-trend discussed above. An inscription of this kind serves precisely the same function as the saints who look appealingly at the spectator, or the participants in an action who disengage themselves partially to turn outward a sad or a compassionate face. Both they and our inscription anticipate the more specific "interlocutors" of Quattrocento art, who are recommended, too, by Alberti in his Treatise on Painting: "It pleases me to find in the representation someone who admonishes us and informs us what is going on in it; or beckons to me with his hand to see . . . or invites you to weep together with them [the figures] or to laugh. . . ."[72]

The words of our inscription are not, it is true, accompanied in any of the three paintings by a figure of Christ in a corresponding attitude of speaking. But in two of the three paintings they are connected with a particular kind of representation. Both the Man of Sorrows in S. Croce (Fig. 121) and the Lamentation in Parma belong to the group of so-called devotional pictures that became common in the fourteenth century.[73] In the painting in Parma, furthermore, the normal landscape of the Lamentation has been eliminated, permitting a concentration on the figures, who fill the entire area. They have been brought very near the frame and the spectator, drawing

[71] Alongside Death, for instance:
 Schermo di savere di richessa
 Di nobiltà . . . ancor di prodessa. . . .
[72] "Et piacemi sia nella storia chi admonisca et insegni ad noi quello che ivi si facci; o

chiami con la mano a vedere; . . . o te inviti ad piagniere con loro insieme o a ridere . . ." (ed. Janitschek, Vienna, 1877, p. 123).
[73] See below, p. 145.

his eye down to the ground and confronting him at close range with a delicately shaded series of sorrowful responses.[74] To representations of this kind our inscription conforms very closely, for it addresses the spectator directly, enjoining him to contemplate the visible pain, grief, and death that have transpired for his sake. It is in fact a distinctive kind of inscription for a devotional picture, a special "devotional legend."

The correspondence of inscription and image is especially close in the instance of the panel in S. Croce (Fig. 121). This does not represent the Man of Sorrows in the manner familiar in Italian painting and sculpture from the first appearance of the subject in the thirteenth century.[75] In all these representations Christ folds his arms across his body, but in the painting in S. Croce he extends them full-length. This new form is essentially peculiar to Florence and to the third quarter of the century (Fig. 125).[76] The flatness, symmetry, and formality of the posture of Christ conform to the art of this period. At the same time the outstretched arms and the open wounded hands are, like the inscription, addressed overtly to the observer. They are demonstrative and suggest declamation. What Christ declaims is written on the gold near by.

The significance that the inscription possesses for us lies in its context in paintings rather than in the originality of the formulation itself. Except for the concluding "e per voi lo portai," it is in fact a line from the Lamentations of Jeremiah that was

[74] Representations of this sort are the forerunners of the "close-ups" of sacred histories that appear in the later fifteenth century in Italy as well as the north (Presentation in the Temple by Mantegna in Berlin; Adoration of the Child by Hugo van der Goes, Wilton House).

[75] See the fundamental study by Erwin Panofsky, "Imago Pietatis," in *Festschrift für Max Friedländer*, Leipzig, 1927, pp. 206-308. To the thirteenth century Italian examples cited by Panofsky (which should not, however, include the painting in the Horne collection, a later derivative work) Garrison has added several panels (*op.cit.*, no. 267, and *Burlington Magazine*, LXXXIX, 1947, pp. 210-211). The early group may be enlarged further by the addition of two miniatures, one in a missal in Cividale (MS LXXXVI, fol. 16) and another, formerly in the Hoepli collection, published by P. Toesca (*La collezione U. Hoepli*, Milan, 1930, pl. XI).

The legend of the appearance of Christ as Man of Sorrows to St. Gregory, associated with the painting of the Man of Sorrows in S. Croce in Gerusalemme, Rome, is apparently another instance of a vision inspired by a work of art, though in this instance the "vision" was actually not that of Gregory himself but of a much later (Trecento?) cleric.

[76] See the fresco in the Cloisters of the Metropolitan Museum (Fig. 125), by Niccolò di Tommaso, as Richard Offner has kindly suggested to me; Giovanni del Biondo, Romer Museum, Hildesheim; close to Biondo, Pieve di S. Giovanni Battista, San Giovanni Valdarno; circle of Jacopo di Cione, private collection, Stockholm (Sirèn, *Giotto and Some of His Followers*, Cambridge, Mass., 1917, II, pl. 191); fresco, late fourteenth century Pistoiese, S. Francesco, Pistoia; Cionesque, Fogg Art Museum, no. 90. The extended arms of Christ are held by angels in the altarpiece by Tommaso Pisano in the Camposanto, Pisa. One example of this type of Christ with extended arms, though the arms are, significantly enough, flexed, was made before the middle of the century; it is in the predella of Taddeo Gaddi's altarpiece at S. Martino a Mensola (*Catalogo della Mostra Giottesca*, Florence, 1943, p. 463).

The posture of Christ with extended arms is anticipated in Dugento Depositions (see the panel in the Bargello, Garrison, *op.cit.*, no. 390).

often quoted in the Middle Ages.[77] Dante paraphrased it in the *Vita nuova*.[78] During the third quarter of the Trecento it reappeared, in its original form, in a Sienese poem, spoken by the Virgin in the course of a long lament beneath the Cross:

> O tutti voi che passate per via
> Attendete e vedete, se dolore
> Simil si trova a la gran doglia mia.
> Pietà vi prenda del mio dolce amore
> Per consolare me triste Maria,
> Che'n croce è posta l'alma mia e'l core.
> Serà nissuno che pietà ne prenda,
> Che'l mio figliuol così morto mi renda?

The poem, called the *Passione di Nostro Signore Gesù Cristo*, was composed by Niccolò di Mino Cicerchia, member of an eminent Sienese family, about 1364;[79] in other words, around the same time as the paintings bearing inscriptions, though the Sienese panel should, I think, be dated a little later. The *Passione* is one of three similar poems that were composed in the Sienese religious circles that we have already discussed: the second, the *Resurrezione di Gesù Cristo*, is the work of the same author, and the third, the *Fanciullezza di Gesù*, was written by the Beato Fra Felice da Massa.[80] Though Fra Felice was a native of Massa, he lived mostly at the Augustinian hermitage of Lecceto near Siena, along with "il Baccelliere," William Fleet. Both he and Cicerchia belonged to the *cenacolo* of St. Catherine, and they were among the twenty-two disciples who accompanied her to Avignon in 1376. Cicerchia, furthermore, was a member of the fraternity of the *Disciplinati della Madonna*, whose chapel under the vaults of the Spedale della Scala was a place of assembly of the followers of Catherine.

V

Though it has attracted very little attention in modern times, the *Passione* was almost as widely known in Italy in the fourteenth century as the *Meditationes vitae Christi*, the most popular text of its kind in the late Middle Ages.[81] The *Meditations*,

[77] Lamentations, I, 12.

[78] *Vita nuova*, chap. VII:
O voi che per la via d'amor passate
Attendete e guardate
S'elli è dolore alcun, quanto mio, grave.
Dante adds that he intends to call the "fedeli d'amore" with the words of Jeremiah. M. Scherillo, in his edition of the *Vita nuova*, Milan, 1921, p. 82 note 3, refers to the use of the line in French poetry.

[79] The poem was published by L. Razzolini in *Scelta di curiosità letterarie*, Bologna, vol. 162, 1878. The quotation above, stanza 195,

appears on p. 68 of this edition.

[80] The *Resurrezione* was published by F. Zambrini, Imola, 1883, and the *Fanciullezza* by D. Perini, Florence, 1927. For an account of all three of these Sienese poems see L. Cellucci in *Archivum Romanicum*, XXII, 1938, pp. 74ff.; also U. Cianciòlo, "Contributo allo studio dei cantari," in *Archivum Romanicum*, XXII, 1938, pp. 221-224, and N. Sapegno, *op.cit.*, pp. 542-543.

[81] Cianciòlo, *loc.cit.*, says there are manuscripts of the *Passione* in all the Italian libraries.

written by Giovanni da San Gimignano some sixty-odd years earlier, served in fact as a model for the *Passione* and for the other two related Sienese poems mentioned above. During the composition of the *Passione*, which consists of 282 stanzas, each of eight rhymed lines, Cicerchia had in mind the latter part of the *Meditations* (chapters 70-84), though he reshaped the narrative, adding or eliminating at will, and reverting to the Gospels or other theological sources.

The *Passione*, like the *Meditations*, is related in many ways to fourteenth century painting. Both the *Passione* and the corresponding part of the *Meditations* tell the story of Christ's last days through the eyes of the Virgin, the Magdalen, and St. John. The authors, like the painters of the time, give less attention to the events that overtook Christ than to their effect upon his closest and most constant companions. The grief and the desperate affection of this group is explored and amplified to the point where it becomes the primary theme. Extended exchanges of sentiment between them, or prolonged monologues, frequently halt and suspend the narrative. In this respect the *Passione* is more radical than the *Meditations*. It contains three lengthy passages of this sort; first, the remarkable plea of the Magdalen, St. John, and the Virgin who, sensing the antagonism of the high priests, beg Christ not to go to Jerusalem. The entreaty of the Virgin alone occupies sixteen stanzas. Second, the lament of the Virgin below the Cross, in the course of which she speaks the lines quoted above. Finally, her sorrowful monologue during and after the deposition, which, unlike the other two passages, is largely independent of the *Meditations*.

The effect of this form of presentation is not simply to give to the narrative the vividness and the sense of immediacy of an eye-witness. Nor is it intended only to enhance, through the testimony of others, the magnitude of Christ's suffering and sacrifice as an incentive to greater piety. The authors of these texts are profoundly sympathetic to the plight of the mother and companions of Christ, sensitive, affectionate persons who are suddenly deprived, for reasons only dimly perceived, of a son or a friend whom they deeply love and revere. Their loss is presented as an essentially familiar human tragedy, and even Christ himself becomes, as one historian has said, simply an humble, patient, benevolent man.[82] The progress of the plan of redemption inherent in these events is much less prominently exhibited, and as the climax approaches, the Virgin, the Magdalen, and St. John do everything they can, though unwittingly, to prevent it.

As a consequence of these values and interests, supernatural signs are largely suppressed. In the *Meditations* certain supernatural occurrences described in the Gospels, such as the transfiguration and the multiplication of the loaves, are only briefly mentioned or omitted (the former is omitted, too, in Giotto's cycle in the Arena Chapel). On the other hand, the *Meditations* introduces an uncanonical scene such as the appearance of Christ to his mother immediately after the Resurrection and Ascension,

[82] Cellucci, *op.cit.*, p. 51.

providing not so much a demonstration of his divine nature as of his filial love, and giving her an opportunity to see that the wounds of her son have healed.

Along with the moral and emotional aspects of their lives, the practical and the domestic become matters of speculation and specification. We are informed in both the *Meditations* and the *Fanciullezza* that during the sojourn of the Holy Family in Egypt the Virgin took in sewing to earn a livelihood, and Christ, when he reached the age of five, tried to increase her meager income. He went about as her agent, looking for work and attempting to collect the sums owed to her. Often her employers took advantage of his youth by paying him only half her due, or nothing at all.

The *Passione* and the Sienese poems contemporary with it do not seem to show a point of view essentially different from the *Meditations*, though they were composed more than fifty years later.[83] They are, likewise, very little closer to the visual arts of their own time than to those of the earlier part of the century. As works of art they and the *Meditations* fall far short of the best painting of the Trecento. They express, however, similar ideas and sentiments, and they contain related formal devices. The monologues and the colloquies in these texts are literary equivalents of the devotional pictures. Both emerge by similar transformations from a similar context of narrative art: the devotional picture by isolating a figure or two from the distractions of narrative action, the monologue or colloquy by suspending the narrative for the more expanded utterance of the participants. The devotional pictures dwell upon the emotions, the mixed joys and sorrows, of the Virgin, the Magdalen and St. John; while Christ, even in the *Vesperbild*,[84] tends to be a more neutral figure. In the historical scenes themselves there is a corresponding shift of attention to this group and to similar qualities of feeling. In the Crucifixion the grieving Virgin and the solicitous figures around her become so prominent as to create at least a second center in the composition. The desperate Magdalen makes an appearance at the foot of the cross. On the way to Calvary the Virgin tries to reach Christ and to intercede, but is prevented by a soldier. Images that represent Christ essentially alone, as the Crucifix (see especially Giotto's), express a pathos that stems from the sudden death of a lithe, beautifully formed youth. Even in death the qualities of life are affirmed.

This affirmation may stress the magnitude of Christ's sacrifice by asserting the values that as God he had to abandon. At the same time, however, it may draw toward opposition the two phases of his nature, raising in a somewhat different way a problem that had already been presented in the earlier Middle Ages. It is implicit in one section of the famous dialogue of St. Anselm, *Cur Deus Homo*, completed in 1098:

"For the question is, why God could not save man in another way, or if He could,

[83] In the *Fanciullezza di Gesù* and a few other writings after the middle of the century G. Weise finds a "liturgisch-erhabenes Moment" and conceptions of a powerful God and a majestic Mary, qualities that are similar to those we have found in painting. For Weise they are harbingers of humanism and the Renaissance (*Geistige Welt der Gotik*, Halle, 1939, pp. 406ff.).

[84] For this type, comparatively rare in Italy, see Meiss, in the *Art Bulletin*, XXVIII, 1946, pp. 8-10.

why He chose to save him in this way. For it not only seems unbefitting for God to save man in this way, but it is not clear of what avail that death is for the salvation of man. For it is a marvelous thing if God is so pleased with, or in such want of, the blood of an innocent person that, unless he is put to death, He cannot or will not spare the guilty."[85]

The subtle balance in Christian thought between the supernatural and the natural, between the requirements of redemption and its consequences for Christ the man, his mother and his companions, has in many early Trecento paintings yielded to a considerable tension. This becomes more explicit in the texts. In the *Passione*, for instance, as the Virgin embraces Christ who is bearing the cross she cries out:

> Anima mia, perchè con tante pene?
> Che hai tu fatto, dolce mio desio?

and:

> . . . figliuol, chi mi t'ha tolto?[86]

In a remarkable passage in the *Meditations*, the Virgin and Mary Magdalen plead with Christ not to venture into Jerusalem for the Passover. When he remains firm in his intention to go so as to fulfill the "prophecies and scripture," the desperate Virgin rebels:

"My son, I am distressed by what you have said, and my heart seems to have left me. Oh God my Father, provide for this, because I do not know what I say. I do not wish to contradict God; but if it pleases you, my son, I beg you to delay for the present, and let us have the Passover here with our friends; and if it pleases him, he will be able to provide other means of redeeming mankind without your death, since everything is possible for him."[87]

Occasionally in painting, too, the latent tension becomes open conflict. In three

[85] Chap. x. See the translation by E. S. Prout, London, n.d., p. 63. Anselm goes on to argue that only the incarnation and death of the son of God could accomplish redemption.

[86] Stanzas 160 and 161 in *Scelta, cit.*, p. 56:
 Oh my soul, why such pain?
 What have you done, my sweet love?
and:
 Son, who has taken you from me?

[87] "Figliolo mio, tutta sonne sbigottita per quello che tu hai detto, e pare che'l core mio m'abbia abbandonato. O Dio Padre, provvedili sopra questo fatto, però ch'io non so che io mi dica. Non gli voglio contraddire; ma se vi piacesse, pregovi che voi lo 'ndugiate per ora, e facciamo la Pasqua qui con questi nostri amici; e se li piacerà, porà provvedere per altro modo di ricomperare la umana generazione senza la morte tua; imperò ch'ogni cosa è possibile a lui." Chap. 72 (ed. Levasti, p. 203). The sense of the passage is slightly, but for our purposes not significantly, different in the Latin redaction (Bonaventura, *Opera Omnia*, Paris, XII, 1868, p. 595). The entire passage is omitted in a nineteenth century English translation (*St. Bonaventure's Life of Our Lord*, New York, 1881).

The question of whether or not the redemption of man might have been accomplished by means other than the incarnation and death of Christ was posed by mediaeval theologians —by Anselm, for instance, in the treatise mentioned above, and by Bonaventura—without however the thought that Mary or anyone else might have opposed the chosen means.

successive scenes of the Passion in a Florentine dossal of about 1325[88] the Virgin clings relentlessly to Christ, pursuing him with her affection in a final attempt to dissuade him from his mission. On the way to Calvary she throws her arm around him, trying to hold him back. As his clothes are removed beneath the cross, she draws very near, imploring him, it seems, to resist (Fig. 118). And she lays her hands upon him when he begins to mount the cross. In a representation of the Ascent of the Cross in Utrecht by Guido da Siena (Fig. 122), and in some later Sienese paintings of this scene, an embattled Virgin has become the chief actor. She forces her way between her son and a group of Jews and soldiers, angrily pushing one of them away while she encircles Christ with her other arm to prevent him from mounting the ladder.[89]

Sentiments and actions of this kind, expressed with varying nuance in the texts we have been considering and in paintings of the late thirteenth or early fourteenth centuries, are opposed by much of the art created after 1350. It accents the super-natural meaning of these events, constantly exposing their connection with salvation. Like the religious leaders of the period it presents the behavior of John and the Marys as universal models of understanding acquiescence and self-denial. In this spirit St. Catherine wrote to a monk: "Flee the memory of the world, of your father and brothers, your sisters and kin: remember them . . . in your prayers."[90] And the criticism which she directed at her mother might almost be applied to the Virgin and the Magdalen as we have seen them portrayed in the paintings and texts cited above. Throughout her early years Catherine opposed Mona Lapa's maternal concern with her health, her appearance, and her prospects of marriage. Catherine upbraided her for her reluctance to offer her daughter to God, urging her to conquer self-love,[91] and saying: "You love less the part of me that I have taken from God than what I have taken from you: that is, your flesh, with which you have clothed me."[92]

In addition to the broader resemblances of form and meaning between the *Passione* and Trecento painting, there are occasionally more detailed similarities of narrative or imagery. We have already mentioned the identity of the lines spoken by the Virgin under the cross with those attributed to Christ in three contemporary paintings. Again, when the Virgin sees Christ die, she is overcome by grief, her "soul crucified,"

[88] The central panel of the altarpiece was painted earlier by the Magdalen master. See R. Offner, *An Early Florentine Dossal*, Florence, n.d., figs. 7-9.

[89] The Virgin intervenes similarly in the panel by a distant follower of Guido in the museum of Wellesley College, Wellesley, Mass. (Garrison, *op.cit.*, p. 129), and a Ducciesque panel in the collection of Lord Lee, bequeathed to the Courtauld Institute, London.

[90] "Fuggite il ricordamento del mondo, del padre e de' fratelli, suore e parenti vostri: ricordateli . . . con sante orazioni" (quoted by Sapegno, *op.cit.*, p. 524).

[91] "Spogliatevi del proprio amore sensitivo" (Sapegno, *loc.cit.*). There were of course great differences in the intellectual and imaginative capacities of Catherine and her mother. The two are cited here as representatives of two differing sets of values; those of the mother, increasingly prominent in the earlier fourteenth century, were not limited to simple people.

[92] ". . . voi amate più quella parte che io ho tratta da voi che quella che io ho tratta da Dio: cioè la carne vostra, della quale mi vestiste" (Sapegno, *loc.cit.*).

the author says, in a bold, displaced, and characteristic metaphor that expresses succinctly his fundamental sympathies. The vivid description of her collapse is strikingly similar to Ambrogio Lorenzetti's in his panel in the Fogg Museum, made some twenty-five years before the poem (Fig. 126):

> Gesù la carne in croce avia confitta:
> L'anima di Maria crucifissa era.
> Giaceva in terra, non potia star ritta
> Tutta si strugge come a foco cera.[93]

Though the painting and the poem agree in attributing unbearable anguish and an extreme physical state to the Virgin, the poem alone ascribes them to Christ. Thus on the way to Calvary, Christ, overwhelmed by the sudden embrace of Mary[94] and exhausted by the weight of the cross on his shoulder, drops his burden and falls to the ground.[95] Though a similar collapse of Christ is gradually evolved in northern representations of the Way to Calvary during the later fourteenth and fifteenth centuries, it is not represented in a single Italian painting of this period, including those lesser works whose level of quality is closest to that of the poem. In Italian representations Christ is scarcely bent under the weight of the cross. His distress is conveyed by mental tension rather than physical collapse. What was acceptable in verbal imagery was apparently judged inappropriate, because too drastic, to the more vivid sphere of the visual.

By recasting the *Meditations* in verse Cicerchia was adapting it for a larger audience and for uses denied the prose. In its new form it could be read, like its prose model, in one of numerous manuscript copies; but it could also be recited or sung, along with similar *cantari*, by the confraternities, in one of which Cicerchia himself was active. It was added at the same time to the repertoire of the *cantastorie*, story-tellers or rather story-singers, who recited religious and secular rhymes in the vernacular to social gatherings, to fraternities, and crowds assembled in the squares or before the churches. Certain forms of "literature"—in which we may include the sermon and the mystery play[96]—thus had a very wide audience, and at the same time also a collective one. In this respect its rhetorical conditions, the conditions of communication, were similar to those of painting, for the majority of paintings, too, were made for public places, and addressed primarily to collective audiences. These conditions were characteristic

[93] *Passione*, stanza 188, in *Scelta, cit.*, p. 65:
The flesh of Jesus was transfixed on the cross:
The soul of Mary was crucified.
She lay on the ground, unable to stand,
All melted, like wax in a fire.
[94] In the *Passione* the Virgin breaks through the crowd and past the soldiers to embrace Christ; in painting she is restrained by a soldier.
[95] End of stanza 160:

Allor cascò Gesù, e la croce lassa.
Stanza 161:
Non poteva star ritto e cadde in terra:
Allor la Madre in braccio l'ha ricolto.
[96] These various forms were closely interconnected. Plays were often given as interludes in sermons, and they were directed if not written by preachers, such as Giovanni da S. Gimignano, author of the *Meditations*.

also of the earlier Middle Ages, but the development of numerous public "literary" forms independent of the liturgy was peculiar to the late medieval towns. Neither the confraternities, the *cantastorie*, nor the mystery plays were prominent before the late thirteenth century, and the vernacular sermon became common only shortly earlier. During the course of the fourteenth and fifteenth centuries, on the other hand, the public character of art began to be altered—"literature" by the development of printing, which produced a great increase in private reading, and painting by an increasing production for private possession and contemplation.

These public, or at least social, occasions for art, connected with an early stage of communal secularized culture, affected the character of the arts themselves. They contributed, in painting, to the maintenance of formality, largeness of scale, and a lucid pantomime. They also promoted the homogeneity of culture. Within a few weeks after Duccio had set up his Maestà in the cathedral or the Lorenzetti had completed their frescoes on the Scala, every Sienese writer, poet, and priest, indeed simply every Sienese, had seen them. Works in smaller buildings, though they received less attention, were constantly visible in more or less regularly frequented places. Similarly, though very few of the Sienese and Florentine painters read formal theological treatises, many of them had doubtless heard the *Passione* soon after its composition, recited in the streets, in the chapel of a fraternity, or at a meeting of the guild.

It is in the light of these circumstances that we must understand the relationships between literature and the arts, and between the arts and religious thought, in the late thirteenth and fourteenth centuries. They provide no warrant for the usual a priori scepticism of the historian about the influence of painting and sculpture upon literature or the religious imagination, and we need not be surprised if St. Catherine's account in 1378 of the mystical experience has the character of a highly perceptive description and interpretation of figures common in painting for some twenty years— figures that are tense, transfixed, their bodies bound, and massive but actually or seemingly suspended (Figs. 1, 47, 59). (The Lord speaks) ". . . the body is often uplifted from the earth by reason of the perfect union that the soul has made with me, almost as if the heavy body had become light. Nevertheless this does not mean that the heaviness of the body had been reduced, but that the union of the soul with me is more perfect than the union of the soul with the body; therefore the strength of the spirit united with me raises the weight of the body from the earth, leaving it motionless . . . the body loses its feeling, so that the seeing eye sees not, and the hearing ear hears not, and the speaking tongue does not utter a sound. . . . The hand does not touch and the feet do not walk; all the members are tied with the bonds of love, and, as it were, contrary to all their natural functions, cry to me the Eternal Father for the separation of the soul from the body, as did Paul, saying, 'Oh wretched man that I am, who will separate me from this body? for I feel within me a perverse law which wars against the spirit.' "[97]

[97] *Libro della divina dottrina*, chap. 79, ed. by M. Fiorilli, Bari, 1912, pp. 154-155. The above translation follows in part that given by A. Thorold, *The Dialogue of the Seraphic Virgin*, London, 1896, pp. 166-167.

VI

THE MADONNA OF HUMILITY
ORIGIN AND DEVELOPMENT

IN THE Museo Nazionale at Palermo there hangs a panel which represents the Madonna seated on a small cushion just above the ground (Fig. 129). She is turned oblique to the picture plane, her head is inclined gently toward the left, her farther leg is raised higher than the nearer one, and she holds close to her body the infant Christ. The Infant draws her breast into his mouth, while at the same time he turns his head away from her and looks out at the spectator. From the head of the Virgin radiate thin spires of gold, at the tips of which are twelve stars. At her feet is visible a small crescent moon. This painting, while of mediocre quality, has an historical importance as the earliest definitely dated (1346) example of a new image of the Madonna. Like several similar paintings it is inscribed NOSTRA DOMINA DE HUMILITATE, and there is no doubt that the lowly seat of the Virgin was intended to express her humility.[1] This new "Madonna of Humility" spread quickly throughout Italy,[2] and by 1375 examples began to multiply in Spain, France and Germany. It was the most popular of all the new subjects created in the late Dugento or early Trecento, and it epitomizes more vividly than any other composition the basic tendencies of the art of this time. It measures thus the great differences between this art and that which emerged from it around the middle of the fourteenth century.[3]

[1] The inscription "Nostra Domina de Humilitate" appears on a number of Madonnas which show not only the lowly posture, but also the Virgin nursing the Child and the symbols of the Woman of the Apocalypse. On the other hand, a Florentine Madonna seated on the ground, in the storeroom of the Academy (no. 3161), wherein the stars, sun, and moon are absent and the Child is not suckling, bears the inscription: RESPEXIT. HUMILITATEM. ANCILLE SUE. ECCE. E. EX. HOC. B.... (Luke, I, 48). This indicates that the humility of the Virgin resided primarily in the single fact that she was seated on the ground, and we shall include in our group every image of the Madonna that exhibits this one feature except compositions such as the Madonna in the Rose Garden, which though they may have been influenced by the Madonna of Humility, contain important additional symbolic forms and belong to a different type.

[2] See the list, long but not nearly complete, in Van Marle, *Development of the Italian Schools of Painting*, VI, p. 69. Betty Kurth (in *Belvedere*, 1934, pp. 6ff.) added one or two paintings to Van Marle's list, which she reprinted in part without, however, any attempt to correct the many erroneous dates and attributions.

[3] Previous comments on the Madonna of Humility have been confined almost wholly to suggestions as to its place of origin. U. Gnoli (in *Enciclopedia italiana*, s.v. Maria Vergine) suggests the possibility of northern Europe, though he does not state what examples he had in mind; H. Thode (*Franz von Assisi*, Berlin, 1904, p. 507), and B. Berenson (*Venetian Painting in America*, N.Y., 1916, p. 3) look to Bologna; B. Kurth (*op.cit*) suggests Siena; R. Oertel (*Marburger Jahrbuch für Kunstwissenschaft*, VII, 1933, p. 193 note 1) a lost work of Simone Martini copied by two panels in Berlin and Palermo, the same conclusion as that advanced above, and Georgiana Goddard King (*Art Bulletin*, XVII, 1935, pp. 474ff.) makes a claim for Spain. M. Salmi

The Madonna of Humility was so radical an innovation that only a leading master in a "progressive" Italian center could have conceived it. The innovation was clearly beyond the talent of the author of the Palermo panel, a mediocre Ligurian painter,[4] and it is significant therefore that his style is completely dependent on Simone Martini. This dependence is all the more revealing because another early Madonna of Humility was likewise made by a painter very close to Simone, possibly Lippo Memmi (Fig. 128).[5] This small panel, no. 1072 in the Kaiser-Friedrich Museum, was probably painted shortly before the Palermo Madonna, and is far superior to it in quality. Although the composition is reversed, and there are minor differences, it resembles the Palermo Madonna so closely that one must infer either a dependence of one (Palermo) on the other (Berlin), or a common prototype. The latter alternative is far more probable, for in view of the small size of the Berlin panel and the absence in it of the moon and stars, it could scarcely have been the model of the Palermo painting. Since the style of both the paintings is Simonesque, there is every reason to assume that their prototype was a Madonna of Humility by Simone Martini.

This hypothetical model has been lost, but one Madonna of Humility by Simone Martini has come down to us—the badly damaged fresco in the tympanum of the Portail Roman of Notre-Dame-des-Doms, in Avignon, painted between ca. 1340 and 1343 (Fig. 130). The Virgin, attended by the donor, Cardinal Stefaneschi, and a number of angels who hold a drapery behind her, is seated on a cushion, as in the Berlin and Palermo panels. The similarities do not extend further, however, for the Child is seated upright upon the Virgin's knee. He holds a scroll in his left hand, and blesses (?) with his right. Simone has here created a more monumental and less sentimental composition, more suitable for a work of this size and position. Probably because of these aspects of the work and its location in Avignon, it had little influence upon later representations of the Madonna of Humility. But its existence strengthens the assumption that Simone painted another Madonna which was imitated in the Berlin and Palermo paintings.

(*Masaccio*, Rome, 1930, p. 110 and in *Rivista d'arte*, II, 1930, p. 309) inclined toward a Marchigian origin, but he has since accepted the conclusions of the present study (*Masaccio*, 2nd ed., 1948, p. 176). Cf. also E. Sandberg Vavalà, *La pittura veronese*, Verona, 1926, p. 114, and C. R. Post, *A History of Spanish Painting*, Cambridge, Mass., II, 1930, p. 231. Miss King, in the article mentioned above, has studied not only the place of origin of the Madonna of Humility, but other problems connected with it. Her views will be commented upon in the latter part of this paper.

[4] The panel bears the inscription: MCCC. XXXX. VI. HOC OPUS PINSIT. MAGISTER. BARTOLO-MEUS. DE CAMULIO. PINTOR. Bartolommeo da Camogli is mentioned in documents between 1339, when he took an apprentice, and 1348, probably the year of his death (cf. Carlo Arù, in *Bolletino d'arte*, ser. 2, I, 1921, p. 267).

[5] B. Kurth, *op.cit.*, gives it to Simone; R. Offner, in the *Arts*, v, 1924, p. 245, to Lippo Memmi; C. Weigelt, *Sienese Painting of the Trecento*, n.d. (1930), note 63, and B. Berenson, in *International Studio*, February, 1931, p. 26, close to Lippo Memmi; R. Van Marle, *op.cit.*, II, p. 226, hesitantly to Donato (the brother of Simone), of whose work there is no documented example extant. There is no evidence for Miss King's statement (*op.cit.*, p. 486) that the painting was made in Avignon.

Beyond the Berlin panel, there are no extant representations of the Madonna of Humility by the immediate circle of Simone in Siena. On the other hand, four paintings by Andrea di Bartolo and his shop are evidently copies of a Madonna of Humility of Simonesque style which resembled closely the Berlin and Palermo Madonnas (Fig. 131).[6] It is clear, furthermore, that the Madonna of Humility was a popular subject in Siena, for there are many examples from this school in the second half of the fourteenth century.[7] These Madonnas, it is true, differ more or less from the Simonesque version represented by the Berlin and Palermo panels. But they differ also from one another, and this absence of a common prototype proves that there was no Madonna of Humility painted in the first half of the century in, or even outside, Siena which rivaled Simone's in fame and importance.

We are brought to the same conclusion by the Madonnas painted outside Siena, in the other Italian centers. Let us turn first to Naples. After the visits of Cavallini, Giotto, and Simone, Naples was largely isolated from the development of Trecento painting, and the few indifferent Neapolitan paintings from ca. 1335 to ca. 1365 are imitations of either Giotto or Simone Martini, or the two together. Because of this comparative isolation and this unusual limitation to two stylistic sources, the Simon-

[6] Two of them are signed by Andrea, one in the Ehrich Galleries, New York, in 1929 (Meiss, in the *Art Bulletin*, XVIII, 1936, fig. 3); another of unknown whereabouts, reproduced by Berenson in *International Studio*, February, 1931, p. 30. A third is in the National Gallery, Washington (Fig. 131), and the fourth in the Stoclet collection in Brussels (attributed by Van Marle, *op.cit.*, v, pp. 449-450, to Simone, with question). In all four, the Child is wrapped in a white drapery and the Child's left arm is held straight, particulars which do not appear in any other examples of the Madonna of Humility. Van Marle, *op.cit.*, v, pp. 449-450, mentions a replica of the Berlin Madonna in a private collection in Rome. The Berlin Madonna (or a painting exactly like it) was copied by a fifteenth century Sienese painter in a triptych of unknown whereabouts reproduced by Berenson in *International Studio*, February, 1931, p. 26, and again, though somewhat more freely, by Giovanni di Paolo in his panel in S. Simeone, Rocca d'Orcia. Additional examples of the Madonna of Humility by Andrea di Bartolo or his circle, in which the composition varies in different ways from the Simonesque type, are in the following collections: Brooklyn Museum, Detroit Museum, Art Institute of Chicago (very Simonesque), private collection in Genoa, and in the market (reproduced in

Dedalo, x, 1930, pp. 345-347).

[7] Bartolommeo Bulgarini, Washington, and shop of this master, Rijksmuseum, Amsterdam (where the Virgin is playing with the Child, who is climbing up into her lap; cf. Meiss, in the *Art Bulletin*, XIII, 1931, fig. 27); Sienese ca. 1365, Berenson collection (same composition as Lanz Madonna); Sienese, late Trecento, Johnson collection no. 153 (Fig. 143); Niccolò di Buonaccorso, unknown whereabouts (reproduced by Berenson, *International Studio*, January, 1931, p. 29); Andrea di Bartolo, two panels of unknown whereabouts (*ibid.*, p. 30), and one in the collection of Mrs. A. E. Goodhart, New York; Paolo di Giovanni Fei, Duomo, Siena, and Platt collection, Englewood; Francesco di Vannuccio, formerly in the Kauffmann Collection.

St. Joseph is seated on the floor alongside the Virgin and the Child in a painting in the Abegg collection, Zurich, by the school of Ambrogio Lorenzetti (reproduced in *The Arts*, v, 1924, p. 247); this is perhaps the earliest Holy Family in western art. Similarly, the domestic elements (low wall, bobbins) which appear in the Johnson Madonna (Fig. 143) and the Niccolò di Buonaccorso, as well as the rather playful, genrelike action in the panels in Amsterdam and the Berenson collection, all seem to have originated in the circle of the Lorenzetti.

esque character of the Neapolitan representations of the Madonna of Humility is very significant: there is every reason to assume that the early Neapolitan examples are based directly upon a painting by Simone Martini. The best of them (Fig. 133), one of the three in the church of S. Domenico Maggiore,[8] was originally on the tomb of Johanna Aquinas, who died in 1345.[9] This evidence for a date not much after 1345 is supported by the style, which follows Simone so closely that it is possible to specify the period of Simone's development upon which it depends: the Neapolitan, represented by the large panel of St. Louis now in the Naples Gallery.[10] Because of this, and the large number of Simonesque Madonnas of Humility among the few extant Neapolitan paintings, one would be tempted to suppose that Simone painted a Madonna of Humility during his stay in Naples around 1317, were not all the extant examples in other regions so much later in date.

Equally Simonesque, and equally close to the composition of the Sienese and Neapolitan Madonnas, are the earliest examples from Bologna (Fig. 134),[11] Padua,[12] Modena (Fig. 136),[13] Pisa (Fig. 132),[14] and Pistoia,[15] none of them before 1350. Like-

[8] The other two are in the chapel of the Crucifixion and in the narthex. Cf. Rolffs, *Geschichte der Malerei Neapels*, Leipzig, 1900, p. 41, and Alinari photo. 33442.

[9] The panel bears the Aquinas coat of arms.

[10] The technique of raising into relief some of the ornament, the fleur-de-lys stamped into the gold border, the angels, as well as the style as a whole, indicate as the source of this painting Simone's panel of St. Louis.

Similar to this Madonna in S. Domenico Maggiore are the paintings in S. Pietro a Maiella (according to Rolffs, a later copy of it) and in S. Chiara (cut down; Van Marle, *op.cit.*, v, fig. 211). A painting in S. Lorenzo (Rolffs, *op.cit.*, fig. 41) shows the motif of the Child taken over into a half-length representation of the Madonna. A Madonna of Humility of the latter part of the century in the Museum of Fine Arts, Moscow (attributed to Roberto Oderisi in *Burlington Magazine*, LI, September, 1927, p. 133), the composition of which differs considerably from the Neapolitan group, is interesting because of the appearance of the Pietà in the pinacle (cf. below, p. 145).

[11] All the Bolognese Madonnas are relatively late in date. Cf. Andrea da Bologna, 1372, Gallery, Pausola; Simone dei Crocefissi in S. Martino, Bologna (Van Marle, *op.cit.*, IV, p. 404, as Vitale); Lippo Dalmasio, in the Pinacoteca in Bologna (photo. Croci no. 3120), in the Gallery at Pistoia, in the Misericordia, Bologna (*ibid*, fig. 231), and in S. Giovanni in

Monte, Bologna (attributed by Van Marle, *ibid.*, p. 403, and Kurth, *op.cit.*, to a much earlier painter, Vitale). Cf. also the Madonnas by Giovanni da Bologna in the Academy, Venice (Fig. 154), and in the Brera in Milan (reproduced by E. Modigliani, in the *Burlington Magazine*, XIX, 1911, p. 22).

A Madonna by Vitale da Bologna in the Poldi-Pezzoli Museum in Milan (Vavalà, in *Rivista d'arte*, Ser. 2, I, 1929, p. 474, fig. 18) shows the Virgin seated on the ground beside the Child, with whom she is playing. This painting is related by its style, its playful character, and by such domestic details as the low wall and the flasks, to the Sienese Madonnas mentioned in note 7.

[12] Niccolò Semitecolo, 1367, Padua, Biblioteca Capitolare. A Veronese Madonna, formerly in the Cannon collection, now in the Museum of Princeton University, shows wider divergences. F. J. Mather (*Art in America*, XXIV, 1936, p. 52) mentions, without definitely approving, the view of J. P. Richter (*The Cannon Collection of Italian Paintings*, Princeton, 1936, p. 11) that the panel was painted by "Altichiero II," presumably before the middle of the century; but the earliest possible date for the painting seems to me to be ca. 1365.

[13] Paolo da Modena, 1372, Modena Gallery (cf. P. Bortolotti in *Atti e memorie delle RR. Deputazioni di Storia Patria per le provincie Modenesi e Parmensi*, VII, 1874, pp. 583ff.).

wise, the Venetian Madonnas, three of which—in the Thyssen collection,[16] in S. Anastasia, Verona, and in the National Gallery, London (Fig. 135)[17]—may have been painted as early as ca. 1355-1365. The early date of these Madonnas, as well as the popularity of the subject in Venice,[18] might suggest the possibility of a Venetian origin of the type; but this must be rejected because of the wholly Sienese character of the composition, and because of the absence in Venice—an unprogressive center at this period, still clinging to Byzantine style—of those sources and analogous motifs which, as we shall see, are all found in Tuscany.

The Marches have sometimes been considered the region where the composition originated because of the number and homogeneity of the examples painted there. The earliest Marchigian Madonna of Humility is the panel in S. Domenico, Fabriano,[19] dated 1359, some fifteen years later than our earliest Sienese examples. It was painted by Francescuccio Ghissi, whose style depends, in general and in this specific work, upon Allegretto Nuzi. There is an almost identical Madonna of Humility by Nuzi in the Gallery of San Severino, dated 1366 (Fig. 137), and he must have painted an earlier example—before 1359—which served as Ghissi's model. This assumed Madonna by Nuzi, made certainly before 1359, was with almost equal certainty not

The panel bears the inscription: LA NOSTRA DONNA D. UMILITA F[RATER] PAULUS DE MUTINA FECIT. ORD[INIS] P[RAE] DIC[ATORUM].

[14] Giovanni di Niccolò, Cà d'Oro, Venice (Fig. 132), and National Gallery, Washington.

[15] In Pistoia there flourished a cult of the Madonna of Humility, centered on the Madonna now in the church of the Madonna dell'-Umilità (cf. note 53). This Madonna, sometimes incorrectly attributed to Giovanni di Bartolommeo Cristiani (Tolomei, *Guida di Pistoia*, Pistoia, 1921, pp. 81, 91, 95), was executed by a Pistoiese painter ca. 1370. Of about the same date, and also of local origin, are the Madonnas in S. Bartolommeo in Pantano (first altar, right) and in the cloisters in S. Domenico. Illuminating is the appearance of this very Sienese composition in Pistoia, a town usually dominated by Florentine style.

[16] Reproduced in *Dedalo*, XI, 1931, p. 1370, and there attributed by Van Marle to Paolo Veneziano. It is close in style to Paolo's Coronation of the Virgin in the Frick collection dated 1358.

[17] The Madonnas in S. Anastasia and in the National Gallery were attributed to Lorenzo Veneziano (active from ca. 1357 to 1372) by E. Sandberg Vavalà (*La pittura veronese*, Verona, 1926, fig. 39, and *Art in America*,

XVIII, 1930, p. 54). The London Madonna, though certainly Venetian, is given to Tommaso da Modena by the catalogue of the National Gallery (1929, p. 366) and by Betty Kurth, *op.cit.*; L. Coletti, in *L'Arte*, N.S. II, 1931, p. 131, attributes it to Giovanni da Bologna.

[18] Later Venetian examples of the type are in the Thyssen collection (reproduced in *Dedalo*, XI, 1931, p. 1371, and there attributed by Van Marle to Caterino); in the Worcester Art Museum (signed by Caterino); S. Maria a Mare, Torre di Palme (Van Marle, *Development*, IV, fig. 44); and Walters Art Gallery, Baltimore (Berenson, *Venetian Painting in America*, New York, 1916, p. 3). The late fourteenth century Madonna in the National Gallery, London (no. 4250) and Caterino's Madonna of Humility in the Walters Art Gallery, Baltimore, differ considerably from this group of Venetian paintings. Cf. also the Madonnas by Giovanni da Bologna mentioned in note 11.

[19] Van Marle, *op.cit.*, V, fig. 106. G. G. King (*op.cit.*, p. 469) discusses the curtain and the marble parapet in this work without recognizing that they were painted in several centuries later.

painted before about 1350, for his first dated work is of 1354,[20] and none of his paintings can be placed much before this.

The fact that the Madonna of Humility appeared in the Marches first in the work of Nuzi is very significant, for he was the first painter of this region who assimilated Tuscan style. His art was based upon the Florentines, particularly Bernardo Daddi and Maso di Banco. A comparison of the San Severino panel, however, with his other Madonnas reveals how he has largely abandoned in that work his typically rugged form in the attempt to achieve a characteristically Sienese rhythmical line and languorous sentiment (Fig. 137). The soft, partly transparent drapery of the seminude Child is Sienese, and he has adopted even the Sienese motif of a loose fold hanging down free from the Child's body, which appears in both the Berlin and Palermo panels. The fact that a master otherwise so completely dependent on Florence adopted a Sienese composition is good proof of the renown of the Sienese prototype, especially when there were Florentine paintings of the subject which he might have imitated.

The earliest extant examples of the Madonna of Humility in Florence were painted in the immediate circle of Bernardo Daddi—the most "Sienese" painter of his generation. The first, the Madonna by the so-called Assistant of Daddi, is on the back of the central panel of the Parry altarpiece, dated 1348 (Fig. 139);[21] the composition was merely laid in and has suffered serious damage, so that only the configuration of the larger forms can be seen today. It was copied closely, however, by Daddi's follower, Puccio di Simone, in the altarpiece now in the Florentine Academy. This painting also has been partly destroyed; the faces have been repainted, and this probably accounts for certain differences from the Parry panel, in which the Madonna looks at the Child, and the Child at the spectator.

This Daddesque composition of the Madonna of Humility is the only early one in all Italy which differs radically from Simone's. Fundamentally Giottesque, it replaces the intimacy of the Simonesque version with a statuesque monumentality. The Virgin is seated more erectly and turned farther toward frontality. The undulating Sienese contours have given way to a bolder construction of mass and space. Symptomatic of the change is the omission of the free-hanging fold of the Child's drapery. The Child is not actually suckling and his body is not drawn so close to the Virgin, so that even

[20] See his St. Anthony in the altarpiece in the National Gallery, Washington, dated 1354 (Offner, *Corpus*, v, pl. 37).

Ghissi's representations of the Madonna of Humility, in addition to the example in S. Domenico, Fabriano (1359) mentioned above, are in S. Andrea, Montegiorgio (1374; Van Marle, *op.cit.*, v, fig. 107); in the Fornari collection, Fabriano (1395; *ibid.*, fig. 108); in S. Agostino, Ascoli Piceno (*ibid.*, fig. 110); in S. Domenico, Fermo (*ibid.*, fig. 109); and in the Vatican Gallery (*ibid.*, fig. 111). Early fifteenth century Marchigian examples are the

Madonna in the museum at Ancona by Carlo da Camerino, and, by the same painter, Madonnas in the Cleveland Museum (*ibid.*, fig. 105), in the Walters Art Gallery, Baltimore, and in the Worcester collection, Chicago (incorrectly attributed by L. Venturi, *Pitture italiane in America*, Milan, 1931, pl. 104, to Jacobello del Fiore).

[21] Offner, *Corpus*, sec. III, vol. III, pl. XIX, and v, p. 117 (where Offner attributes the painting to a collaborator of Daddi whom he calls the Assistant of Daddi).

though he looks out at the spectator, he remains quiet and reposeful, without the dynamic contrapposto of the Simonesque motif.

Since the Parry Madonna was made at the end of the career of Daddi and the Assistant of Daddi—both painters apparently died in the plague—it is not impossible that one of these masters painted a Madonna of Humility earlier. This seems quite unlikely, however, because the subject was represented only once by the later followers of Daddi, and this work, in Dijon, actually draws away from Daddi toward Simone's composition.[22]

It is interesting that the most numerous and most essential modifications of the Madonna of Humility during the course of the later fourteenth century were made in Siena, where the image originated, and in Florence, where it was soon adopted. These changes demonstrate once again the exceptional vitality of the two schools. In Siena the most important innovation was made during the second quarter of the century. At that time, as we have seen, the interior or domestic version was introduced, very probably by the Lorenzetti (Fig. 143). In Florence, where the Madonna of Humility appears to have been introduced early in 1348, the major changes occurred a few years later, and they conform to that artistic and religious trend that we have described in preceding chapters. The beautiful Madonna designed by Orcagna and completed by Jacopo di Cione, now in the National Gallery, Washington (Fig. 140), derives from the Parry Madonna, but in it there is a greater "distance" between the Virgin and Child and between them and the spectator. The Child is moved still farther from the Virgin's breast; he now lies so low in her lap that only one of his extended arms and hands can reach it.

This composition was copied many times,[23] and it is the one which appeared most frequently in Florence in the later Trecento.[24] Some painters of this period, moreover, formalized the image still further by representing the Child seated erect on the Virgin's knee.[25] Around 1390-1400, however, painters of the school of Agnolo Gaddi

[22] *Ibid.*, sec. III, vol. V, pl. 31.

[23] Panels in: the Tolentino sale, American Art Galleries, Dec. 8-11, 1926, no. 764 (Giovanni del Biondo); Academy, Florence (central panel of a triptych; in the wings Michael and Gabriel, Anthony and Paul); Academy, Florence, storeroom, no. 3161 (by a follower of Spinello Aretino); Museum, Avignon (by Niccolò di Pietro Gerini); church in Cevoli, near Pisa (close to Lorenzo di Niccolo); Satinover Galleries, New York (Orcagnesque; photo. Reali 218); two Orcagnesque panels of unknown whereabouts (reproduced in *Dedalo*, XI, 1931, pp. 1308 and 1310); formerly G. G. Barnard collection, New York (Orcagnesque); and in the fifteenth century, Masolino, Alte Pinakothek, Munich.

An Orcagnesque Madonna in the Musée Bonnat, Bayonne, may be described as midway between the Dijon and Cione compositions.

[24] There are a few Florentine examples of this period which *do* represent the suckling Infant, but he is placed entirely in profile. Cf. Florence Academy no. 3156, Orcagnesque; and P. Weiner collection, Leningrad (reproduced in *Starye-Gody*, 1908, p. 712; attributed by Van Marle, *op.cit.*, IV, p. 367, and by Kurth, *op.cit.*, to the school of Bernardo Daddi, whereas it is, in my opinion, a partly repainted work of the end of the fourteenth century).

[25] Madonnas in the Municipio, Chianciano; formerly in the Chiesa collection, Milan; no. 7689 in the gallery at Strasbourg (much repainted); no. 345 in the Museum at Münster; two panels by followers of the Cioni in the storeroom of the Uffizi; collection Dard of the

(Fig. 142)[26] reversed the tendencies of the preceding development in Florence. As in other instances that we have cited,[27] they reverted to the compositions of the second quarter of the century, in this case to the Madonna of Simone Martini.

Though Orcagna's painting in Washington and other similar variants of the Madonna of Humility (Fig. 138)[28] exemplify the new trend of Florentine painting in the third quarter of the century, they do not modify the essential meaning of the image. During this period, however, another version of the Madonna was introduced that involved a radical departure from the original type. In it the seated Virgin is raised high in the gold field above the ground plane (Fig. 145).[29] Her cushion, often elevated with her, was occasionally placed on a small bank of clouds. As in the Coronation, she becomes less accessible than earlier to the attendant saints or the spectator, who look up at her from below. This new composition may in fact have been influenced by the legend of the Virgin in the sun revealed to Augustus by the sibyl. Before the appearance of the "celestial version" of the Madonna of Humility, however, the Virgin was usually shown standing or half-length in representations of this legend. In any event the Virgin in our "celestial version" is less a Madonna of Humility than a remote and visionary apparition.

This "celestial version" of the Madonna of Humility persisted in the early Quattrocento,[30] and it is the ancestor of later Renaissance compositions such as Raphael's *Madonna di Foligno* or Titian's Ancona and Vatican Madonnas. In all these later works, however, the small band of clouds under the Virgin was enlarged to a prominent cloudbank, providing a plane, however permeable, beneath her, and giving the design a certain naturalistic plausibility. The Quattrocento adopted also the true Madonna of Humility. Up to 1450 it was almost as popular as in the preceding century, and it appeared also in sculpture.[31] The Quattrocento tended on the whole to

Dijon Museum (ca. 1400); collection Baron Lazzaroni, Paris (ca. 1400).

[26] Madonnas in: Berlin, Kaiser-Friedrich Museum (Fig. 142), Museo Nazionale, Florence, and Walters Art Gallery, Baltimore, all by the "Master of the Straus Madonna"; three panels of unknown whereabouts (reproduced by Berenson in *Dedalo*, XI, 1931, pp. 1308-1310). Also, though somewhat less closely related, no. 62 in the Parry collection. The reversion of these works to the Simonesque composition exemplifies the neo-Gothic aspect of Florentine painting around the turn of the century.

Unique in the school of Florence from ca. 1350 to ca. 1380 (except the *Madonna della Pura*) is an Orcagnesque Madonna formerly in the collection of L. Douglas, for it is a very close imitation of the Simonesque composition, and shows also the twelve stars.

[27] See above, p. 40.

[28] See above, p. 41.

[29] See the panel by a follower of Nardo di Cione in the Academy, Florence (Fig. 145); the panel by a follower of Gerini in the Museum of Chateauroux; the altarpiece by Mariotto di Nardo in the Academy, Florence; Cionesque panel, Academy, Florence (Meiss, *Art Bulletin*, XVIII, 1936, fig. 13).

[30] See, for example, Lorenzo Monaco, Pinacoteca, Siena.

[31] The marble Madonna of Humility in the National Gallery, Washington, attributed tentatively to Quercia by C. Seymour, Jr., and H. Swarzenski (*Gazette des beaux-arts*, XXX, 1946, pp. 129ff.), is probably the earliest example of the image in Italian sculpture, but not, as the authors say, the earliest example in sculpture anywhere. See the northern examples, earlier and contemporary, mentioned in notes 43 and 45.

monumentalize and to ennoble the representation. Whereas in the fourteenth century the Virgin sits on a cushion on the ground, and the setting, when any is shown, is a simple domestic one, in the fifteenth century she is often raised on a dais above the floor, a rich brocade is spread behind her,[32] and elaborate stone architecture rises in the background.[33] The Child, furthermore, is rarely shown suckling.

A number of Quattrocento representations, however, contain a reference of a different kind. In a Madonna of Humility in the National Gallery, Washington—a completely repainted work probably executed originally by Masaccio or upon his design—in several Madonnas from the circle of Donatello,[34] and in a Madonna by Domenico di Bartolo (Fig. 141), the Virgin is represented with bare feet. Thus to the Virgin's humility these works add poverty, the great Franciscan virtue.

Although both the creation and the major part of the later development of the Madonna of Humility were due to Tuscan painters, one important innovation was apparently made outside this region, in northern Italy and probably in Venice. In Giovanni da Bologna's Madonna in the Venice Academy, as well as in Caterino's Madonna in the Worcester Museum, painted around 1380 or 1385, the usual bare floor has been transformed into a flowered field or garden (Fig. 154). This "garden type," idyllic and colorful, was especially congenial to the period around 1400. The garden was sometimes given a semicircular shape that conveyed a cosmological meaning. In Giovanni da Bologna's panel in Venice (Fig. 154) its curvature is similar to that of the arc of heaven in the same painter's representation of the celestial type in the Brera. The garden was often identified, on the other hand, with the *hortus conclusus* of the Song of Songs, as in the French miniature cited below (Fig. 153), or Stefano's panel in the Verona Gallery. Though the garden type was developed chiefly in northern Italy, it was adopted also by other centers, such as Siena.[35] Only a slight change was needed to transform it, in the fifteenth century, into the representation of the Madonna in the rose garden.[36]

During the third quarter of the fourteenth century Simone Martini's composition of the Madonna of Humility was taken up in the three regions of Europe where painters were most attentive to Italian Trecento style and iconography. We meet with it in Bohemia in the panel in Sts. Peter and Paul on the Wyschehrad, Prague.[37] It was

[32] Fra Angelico, National Gallery, Washington; Gentile da Fabriano, Museo Civico, Pisa; school of Angelico, Ad. Schaeffer collection, Frankfurt.

[33] Fra Angelico, Pinacoteca, Turin.

[34] *Donatello, Klassiker der Kunst*, pp. 91-93.

[35] Madonnas by Andrea di Bartolo in the Brooklyn Museum, in the Goodhart collection, New York, and the two reproduced in *International Studio*, January, 1931, p. 30.

[36] These late Trecento and early Quattrocento Italian Madonnas of the "garden type" invalidate the argument of L. Maeterlinck

(*L'énigme des primitifs français*, Ghent, 1923, pp. 98ff.) that the composition of the Virgin seated in a garden is not German in origin, but French, whereas actually it appeared first in Italy. Furthermore, Maeterlinck tried to prove his thesis by dating around 1350 a Madonna in the Louvre, which, though possibly based upon an earlier work, was actually painted in the middle of the fifteenth century.

[37] Cf. B. Kurth, *op.cit.*, fig. 11. In the early fifteenth century the Madonna of Humility (but no longer the Simonesque composition) appears in the school of Cologne (panel for-

introduced into Spain by the most Simonesque of the Catalan painters, Jaime Serra (Fig. 148).[38] Furthermore, Spain, which at this period became almost as dependent upon Tuscany as were some north or south Italian centers, took up even Bernardo Daddi's composition of the Madonna,[39] though in Italy itself this composition seems to have had no influence outside Florence. The first example of the Madonna of Humility in France is, so far as I know, a miniature in a Book of Hours in the Morgan Library, made about 1360 (Fig. 147). The miniature was painted in the outlying region of Metz[40] and is rather poor in style, so that it probably derives, not directly from an Italian composition, but from an earlier French example made in a more progressive French center. Inasmuch as the style shows some resemblance to Pucelle and his followers in Paris, it seems possible that the Madonna of Humility was introduced in France by these painters, who were the first to assimilate Italian (Sienese) style and iconography. It is a notable fact that the Madonna in Morgan MS 88, like the early examples in Bohemia and Catalonia, follows the Simonesque version common throughout Italy, *not* the composition of Simone's fresco at Avignon. This Avignon fresco, though prominently exhibited in what is usually regarded as the great center for the dissemination of Italian style, seems to have had no influence in France whatever.

The Madonna in Morgan MS 88 differs in a number of ways from the usual Italian composition. The Child is, remarkably enough, entirely nude. The Virgin places one hand on her breast, as in many northern Nativities and in the Daddesque Madonna of Humility at Dijon. The crescent moon shows a man's face, common in northern, especially German, representations of the Apocalyptic Woman and the Virgin on the moon. Furthermore, the floor or ground plane under the Madonna is missing, and the

merly in the Weber collection, reproduced by Worringer, *Anfänge der Tafelmalerei*, fig. 95), and in Germany may be found also the "garden type" (panel by the school of Lochner in the Alte Pinakothek, Munich).

[38] The earliest Spanish example is probably the Madonna by Jaime Serra at Palau (Fig. 148), not the painting in the Ramon collection, Saragossa, as B. Kurth, *op.cit.*, claims. It was made ca. 1360-1375. Later Spanish examples, all following closely this Palau composition, are in the following places: S. Salvador, Valencia (reproduced in *Museum*, VII, p. 290); Private collection, Madrid (*ibid.*, p. 281); Muntadas collection, Barcelona; Museo de la Ciudadela, Barcelona (from Torroella de Montgri, reproduced in Post, *op.cit.*, II, fig. 169); no. 44 of the Bosch collection, Prado (*ibid.*, p. 272); Plandiura collection, Barcelona (*ibid.*); Valencia, Museo Diocesano no. 15 (*ibid.*, p. 274).

Miss King, *op.cit.*, pp. 489-490, inclines to the belief that the Madonna of Humility was created simultaneously in Spain and Italy. This would seem highly improbable because of the very great similarities of the Italian and Spanish examples (these compose a type as fixed as the Hodegetria, as Miss King herself observes). She also suggests the possibility that the Italian examples depend upon the Spanish, a view that is not tenable because of the chronological facts, the formal qualities of the type (see the second half of this chapter), and the fact that the first Spanish Madonnas appear only in the works of painters whose style and iconography were derived to a very great extent from Italy.

[39] Panel in the Obrería del Cabildo, Cordova (Post, *op.cit.*, III, p. 308 and fig. 359).

[40] The Book of Hours is for the use of Metz. MS 91 in the Walters Art Gallery shows a similar style.

cushion has been replaced, apparently through a misunderstanding, by large folds of the Madonna's mantle.[41] Many of these peculiarities reappear in a miniature in a Book of Hours of unknown whereabouts, painted in the same region but a little later in date.[42]

In the late fourteenth and early fifteenth centuries, when French painting was in its most Italianate phase, the Madonna of Humility attained a certain currency there. Some of these later French Madonnas resemble closely the Simonesque type,[43] but the majority introduce modifications of the original version, and show a wide variety of composition (Fig. 151).[44] The most remarkable variant is a Madonna in a Book of Hours in the British Museum, Yates Thompson MS 37, painted by a follower of Jacquemart de Hesdin (Fig. 150). This extraordinary miniature is a close copy of Ambrogio Lorenzetti's Madonna in the large Maestà at Massa Marittima (Fig. 149), or a Madonna of Humility by this painter in which he used a similar grouping of the Madonna and Child. The Yates Thompson miniature, or possibly an original by Ambrogio, was copied ca. 1410 in Brit. Mus. Harley MS 2952, fol. 71v, a manuscript which shows strong Italian tendencies and which contains three Humility Madonnas of different types (fols. 71v, 86v, 115). The reproduction of Ambrogio's great Madonna in a miniature a few centimeters high is a striking example of the enthusiasm of French illuminators of this period for the plastic and monumental qualities of Italian art, for Italian panel and fresco painting rather than for Italian illumination. To the latter they were relatively indifferent.

In the early fifteenth century French painters took up the "garden type" (Fig. 153),[45] which had been evolved in north Italy around 1380 (Fig. 154). This type, as well as earlier versions of the Madonna of Humility, appeared around the same time also in the Netherlands.[46] Similarly, painters working in France probably adopted

[41] The Madonna is adored by a lady whose prayer, written on the background beside her, is: "Glorieuse vierge pucelle q de la tres douce memelle e latas to tres chiers efans Fait ma cocience si belle que la moe arme ne chancelles iour de mo trespacement."

[42] Cf. the *Catalogue of Manuscripts.. offered for sale by J. and J. Leighton, London,* n.d. (ca. 1915), no. 321, with reproduction of the Madonna of Humility.

[43] See the Madonna in a Book of Hours formerly in the Chester Beatty collection, by a follower of the Boucicaut Master; the Madonna in Brit. Mus. Harley MS 2952, fol. 115, ca. 1410; a wood statuette in the Louvre, no. 153, late fourteenth century, which is an almost exact translation into sculpture of Simone's composition.

[44] Paris, Bibl. Nat. lat. 924, fol. 241 (Leroquais, *Les livres d'heures de la Bibl. Nat.,* pl. 22), made ca. 1400 by a painter influenced by

Jacquemart de Hesdin; Paris, Bibl. Nat. lat. 1161, fol. 130v, by the Boucicaut Master (Fig. 151); the Royal Library, The Hague, MS 76. G. 3., fol. 298v, a poor manuscript of ca. 1400-1410, probably northeast French in origin; the Bedford Hours, Brit. Mus. Add. 18850, fol. 25; Victoria and Albert Museum MS 8. 12. 02-1647, fol. 126, a hitherto unrecognized manuscript by the shop of the Rohan Master.

[45] Walters Art Gallery MS 232, made ca. 1405-1410 by a follower of the Boucicaut Master. The Virgin, wearing a crown, is seated in a garden, identified with the *hortus conclusus.* A very similar Madonna, but with St. Joseph and without the enclosure (a Holy Family, then), appears in Morgan MS 359, fol. 31v, painted by a follower of the Boucicaut Master. Cf. also Brit. Mus. Cotton Domitian A XVII, fol. 75, ca. 1430.

[46] For the Madonna of Humility in the Netherlands cf. The Hague, Royal Library,

the "celestial type" (Fig. 145), though I can cite no examples; in any event, the composition was known in the Netherlands (Fig. 146).[47] Finally the Master of Flémalle developed the "domestic type" (Fig. 143), basing his Madonna in the National Gallery, London (Fig. 144) and in the Hermitage either upon intermediate French or Flemish examples or directly upon Italian models. This master showed a continuous interest in lowly posture. The Virgin in his Mérode Annunciation is seated on the floor, and the Madonna from his circle in the Kaiser-Friedrich Museum is, as we have seen, seated on the flowering ground. This interest distinguishes him from his pupil, Roger van der Weyden, and from Jan van Eyck. Neither Jan nor Roger nor indeed any fifteenth century master in Italy employed the "domestic type" of the Madonna of Humility.[48] Furthermore, though Jan represented the Madonna in a garden, she is standing (Antwerp), and the Virgin in Annunciations by both Roger and Jan is raised to a kneeling position.

The Italian, French, Bohemian, and Spanish examples of the Simonesque type of the Madonna of Humility form a uniquely homogeneous group in the art of the fourteenth century. There is not even in any single Italian school a series of paintings of one subject which resemble each other so closely as do these Madonnas. This resemblance and this wide diffusion is partly accounted for by the fact that the composition was created by Simone Martini, whose style exerted a far greater influence throughout Italy and Europe than did that of any other painter.[49] It seems clear, how-

MS 133.D.14., fol. 11v, ca. 1415-1420; Walters MS 172, ca. 1435; and Walters MS 211, ca. 1425; and in Flemish sculpture cf. the tomb relief of Gerard Parent, Ste.-Wandru, Mons, early fifteenth century, and a Madonna of the same period, no. 185 in the Mayer van den Bergh Museum in Antwerp.

For the garden type in the Netherlands cf. Walters MS 215, ca. 1410; The Hague, Royal Library MS 74. G.34, fol. 15, ca. 1425; Walters MS 170, ca. 1420-1425; Walters MS 246, ca. 1435; Victoria and Albert Museum, MS 8.12.02 (1691), fol. 61v, ca. 1435-1440, probably English but under strong Flemish influence; panel related to the Master of Flémalle, Kaiser-Friedrich Museum, Berlin. The "garden type" usually omits the sun, stars, and moon, but occasionally (The Hague, Royal Library, MS 131.G.3, fol. 14, ca. 1430—cf. Byvanck, *La miniature hollandaise*, I, pl. 6) the Virgin in a garden wears a crown of stars, and the moon appears in the grass!

[47] Morgan Library MS 46, fol. 85v; Walters Art Gallery MS 166, fol. 61v, both Flemish, ca. 1425-1430.

[48] Except perhaps Roger in the instance of the related, but more formal, Madonna known in a number of copies; cf. Friedländer, *Altniederländische Malerei*, II, p. 135.

M. Davies, in the *Catalogue of the Early Netherlandish School, National Gallery*, London, 1945, p. 17, doubts my classification of Flémalle's panel in London as a Madonna of Humility because, as he says, "the Virgin does not appear to be sitting on the ground." But in almost all the representations of the Madonna of Humility, as in the painting in London, the Virgin is elevated a little above the ground by a cushion or some other low seat, implied when not clearly visible.

[49] The wide diffusion of the composition and its prevalence in Venice might suggest the possibility of a Byzantine origin (cf. Kurth, *op.cit.*). There are, however, no Humility Madonnas in Byzantine art, and even of the *Maria lactans* there are only a few examples before the fifteenth century. Several of these, furthermore, seem to be dependent on western prototypes. The composition in every other respect is un-Byzantine; I refer particularly to the seminude Child, the Virgin seated on the ground, the sentimental relationship between

ever, that Simone's authority alone could scarcely in itself have led to so large and so unusually faithful a series of imitations. Religious and devotional interests must have played a part. A large proportion of the surviving Madonnas was made for Dominican churches. In Naples, for instance, three are in S. Domenico, only one in Franciscan S. Chiara. In the Marches three are connected with the Dominicans, one with the Augustinians, but none with the Franciscans. Of the numerous early Italian examples of the Madonna with the heavenly symbols, only two (Palermo and S. Chiara, Naples) can be traced to the Franciscans, but nine are Dominican, and one, the panel in Modena (Fig. 136) was painted by a member of this order.[50] Clearly then the image was fostered especially by the Preaching Friars.[51] It seems possible, too, that Simone

the figures and the spectator, and the numerous other aspects to be discussed in the latter part of this chapter.

[50] These facts controvert the thesis of G. G. King (*op.cit.*) that the image was created in the circle of the Spirituals. Her arguments in support of this thesis, are, as I understand them: (1) examples of the Madonna of Humility are most frequently found in the centers of the Spiritual Franciscans; (2) within these regions the paintings appear "a little more often in the churches of the Franciscans"; (3) the character of the type is prepared in the Arab and Armenian Gospels of the Infancy, probably familiar to the Spirituals from the late thirteenth century on; and the apocalyptic aspect of the type may be referred to the interest of this sect in the Apocalypse. Miss King has considered only that version of the Madonna of Humility in which the stars, sun, and moon are present, but even this version shows no special connection with the Spirituals. As for the Arab and Armenian Gospels of the Infancy, and the writings of St. Ephrem Syrus, they contain neither any specific points of reference to the Madonna of Humility, nor any general content which is not familiar in much better-known contemporary (i.e. thirteenth-fourteenth century) writings, especially the famous *Meditationes vitae Christi*. It is notable, too, that whereas the Apocalypse held a central position in the thought of the Spirituals, Joachim de Flore's *Expositio*, the chief source of this interest, identifies the Woman in the twelfth chapter *not* with the Virgin Mary, but with the Church.

To the Spiritual Franciscans and to these sources Miss King refers other compositions also, such as Pietro Lorenzetti's Madonna in S. Francesco, Assisi. The motif of Pietro's Madonna, which she claims the painter found in Umbria, and which she believes is explained by a hymn of St. Ephrem Syrus, appeared already in Pietro's Madonna at Montichiello, his earliest extant work made some time before his activity in Umbria, and was inspired by the similar emotional and dramatic compositions of Giovanni Pisano (Madonnas in the Duomo, Pisa, and the Arena Chapel).

[51] There was an altar dedicated to the Madonna of Humility in S. M. Novella, Florence, in 1361 (J. Wood Brown, *The Dominican Church, cit.*, p. 124).

Some Madonnas were painted for confraternities: the panel in the Palermo Museum for the Disciplinati, and the painting by Giovanni da Bologna in the Venice Academy for the Scuola di S. Giovanni Evangelista (cf. the identification, in the Madonna of Humility, of the Virgin with the Woman described in the Apocalypse of St. John). Though most of the confraternities worshipped the Virgin in various phases (the most common being *Madonna di Misericordia*), few, if any, were under the advocacy of *Madonna d'Umiltà* (cf. G. M. Monti, *Le Confraternità medievali dell'alta e media Italia*, Venice, 1927). The "humble Madonna" was occasionally made advocate of ecclesiastical groups of other kinds, as in the instance of the Monastery at Longchamps near Paris, founded in 1255 for the Clarissans by Isabelle of France, sister of St. Louis (cf. G. Duchesne, *Histoire de l'abbaye royale de Longchamps*, Paris, 1906). Not long after its establishment as "l'abbaye de l'humilité de la Sainte Vierge Marie" it was reproved for its refusal to admit poor girls.

Martini's original Madonna was the center of a cult.[52] It may have been painted to celebrate an important occurrence, or, after its creation, it may have exhibited miraculous powers, which became known throughout Italy.[53] The whereabouts of this famous Madonna, however, remains yet to be discovered.

THE MEANING OF THE IMAGE

The Simonesque type of the Madonna of Humility belongs to that group of compositions commonly called devotional images.[54] These images, which appeared first in the late thirteenth and early fourteenth centuries, embody in the most distinctive and novel way those tendencies apparent in all the art of this period to establish a direct, sympathetic, and intimate emotional relationship between the spectator and the sacred figures. They usually show only a few figures, who are outwardly quiet and inactive but involved in a very emotional—usually pathetic—relationship, such as that of the Virgin who holds an arm of her dead son, or St. John resting his head on Christ's bosom. The very name of our type, the Madonna of *Humility*, indicates that the Virgin is represented in a particular mental state and proves its connection with a devotional picture such as the "*Pietas* Christi" or "Man *of Sorrows*." But it is to the "Vesperbild" that the Madonna of Humility is most closely related. The two are complementary or polar themes, presenting Christ in the lap of the Virgin at the beginning and end of his life on earth. One of them epitomizes the joys of the Virgin, the other her sorrows. And in the cycles of the Seven Sorrows and the Seven Joys there appear the Lamentation, a scene that closely resembles the Vesperbild, and the Nativity, a source, as we shall see, of the Madonna of Humility. These two devotional pictures emerged, moreover, around the same time and in the same circles—Simone Martini and the Lorenzetti—and in Italy they have a common form, since in both the Virgin is seated on the ground.[55] In a sense both compositions are transformations of

[52] Inasmuch as the Humility Madonna so often shows the Virgin nursing the Child, it is worth noting that the cult of *Maria lactans* was widespread in the fourteenth century. Sacchetti, in *Novella* 60, says of Florence: "non è cappella che non mostri aver del latte della Vergine Maria." He adds that such claims are deceptions, for the milk of the Virgin could not possibly be exhibited everywhere in the world. On the possible connection in Spain between the Madonna of Humility and relics of the milk see Leandro de Saralegui, in *Museum* (Barcelona), VII, pp. 288-289.

[53] The Madonna of Humility painted ca. 1370 by a Pistoiese master (cf. note 15) and now on the high altar of the Madonna dell'-Umilità in Pistoia was famous for a miracle. It was originally on the wall of the campanile of the church of S. Maria foris-portae. In 1490, according to Fr. Tolomei, *loc.cit.* (who borrows from C. Bracciolini, *Trattato delle grazie della Madonna dell'Umilità*, Florence, 1580) "fu veduta questa immagine spargere sudore, o vero liquore dalla sua testa." In 1509, following this miracle, a more magnificent church for the Madonna was begun by Ventura (cf. G. Vasari, *Vite*, ed. Milanesi, IV, pp. 165-166, and A. Chiappelli, *Pistoia*, Florence, 1923, pp. 283ff.), and to this church, called the "Madonna dell'Umilità," Ammanati transferred the painting in 1579.

[54] For a discussion and definition of the "Andachtsbild" see E. Panofsky, in *Festschrift für Max J. Friedländer*, Leipzig, 1927, pp. 264ff. See also above, pp. 123-124.

[55] These comments do not apply to the Vesperbild in northern sculpture, but to the cor-

the traditional representation of the Madonna and Child, and though the creation of the Madonna of Humility did not involve so startling a substitution or inversion as the Vesperbild, it was nonetheless a radical innovation.

Of the many aspects of the Madonna of Humility, let us consider first the representation of the nursing Child. The *Maria lactans* is not at all new to Christian art.[56] It was known from the early Christian period on, and became quite common in the later thirteenth century in the north and in Italy.[57] But these late thirteenth century representations, and even the Italian examples of the early fourteenth century,[58] show the Child seated or held erectly, and thus do not convey the warm and intimate sentiment of the Madonna of Humility.

The intimacy between the Virgin and Child in the Madonna of Humility effects a like intimacy between these figures and the spectator, and this is greatly enhanced by the behavior of the Child. Though nursing, he turns to look directly outward, and the Virgin in most examples does likewise. Now this direct, sympathetic contact between figures and spectator, a kind of relationship which was evolved in the later thirteenth and fourteenth centuries, was developed more extensively in Siena than anywhere else in Italy or Europe. Already in the thirteenth century the Sienese showed an interest in this sympathetic address, in the Madonnas, with their wistfully inclined heads and appealing look, and even in historical scenes, which the Sienese tended to transform into devotional pictures also.[59] In this we find, then, further evidence for the attribution of the original Madonna of Humility to a painter of the Sienese school.

The turn of the head and glance of the Infant out toward the spectator, while his body faces the Virgin and he presses her breast into his mouth, results in a combination of movements that is one of the remarkable innovations of early Trecento Italian art. The Child, like Christ in contemporary paintings of the Way to Calvary, is presented at a moment when he is involved in two opposed interests and movements. And

responding representation in Trecento painting. See my discussion of the latter in *Art Bulletin*, XXVIII, 1946, pp. 8-10.

[56] On the history of the *Madonna del Latte* cf. L. Tramoyeres Blasco, *La Virgen de la leche en el arte*, in *Museum*, III, 1913, pp. 79ff.; N. Baldoria, in *Atti del Reale Istituto Veneto di Scienze*, ser. 6, vol. VI, 1888, p. 777.

[57] Earlier, in the Romanesque period, the *Maria lactans* was much less frequently represented, and the form of the representation was often quite different. Nursing was often *referred to* (rather than actually shown) by the extension of one hand of the Child toward the Virgin's breast. (Cf. the Madonna from Anzy-le-Duc, now in the Museum at Paray-le-Monial, and the "Vierge de la rue de St. Gengoulf," Metz, both twelfth century.) In addition to this type, however, there are Romanesque representations in which the Child draws the breast toward his mouth or into it. Cf. Dijon MS 641, fol. 21v (C. Oursel, *La miniature du XII s. à Citeaux*, Dijon, 1926, pl. 33); S. Andrea, Barletta (A. K. Porter, *Romanesque Sculpture of the Pilgrimage Roads*, p. 252); Liège, Musée de L'Institut Archéologique (Helbig, *L'Art Mosan*, Brussels, 1906, I, pl. 6).

[58] For example, Magdalen Master, Yale University; Florentine early fourteenth century, Academy, Florence; follower of Duccio, L. Rabinowitz collection, New York (Van Marle, *op.cit.*, II, fig. 95).

[59] Cf. the angel leading Peter from prison in the altarpiece of St. Peter, Siena Gallery, as early as ca. 1280.

these movements, turning in divergent directions in space, are organically integrated in such a way that they suggest a sudden, temporary shift of interest, responsive to an individual will.

The only example of a similar motif for the Child in all western art before the fourteenth century is in the earliest known representation of the Madonna, the second century painting of the Vision of Isaiah in the catacomb of Priscilla.[60] In this painting (Fig. 156), which is dependent upon late antique art, the Child shows a similar though more highly developed contrapposto, and even the gesture of the bent, upraised arm is alike. This is a striking example of the affinities between the principles of antique art and those that began to manifest themselves in the Italian Trecento. And it is not surprising that the motif should have been developed in the Renaissance, as in the *Madonna della Casa Litta* in the Hermitage.

This posture of the Child in the Madonna of Humility is not to be found in any of the extant Madonnas by Simone himself. But whereas its appearance in Venice or any other Italian school beyond Tuscany in the second quarter of the century would be quite unexpected, it was known in Siena even outside the Madonna of Humility. It appears in the half-length Madonna in S. Francesco, Siena, by Ambrogio Lorenzetti (Fig. 155), as well as in later paintings of the Sienese school or tradition.[61] Ambrogio's Madonna was painted around the time of the creation of the Madonna of Humility. It may even have been made before it, for the dynamic motif of the Child, more highly developed in Ambrogio's panel than in the Madonna of Humility, is also more deeply Lorenzettian than Simonesque in character.

Though the Madonna of Humility has been described above as a transformed Madonna and Child, the *process* of its formation seems to have resembled that of other devotional pictures—the isolation of a group of figures appearing in an historical scene. The scene in this instance was the Nativity. During the first third of the Trecento the successive representations of the Nativity in Florence show an increasingly affectionate and intimate relationship between the Virgin and Child. In Giotto's fresco in the Arena Chapel the reclining Virgin turns and reaches for the Child. In the Giottesque fresco in the lower church of St. Francis, Assisi (as also in Taddeo Gaddi's fresco in the Baroncelli Chapel and his panel in Dijon), she holds him before her. And finally, in paintings by Bernardo Daddi (1333)[62] and Taddeo Gaddi (1334; Fig. 159), the

[60] J. Wilpert, *Die Malereien der Katakomben Roms*, Freiburg i/B, 1903, p. 187. Wilpert, unlike De Rossi and some other scholars, believes that the Virgin is not actually giving her breast to the Child. All that concerns us, however, is that the Child is reaching for it.

[61] Madonna by a follower of Bartolo di Fredi, Perkins collection, Lastra a Signa; Madonna in the tradition of Simone Martini, S. Lorenzo, Naples; standing Madonna, under Sienese influence, in S. Pietro, Tuscania; fresco in S. Giovenale, Orvieto, dated 1399, a hitherto unrecognized work of Pietro di Puccio (reproduced in Van Marle, *op.cit.*, v, fig. 73); fresco by a follower of Nardo di Cione in S. Ambrogio, Florence; Madonnas by Barnaba da Modena in S. Matteo, Tortosa, in the Gallery of Pisa, and in Lavagnola. In sculpture, cf., for example, Madonna on S. M. della Spina, Pisa.

[62] Triptych in the Bigallo, Florence, which was copied by a pupil of Daddi in the triptych,

Infant nurses at her breast. This representation, which has no counterpart in Sienese painting,[63] may well have been influenced by northern Nativities (Fig. 157),[64] as well as by the description of this scene in the *Meditationes vitae Christi,* probably written by Giovanni da S. Gimignano between ca. 1290 and ca. 1310:

"Whan tyme of that blissed byrthe was come / that is to say the Sonday at mydnyt / goddis sone of heuene as he was conceyued in his moder wombe by the holy goost with outen seede of man / so goynge out of that wombe with outen trauaille or sorwe / sodeynely was vppon hey at his moder feete. And anon sche / deuoutly enclynande / with souereyne joye toke hym in hir armes and swetely clippyng and kessynge leyde him in hir barme / and with a fulle pap / as sche was taut of the holy goost / wisshe hym al about with hir swete mylk. . . ."[65]

The group of the Virgin nursing the Child in Daddi's and Taddeo Gaddi's Nativities shows the very closest resemblance to the Madonna of Humility.[66] Considered in isolation, it is, indeed, the composition, save for the absence of the turn of the Child's head. Though this form of the Nativity was undoubtedly the main source of the Madonna of Humility, the composition may have been influenced also by the analogous figure of Eve, the antitype of the Virgin, nursing her child after the expulsion from the Garden (Fig. 160).

The fact that the Virgin seated on the ground nursing her Child could, in the early Trecento, be isolated from the Nativity in order to serve alone as an image of the Madonna and Child, presupposes certain general tendencies in the art of the time. Though for many centuries, in Byzantine art at least, the Virgin was seated on a mattress on the ground in the historical scene of the Nativity, she was never, until the appearance of our type, placed so lowly in the Madonna and Child. In the thirteenth century not only the Madonna but even the Virtue Humility usually sat enthroned

Kaiser-Friedrich Museum, Berlin, no. 1064. Cf. also the panel by a pupil of Taddeo Gaddi (*Catalogue of the Somzée Sale,* Berlin, May 26, 1904, no. 296).

[63] While no examples of the Nativity by Simone Martini or either of the Lorenzetti have come down to us, those intimations of their compositions that we can gain from later paintings under their influence (such as the Nativity by "Ugolino Lorenzetti" in the Fogg Museum) reveal nothing comparable to the Nativity by Daddi or the Madonna of Humility. The Sienese Nativities, up to ca. 1360 at least, usually show the Virgin seated alongside the crib, in which the Child lies.

[64] This northern representation of the Virgin nursing the Child in the Nativity appeared already in the late thirteenth century in Bologna (cf. the miniature in a Bolognese

Bible of the end of the Dugento, reproduced by Warner, *A Descriptive Catalogue of the Illuminated Manuscripts in the library of C. W. Dyson Perrins,* Oxford, 1920, pl. 53).

[65] Quoted from the early fifteenth century English translation (a very free translation in some places) by N. Love, *The Mirrour of the Blessed Life of Jesus Christ,* published by the Roxburghe Club, Oxford, 1908, p. 46.

[66] The similarity is so great that one might suppose the reverse, that the group in the Nativity was inspired by the Madonna of Humility, were it not for the existence of successive stages in the development of the motif within the Nativity, and for the fact that the representation of the Virgin seated on the ground appeared in the Nativity long before it did in the Madonna of Humility.

like a queen.[67] Theologians had asserted, to be sure, that the root of "humilitas" was "humus."[68] "Humilis dicitur quasi humo acclinis," they said, but this image of closeness to the earth did not appear in the arts until the Italian Trecento. It remained for the Italian painters of this period to enact the virtue in the Madonna of Humility, just as Giotto enacted the virtues in the Arena Chapel, endowing each with appropriate behavior and emotional expressiveness.

The Madonna of Humility is not the only Trecento representation of the Virgin in which, for the first time, she is shown in contact with the ground. Instances of a seated, kneeling, or reclining Virgin are so numerous that they compose the most common innovation in Tuscan late Dugento and early Trecento painting. She is frequently seated on the ground in the Crucifixion,[69] the Adoration of the Magi,[70] and the Annunciation[71]—a moment when she particularly manifested her humility.[72] She kneels in the Nativity,[73] the Annunciation,[74] and the Coronation.[75] She lies pros-

[67] For examples of this representation, cf. K. Künstle, *Ikonographie der christlichen Kunst*, Freiburg i/B, 1928, pp. 158-160.

[68] See Isidore of Seville, *Etymologiarum*, Lib. x (cf. Migne, *Pat. lat.*, vol. 82, col. 379), or Thomas Aquinas (quoting Isidore), *Summa theologica*, II, II, q. 161, a. 1. Jacopo Passavanti (*Specchio di vera penitenza*, ed. Lenardon, p. 296) tells of the entry of S. Ilario into a gathering of the pope and bishops. They were all seated on "alte sedie," but none rose nor made room for the saint, so he sat on the floor, saying "Domini est terra." Immediately the ground rose, elevating him to the level of the ecclesiastics.

[69] Early examples are a Ducciesque Crucifixion of unknown whereabouts (reproduced in *Dedalo*, XI, 1930, p. 267) and the relief on the third pier at Orvieto. Cf. also a Daddesque triptych of 1334 in the Fogg Museum and a Crucifixion by a follower of Simone, Boston, Museum of Fine Arts. In Crucifixions painted in small initials in manuscripts, where the space was very limited, the Virgin and St. John are sometimes crouching at the ground line already in the thirteenth century.

[70] Cf. Barna, Collegiata, S. Gimignano; Baronzio, altarpiece of 1345 in Urbino; Riminese panels (the motif is especially common in this region) in the Parry collection and the National Gallery, Washington. In these paintings, in accordance with the interest of the Trecento in spatial and narrative continuity, the setting of the Adoration of the Magi has become exactly the same as the Nativity, and the two scenes are sometimes so closely identified that the Virgin can be shown lying on

her mattress while the Magi adore the Child (panel by the School of Giotto in the Metropolitan Museum; here the Annunciation to the Shepherds is also shown). This combination of the various moments in one scene occurred already in the Dugento, for example in a panel in the Stoclet collection, Brussels.

[71] Cf. the two panels of the Virgin Annunciate in the Stoclet collection and the Annunciation in Berlin (by the master of the Straus Madonna), all by followers of Simone Martini; and the Annunciation by Bartolommeo Bulgarini in the Johnson collection. The motif appears also in the school of Bernardo Daddi (for example, the triptych in Dijon), and in Taddeo Gaddi's fresco in S. Croce.

[72] The reply of the Virgin to the angel Gabriel "ecce ancilla domini" (Luke, I, 38) and her hymn to the Lord shortly thereafter (Luke, I, 48-52) were often selected by mediaeval writers as examples of humility (cf. Origen, *Homilia VIII in Lucam*, in *Die griechischen christlichen Schriftsteller der ersten Jahrhunderte, herausgegeben von der Kirchenvater Commission der preuss. Ak. der Wiss.*, Berlin, IX, 1930, pp. 58-60, Dante, *Purgatorio*, x, and Thomas Aquinas, *loc.cit.*). The Annunciation, moreover, is represented in the spandrels above several of the Madonnas. The angel Gabriel appears at the right of the Virgin in the Cleveland panel.

[73] Pacino di Buonaguida, Tree of Life, Academy, Florence; Taddeo Gaddi, Academy, Florence; Bernardo Daddi, Uffizi. The representation of the Virgin kneeling in the Nativity, known to Italian art in the early Trecento, as these examples show, became quite com-

149

trate on the ground in the Crucifixion.[76] Similarly other sacred figures are for the first time shown seated on the ground, as St. John in the Crucifixion,[77] or kneeling, as the apostles in the Ascension,[78] the angel Gabriel in the Annunciation,[79] the Magdalen at the foot of the cross.[80] Most of these motifs originate in Tuscany, some of them in Siena and in the work of Simone Martini.

These new motifs imply a certain development of tridimensional space, particularly with respect to a receding horizontal ground plane; for the body, in contact with the ground, measures a greater space inward on it than do the feet, especially when the figure is placed oblique to the picture plane. And while each of these postures has a special significance in the context of the historical scene in which it appears, they all are the expression of a new attitude toward sacred history and the transcendental realm. For the sacred figures, inhabiting a more natural world, behave in a more familiar human way. They tend to feel and act like the spectator.[81] This relationship

mon—in fact the usual form—from about 1400 on, partly because of the great influence of a vision of St. Bridget (of 1370), as H. Cornell, *Iconography of the Nativity of Christ*, Uppsala, 1924, has shown. Nativities based on St. Bridget's vision may be found earlier than the first example (of ca. 1400) cited by Cornell, for two paintings of this type by Niccolò di Tommaso were made around 1375-1385 (panel in the Vatican Gallery, which Cornell knew but attributed to a fifteenth century painter, Sano di Pietro; and one in the Philadelphia Museum).

[74] The kneeling Virgin in the Annunciation seems to have been introduced by Giotto in the Arena Chapel fresco. There are one or two examples of the Virgin kneeling in the Annunciation in mediaeval art before Giotto, but these (like the pre-Trecento examples of other seated or kneeling figures discussed above) are sporadic, and the motif was not commonly used before the Trecento.

[75] Cf. a Giottesque Coronation in the collection of Lord Rothermere, London; a Bolognese miniature of the end of the Dugento: Choral VII, S. Domenico, Gubbio, fol. 77 (reproduced in *Bollettino d'arte*, VIII, 1929, p. 540; panel no. 125 in the Museum, Valencia, by a late follower of Duccio (Meiss, in *Journal of the Walters Art Gallery*, IV, 1941, fig. 22); Vitale, altarpiece in S. Salvatore, Bologna, probably 1353; Vitale (?), panel in the Stoclet collection, Brussels; Barnaba da Modena, panel in the National Gallery, London; Turone (1360), Museo Civico, Verona. The motif would seem, then, to have been particu-

larly popular in Emilia and north Italy. P. Durrieu's claim of a French origin for the kneeling Virgin in the Coronation (*Mémoires de l'Academie des Inscriptions et Belles-Lettres*, 1911, pp. 381ff.) cannot be accepted, inasmuch as the earliest French instances (Brussels MS 11060/1 and compositions by the Limburgs and the Boucicaut Master) date from the late fourteenth and early fifteenth centuries, and are clearly dependent upon Italian prototypes.

[76] This motif is most frequent in Siena. See Simone Martini, Antwerp; Ambrogio Lorenzetti, Fogg Museum (Fig. 126); **Barna, Collegiata, San Gimignano** (Fig. 92). An early example outside Siena is the Cavallinesque Crucifixion in S. M. di Donna Regina, Naples.

[77] One of the earliest extant examples is the fresco in S. Maria in Vescovio, of the late thirteenth century (reproduced in *Bollettino d'arte*, XXVIII, 1934, p. 93). See also the third pier at Orvieto.

[78] Appeared first, it seems, in Giotto's fresco in the Arena Chapel.

[79] Appeared first in the Arena Chapel and in Duccio's *Maestà* (Annunciation of the Death of the Virgin). All the new Italian figure motifs discussed above were, like the Madonna of Humility itself, taken up by Spanish and north European art in the second half of the fourteenth century.

[80] Cf. school of Guido da Siena, pinnacle with the Crucifixion, Jarves collection, New Haven; Giotto, fresco in the Arena Chapel.

[81] Indications of this change are to be found also in contemporary legends, such as the one concerning Jean Firman, a Franciscan, who

with the beholder is implied by the appearance of the devotional pictures discussed above, and it makes possible later, in the second half of the fifteenth century, the impersonation of a sacred person by a contemporary—Quattrocento—one.

The attitudes and emotions expressed by these new postures involve the movement of the entire body, not only, as earlier, one part, the head or a hand. These attitudes seem, furthermore, to center in most cases within a certain limited range. This is particularly true of the Virgin, who shows an unceremonial forthrightness, simplicity, and even homeliness, values arising among the Tuscan townspeople in the new republican communes.[82] Similarly, in the Madonna of Humility she sits on the ground nursing her Child "in public," more like a simple housewife or a poor peasant than the Queen of Heaven (Fig. 161).[83]

The representation of the Madonna suckling her Child had a special significance in late mediaeval art and thought. Since it showed that situation in which the Virgin was most concretely and intimately the mother of Christ, it set forth that character and power which arose from her motherhood, i.e. her role as *Maria mediatrix*, compassionate intercessor for humanity before the impartial justice of Christ or God the Father.[84] Thus, in chapter 39 of the *Speculum humanae salvationis* (written ca. 1324), when Christ intercedes before God the Father by showing his wounds, the Virgin intercedes by exhibiting her breasts—a reference to that moment which is portrayed in the *Madonna del Latte* and the *Madonna dell'Umilità*. Furthermore, the representation of the Virgin suckling Christ sets forth not only her authority to intervene and protect, but also her inclination to do so. For the act of nursing signified moral qualities, such as benevolence and mercifulness. It had this meaning in the representation of the virtue Charity as a female figure with children at her breast (Fig. 110). In the Middle Ages the Virgin was believed to be the mother and nurse not only of Christ but of all mankind.[85] She was the *Mater omnium*, as the Madonna of Humility

wanted to see the Virgin, not as she was in heaven, majestic and splendid, but in the poor and humble condition in which she lived on earth. The Virgin answered his prayer and appeared to him thus (P. Sausseret, *Les apparitions et révélations de la très Sainte Vierge*, Paris, 1854, II, p. 33).

[82] It is noteworthy that Francisco Pacheco, representing the aristocratic and classicistic tendency in Spain ca. 1600, condemns, as an example of lack of "decoro," a representation of the Virgin seated on the ground with bare feet (cf. *Arte de la pintura*, 2nd ed., Madrid, 1866, vol. I, book II, p. 249). Similarly, Molanus, *De historia sacrorum*, Louvain, 1570 book II, chap. xxxi (in Migne, *Cursus theologiae*, xxvii) feels called upon to defend, against those contemporaries who considered

it vulgar, the representation of the Virgin showing her breast to Christ.

[83] Cf. also other representations of peasant women, such as the one in the MS of Aristotle's *Economics* (Brussels, 11201, fol. 359v) by the atelier of Jean Bondol, which seems to derive from representations of Adam and Eve after the expulsion from the Garden (Fig. 160).

[84] A specific reference to the Virgin as intercessor, particularly at the Last Judgment, is given in the Marchigian Madonna of Humility in Cleveland. To the right of the Virgin is introduced St. Michael, holding the sword and the scales. For a discussion of *Maria mediatrix* and *advocata*, cf. P. Perdrizet, *La Vierge de Miséricorde*, Paris, 1908, *passim*.

[85] Anselm: "Ad te (virginem) nutricem nostram" (*Maxima bibliotheca veterum patrum,*

in S. Domenico, Naples is labeled, and consequently also the *nutrix omnium*. Mediaeval writers frequently referred to the Virgin as the nurse of the faithful, and in numerous miraculous appearances she gave to various people some of her milk, often three drops, symbolizing the Trinity. One of the beneficiaries was St. Bernard, who in a Majorcan panel of the fourteenth century is shown kneeling before the Virgin—a statue of the *Madonna del Latte* come to life, according to the legend—and drinking her milk (Fig. 158).[86]

If the representation of the Virgin nursing the Child signifies her mercy, then her lowly posture expresses her solicitude for *all* souls, even the sinful, in the love of whom she manifested her deepest humility.[87] Though Mary was always considered the humblest of beings, this quality of her nature was emphasized especially during the late thirteenth and fourteenth centuries by writers such as Jacopone da Todi ("l'umiltà profonda che nel tuo cor abonda"[88]), Petrarch ("Vergine umana e nemico d'orgoglio"),[89] and Giovanni da San Gimignano, who, in the description of that very scene which inspired the Madonna of Humility wrote: "Potuistis etiam attendere in utroque profundissimam humilitatem in hac ipsa Nativitate."[90]

Humility was an essential Christian virtue. Although in formal classifications it did not receive a place among the three theological and four cardinal virtues, being usually

XXVII, 443a); Jacopo da Voragine: "Maria dat nobis lac pietatis et misericordiae" (*Mariale*, Venice, 1497, p. 33); Richard of St. Victor: "Beata virgo et peccatoribus reconciliationis et piis gratiae lac fundit" (Migne, *Pat. lat.*, vol. 196, col. 475a). See also the following invocation to the Madonna, quoted from the *Saltero della Beata Vergine Maria*, a vulgarization by a late Trecento Sienese of a Latin psalter attributed to Bonaventura: "Porgine una goccia delle grazie delle tue mamme, e con abundante latte di tua soavità reficia li nostri cuori" (*Scelta di curiosità letterarie*, vol. 126, 1872, p. 10).

[86] See for similar representations, Brit. Mus. Egerton MS 2781, fol. 24v (English[?], middle of the fourteenth century), and the late fifteenth century Marchigian painting in the Palazzo Comunale, Chieti, where streams of milk are shown passing from the Virgin's breasts into the mouths of souls in Purgatory. For mediaeval legends of similar miracles cf. Mussafia, *Studien zu den mittelalterlichen Marienlegenden*, in *Sitzungsberichte der K. Akademie der Wissenschaften*, Wien, philosoph.-hist. Klasse, vol. 115, pp. 6, 16, 18, 31, 32, 37, 51, 77, 91; vol. 119, pp. 5, 26; vol. 139, pp. 9, 12. Illuminating is the legend of the blessed Paula of Florence, who lived in a cell at Camalduli. Her greatest happiness lay in

the contemplation of an image of the Virgin suckling the Child. As recompense for her devoutness, the Virgin with the nursing Child appeared to her one day (in 1368?) and the Infant allowed a few drops of milk to fall upon Paula's lips (Sausseret, *op.cit.*, II, p. 46). The image before which Paula prayed may well have been a Madonna of Humility. In this connection we should recall the miraculous image of the Madonna in Pistoia (cf. note 53), which was believed to have poured forth "sudore, o vero liquore dalla sua santa testa," an occurrence which would seem to be a displacement and transformation, in the interest of propriety, of the issuance of milk from the Virgin's breast; the latter, indeed, was said to have occurred in a number of instances, notably the famous Madonna in Saint-Vorle de Chatillon-sur-Seine (Sausseret, *op.cit.*, I, p. 202).

[87] "Hic ostendit Domina Nostra suam veram humilitatem, quia amat peccatores eisque misericordissima est" (Sermon of St. Humility [† 1310] in *Acta sanctorum*, May, V, p. 217).

[88] *Lauda* II, 16. Cf. also H. v. d. Gabelentz, *Die kirchliche Kunst im italienischen Mittelalter*, Strasbourg, 1907, p. 176.

[89] Canzone XXIX, 118.

[90] *Meditationes vitae Christi*, in *Opera omnia S. Bonaventurae*, Paris, 1871, XII, p. 519.

attached to temperance, it was, on the other hand, believed to be the primary condition for the attainment of the other virtues, the "spiritualis aedificii fundamentum" as Thomas Aquinas says.[91] And in a tree of virtues which appears in moral treatises from the twelfth century on, humility was placed at the bottom, as the *radix virtutum* (Fig. 162).[92] Now just as humility is the root from which the tree of virtues grows and by which it is nourished, so is the Virgin the condition of the incarnation of Christ, the *radix sancta*, as she is sometimes called.[93] She appears as such in a painting by Simone dei Crocefissi in the gallery at Ferrara (Fig. 163). And these two conceptions, of the Virgin as the *radix sancta* and of humility as the *radix virtutum*, are not only analogous, but also interdependent, for Mary could become the mother of Christ just *because* of her humility.[94]

In accordance with a principle of polarity that was pervasive in Christian thought, humility implied sublimity. These two qualities were combined in the Beatitudes, and we find them united everywhere in mediaeval literature—in Richard of St. Victor ("quanto humilior, tanto sublimior"),[95] in Dante ("Vergine madre, figlia del tuo figlio, umile e alta più che creatura"),[96] in Jacopo Passavanti, whose image "Quanto Maria più umile sedeva, tanto maggiore grazia riceveva" might well have been suggested by one of our paintings. One of Petrarch's verses is more reminiscent of the "celestial type" of the Madonna of Humility: "Vergine santa . . . che per vera ed altissima umilitate salisti al ciel. . . ."[97] Thus a common mediaeval symbol of humility was the dove, a gentle bird that appeared "humbly" in the meadows and yet could fly high in the sky.

This "polar thinking" produced one of the most remarkable aspects of the Madonna of Humility, the almost paradoxical combination of the humble image of the mother nursing her Child with the awesome Woman described in the twelfth chapter of the Apocalypse: "And there appeared a great wonder in heaven; a woman clothed with the sun, and the moon under her feet, and upon her head a crown of twelve stars. . . ."

[91] *Op.cit.*, II, II, Q. 161, A. V.

[92] Cf. the treatise (called to my attention by Professor Erwin Panofsky) *De fructibus carnis et spiritus*, apud Migne, *Pat. lat.*, vol. 176, col. 998 (attributed to Hugh of St. Victor).

[93] Sermon of St. Humility in *Acta sanctorum*, May, v, p. 216.

[94] Luke, I, 48-52. St. Augustine: "Facta est certe humilitas Mariae scala coelestis per quam descendit Deus ad terras" (Migne, *op.cit.*, vol. 39, col. 2133). Also St. Bernard, *ibid.*, vol. 183, cols. 61-2, and St. Bridget, *Revelationes* (ed. Antwerp, 1626, II, p. 389).

[95] Apud Migne, *op.cit.*, vol. 196, col. 1330. Also *ibid.*, vol. 176, col. 998. Cf. also Luke, I, 58: "deposuit (Deus) potentes *de sede* et exaltavit humiles," a graphic phrase which parallels closely the process of formation of the Madonna of Humility.

[96] *Paradiso*, XXXIII.

[97] Canzone XXIX, 40-43. For Passavanti see the *Specchio, cit.*, p. 296.

Thus humility was sometimes represented in the fifteenth century as a figure with bowed head but with, at the same time, wings attached to the shoulders, breast, and legs (German MS of the fifteenth century, Rome, Bibl. Casanatense, Cod. 1404, fol. 11v, cf. F. Saxl, in *Festschrift für Julius Schlosser*, Vienna, 1927, p. 118; and a second figure of this type [also in an early fifteenth century German MS—Rome, Vat. pal. lat. 1726, fol. 48v] bearing a scroll on which is inscribed "Qui se humiliat exaltabitur").

The Virgin is *Regina coeli* as well as *Nostra domina de humilitate*, and thus "*Regina humilitatis.*"

All these ideas set forth in the Trecento image of the Madonna of Humility, and even the specific symbols by which they are expressed, had already been brought together into a kind of constellation in thirteenth century thought. In his first sermon on the Annunciation, Bonaventura, discussing the mystery of the incarnation and the twelve metaphors by which it may be apprehended, says: "Notandum igitur, quod incarnationis mysterium sic est duodecim metaphoris designatum, quae a terra humilitatis[98] incipiunt et in sole sapientiae divinae sistunt Unde, quia hae duodecim metaphorae beatem Virginem et eius Prolem insinuant, convenienter de ipsa dicitur illud apocalypsis: mulier amicta sole, scilicet ornata Divinitatis claritate;[99] lunam, temporalium mutabilitatem, habens sub pedibus;[100] et in capite habens coronam duodecim stellarum[101] propter dictum mysterium duodecim metaphoris designatum. . . ."[102]

The Woman of the twelfth chapter of the Apocalypse was usually believed to be a metaphor of the Church, but Bonaventura, like several other mediaeval writers, connects her with the Virgin.[103] In the arts, on the other hand, the Woman was very

[98] The earth was a common mediaeval symbol of the Virgin's humility (cf. also Albertus Magnus, *De laudibus B. Mariae*, Liber Octavus, c. 1). See also note 66.

[99] The sun, which appears less frequently in the Madonna of Humility than the other symbols, is represented by rays projecting from the Virgin's body or by a gilt disc, either behind her, on her drapery (a specialty of the Venetian examples) or beside her (Marchigian panel, Cleveland).

[100] See the Madonna by Giovanni del Biondo in the Vatican Gallery, with the moon at the feet of the Virgin, and below the moon, a decomposed human corpse (Fig. 52).

[101] The twelve stars were sometimes held to prefigure the twelve apostles (cf., for example, *Speculum humanae salvationis*, chap. 36, and Albertus Magnus, *Opera omnia*, Paris, 1899, vol. 38, p. 653). In each of the twelve stars in the Marchigian panel in the Museum at Cleveland is a small bust of an apostle. In the *Speculum* (chap. 36), the Apocalyptic Woman prefigures the Coronation of the Virgin; and in the Madonna of Humility two angels are sometimes shown lowering a crown onto the Virgin's head.

[102] Bonaventura, *Opera omnia* (Quaracchi ed.), IX, p. 659.

[103] Cf. Beissel, *Geschichte der Verehrung Maria in Deutschland*, pp. 260, 347, and A. Salzer, *Die Sinnbilder und Beiworte Mariens in der deutschen Literatur und lateinischen Hymnenpoesie des Mittelalters*, Linz, 1893, pp. 481ff. The sun, moon, and stars were brought into connection with the Virgin also in innumerable poetic similes, some of them probably influenced by the Apocalypse (see Salzer, *op.cit.*, pp. 377, 391, 399). Especially relevant, because they are Italian and approximately contemporary with the creation of the Madonna of Humility, are the phrases in the *laudarii* (cf., for example, *Il laudario dei Battuti di Modena*, ed. by G. Bertoni in *Zeitschrift für romanische Philologie*, XX, 1909) and the apostrophe of Petrarch, Simone's friend, to the Virgin:

Vergine bella, che di sol vestita,
Coronata di stelle, al sommo sole. . . .
<div align="right">(Canzone XXIX, 1)</div>

Post, *op.cit.*, II, p. 232, assumes that the celestial symbols refer to the immaculate conception of the Virgin. While they have this meaning in representations of the Immaculata in the late sixteenth and seventeenth centuries, there is no evidence of it in the Madonna of Humility, neither in the inscriptions on the paintings nor in their distribution, for the Dominicans, who were opposed to the idea of the virgin birth of Mary, would not have favored an image that advanced it. The idea is not mentioned, moreover, by those late

seldom identified with the Virgin until the fourteenth century, and the first large group of monuments which exhibits this identification is the Madonna of Humility.[104] It is interesting, moreover, that the identification occurred when there existed between the two a similarity not only of content, but also of form. For the woman in a number of English and French Apocalypses of the thirteenth century is shown seated with one leg raised higher than the other, like the Virgin in the Madonna of Humility and in the Nativities discussed above (Fig. 164).[105]

Curiously enough, among the surviving paintings only one Florentine Madonna of Humility[106] and no Sienese shows the attributes of the Apocalyptic Woman. Though these attributes are often not represented in the Madonnas of other Italian schools, Tuscany alone seems to have consistently avoided identification of the Virgin with the Woman of the Apocalypse. The absence of the heavenly symbols in one of the very earliest Madonnas—the Simonesque painting in Berlin—suggests the possibility that the composition of the Madonna seated on the ground nursing the Child was created first, and the identification with the Apocalyptic Woman was made a little later, outside Siena and Tuscany. On the other hand, the very early Madonnas in Palermo (1346), and in S. Domenico, Naples (shortly after 1345), widely separated but wholly

mediaeval theologians such as Bonaventura who connect the Virgin with the Apocalyptic Woman. It is significant, too, that the earliest Italian Immaculata pictures (Crivelli, London; Signorelli, Cortona; Piero di Cosimo, Uffizi) do not show any resemblance to the Madonna of Humility, and most of them do not include the apocalyptic symbols.

[104] For the identification of the Virgin with the Woman of the Apocalypse outside the Madonna of Humility, see the thirteenth century glass window in St. Elizabeth, Marburg (Beissel, *op.cit.*, p. 349), fourteenth century German sculptures in the church of the Cistercians, Doberan, and in the Erfurt Museum (Pinder, *Deutsche Plastik*, I, p. 106), and a panel by Giovanni del Biondo in the Vatican Gallery (Fig. 52). All of these represent the *standing* Virgin.

[105] Paris, Bibl. Nat. fr. 403; Cambridge, Trinity College R. 16.2; Oxford, Bodl. Douce 180; Oxford, Bodl. Auct. d. 4,17; Cambrai, no. 422; Dyson Perrins collection no. 10.

King (*op.cit.*), who favors a Spanish origin of the Madonna of Humility, refers to the Beatus MS from las Huelgas in the Morgan Library as a possible source of the type. This relationship seems, however, very improbable, because for one thing the Morgan MS (and other examples of the Beatus, such as the tenth century MS Madrid, Real Academia de la

Historia no. 33) shows the Woman seated on the ground only after the angel has taken her child and she has fled to the wilderness; and she is *not* accompanied by the stars, sun, and moon. The Woman is represented again in the same miniature, this time with the celestial symbols, but then she is *standing* (as usual in the Spanish Beatus MSS, cf. Madrid Academia no. 33, Paris, Bibl. Nat. nouv. acq. lat. 1366; in Berlin, Staatsbibliothek theol. lat. 561 she is seated on a kind of throne), so that neither figure combines all the elements which appear in the English and French Apocalypses mentioned above.

The Byzantine composition of the Apocalyptic Woman, as reflected in the *Hortus deliciarum* (the miniature illustrating the twelfth chapter of the Apocalypse contains Greek inscriptions) and in later Russian miniatures (cf. G. Buslaev, *Collection of Miniatures from Illuminated Apocalypses, taken from Russian Mss. of the XVI-XIX Centuries* (Russian), St. Petersburg, 1884, pls. 67, 85, 103, 146, 156) shows a standing woman.

[106] Orcagnesque panel formerly in the collection of Langton Douglas. The Madonna of Humility in the Museo di S. Croce and the one by Fra Angelico in the Rijksmuseum, Amsterdam, also show a number of stars in the Virgin's halo.

Simonesque, show the stars and the moon, so it seems likely that the assumed Madonna of Humility by Simone Martini represented the fully developed form.

The Simonesque form of the Madonna of Humility illuminates in a remarkable way the humanistic character of early Trecento art, so profoundly different from that of the third quarter of the century. It clarifies also the historical position of this earlier art, its progressive qualities and its relationship with preceding arts. Although both of the figures which are combined in the Madonna of Humility, the seated Woman of the Apocalypse and the Virgin nursing the Child in the Nativity, existed in the north in the thirteenth century, they were fused into a single image only by Italian painters early in the fourteenth century. And the Madonna of Humility, based upon these two north European figures, exhibits at the same time one form—the spatial contrapposto of the Child—which is not mediaeval but which shows resemblances with antique art.[107] On the other hand, the representation in a rather formal image of a sacred person seated humbly on the ground is foreign to the Middle Ages and without analogy in antiquity;[108] it is new, and in a sense "modern."

[107] Even the northern fifteenth century paintings of the Madonna of Humility (Master of Flémalle) or the Maria Lactans (Jan van Eyck, Roger van der Weyden) do not attempt this contrapposto.

[108] Even the concept "humilitas" did not, in Greco-Roman antiquity, signify a virtue; it meant lowliness, baseness, or meanness.

VII

BOCCACCIO

I

ON FIRST consideration the secular literature of the third quarter of the fourteenth century, apart from the chronicles, seems to disclose a different state of mind than the painting. We have already, to be sure, observed certain similarities: a growing piety and melancholy, especially in the writing of Franco Sacchetti and his brother Giannozzo.[1] Among the numerous poems on death and the gruesome decay of the flesh, one by Antonio Pucci was, like several paintings, directly descriptive of the plague.[2] But this period is most memorable for the composition of the *Decameron* and for the beginning in Florence, again with Boccaccio, of an intensive study of ancient language and literature. It is true that one would not expect in contemporary religious painting the sparkling humor or the irony of the *Decameron*, which was often directed at the Church. But there is nothing in it either that remotely resembles Boccaccio's free inquiring intelligence and his fascination with the diversity of life and morals in the world around him. Tuscan painters and sculptors of this period were, furthermore, conspicuously indifferent to ancient art; their styles are fundamentally dissimilar from it, and there is not, so far as I know, a single instance of assimilation of its qualities of form. No painting of the time exhibits an organic conception of the figure, a spatial movement and a contrapposto so reminiscent of ancient art as Ambrogio Lorenzetti's Madonna in S. Francesco (Fig. 155). There is nothing comparable to the statuesque serenity of the senatorial apostles of Cavallini, which made so deep an impression on Giotto. Though we know there were ancient sculptures in Florence in the third quarter of the century—Benvenuto da Imola saw a marble Venus attributed, like most ancient statues at this period, to Polyclitus[3]—we do not hear that any Florentine artist of the time was delighted by it as Ambrogio had been earlier by a statue of Lysippus in Siena. In no painting of the period is there anything like Ambrogio's knowing approximation to ancient statuary in his figures of Peace and Security in the Town Hall at Siena. I do not recall during our period, either, a record of a commission similar to Ambrogio's for a series of stories from Roman history.[4] Not until the late

[1] On Franco Sacchetti, see De Sanctis, *Storia della letteratura italiana*, Naples, 1893, I, pp. 357-363. On Giannozzo, see Sapegno, *Storia letteraria d'Italia, Il trecento*, p. 490. See also chap. III, notes 1 and 2.

[2] See Sapegno, *op.cit.*, pp. 412-413.

[3] See his commentary on Canto X of *Purgatory* (*Comentum*, Florence, 1887, III, p. 280).

[4] Outside of Tuscany, however, and particularly in Padua, where the influence of Petrarch was great, developments were somewhat different. A cycle of murals based on Petrarch's *De viris illustribus*, and like later Paduan art, antiquarian in character, was painted in the Carrara palace in Padua (see J. v. Schlosser in *Jahrbuch der Kunsthistorischen Sammlungen*, XVI, 1895, pp. 183ff., and a forthcoming article by T. Mommsen). Around 1375, at the very

fourteenth or early fifteenth century do such connections with ancient art reappear. Between the two historical moments the painters of the third quarter, or even second half, of the fourteenth century were attracted rather by the Byzantine and Romanesque art of the Dugento, and by Simone Martini and northern Gothic styles related to his.

In these respects it is evident that the historical evolution of the arts of painting and literature did not exhibit a close chronological conformity. Because of motives, conditions, and accidents peculiar to each, related impulses appeared at somewhat different times, as they not infrequently do. But there are other aspects of the life and work of Boccaccio, the one major literary figure of the period in either Florence or Siena, that are more suggestive of the character of contemporary painting and of a similar response to the events of the time.

II

Boccaccio was born in Paris in 1312, the natural son of a merchant of Certaldo who had become an associate of the Bardi Company in Florence.[5] Boccaccio's father brought him to Florence at a very early age, and when he was around ten or fifteen sent him off to work in a commercial house at Naples. A few years later Boccaccio obtained permission from his father to study law; and while he pursued this work for several years, he devoted himself increasingly to literature. He moved in the gay, cosmopolitan circles of the court of King Robert, and won the love of Maria d'Aquino, a natural daughter of the king. Around 1340 he was called back to Florence by his father, who suffered severe financial reverses shortly afterward when the Bardi Company went bankrupt. Soon Boccaccio felt the pinch of poverty, and he was never free of it for the rest of his life. Petrarch, who had become a good friend, invited Boccaccio to come to live with him, hoping thus to relieve his troubles.[6] We know very little of Boccaccio's life during the 'forties, but he was in Florence in 1349, in time to witness the desolation following the Black Death, and from 1350 to his death in 1375 he took an active part in the political and cultural life of the city.

While in Naples and during the first six or seven years after his departure Boccaccio composed in prose and verse a series of romances: *Filocolo, Filostrato, Teseide, Ameto, Amorosa visione, Fiammetta, Ninfale fiesolano*. Some were directly inspired by his relationship with Maria d'Aquino. They all deal with love and a spirited, buoyant, or idyllic life. Though inevitably they include disappointments and rejections, their

end of our period, Giovanni Dondi, a member of Petrarch's circle, showed an interest in pagan as well as Christian monuments in Rome. He reported their measurements, collected inscriptions, and wrote of a celebrated sculptor resident in Rome (name not given) who was studying ancient art (see Prince D'Essling and E. Müntz, *Pétrarque*, Paris, 1902, pp. 44-45).

[5] The chronology of Boccaccio's early life is controversial. I follow the recent summary by Sapegno, *op.cit.*, 1942, pp. 278ff.

[6] See Francesco Corazzini, *Le lettere edite e inedite di Messer Giovanni Boccaccio*, Florence, 1877, p. 132.

characters are not disenchanted, despite occasional avowals to the contrary. The earlier of these works are passionately subjective; the later ones show a greater detachment from his own experience and a growing insight into the rich diversity of human life. This development culminates in the *Decameron*, written between 1348 and 1353, immediately after the Black Death.

For Petrarch the plague had been a great personal calamity: Laura and four of his closest friends died in it. Shocked and saddened, he turned with strengthened conviction to religion.[7] Boccaccio, on the other hand, gave no immediate sign of a deep disturbance. Although the Black Death is vividly described in the Proemio of the *Decameron*, it is only a dramatic pretext for the formation of the group of story-tellers and their escape from Florence to an isolated villa. There is no trace of guilt, a persistent sadness, or asceticism in the entire work.

In the *Corbaccio*, however, written in 1354-1355 immediately after the *Decameron*, we are presented with a startling change of mood. This gloomy vision of an arid wilderness and of bestial people was composed, Boccaccio says, after he had been enjoined by a spirit from purgatory to disseminate the truth about women and passion. It is a bitter exposure, written with an insistent moral and didactic intent. He turns upon love, the central theme and value of all his earlier work, to degrade it; its motives become ignoble and its physical aspects revolting. Beneath this rancorous and truculent rejection there lingers, however, a sensuality that the author's growing asceticism has not fully quenched.

Students of Boccaccio have accounted in various ways for this sudden change in his art. Some have maintained that the *Corbaccio* is simply autobiographical, provoked by the ridicule of a Florentine lady to whom the author had made advances[8]—though this was certainly not the first time he had been jilted. Others have referred to his advancing age and to fear of death, or to the influence of Petrarch's more constant piety. But even if all these things played a part, they do not exclude the cumulative effect on Boccaccio of the events of the 'forties—the Black Death, the bankruptcies, which brought him poverty, and the political revolution, which, as we have seen, he bitterly attacked.[9] Nor do they diminish the likelihood that he was responsive to the new moral and religious atmosphere in Florence.

[7] H. Hauvette, *Le Boccace*, Paris, 1914, p. 201; Sapegno, *op.cit.*, pp. 182-184; and H. Baron in *Speculum*, XIII, 1938, p. 9. On Petrarch's professed religious aspirations and ascetic inclinations see his letter of 1352 to his brother Gherardo (J. H. Robinson and H. W. Rolfe, *Petrarch*, New York, 1899, pp. 396-403).
Writing to Boccaccio toward the end of the epidemic of 1363, Petrarch said that the plague would not cease until men became penitent and were converted to a religious life. In this sad letter, in which he lamented the death of two more of his friends, he said to Boccaccio: "Of my old friends, only you remain" (*Lett. sen.*, III, 1). Just a few weeks later, news from Florence led him to fear that Boccaccio, too, might have succumbed, and he wrote a hasty note inquiring anxiously whether he was still alive (*Lett. sen.*, III, 2).

[8] See T. C. Chubb, *Life of Boccaccio*, New York, 1930, pp. 183ff. Sapegno, *op.cit.*, p. 366, speaks uncertainly of an "autobiographical element."

[9] See p. 70.

The *Corbaccio* is a sort of inverted romance, the last of Boccaccio's wholly imaginative works. While its venom and its invective are exceptional, it represents in many ways a turning point in his career. One of the foremost Boccaccio scholars of the past generation has entitled his chapter dealing with it and other works written immediately after the *Decameron*, "Retour à la tradition mediévale."[10] In all these writings the asceticism and the stringent moral intention of the *Corbaccio* persist. Between 1355 and 1360, not long then after the bankruptcies, the fall of the oligarchy, and the plague, he wrote a study on the reversals of fortune, the *De casibus virorum illustrium*. In it he sketches the lives of famous men from Adam to his own time who through pride or folly had fallen from happiness and high position into misery. The ghosts of these men parade before the author in his study. He acts as a judge, deliberating each case, addressing some with pity, reproving others, and frequently extracting a principle about the conduct of life. His interest is as much moral as historical, unlike Petrarch's in the *De viris illustribus* that he had begun in 1338. To some extent the *De casibus* was anticipated in Boccaccio's earlier writing. Examples of decline and fall appeared in the description of the Hall of Fortune in the *Amorosa visione* (1342), but there they had comprised a secondary, not a central, theme. Similarly Boccaccio professed a didactic purpose in several of his earlier works, usually at the very end, as in the *Filostrato* or the *Fiammetta*. The latter was intended, he or rather Fiammetta says, as an inducement to moderation, a warning against the pains and perils of complete abandon in the "labyrinth of love." But these limited comments, seemingly afterthoughts or gestures of moral justification, are different from the pervasive didacticism and the doctrinaire morality of the *De casibus*.

Shortly after undertaking his account of the misfortunes of famous men Boccaccio began a parallel treatise on women, *De claris mulieribus*, though in this work the moralization is not quite so pointed. At this time, too, he began to occupy himself with Dante. He planned an extensive commentary on his great religious poem, of which he completed only a part, and he wrote a Life or, more precisely, a *Trattatello in laude di Dante*. In this tribute to Dante as scholar and poet, Boccaccio dwelt on the themes with which he had recently become preoccupied. He exalted the life of solitude and tranquillity; if Dante had had it, he says, he "would have become a God on earth."[11] Instead he was burdened with a "violent and insufferable passion of love," and, on top of this, a wife. Boccaccio seized upon these circumstances as the occasion for an invective against love, women, and marriage reminiscent of, though less violent, than the *Corbaccio*.[12]

[10] H. Hauvette, *Littérature italienne*, Paris, 1924, p. 151; and *Boccace*, pp. 344ff., 476.

[11] See the translation by J. R. Smith in the *Earliest Lives of Dante*, New York, 1901, p. 33.

[12] It is interesting that Leonardo Bruni, in the Proemio to his own Life of Dante, should have said that Boccaccio wrote "the life and habits of that sublime poet as though he were writing the *Filocalo*, the *Filostrato*, or the *Fiammetta*. For it is filled with love and sighs and burning tears, as though man were born into this world for no other purpose save to find himself in those ten amorous days, wherein enamored ladies and gallant youths

Boccaccio's moral and ascetic inclination after 1354 led him to turn against his own earlier work. In a remarkable letter written in 1373 to his friend Mainardo Cavalcanti, to whom he had dedicated the *De casibus virorum illustrium*, he said of the *Decameron*:

"I am certainly not pleased that you have allowed the illustrious women in your house to read my trifles; indeed I beg you to give me your word that you will not permit it. You know how much in them is less than decent and opposed to modesty, how much stimulation to wanton love, how many things that drive to lust even those most fortified against it. . . . My feminine readers will judge me a filthy pimp and an incestuous old man, shameless, foul-mouthed and malignant, eager to spread tales of the dissoluteness of others. . . ."[13]

In provocative circumstances Boccaccio's sense of guilt could mount to panic. Earlier, in 1362, he had received a visit from a monk, who brought a sinister prophecy from Pietro Petroni, a Carthusian of Siena who had died a short time before. Petroni was renowned in Siena for his holiness, and Giovanni Colombini undertook to celebrate it in a life. As a reward for his sanctity the Blessed Pietro had been permitted to see the face of Christ before he died, and he thus acquired the power of penetrating the future. Through his messenger he warned Boccaccio, as he intended to warn Petrarch and others, that his death was imminent and that unless he immediately renounced poetry and profane writing he would be eternally damned.[14] Boccaccio, whose even temper as a young man had won him the nickname "Johannes tranquillitatum," was terrified. He decided to abandon the world and to devote himself wholly to a religious life. He offered to sell his library to Petrarch. But Petrarch's calm reply deterred him. In a letter which is our chief source for the incident, since Boccaccio's anxious letter to him is lost, Petrarch began to parry the threat by a cool reference to human frailty, exhibiting a composure and a scepticism of human motive that Boccaccio, too, had

recount the Hundred Tales" (J. R. Smith, *op.cit.*, p. 81). This is obviously unjust, but Bruni probably sensed in Boccaccio a lingering attraction for the very things he vilified.

[13] ". . . non lodo certamente che tu abbi permesso che le inclite tue donne di casa leggano le mie bazzecole, che anzi ti prego di darmi parola di non farlo. Sai quanto in quelle è di meno decente e contrario all'onestà, quanti stimoli ad infausta Venere, quante cose che sospingono a scelleraggine i petti sebbene ferrei, . . le leggenti mi stimeranno un sozzo ruffiano ed incestuoso vecchio, impudico, turpiloquo maledico, ed avido divulgatore delle scelleraggini altrui. . ." (Corazzini, *op.cit.*, pp. 289-290).

In 1373 Petrarch expressed a similar opinion of the *Decameron*. Writing to Boccaccio about a copy of it that he had acquired, he confessed (quite haughtily) that he had not read it through, partly because it was long and written in the vulgar for the people (so that it would take his time from more serious concerns), partly because it was too "free" (*libero e lascivo*). The moral character of the story of Griselda pleased him, however, so he translated it into Latin and sent Boccaccio a copy (*Ep. sen.*, XVII, 3).

[14] In the life of Petroni completed by Bartolommeo of Siena in 1619, and based upon Colombini's life, the monk tells Boccaccio that the works he had published were "the tools of the devil, devised to equip men for debauchery and to lure them to it." "You are," he said, "furnishing to others an example of baseness and wantonness by your language, your writing, and your character" (*Acta sanctorum*, May, VII, pp. 228-229).

possessed earlier, but had lost. "The vision was indeed astounding," Petrarch said, "if only it be true. For it is an old and much-used device, to drape one's own lying inventions with the veil of religion and sanctity, in order to give the appearance of divine sanction to human fraud." The study of literature, he adds, has never been incompatible with religion. Jerome and Augustine have proved that.

"I cannot understand why such advice should be given to an educated person in the full possession of his faculties, . . . one who realizes what can be derived from such studies for the fuller understanding of natural things, for the advancement of morals and of eloquence, and for the defense of our religion. I am speaking now only of the man of ripe years, who knows what is due to Jupiter the adulterer, Mercury the pander, Mars the manslayer, Hercules the brigand, and—to cite the less guilty—to the leech Aesculapius, and his father, Apollo the cither-player, to the smith Vulcan, the spinner Minerva; and, on the other hand, to Mary the virgin-mother, and to her son, our Redeemer, very God and very man. . . .

"Neither exhortations to virtue nor the argument of approaching death should divert us from literature; for in a good mind it excites the love of virtue, and dissipates, or at least diminishes, the fear of death. . . .

"But I will trouble you no longer with these matters, as I have already been led by the nature of the subject to discuss them often. I will add only this: if you persist in your resolution to give up those studies which I turned my back upon so long ago, as well as literature in general, and, by scattering your books, to rid yourself of the very means of study—if this is your firm intention, I am glad indeed that you have decided to give me the preference before everyone else in this sale. . . . I cannot, however, fix the prices of the books, as you most kindly would have me do. I do not know their titles and number, or their value. . . ."[15]

It is a curious and interesting fact that the *Passione di Gesù Cristo*, the poem by Niccolò Cicerchia that we have discussed above, was attributed to Boccaccio in the fifteenth century, and for a long time was believed to have been written by him after this "conversion" of 1362, in atonement for the moral freedom of his earlier work.[16] Though this conversion was actually only a passing crisis, it is highly significant for what it reveals of the growth of Boccaccio's religious impulses and of his inner tension during the latter part of his life. It is possible that he received priestly orders somewhere around this time, and in 1366 he is said to have performed the pious act of commissioning two altarpieces for a church in Certaldo.[17] After considering Petrarch's letter, he returned to his work. Upon completion of the *Corbaccio* he had abandoned imaginative writing for scholarship, and in the early 'sixties he was preparing a comprehensive treatise on the ancient gods, *De genealogiis deorum gentilium*. This work, together with his cooperation with Leontius Pilatus in a translation of Homer

[15] *Ep. sen.*, I, 4, translated by Robinson and Rolfe, *op.cit.*, pp. 384-396.

[16] See *Scelta di curiosità letterarie*, vol. 162, 1878, p. xx, and L. Cellucci, in *Archivum Romanicum*, XXII, 1938, p. 74.

[17] See above, p. 10.

from the Greek, was probably the more immediate object of the Blessed Pietro's denunciation and of Boccaccio's guilt.

The *Genealogy* was begun before 1350, a first draft was completed around 1360, shortly before the prophetic message, and Boccaccio was still revising the manuscript in 1373. It was the major task of his later years. Though devoted to pagan mythology (interpreted historically, allegorically, and in a Christian sense) it contains some signs of the same conflict that is evident in his other work after the *Decameron* and in the disturbance of 1362. To the thirteen books dealing with the ancient gods, Boccaccio added, probably after 1366, two in defense of poetry, which for him was identified chiefly with the poetry of the Greeks and Romans. An interest in it required a defense, he felt, against the indifference of the *bons vivants* and the scorn of the philistines, mostly jurists, who asserted that neither the writing nor the study of poetry was lucrative. Even more dangerous was the opposition of the conventionally pious and the sanctimonious, who attacked it in the name of theology and religion. One of these, "a certain venerable man, in other respects of eminent sanctity and learning . . . once exhibited the prejudice [against poetry] on an occasion not altogether to his credit. . . . For it happened one morning in our University that he was reading from the desk the Gospel according to St. John to a large audience, when suddenly he came upon the name of poet. Forthwith he became flushed, his eyes took fire, and raising his voice, he broke into a perfect frenzy and poured out one false charge after another against poets. And finally, to show the justice of his case, he averred—nay, almost swore: 'I have never seen, nor do I wish to see, a volume of poetry!' "[18]

People of this sort posed the same issue that had disturbed Boccaccio so profoundly in 1362. Indeed, he and Petrarch, the two pioneering humanists, were confronted with it during the whole of the latter part of their lives.[19] Although under the spell of the Blessed Pietro's prophecy Boccaccio had concluded that religion and ancient literature were incompatible, he held more consistently to the belief expressed a year or so earlier in the *Trattatello*[20] that poetry and theology were related in character and function. They both reveal the mystery of life, he said. They have the same moral purpose, and they employ similar methods: allegory and symbolism. Theology is the poetry of God.[21]

His position in the *Genealogy* is similar. But it is accompanied by what the author

[18] XIV, 15; C. G. Osgood, *Boccaccio on Poetry*, Princeton, 1930, p. 73. As early as 1336 Petrarch had been rebuked by Bishop Giacomo Colonna for his interest in pagan writings (see *Ep. fam.*, II, 9).

[19] For Petrarch, see, for example, *Ep. fam.*, XXII, 10.

The issue was raised in Florence in the late fourteenth century by the Camaldolite Giovanni di Duccio da S. Gimignano and by the *Lucula noctis* (1405) of Giovanni Dominici, a Dominican who had been deeply influenced by St. Catherine. Coluccio Salutati replied to both these attacks with arguments similar to Boccaccio's (see V. Rossi, *Il quattrocento*, Milan, 1938, pp. 54-57).

[20] The first version was probably written between 1357 and 1362 (see Sapegno, *op.cit.*, p. 389).

[21] See J. R. Smith, *The Earliest Lives*, pp. 51-54. Boccaccio's conceptions are not novel. They belong to the mediaeval tradition of the allegorical interpretation of poetry, and were influenced particularly by Dante and Petrarch.

of the excellent translation of the *Defense* calls "an anxious display of orthodoxy."[22] Boccaccio does not deny that some people, the young for instance, will be harmed by reading the ancients,[23] and he tries to disarm his pious opponents and at the same time quiet his own conscience by a reluctant and somewhat equivocal admission of the superior claims of religion: ". . . I grant freely that it would be far better to study the sacred books than even the best of these works [of ancient poetry], and I suppose they who do so are more acceptable to God, to the high Pontiff, and to the Church. But we are not all at all times subject to one inclination, and occasionally some men incline to poetical writers. And if we so incline, or turn to them of our own accord, what sin or harm is there in that?"[24] Petrarch, facing the same problem as Boccaccio, implies a similar judgment of better and worse, but on the grounds of distinctive qualities in the two spheres. "I think I can retain my love for both the Christian writers and the ancients," he wrote, "so long as I keep in mind which is preferable for style and which for content."[25] When he turned to the figure arts, however, where his insights were more limited and he saw little beyond the subject, he did not maintain this distinction, and he coupled with his judgment a warning. "To enjoy sacred images that remind the spectator of heavenly blessings is often pious, and useful for the stimulation of the mind. Profane ones, though they are sometimes moving and rouse us to virtue when the diffident mind is warmed by the recollection of noble deeds, should nevertheless not be equally loved or worshipped, lest they become witnesses of folly or ministers of avarice or rebels against faith and true religion and against that noted precept: beware ye of images."[26]

III

The conflict that Boccaccio felt more or less urgently from 1354 on is related to the tensions in contemporary painting. The terms, it is true, are rather different. Boccaccio, together with Petrarch, was confronted by the diversity of two dissimilar, historically differentiated universes of thought and feeling. One, the antique, these scholars themselves had done much to evoke; the task of harmonizing the two had scarcely begun. The painters, on the other hand, were committed for the most part to the traditional Christian themes. For them the conflict lay within the sphere of religious art, between dissimilar or even opposed qualities of content and form. But in a larger sense these differences between the painters and the writers are not so

[22] Osgood, *op.cit.*, p. 195 note 1. See especially book xv, 9, and the Proemio to book IX.

[23] Petrarch makes a similar point in a letter to Boccaccio cited in note 15.

[24] Osgood, *op.cit.*, p. 82.

[25] *Ep. fam.*, XXII, 10.

[26] "Delectari quoque sacris imaginibus, quae spectantes beneficii coelestis admoneant, pium saepe, excitandisque animis utile: prophanae autem, etsi, interdum moveant, atque erigant ad virtutem, dum tepentes animi rerum nobilium memoria recalescunt: amandae tamen aut colendae aequo amplius non sunt, ne aut stultitiae testes, aut avaritiae ministrae, aut fidei sint rebelles, ac religioni verae, et praecepto illi famosissimo: Custodite vos a simulachris" (*De Remediis*, quoted by Prince D'Essling and E. Müntz, *Pétrarque*, Paris, 1902, p. 58).

considerable as they might seem. For the more natural conception of man, presented in the art of the first half of the century and still haunting the painters after 1350, was related, historically and ideologically, to the interest in the ancient world. The growth of "humanism" and a more secular culture preceded, as a necessary condition, the broad revival of antiquity. There are unmistakable signs of this connection in the period we have been studying. When during the 'sixties and 'seventies Boccaccio was driven by a religious conscience, he both disowned the *Decameron*, the finest flower of early Florentine secular art, and tried to dispose of his library, rich in ancient writing. For the painters the rejection was more profound and more constant. Creating almost exclusively for the Church and for an audience larger than Boccaccio's, Orcagna and his contemporaries suppressed qualities of the art of Giotto and Ambrogio that were both naturalistic and "antique." And although they felt unable wholly to resist the power and magnetism of these forms, they opposed to them qualities of a very different kind, expressive of a more intense piety, a mystical rapture, or simply a firmer adherence to the doctrine and institutional authority of the Church.

The tension in the art and literature of the third quarter of the century arises then from a conflict between an old and a newer mode of life and thought. This conflict would inevitably have accompanied the growth of the new, but it was made far more acute by the disturbances and disasters of the time. Some of these events, like the plague, were more accidental and unprepared; others, like the financial crisis and the social struggles, were rooted in the new forms of life themselves. They seemed to challenge all at once, in the name of mediaeval society and mediaeval Christianity, the new individualism, the new secularity, and the new economic order.

In these respects, then, this was a period of crisis, the first crisis of what we may call, in its larger sense, humanism. It was to be followed by similar critical periods—though the causes and the alternatives were somewhat different—in the later fifteenth century and in the sixteenth. It is to Crivelli and the late Botticelli or Pontormo and Tintoretto that the painting of our time is peculiarly related, rather than to Masaccio, Piero della Francesca, Titian, or Raphael. To them it offered models of aspiring, though tormented, spirituality, of emotionally exciting color and light, and a strained, disharmonious unity of plane and space, line and mass, color and shape.

APPENDIX I
CHRONOLOGICAL TABLE

THE following is a chronological list of the more important events, artistic, religious, social, and literary, that are discussed in the present volume. Those that cannot be rather precisely dated are excluded. Facts about artists and works of art are in italics.

1341. Florence defeated in its attempt to acquire Lucca.

1342. Florentine political power transferred by the merchant oligarchy to the Duke of Athens.

1343. Failure of the Peruzzi Company. Beginning of the period of bankruptcies and depression.
Expulsion of the Duke of Athens, and formation of a new regime representative of all sections of the Florentine middle class.

1344.

1345. Bankruptcy of the Bardi Company.

1346. Famine in Tuscany.

1347. Scarcity in Tuscany.
Birth of St. Catherine of Siena.

1348. The Black Death (June-September).

1349. Congregation of the Flagellants.
Boccaccio's *Decameron* (between 1348 and 1353).

1350. Jubilee in Rome.

1351.

1352. *Orcagna undertakes the Or S. Michele tabernacle (work continued through 1359).*
Giovanni dalle Celle in retirement at Vallombrosa.

1353. *Bartolo di Fredi and Andrea Vanni open a workshop in Siena.*

1354. *Orcagna begins the Strozzi altarpiece (finished 1357).*
Sermons of Jacopo Passavanti, which were incorporated in his *Specchio di vera penitenza*.
Boccaccio's *Corbaccio*.

1355. Revolution in Siena: fall of the merchant oligarchy and rise of the *Dodicini*.
Conversion of Giovanni Colombini.
(ca.) Boccaccio's *De casibus virorum illustrium*.

1356. Ravages of the marauding *condottieri* (through the 'sixties).
(?) *Altarpiece by Nardo, New-York Historical Society.*

1357. (ca.) *Nardo painting in the Strozzi Chapel.*
Death of Jacopo Passavanti.

1358.

1359.

1360. (ca.) *Meeting of Florentine artists at S. Miniato, described by Sacchetti.*

1361.

1362. *Polyptych, Siena Gallery, by Niccolò di Ser Sozzo and Luca di Tommè.*
Triptych, Siena Gallery, by Giacomo di Mino.
Boccaccio frightened by the prophecy of the Blessed Pietro Petroni.
(?) William Fleet settled at Lecceto.

1363. Recurrence of the plague.
Colombini recalled to Siena.
Catherine of Siena became a Dominican tertiary.

1364. *Madonna of Mercy Pienza, by Bartolo di Fredi.*
Presentation in the Temple, Florence, Academy, by Giovanni del Biondo.
(ca). Composition by Niccolò Cicerchia of the *Passione di Gesu Cristo*.

1365. *Frescoes by Giovanni da Milano, S. Croce, Florence.*

1366. *Andrea da Firenze painting the frescoes in the Spanish Chapel (through 1367).*
(ca.) *Death of Nardo di Cione.*
Crucifixion, Pisa Museum, by Luca di Tommè.

1367. *Old Testament cycle, Collegiata, S. Gimignano, by Bartolo di Fredi.*
Orcagna undertakes the St. Matthew altarpiece (completed 1369).

Polyptych, Siena Gallery, by Luca di Tommè.

The Order of the Gesuati, consisting of Colombini and his followers, founded by Urban V.

1368. Defeat of the *Dodicini* in Siena, and rise of the *Riformatori.*
Foundation of the Observant section of the Franciscan Order.

1369.

1370. *Altarpiece by Jacopo di Cione, National Gallery, London (through 1371).*
Altarpiece by Luca di Tommè, Museo Civico, Rieti.
Foundation of the Brigittine Order.

1371. *Triptych by Niccolò di Tommaso, S. Antonio, Naples.*

1372.

1373. *Coronation of the Virgin, Academy, Florence, chiefly by Jacopo di Cione.*

1374. Interrogation of Catherine of Siena in the Spanish Chapel.
Recurrence of the plague.
Composition of the *Miracoli della B. Caterina.*

1375. Beginning of the war of Florence against Pope Gregory XI (War of the Eight Saints).
Stigmatization of Catherine of Siena.
Death of Boccaccio.

1378. Revolt of the Ciompi.

1380. Death of St. Catherine.

1382. Restoration of the Florentine oligarchy.
Deposition, Montalcino, by Bartolo di Fredi.

1385. Restoration of the oligarchy in Siena.

APPENDIX II

FACTS ABOUT THE PAINTERS

THE following paragraphs are intended to provide the reader with chronological information about the painters discussed in the present volume, some of whom are not well known. They will also substantiate the statements made above (p. 53) that almost all of these painters appeared as independent masters during the course of the 'forties and 'fifties. For these purposes I have brought together the relevant facts, in most cases actually everything that we know about the career of the artist. Information of this sort about Orcagna has already been given above (p. 13) and about Barna we know nothing. The most recent article cited for each painter usually contains a list of the paintings that are generally (but not always correctly) accepted as his at the present time. There the reader will also find a bibliography. I have added a few new facts, and proposed several new attributions.

NARDO DI CIONE entered the guild of physicians and apothecaries in 1343 or 1344, at the same time as Orcagna. He is mentioned in Florence in 1351 and 1354, and perhaps in 1356 he painted the Madonna in the New-York Historical Society (Fig. 11). He made his will in 1365, and died before the middle of the next year.[1]

ANDREA DA FIRENZE matriculated in the Florentine guild at the same time as the Cioni. He is recorded as an inhabitant of the quarter of S. M. Novella at intervals from 1351 to 1376. The first commission of which we hear is that for the frescoes in the Spanish Chapel. On December 30, 1365, he agreed to complete these frescoes within two years from January 1, 1366. In 1377 he received a final payment for the mediocre frescoes of S. Ranieri in the Camposanto at Pisa.[2]

GIOVANNI DEL BIONDO probably came to Florence from the Casentino and became a citizen in 1356;[3] around this time, if the attribution I have proposed above is correct, he was working as an assistant in the Strozzi Chapel (Fig. 17). There is a record of an altarpiece made by him in 1360,[4] and from the Presentation in the Temple of 1364 (Fig. 13) to the Madonna of 1392 at Figline a long series of his works, many of them dated, has survived.

GIOVANNI DA MILANO, a painter of Lombard origin, was in Florence serving as a master's assistant in 1350. In 1363 he joined the Florentine guild. In 1365 he executed the frescoes in the Rinuccini Chapel in S. Croce (Figs. 27, 36, 37) and the Pietà in the Academy, the only two extant dated works by him. In 1369, when we last hear of him, he was working in the Vatican.[5]

[1] See H. Gronau, in Thieme-Becker, *Künstlerlexikon*, XXVI, 1932, p. 39.

[2] See G. Poggi in *Enciclopedia italiana*, III, 1929, p. 200; Vasari, *Vite*, ed. Milanesi, I, p. 550; Supino in Thieme-Becker, I, 1907, p. 452; I. Taurisano, in *Il rosario*, ser. III, vol. III, 1916, pp. 217-230.

[3] See G. Poggi, in *Rivista d'arte*, V, 1907, p. 26. Also Milanesi in Vasari, I, p. 669 note 2.

[4] Van Marle, *Development of the Italian Schools of Painting*, III, p. 519, mistakenly identifies with this altarpiece a panel of S. Verdiana in S. Verdiana, Castelfiorentino, actually Sienese and close to Ugolino.

To his known paintings should be added a somewhat repainted Annunciation, no. 181 in the National Gallery, Washington (*Preliminary Catalogue*, Washington, 1941, p. 69) and a Virgin Annunciate in the W. B. Chamberlin sale, Christie's, Feb. 25, 1938, no. 21, as Jacopo di Cione.

[5] See P. Toesca, in *Enciclopedia italiana*, XVII, 1933, pp. 248-249, and W. Suida in Thieme-Becker, XIV, 1921, pp. 127-130.

JACOPO DI CIONE, a younger brother of Nardo and Orcagna, is first mentioned in documents in 1365, but his Madonna now in the Stoclet collection, Brussels, is dated 1362.[6] He entered the painters' guild in 1368-1369, around the time when he completed the altarpiece of St. Matthew begun by his brother Andrea (Fig. 59). He painted the S. Piero altarpiece, parts of which are now in the National Gallery, London, in 1370-1371, and in 1373 he received a payment for the completion of the Coronation of the Virgin now in the Academy, Florence (Fig. 56). He is last mentioned in 1398.[7]

NICCOLÒ DI TOMMASO was registered in the Florentine guild in 1343-1344, and from 1358 to 1376 we hear of him in Florence. His one dated work, a triptych in S. Antonio, Naples, is of 1371.[8]

The common conception of the career of NICCOLÒ DI SER SOZZO TEGLIACCI has been shaped by the belief that the signed miniature of the Assumption in the Archivio di Stato, Siena, was painted between 1332 and 1336.[9] This miniature is undoubtedly one of the earliest works of the master, but its style suggests a date some ten years later than the one hitherto given, and this is not conclusively controverted by any evidence in the manuscript itself. The *Caleffo del Assunta* in the Archivio di Stato, Siena, consists of copies of imperial privileges, papal bulls, pacts with feudal families and with other cities, and similar papers extending from 813 to 1336.[10] On the verso of the miniature, the only one in the codex, is an inscription stating that the work of *compilation* and *copying* was completed in 1336. The miniature, however, could conceivably have been made later. It appears on folio 8, half of a binion that is bound around three binions (six folios) that contain the index. The corresponding folios 1 and 1v are blank, so that this binion containing the miniature might well have been added later. Furthermore, the script on folios 8 and 8v is different from that in the rest of the manuscript. The known documents referring to the painter, moreover, give us no certain indication that his career began before the late 'forties. In 1348 he was required to make a certain payment, and in 1353 (?), 1357, 1359, 1361, 1362 he held municipal office.[11] He died, probably of the plague, in June 1363. His one dated work is the polyptych of 1362 in the Pinacoteca, Siena, and all his panels seem to me to have been made in the last fifteen years of a career cut short by the epidemic.[12] To the known group of his panel paintings should be added the following: a Madonna Enthroned in the National Gallery, Washington, of which only the upper half survives (Fig. 120)[13]; another enthroned Madonna, once in a Russian collection, which I shall publish elsewhere, and the altarpiece of

[6] See R. Offner, in *Burlington Magazine*, LXIII, 1933, p. 83.

[7] See H. Gronau, in Thieme-Becker, XXVI, 1932, p. 39.

[8] *Ibid.*, XXV, 1931, p. 439.

[9] Van Marle, *op.cit.*, II, fig. 377.

[10] See *Indice sommario, R. Archivio di Stato*, Siena, 1900, p. 15.

[11] See C. Brandi, in *L'arte*, n.s. III, 1932, p. 223, and F. M. Perkins in Thieme-Becker, XXXII, 1938, p. 501. Brandi cites also a payment for miniatures made in 1338 to one "Niccholello."

[12] It may be significant for an estimate of the age of the painter that his father was still active in political life not only in 1355, as Brandi (*loc.cit.*) has shown, but as late as 1368. See the chronicle of Neri di Donato for that year: "Ser Sozzo Tegliacci impetrò la Rocca Albegna . . ." (*Rerum Italicarum scriptores*, Bologna, XV, part VI, 1932, p. 622).

[13] No. 453. See the *Preliminary Catalogue*, Washington, 1941, p. 116, which cites the attribution of the panel by F. M. Perkins to the early period of Luca di Tommè when he was working in collaboration with Tegliacci. In my opinion, on the other hand, the figure of the Madonna shows Tegliacci under the influence of Luca.

the Assumption, mentioned above, in the Museum of Fine Arts, Boston (Fig. 25).[14] The figures in the pinnacles and the roundels are, however, by a Florentine master contemporary with Niccolò.

The first record of the long career of BARTOLO DI FREDI is of 1353, when he opened a workshop with Andrea Vanni.[15] From this time until his death in 1410 there is an almost uninterrupted series of notices of his activities as a painter and in the service of the city. His first extant dated work, which is also signed, is the Madonna of Mercy of 1364 in the museum at Pienza,[16] but the signed Madonna at Cusona was certainly painted earlier. The Old Testament cycle in the Collegiata, S. Gimignano (Figs. 80, 82) bears the newly discovered date 1367.[17] The Deposition in S. Francesco, Montalcino, is dated 1382, and the large altarpiece divided between the galleries of Montalcino and Siena is of 1388. He continued to work at least until 1397.[18]

Though ANDREA VANNI maintained a workshop in Siena with Bartolo di Fredi from 1353 to 1355, he left town in 1354 on the first of a series of diplomatic missions to Naples and other cities. Of the numerous paintings of which there are records in Siena from 1367 on, only the panels in the Siena Gallery possibly of 1394 or 1396, the Madonna in S. Francesco of 1398-1400, and the dull altarpiece of 1400 in S. Stefano have survived. He is mentioned for the last time in 1413, and died shortly afterward.[19]

GIACOMO DI MINO DEL PELLICCIAIO is mentioned as one of the three best Sienese painters in a Pistoiese record of about 1349. There are references to his work in Siena from 1354-1355 on, and he was admitted to the guild in 1355. The date on his Madonna at Sarteano, which has been read 1341 or 1342, is problematic, and F. M. Perkins has recently proposed 1353.[20] This very mediocre painting has almost none of the stylistic qualities that we have been considering; they appear, however, in his triptych of 1362 in the Pinacoteca, Siena (Fig. 61), and in other paintings, presumably later (and certainly better) than the Sarteano Madonna. He is last mentioned in 1389, and by 1396 he was dead.

The name of LUCA DI TOMMÈ appears on the roll of the painters' guild in 1356. In 1362 he signed with Niccolò di Ser Sozzo the polyptych now in the Pinacoteca, Siena. His Crucifixion in Pisa is dated 1366, the polyptych of St. Anne in the Pinacoteca, Siena, 1367, and the altarpiece in the Museum at Rieti 1370. We last hear of him in 1389.[21]

[14] See *Catalogue of Paintings*, Boston, 1921, pp. 4-5, no. 3; F. M. Perkins, in *Rassegna d'arte senese*, I, 1905, p. 74; Van Marle, *op.cit.*, II, p. 495, all as Bartolo di Fredi. B. Berenson, *Italian Pictures of the Renaissance*, Oxford, 1932, p. 312, as Luca di Tommè.

[15] S. Borghesi and E. L. Banchi, *Nuovi documenti per la storia dell'arte senese*, Siena, 1898, p. 27.

[16] C. Brandi, in *Bullettino senese di storia patria*, 1932, p. 5.

[17] E. Carli, in *Critica d'arte*, VIII, 1949, pp. 75-76.

[18] Most of the documentary evidence is given by G. Milanesi, *Documenti per la storia dell'-arte senese*, Siena, 1854, II, pp. 36-37. The oeuvre of Bartolo di Fredi is more encumbered with the works of other, inferior, painters than that of any master of the fourteenth century. In a forthcoming study Professor Lucile Bush undertakes the task of disposing of the weeds.

[19] See A. M. Ciaranfi in *Enciclopedia italiana*, XXXIV, 1937, p. 975, and G. de Nicola in Thieme-Becker, I, 1908, pp. 464-465.

[20] *Bullettino senese di storia patria*, n.s. I, 1930, p. 243. Perkins compiles here the known facts of Mino's career.

[21] F. M. Perkins in Thieme-Becker, XXIII, 1929, p. 427; C. Brandi, in *L'arte*, n.s. III, 1932, pp. 223-236.

Of FRANCESCO DI VANUCCIO there is certain mention in 1367, and again in 1403, by which time he was probably dead.[22]

NICCOLÒ DI BUONACCORSO is first heard of in 1372 and 1376, when he held public office in Siena. There was once a polyptych, signed by him and dated 1387, in Costalpino. He died in 1388.[23]

FRANCESCO TRAINI is related in a special way to the painters discussed in the foregoing paragraphs. His frescoes in the Camposanto at Pisa resemble their work in certain aspects of iconography and content, as we have seen. His style however is fundamentally different, associating itself rather with the Lorenzetti and other masters of the second quarter of the century. We first hear of him as a painter, in fact, as early as 1321. He was paid for the triptych in S. Catarina in 1344-45, and it is possible that he is the painter Francesco who is named in a document of 1363.[24] In an article in *Critica d'Arte*, VIII, 1949, pp. 192-201, G. Paccagnini argued that the inscription with Traini's signature on the St. Dominic triptych is not authentic, and he drew from this premise a series of radical conclusions with respect to the identity of the painter. The judgment of other students, however, including the present writer, that the inscription is original has been confirmed by a careful technical examination conducted recently by Prof. Piero Sanpaolesi, who has kindly communicated to me in detail the results. (Prof. Sanpaolesi will publish his observations shortly.) Paccagnini's main argument thus falls to the ground. It may also be said that his identification of Traini with the St. Thomas rather than the St. Dominic altarpiece presents other serious difficulties. For whereas the style of the St. Thomas panel is profoundly Sienese and is a rather isolated phenomenon in Pisa,[25] the author of the St. Dominic altarpiece is intimately connected with earlier and later Pisan art—with Giovanni Pisano, by whom he was deeply influenced, and with contemporary and later Pisan painters, Cecco, Gera, Giovanni di Niccolò, all of whom were dependent upon him, as I have shown. The St. Dominic master therefore conforms far more adequately to the long career of Traini in Pisa that the documents present.

[22] See R. Offner, *Art in America*, xx, 1932, p. 103.

[23] See C. Brandi, in Thieme-Becker, xxv, 1931, p. 431. To Niccolò's oeuvre should be added a St. Lawrence, formerly in the State Museum, Gotha, and sold in 1932 at Sotheby (Moray and other collections, June 9, no. 110, p. 42). This panel was attributed by Berenson, *Italian Pictures*, p. 183, to Fei.

[24] Meiss, in *Art Bulletin*, xv, 1933, pp. 172-173.

[25] The recent attributions to this master by G. Vigni in *Bollettino d'arte*, xxxiv, 1949, pp. 311-321, and by L. Coletti, *I primitivi*, Novara, II, 1943, p. 65 note 90, are not tenable.

APPENDIX III

SOME RECENT CRITICISM OF ORCAGNA AND OF THE FLORENTINE PAINTING OF HIS TIME

UNTIL quite recently Florentine painting of the third quarter of the fourteenth century has been judged with values derived from the art of Giotto and his circle.[1] Critics have pointed to the lack of qualities such as tridimensional space and linear perspective. The painters, particularly Orcagna—the only one who attracted much attention—seemed able neither to maintain Giottesque style nor to create a new one themselves. What originality they were believed to possess was defined chiefly as a more extensive assimilation of Sienese form. Inasmuch, however, as the style of Siena, particularly of Simone Martini, was judged irreconcilable with that of Giotto, the works in which the two were combined were found lacking in unity and coherence.[2] The criticism of Sienese painting itself was quite similar.[3] And although the discussion of single paintings from both schools sometimes contained fresh insights, it is only recently that attempts have been made to re-evaluate the art of the time, at least that of Orcagna and a few of his Florentine contemporaries. George Gombosi was, I believe, the first. In a brief introduction to his little monograph on Spinello Aretino, published in 1926,[4] he characterized the style of Orcagna and Nardo in terms that were by then familiar—flat, linear, symmetrical, hieratic—but he perceived a consistency in these qualities, and a sort of negative purposiveness. The art of these painters seemed to him deliberately opposed to that of Giotto and his followers, and since it incorporated some elements of pre-Giottesque painting, he described it as reactionary. He referred the appearance of this reactionary style to Dominican scholasticism and to the failure of the masses to comprehend the style of Giotto and his followers, though he did not indicate why either of these things should have affected painting at this particular time, rather than earlier or later. His brief account of the art of the period was inadequate in other ways also. He distinguished, but not clearly, the "reactionary" style of the Cioni from a "Gothicizing" trend inaugurated by Giovanni da Milano and Andrea da Firenze,[5] and he confused the reactionary style by tracing its origin to Francesco Traini, whose art he completely misunderstood. He tied the art of the Cioni to a revival of mural painting, overlooking the surviving frescoes of Maso and Taddeo and the records of lost murals, and he attributed this revival to the "architectonic" spirit of the Cioni.[6]

[1] This view is already implicit in Vasari's *Lives*. Ghiberti wrote favorably of Orcagna; this master was however the latest Florentine whom he discussed in his *vite* and the only artist of his period. Ghiberti was interested above all in the richly sculptured tabernacle in Or San Michele, for which he reported the fabulous cost mentioned above (pp. 78-79).

[2] See P. Toesca, *Florentine Painting of the Trecento*, Florence, 1929, pp. 51-53; W. Suida, *Florentinische Maler um die Mitte des vierzehnten Jahrhunderts*, Strasbourg, 1905, pp. 10-11; Vitzthum-Volbach, *Italienische Malerei und Plastik des Mittelalters*, Wildpark-Potsdam, 1914, p. 306; Van Marle, *op.cit.*, III, p. 472. All these writers find some positive values

also in the painting of this period, especially Orcagna's.

[3] See C. Weigelt, *Sienese Painting of the Trecento*, New York, n.d.

[4] *Spinello Aretino*, Budapest, 1926, pp. 7-23.

[5] Just recently, on the other hand, Orcagna himself has been characterized as the leader of the Gothic movement in Florence (L. Beccherucci, in *Bollettino d'arte*, XXXIII, 1948, p. 155).

[6] Gombosi's criticism of the Cioni has been discussed in the course of reviews of his book by R. Salvini (*Kritische Berichte*, VI, 1937, pp. 119-124) and U. Procacci (*Rivista d'arte*, I, 1929, p. 273). Both of these reviews seem to me unjustifiably negative. Procacci maintained that spatiality and planarity were not histori-

Both Gombosi and, a few years later, Hans Gronau[7] dwelt on only one aspect of Orcagna's art, disregarding other opposed qualities that were described shortly afterward by Toesca: "Plastic modeling, at times rivaling the hardness and solidity of metal, combined with the treatment of the rest as pure surface ornament. . . ."[8] These conflicting qualities signified for Toesca as for others a disconcerting and unsuccessful attempt to join the style of Giotto and the Sienese. Roberto Salvini found in them, however, the essence of Orcagna's art. His analysis of the style of the Strozzi altarpiece, published in 1937,[9] was not only exceptionally sensitive and subtle but was the first to admit tension and conflict as positive values. In this respect his judgment and the similar one in the present book reflect the developing criticism of the art of the sixteenth century and the character of the arts in our own time. The tension between line and volume, volume and plane, is expressive, Salvini said, of a psychic tension between a "spiritual striving or a religious activism" and a "tenacious affection for the nature of man." He pointed to a similar fervor in the preaching of the contemporary Dominican, Jacopo Passavanti, and suggested that in both Passavanti and Orcagna it may have been a consequence of the plague.

Salvini did not develop these conceptions. They are similar to, and they influenced, those that the present writer was forming at that time with respect to Sienese as well as Florentine painting, and which he set forth briefly in the course of articles published from 1933 to 1946.[10] The main ideas of the present book were presented to the annual meeting of the College Art Association in January, 1948, and they were developed at greater length in a paper read before the Columbia University Seminar on the Renaissance in November, 1949.

The characterization of Florentine painting of the third quarter of the century in Frederick Antal's recent book[11] is similar to Gombosi's, but it has become part of a broad scheme of the development of Florentine painting in the fourteenth and early fifteenth centuries that is set within a framework of social, or more precisely class, reference. Antal distinguishes two constant trends or styles in Florentine painting. One, represented in the fourteenth century by Giotto and Maso, is characterized by rationality and concentration, the other by emotionality, planarity, "realism of detail," and symbolism. The former is the art of the wealthy, progressive, cultured section of the upper middle class, the latter, which he calls "popular," is associated with the rest of Florentine society. Giotto's art of the "intellectual" elite of the upper middle class was accompanied in the early fourteenth century by the styles of the S. Cecilia Master, Jacopo del Casentino, Pacino di Buonaguida, etc., ranged on a scale of "popularity" and corresponding to progressively lower social groups. Toward the end of Giotto's career, and more decisively after his death, the upper middle class and its art entered into a decline (Taddeo Gaddi, Daddi). Then, in the third quarter of the century, when the lower middle class acquired a share in political power, the "progressive upper middle class" made artistic "concessions" to the lower middle class, contriving, through the agency of the Dominicans, to give its own art a more "popular" character. The

cal modes, but were adopted by the same artist on different occasions. Several objections that Salvini raised, such as the impossibility of an actual revival of pre-Giottesque form in the middle of the fourteenth century, seem to me a pedantic distortion of Gombosi's meaning.

[7] *Orcagna und Nardo di Cione*, Berlin, 1937. This book, however, made valuable contributions to problems of chronology, author-ship, and iconography, for which it has been cited frequently in the preceding text.

[8] P. Toesca, *loc.cit.*

[9] "La Pala Strozzi," in *L'arte*, n.s. VIII, 1937, pp. 16ff.

[10] *Art Bulletin*, XV, 1933, pp. 151-152; XVIII, 1936, pp. 447-448; XXVIII, 1946, pp. 7, 12-14.

[11] *Florentine Painting and Its Social Background*, London, 1947, pp. 187-217, 247-251.

art of Orcagna and Nardo is least compromised by the admission of "popular" qualities, but these increase progressively from Jacopo di Cione, Niccolò di Tommaso, Andrea da Firenze, Agnolo Gaddi, and Antonio Veneziano to Giovanni del Biondo, whose painting is most completely identified with the taste of the lower classes.[12]

I have elsewhere published a fuller summary of Antal's thought, together with a detailed critique. I refer the reader to this review[13] and to those written by other historians.[14] In the course of a quite recent article devoted primarily to the attribution of several sculptures to Orcagna, W. R. Valentiner characterized the style of this master in much the same way as Salvini.[15] He went on, however, to attribute the "lack of depth" in Orcagna's compositions to the fact that he was primarily a sculptor. He related the religious intensity of Orcagna's art to the economic and social crisis and the plague.[16] He found evidence of the effect of the plague on this master in a wood crucifix in the Cappella della Pura of S. M. Novella, which he attributed, with question, to him. In it the body of Christ is covered with rather evenly spaced boils. The style of this work seems to me very different from Orcagna's. It remains to be proved, I think, that the work is Tuscan or even Italian. Certainly the little paintings on the cross are not.

[12] Essential to Antal's thought at this point is the conception of a basic relationship between this group of painters and certain "popular" masters of the earlier part of the century—Pacino, the Biadaiolo Master, etc. (see above, pp. 6-7). This conception seems to me to imply a misunderstanding of both groups.

Agnolo Gaddi and Antonio Veneziano, furthermore, actually belong to a later and quite different stage in the history of Florentine painting and they seem to me to be harbingers of the style of the early fifteenth century. I suspect, in fact, that Antonio's space and color and light were studied carefully by the painters of the early Renaissance.

[13] *Art Bulletin*, XXXI, 1949, pp. 143-150. For comments on some of Antal's ideas that refer particularly to the painting of the third quarter of the century see above, chap. I, note 156; chap. IV, note 15.

[14] R. Krautheimer, in the *Magazine of Art*, XLI, 1948, p. 318; H. Gronau, in the *Burlington Magazine*, XC, 1948, pp. 297-298; W. Cohn, in *Belfagor*, 1948, pp. 742-744; T. Mommsen, in *Journal of the History of Ideas*, XI, 1950, pp. 369-379.

[15] *Art Quarterly*, XII, 1949, pp. 48-68, 113-128.

[16] In his brief summary of these events, he described the political conflict as a struggle between the nobility and the lower classes, but this was not an important aspect of the civil strife of the time.

APPENDIX IV

A NEW POLYPTYCH BY ANDREA DA FIRENZE

THE curious painting in the National Gallery, London, whose authorship and formal peculiarities have been discussed above,[1] exhibits an iconography that is as uncommon as its shape (Fig. 63). At the Madonna's right are the half-length figures of Saints Mark, Peter Martyr, Thomas Aquinas, Dominic, and Luke; on the opposite side, John the Evangelist, Gregory, Catherine, Mary Magdalen, and a bishop labeled Thomas, undoubtedly Thomas of Canterbury. Thus three of the evangelists appear in an order that implies a symmetrical completion: Luke and John alongside the Madonna, and Mark at the extreme left. We should certainly expect Matthew at the extreme right, but he is missing, his place occupied by Thomas of Canterbury.

The representation of as many as three evangelists in a polyptych is very unusual in the fourteenth century, and suggests a connection with a center of learning. Judging from Van Marle's lists,[2] the only comparable representation in Florentine Trecento painting is, in fact, the four evangelists in the Spanish Chapel. The presence in the polyptych of Peter Martyr, Dominic, and Thomas Aquinas prove it to be Dominican, and there are cogent reasons for identifying this Dominican center as S. M. Novella, within the precincts of which Andrea da Firenze painted his monumental cycle of frescoes. All ten of the saints represented in the panel were titulars of altars in this church in the late fourteenth century.[3] St. Thomas of Canterbury, very seldom represented in Tuscan painting, was the titular of one of them,[4] and as far as I can discover St. Matthew, who was omitted from the polyptych, had no altar in the church. This extensive correspondence can scarcely be accidental. The polyptych appears in fact to be a sort of hagiographic compendium of the church.

Having gotten the painting into S. M. Novella, we can perhaps pursue it still further within the church. The most honored saint in the panel is Luke, who appears immediately to the right of the Madonna. Now Luke was rarely represented in Florentine Trecento painting. Apart from his presence as one of the evangelists in the Spanish Chapel, Van Marle's index lists only three examples of the fourteenth century, and one of these is in the cloisters of S. M. Novella.[5] St. Luke was, however, the titular of the Gondi Chapel of S. M. Novella, located immediately to the left of the choir.[6] The early date of the construction of this chapel is proved by the fragments of Cimabuesque frescoes preserved in the vaults, and Vasari tells us that in it Cimabue learned the *maniera greca* by watching Byzantine masters

[1] Pp. 47-48.

[2] Van Marle, *op.cit.*, VI, p. 122.

[3] See J. Wood Brown, *The Dominican Church of S. M. Novella*, Edinburgh, 1902, pp. 115-135. Wood Brown mentions only five additional altars, dedicated to Saints Lawrence, Louis, Elizabeth of Hungary, Michael, and the Resurrection of Lazarus.

[4] The altar of the Minerbetti family, supposedly descendants of refugee relatives of the saint (see Wood Brown, *op.cit.*, pp. 121-122). In his will of 1308, Maso de' Minerbetti stipulated that he was to be buried near the altar of St. Thomas, and he left a piece of land to provide for the celebration of the

saint's feast in the church (G. Richa, *Notizie istoriche delle chiese fiorentine*, Florence, IV, 1776, p. 68—the notice was kindly called to my attention by Martin Davies).

The martyrdom of St. Thomas of Canterbury is represented in a Dominican miniature by the shop of Pacino in the collection of V. Hoepli, Milan (Offner, *Corpus*, sec. III, vol. II, pt. II, pl. X[1]). Perhaps the codex to which this miniature belonged was also made for S. M. Novella.

[5] Van Marle, *loc.cit.*

[6] Wood Brown, *op.cit.*, p. 132. Richa, *op.cit.*, III, p. 69.

paint frescoes.[7] But much more relevant at the moment is the biographer's statement that there was in the chapel a "tavola" representing the Madonna, Luke, and other saints (notice the enumeration!) by Simone Martini.[8] And this is the painter to whom Vasari ascribed the frescoes in the Spanish Chapel!

But if the painting was in the Gondi Chapel, where could it have been placed? Vasari describes it simply as a "tavola," and in a chapel a polyptych would be placed on the altar. The iconography and the shape of the work are indeed those of a retable, but the size is not. It is only about 42 inches wide,[9] whereas the width of altarpieces, including those comparable to the London polyptych in shape, is usually no less than 60 or 70 inches. Was it made by Andrea then for a small private altar of one of the Gondi, perhaps as a replica of the polyptych which stood on the altar of the family chapel? If this is true, then the design of the painting in London, together with Vasari's statement, suggest that the altarpiece in S. M. Novella was painted by Andrea also.

[7] Vasari, ed. Milanesi, I, p. 247. Richa (*loc.cit.*), quoting the *Sepoltuario* of the church, says that the construction of the chapel did not begin until after 1325.

[8] Vasari, ed. Milanesi, I, p. 549.

[9] The panel of the Madonna is 11 inches high, the others 5¼ inches, exclusive in each instance of the frame.

INDEX

THE term "follower" is used throughout the Index to signify all the degrees of dependence of one painter upon another that are more precisely conveyed—as they are in the text—by terms ranging from "wokshop of" to "remote follower of."

The author wishes to express his gratitude to Mrs. Esther Mendelsohn and Mrs. Louise W. Carlson for their work on the Index, and he feels especially thankful to Miss Helen M. Franc, who expanded it and gave it its final form.

SCHEDULE OF PHOTOGRAPHS

Unless listed below, all photographs are reproduced by courtesy of the museum or collector specified in the list of reproductions.

Alinari, Florence: Figs. 1, 2, 5, 8, 15, 26, 28, 33, 35, 36, 37, 41, 45, 47, 53, 55, 56, 57, 58, 65, 67, 72, 75, 80, 86, 88, 92, 93, 97, 101, 102, 108, 110, 114, 129, 166.

Anderson, Rome: Figs. 14, 16, 23, 29, 38, 44, 51, 52, 73, 74, 76, 77, 78, 81, 85, 87, 94, 96, 98, 103, 109, 111, 133, 141.

Bencini, Florence: Fig. 116.

Brandi, U., Siena: Fig. 61.

Brogi, Florence: Figs. 6, 7, 10, 19, 27, 30, 31, 32, 34, 39, 54, 59, 60, 64, 69, 70, 79, 89, 91, 95, 113, 134, 155, 168.

Cipriani, Florence: Figs. 9, 71, 121.

Fiorentini, Venice: Fig. 132.

Frick Art Reference Library, New York: Figs. 12, 17, 115, 119, 136, 154, 162.

Gabinetto Fotografico Nazionale, Rome: Figs. 3, 149, 163.

Lombardi, formerly Siena: Fig. 124.

Mas, Barcelona: Fig. 148.

Soprintendenza, Florence: Figs. 66, 83, 84, 138, 145.

Soprintendenza, Parma: Fig. 123.

From J. Wilpert, *Die Malereien der Katacomben Roms*, Freiburg, 1903, pl. 22: Fig. 156.

PLATES

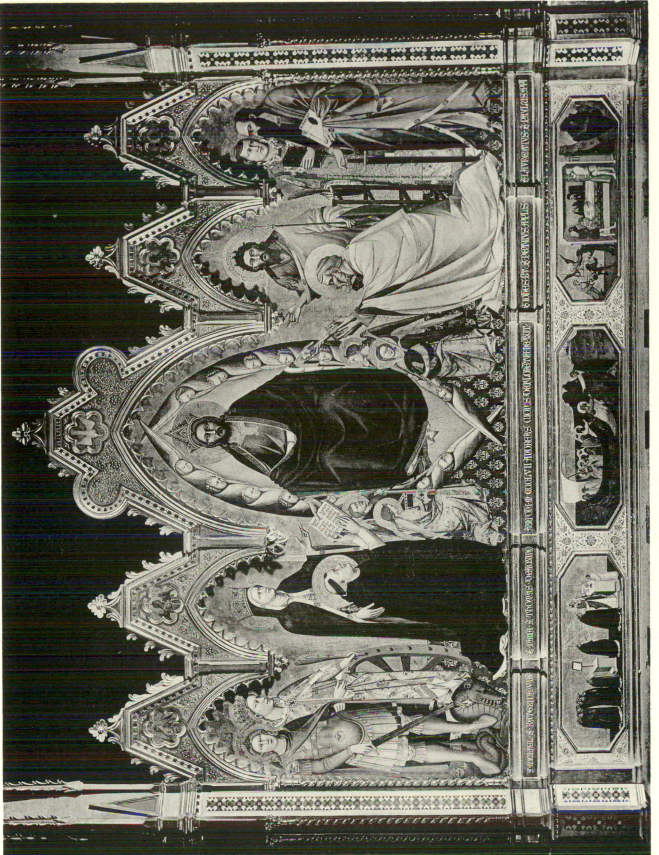

1. Orcagna, The Strozzi Altarpiece, S. M. Novella, Florence. 1354-1357

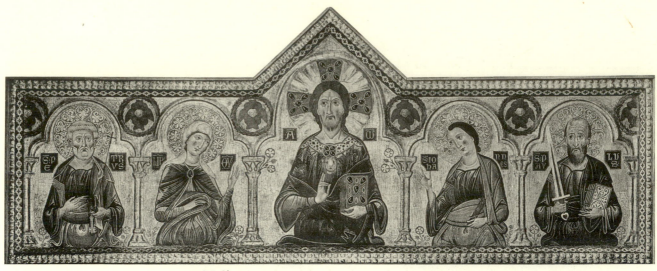

2. Meliore, Polyptych, Academy, Florence. 1271

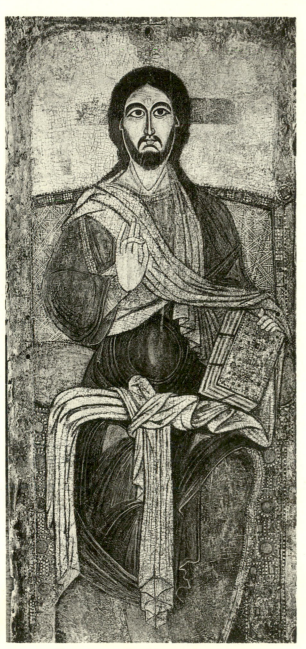

3. Roman, early thirteenth century,
Christ Enthroned, Duomo, Sutri

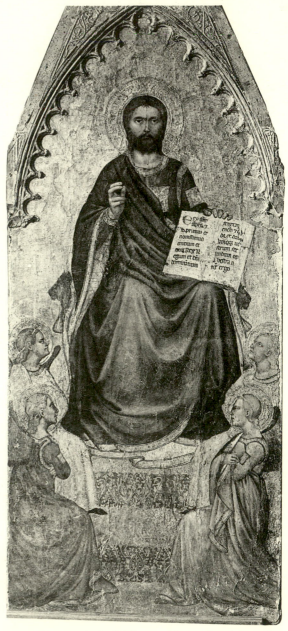

4. Giovanni da Milano, Christ Enthroned,
Contini collection, Florence

5. Orcagna and Associates, detail of the tabernacle, Or San Michele, Florence. 1352-1359

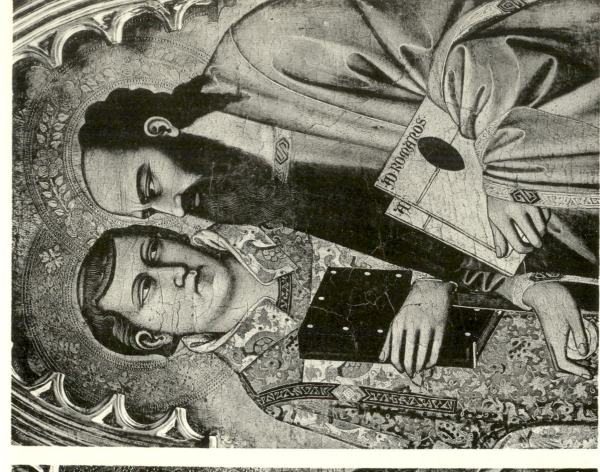

7. Orcagna, Saints Lawrence and Paul, detail of Fig. 1

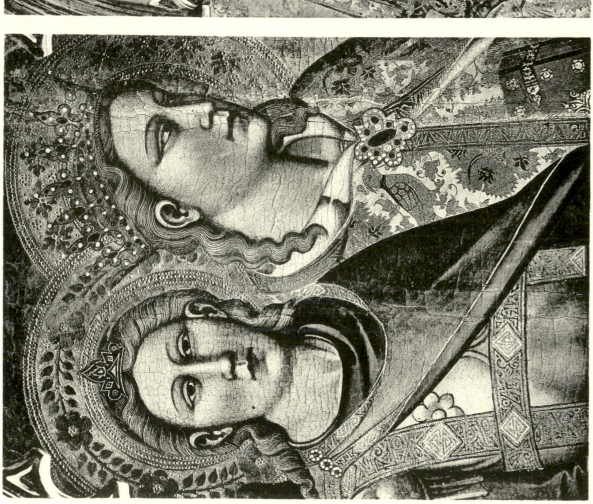

6. Orcagna, Saints Michael and Catherine, detail of Fig. 1

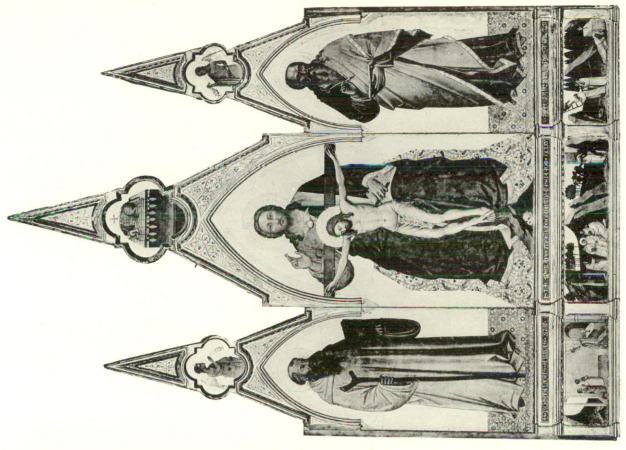

9. Follower of Nardo, Triptych, Academy, Florence. 1365

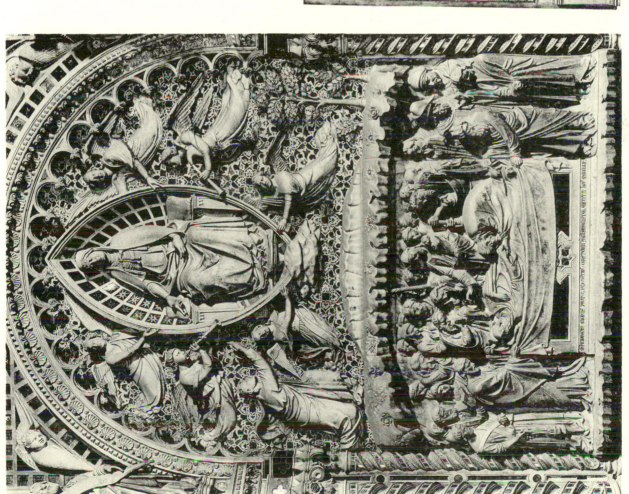

8. Orcagna, Death and Assumption of the Virgin, Or San Michele, Florence

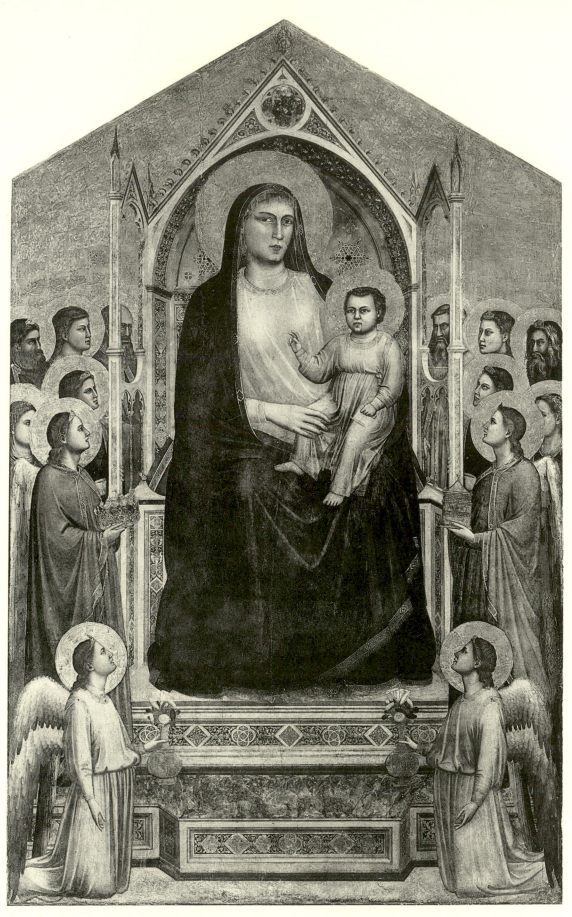

10. Giotto, Madonna, Uffizi, Florence

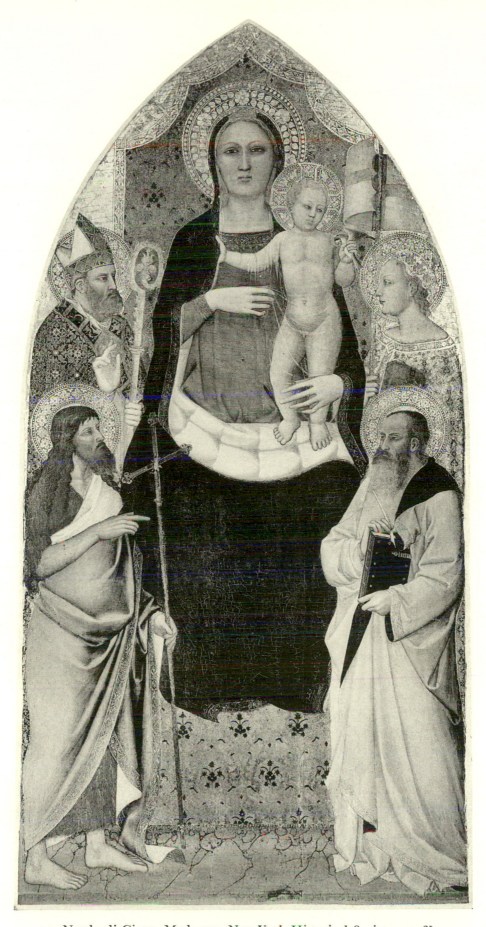

11. Nardo di Cione, Madonna, New-York Historical Society. 1356?

13. Giovanni del Biondo, Presentation in the Temple, Academy, Florence. 1364

12. Taddeo Gaddi, Presentation in the Temple, Academy, Florence

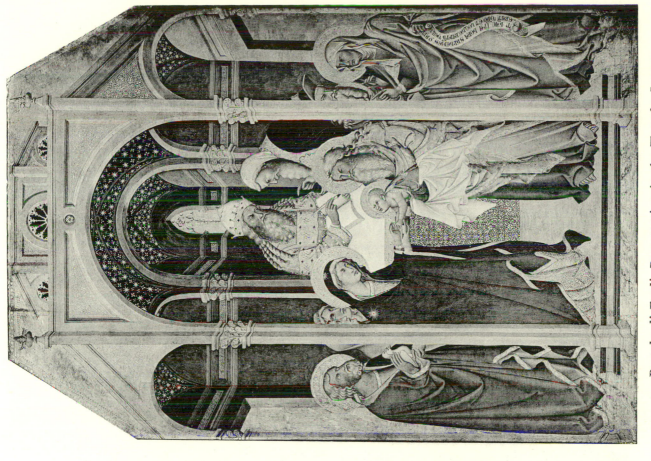

15. Bartolo di Fredi, Presentation in the Temple, Louvre

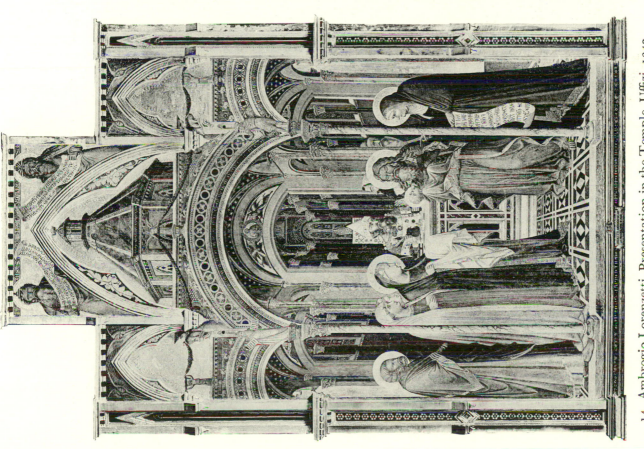

14. Ambrogio Lorenzetti, Presentation in the Temple, Uffizi. 1342

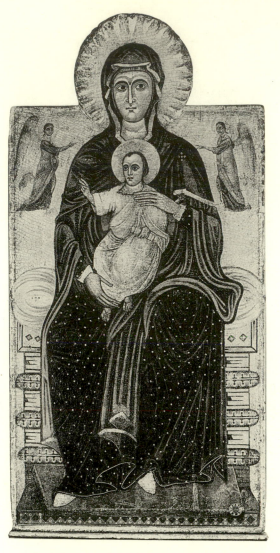

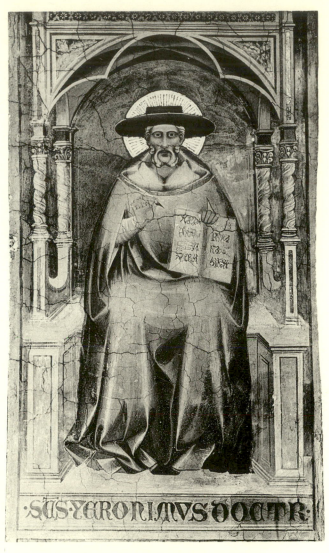

16. The Bigallo Master, Madonna,
A. Acton collection, Florence

17. Giovanni del Biondo, St. Jerome,
S. M. Novella, Florence

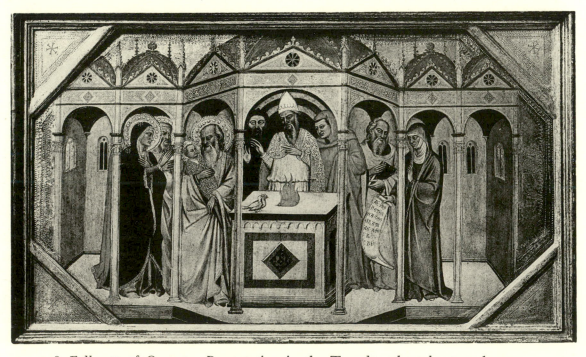

18. Follower of Orcagna, Presentation in the Temple, whereabouts unknown

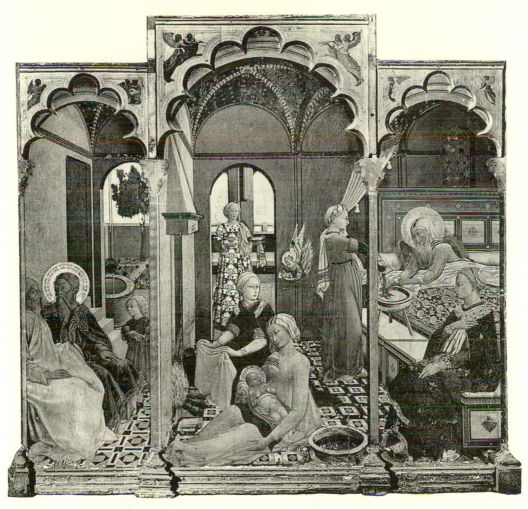

19. Osservanza Master, Birth of the Virgin, Collegiata, Asciano

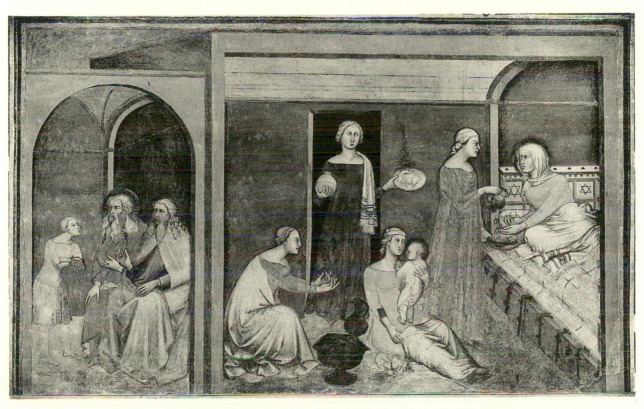

20. Bartolo di Fredi, Birth of the Virgin, S. Agostino, S. Gimignano

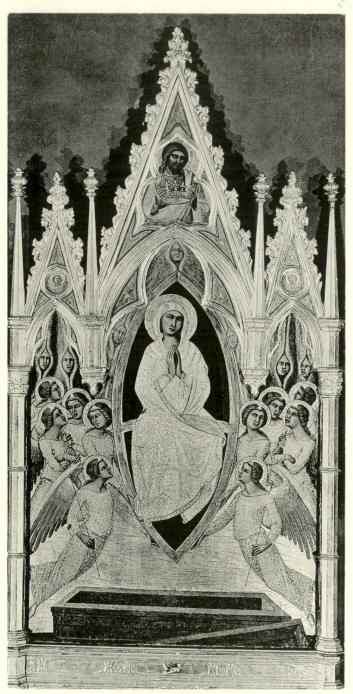

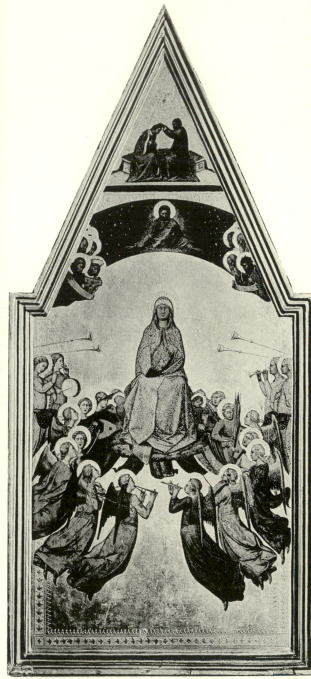

21. Luca di Tommè, Assumption of the Virgin, Gallery of Fine Arts, Yale University

22. Follower of Simone Martini, Assumption of the Virgin, Alte Pinakothek, Munich

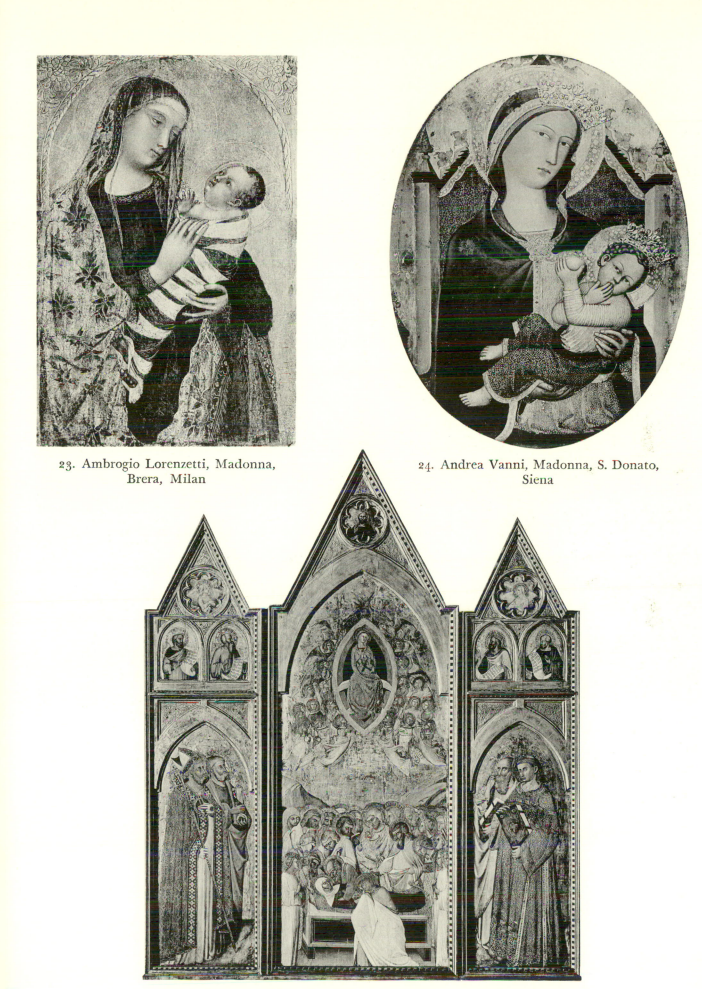

23. Ambrogio Lorenzetti, Madonna,
Brera, Milan

24. Andrea Vanni, Madonna, S. Donato,
Siena

25. Niccolò di Ser Sozzo Tegliacci, Triptych, Museum of Fine Arts,
Boston (pinnacles by a Florentine painter)

26. Giotto, Meeting at the Golden Gate, Arena Chapel, Padua. ca. 1305

27. Giovanni da Milano, Meeting at the Golden Gate, S. Croce, Florence. 1365

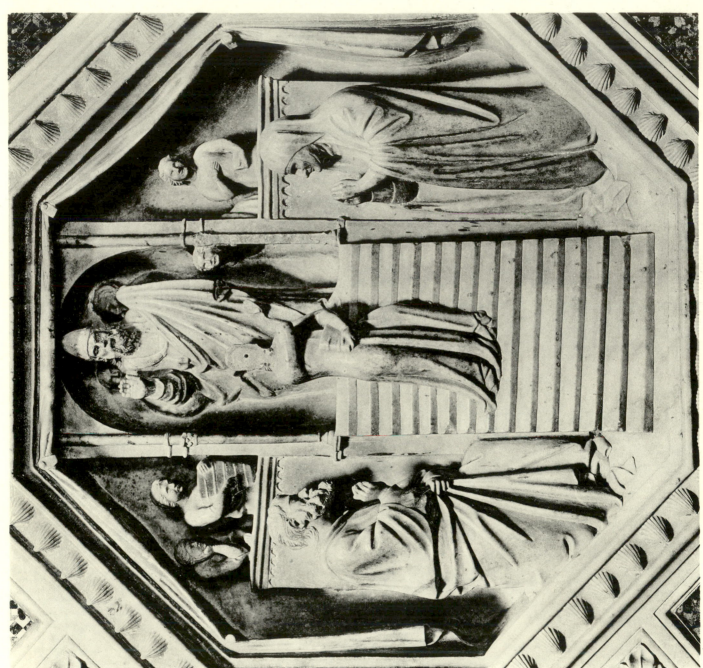

28. Orcagna, Presentation of the Virgin, Or San Michele, Florence

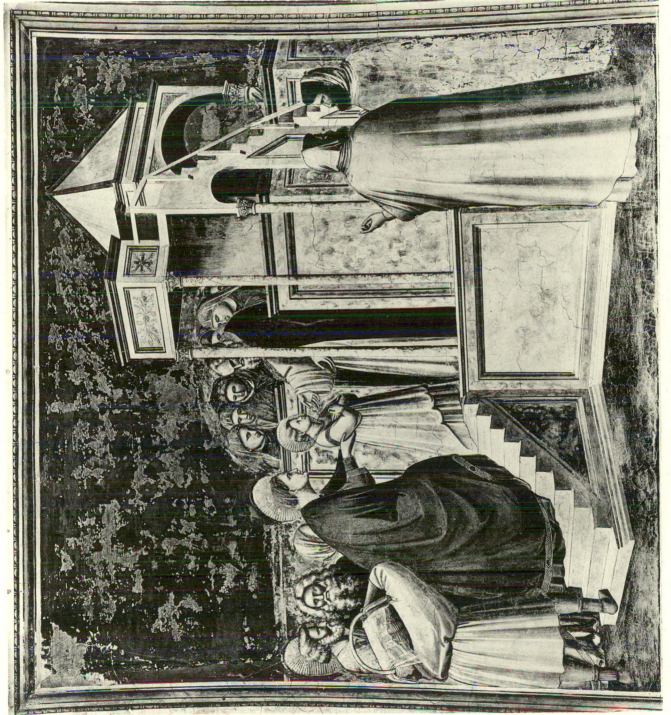

29. Giotto, Presentation of the Virgin, Arena Chapel, Padua. ca. 1305

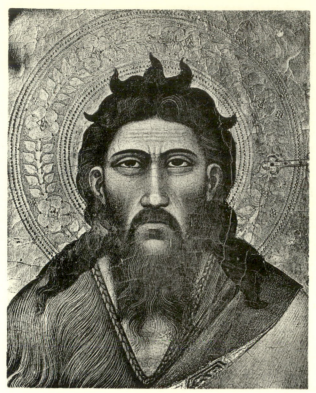

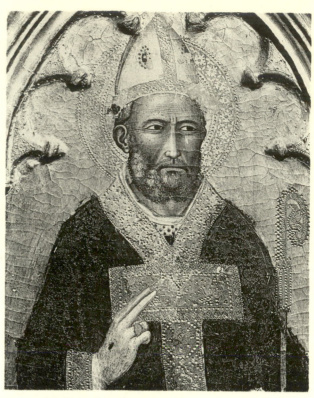

30. Orcagna, head of the Baptist,
detail of Fig. 1

31. Andrea da Firenze, head of St. Nicholas,
detail of Fig. 64

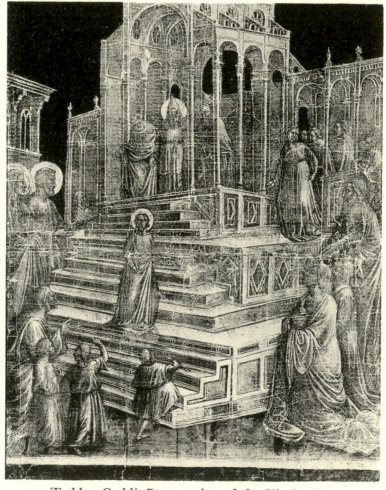

32. Taddeo Gaddi, Presentation of the Virgin, Louvre

33. Taddeo Gaddi, Meeting at the Golden Gate, S. Croce, Florence

34. Pisan, late thirteenth century, Expulsion of Joachim, Museo Civico, Pisa

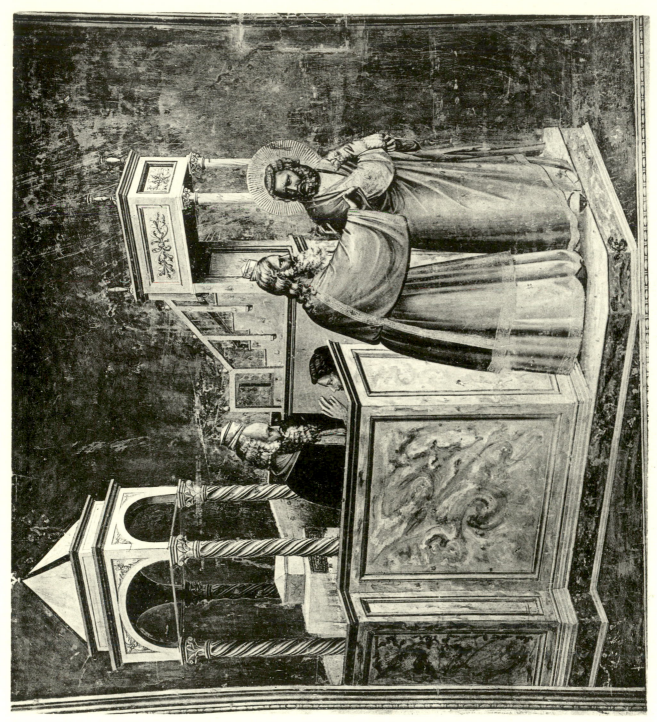

35. Giotto, Expulsion of Joachim, Arena Chapel, Padua. ca. 1305

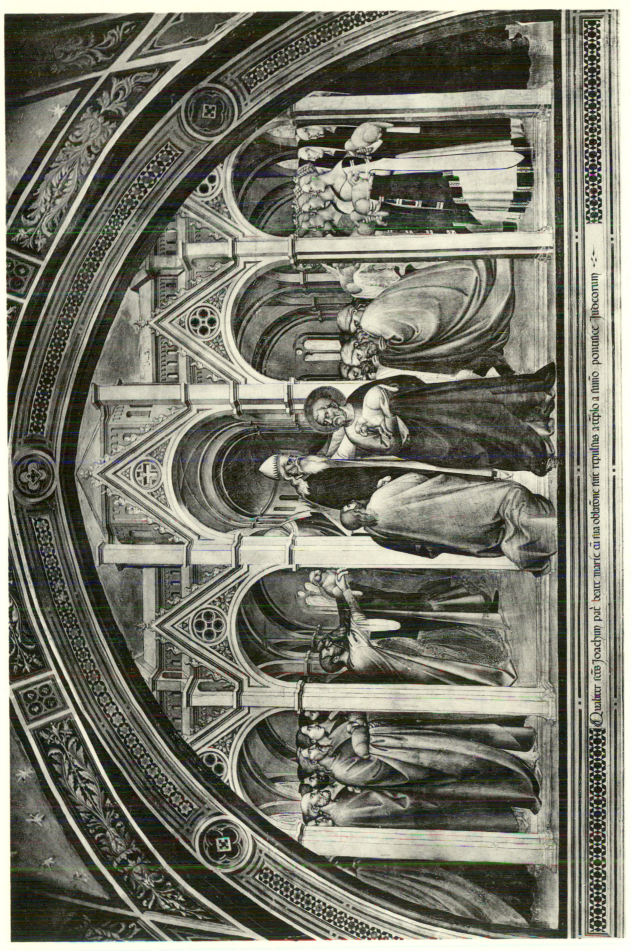

36. Giovanni da Milano, Expulsion of Joachim, S. Croce, Florence. 1365

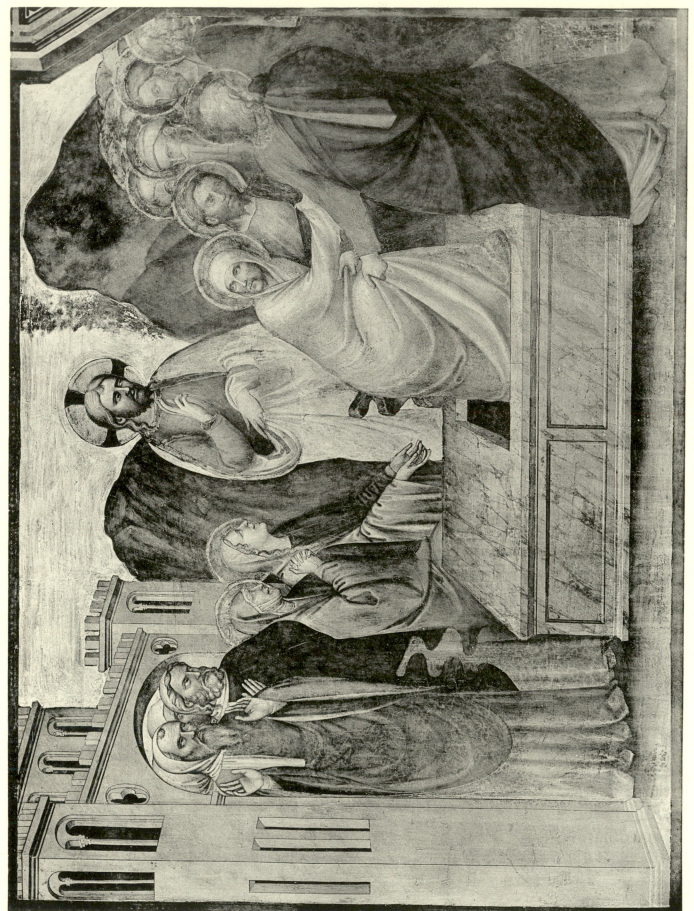

37. Giovanni da Milano, Resurrection of Lazarus, S. Croce, Florence. 1365

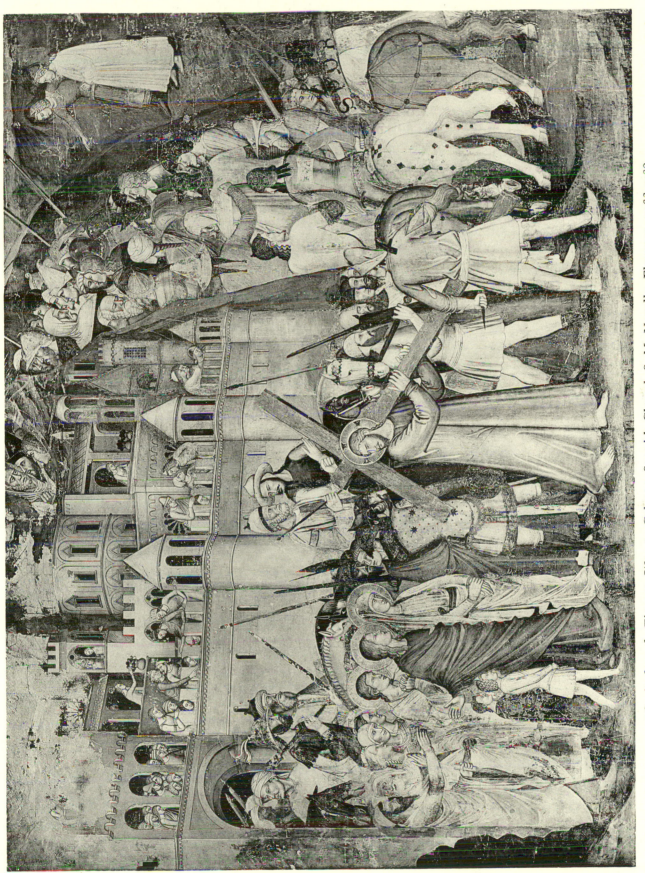

38. Andrea da Firenze, Way to Calvary, Spanish Chapel, S. M. Novella, Florence. 1366-1368

39. Close Follower of Orcagna, Pentecost, Badia, Florence

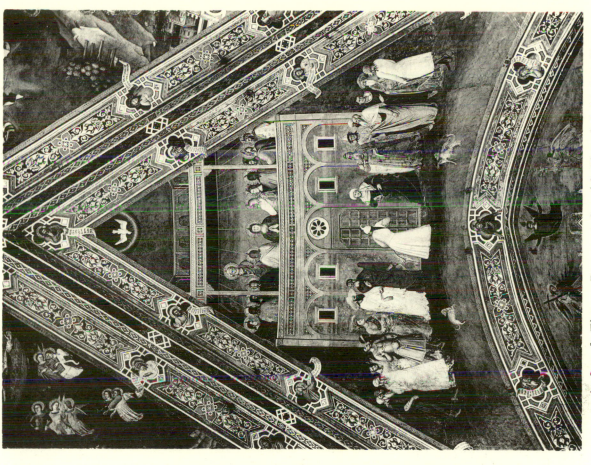

41. Andrea da Firenze, Pentecost, Spanish Chapel, S. M. Novella.
1366-1368

40. Taddeo Gaddi, Pentecost, Kaiser-Friedrich Museum, Berlin

43. Florentine, ca. 1410, *Holy Face*, Horne Museum, Florence

42. Follower of the Cioni, *Holy Face*, whereabouts unknown

46. Sienese, late fourteenth century, Sudarium,
Lanz collection, Amsterdam

45. Venetian, ca. 1325, Sudarium,
Museo Civico, Trieste

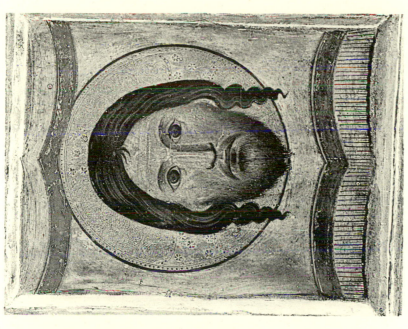

44. Andrea da Firenze, pilgrim,
detail of Fig. 94

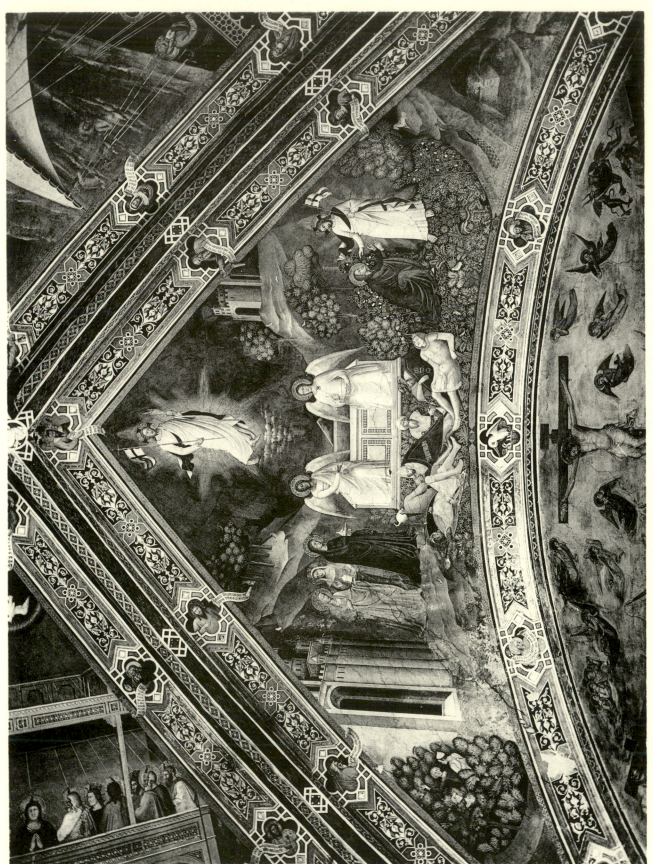

47. Andrea da Firenze, Resurrection, Spanish Chapel, S. M. Novella. 1366-1368

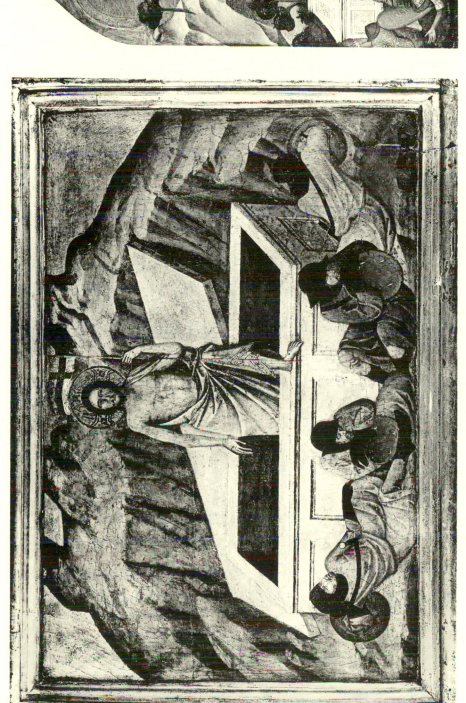

49. Jacopo di Cione, Resurrection,
National Gallery, London. 1370-1371

48. Ugolino da Siena, Resurrection, National Gallery, London

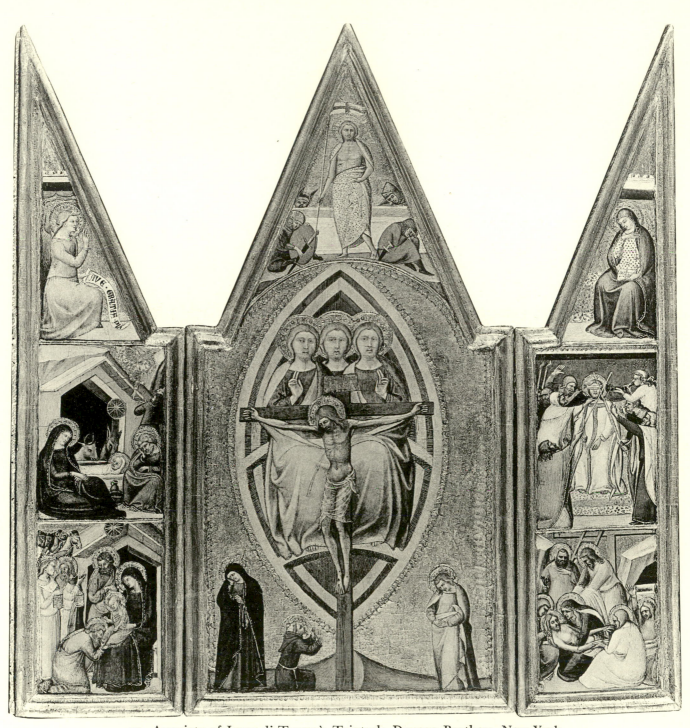

50. Associate of Luca di Tommè, Triptych, Duveen Brothers, New York

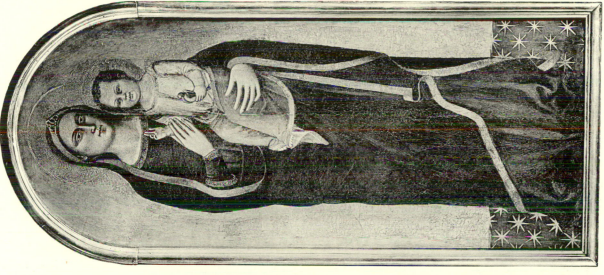

53. Jacopo di Cione, Madonna, Ss. Apostoli,
Florence

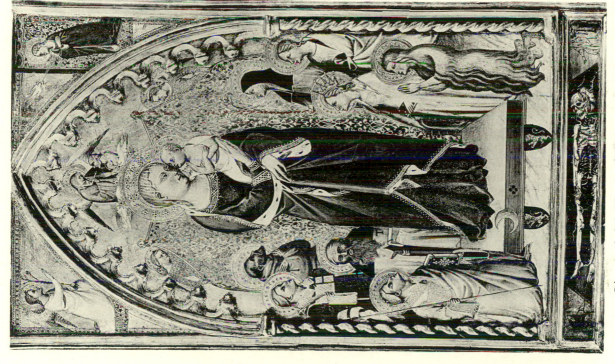

52. Giovanni del Biondo, Madonna and Saints,
Vatican Gallery

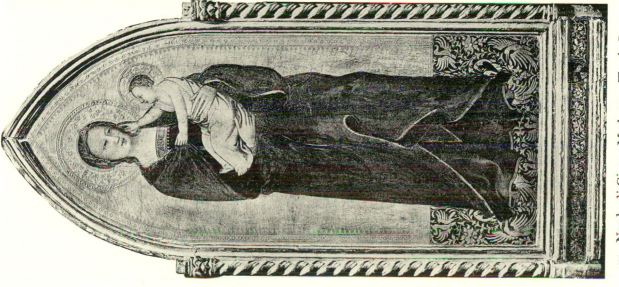

51. Nardo di Cione, Madonna, Tessie Jones
collection, Newburgh, New York

55. Jacopo Torriti, Coronation of the Virgin, S. M. Maggiore, Rome. 1295

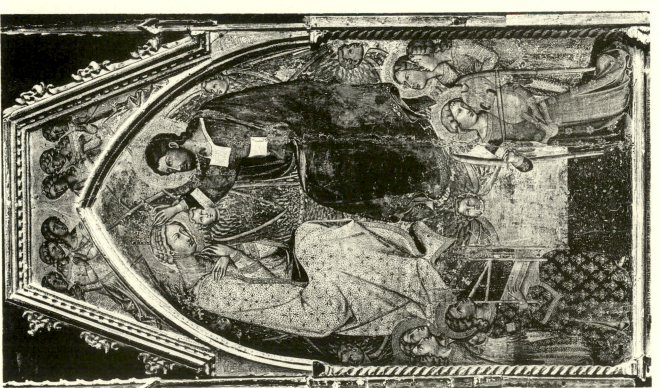

54. Bartolo di Fredi, Coronation of the Virgin, Museo Civico, Montalcino. 1388

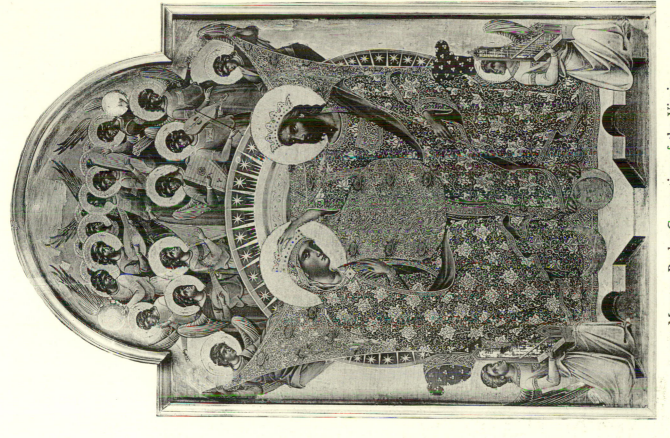

57. Maestro Paolo, Coronation of the Virgin,
Brera, Milan

56. Jacopo di Cione, Coronation of the Virgin,
Academy, Florence. 1373

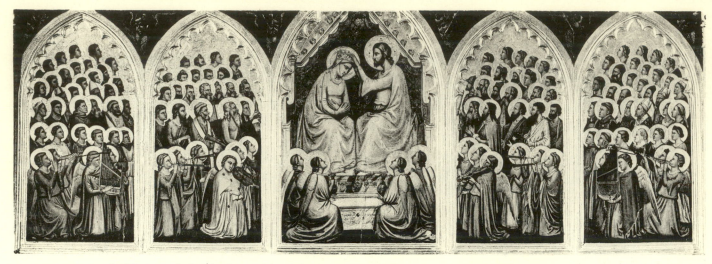

58. Master of the Stefaneschi Altarpiece, Coronation of the Virgin, S. Croce, Florence

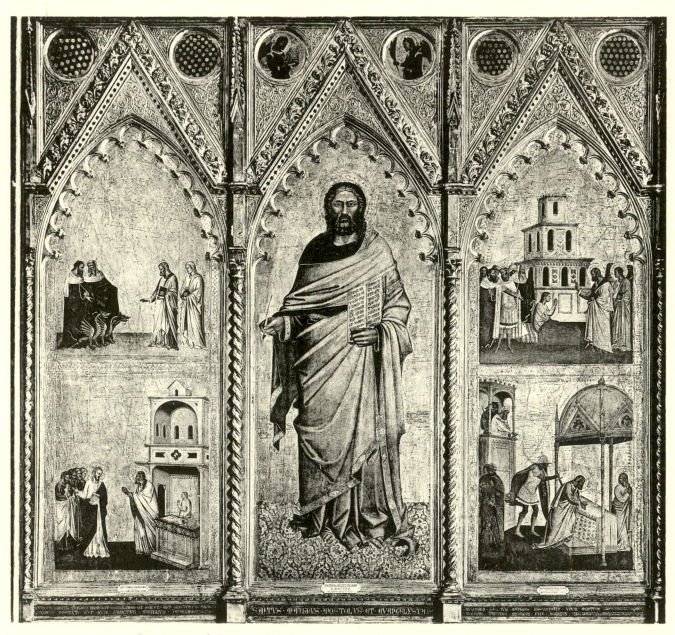

59. Orcagna and Jacopo di Cione, St. Matthew Altarpiece, Uffizi. 1367-1369

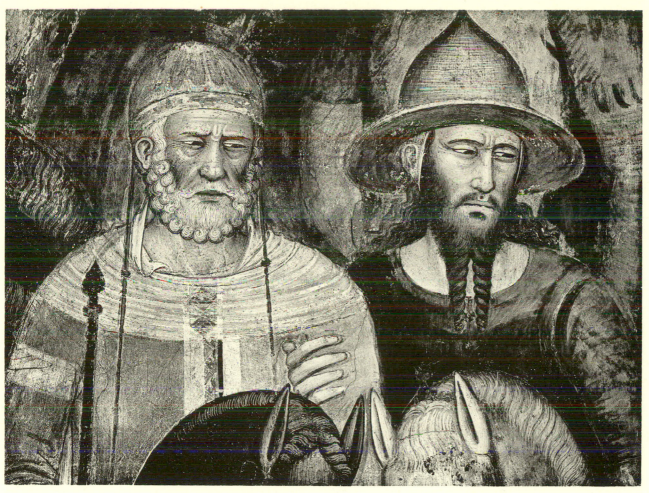

60. Andrea da Firenze, heads of two soldiers, detail of Fig. 96

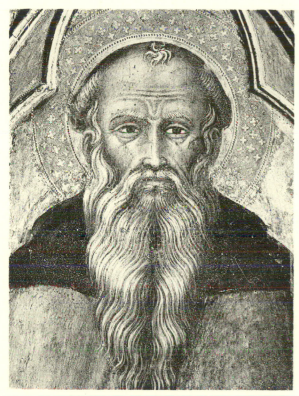

61. Giacomo di Mino del Pellicciaio, head of St. Anthony, Pinacoteca, Siena. 1362

62. Andrea Vanni, head of St. Peter, Museum of Fine Arts, Boston

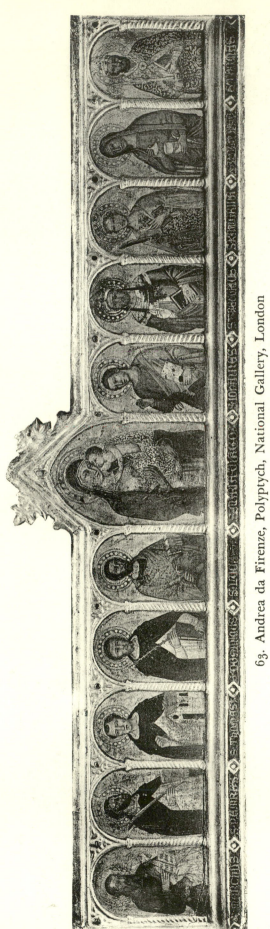

63. Andrea da Firenze, Polyptych, National Gallery, London

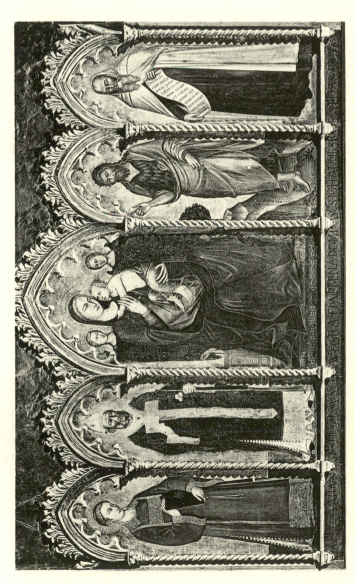

64. Andrea da Firenze, Polyptych, S. M. del Carmine, Florence

67. Duccio, Deposition, Opera del Duomo, Siena. 1310-11

66. Bartolo di Fredi, Deposition,
S. Francesco, Montalcino. 1382

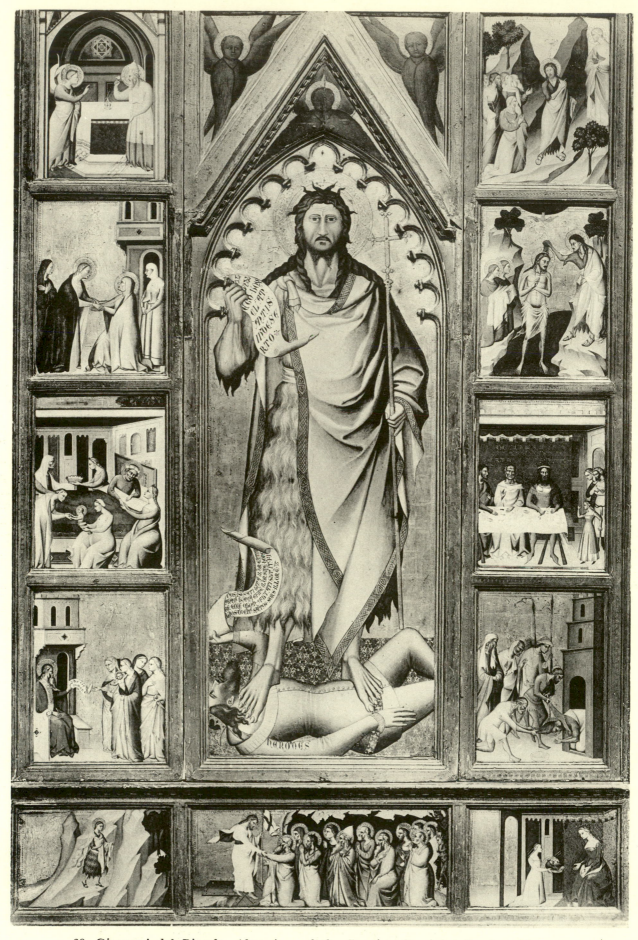

68. Giovanni del Biondo, Altarpiece of the Baptist, Contini collection, Florence

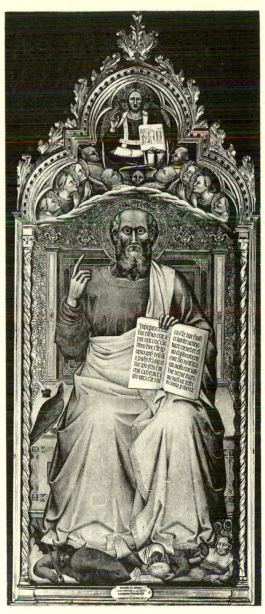

69. Giovanni del Biondo, St. John
Evangelist, Uffizi, Florence

70. Giovanni del Biondo, St.
Zenobius, Duomo, Florence

71. Pride, Avarice, and Vainglory, detail of Fig. 69

72. Giotto, Caritas, Arena Chapel,
Padua

73. Giotto, Faith, Arena Chapel,
Padua

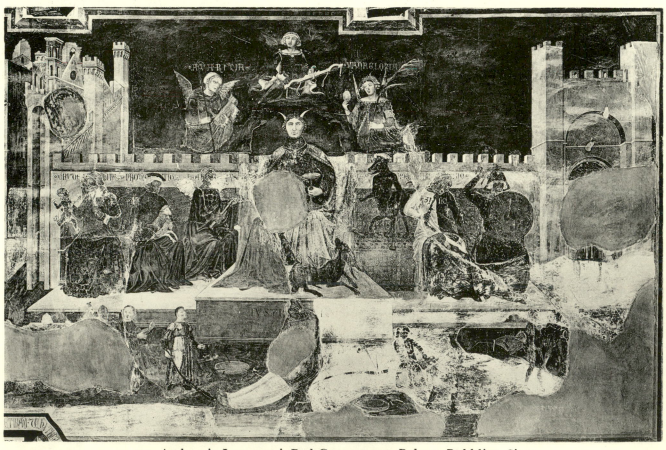

74. Ambrogio Lorenzetti, Bad Government, Palazzo Pubblico, Siena

76. Barna, Way to Calvary, Collegiata, S. Gimignano

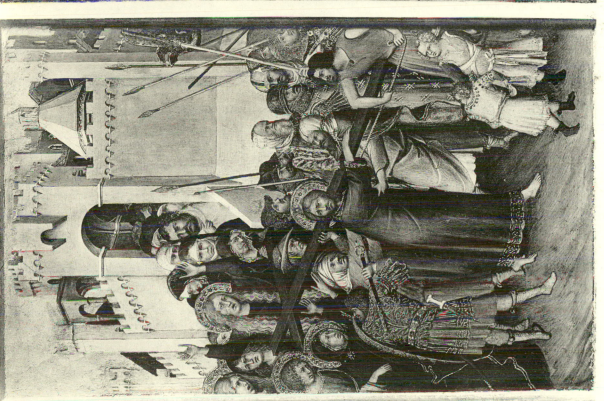

75. Simone Martini, Way to Calvary, Louvre

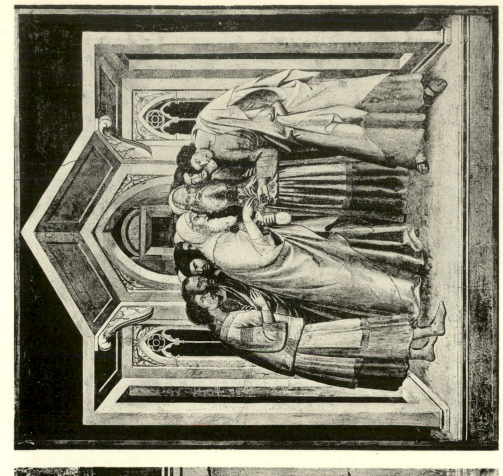

78. Barna, The Pact of Judas, Collegiata, S. Gimignano

77. Duccio, The Pact of Judas, Opera del Duomo, Siena. 1310-11

79. Barna, The Last Supper, Collegiata, S. Gimignano

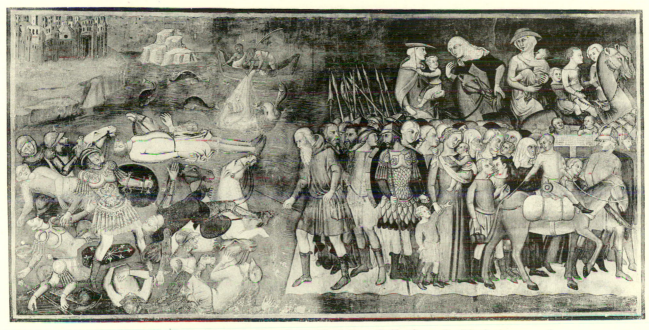

80. Bartolo di Fredi, Crossing of the Red Sea, Collegiata, S. Gimignano. 1367

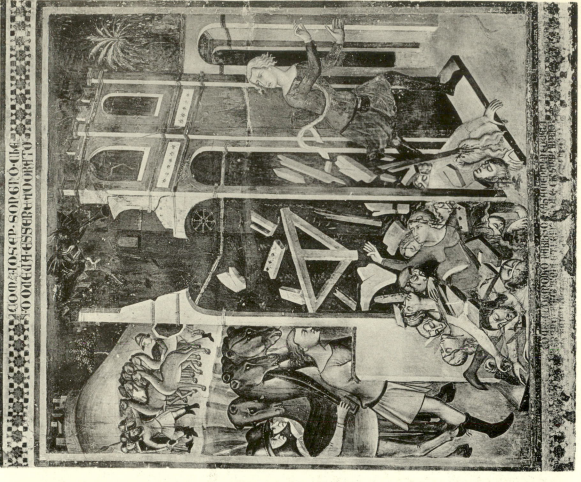

82. Bartolo di Fredi, Death of the Children of Job, Collegiata, S. Gimignano. 1367

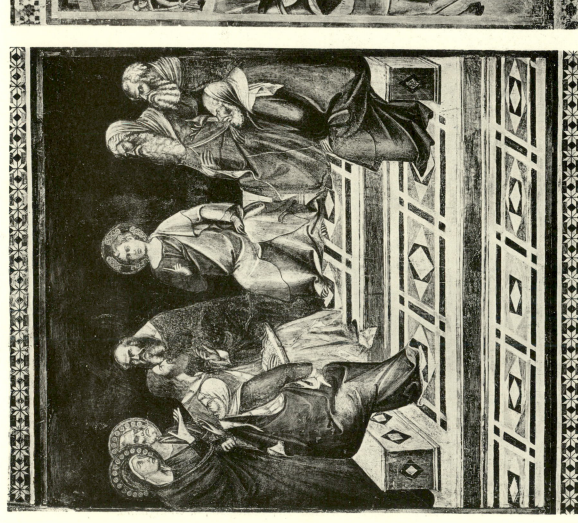

81. Barna, Christ Teaching in the Temple, Collegiata, S. Gimignano

83. Assistant of Orcagna, detail of Hell, S. Croce, Florence

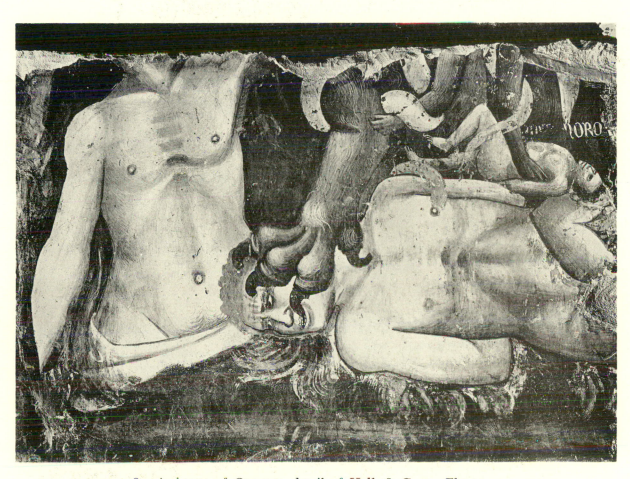

84. Assistant of Orcagna, detail of Hell, S. Croce, Florence

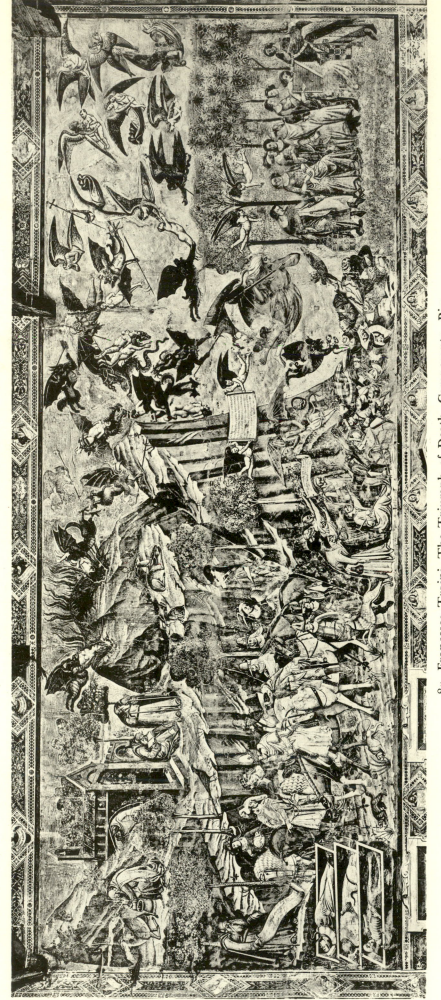

85. Francesco Traini, The Triumph of Death, Camposanto, Pisa

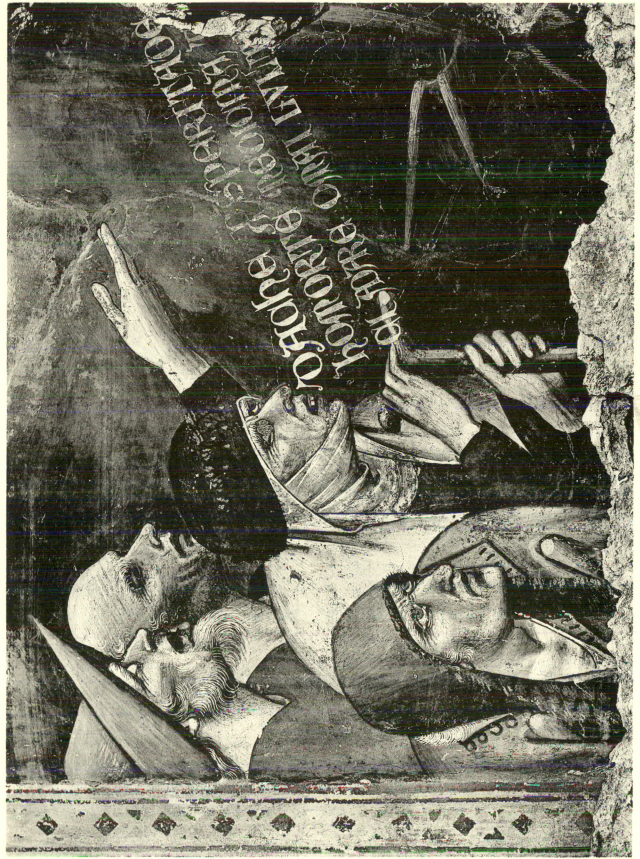

86. Orcagna, fragment of the Triumph of Death, S. Croce, Florence

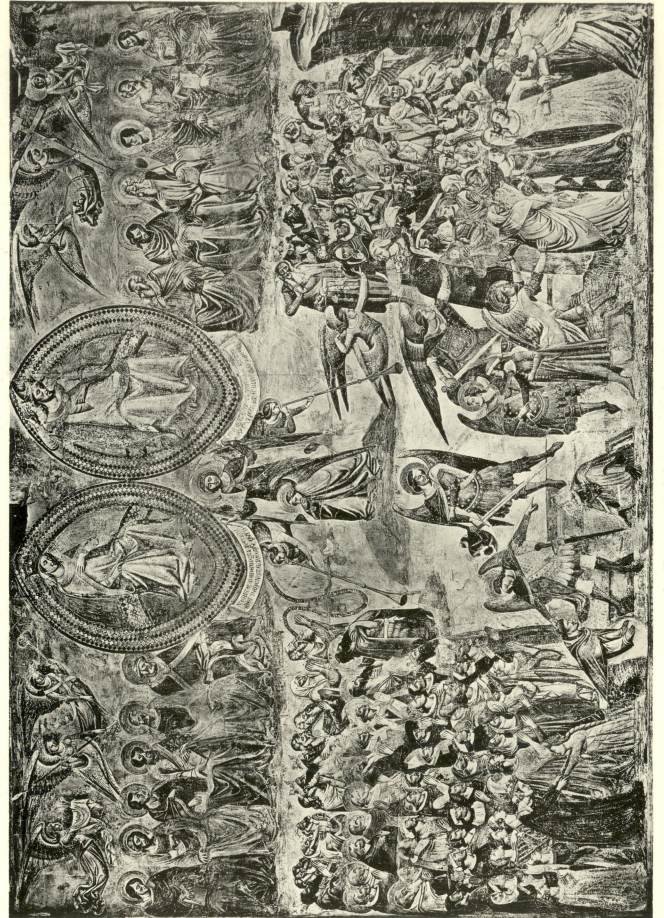

87. Francesco Traini, Last Judgment, Pisa

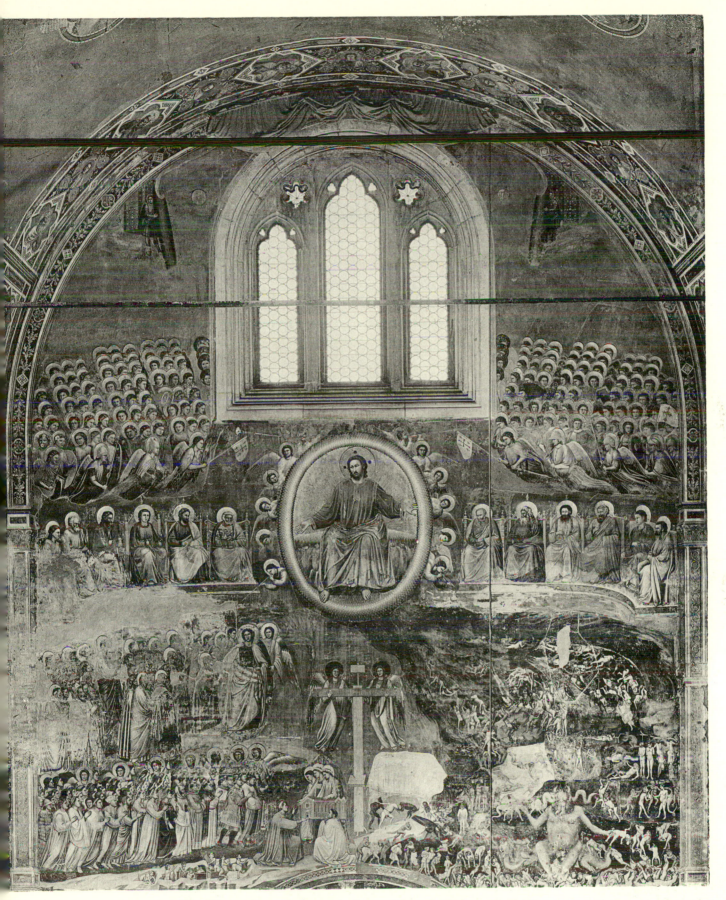

88. Giotto, Last Judgment, Arena Chapel, Padua. ca. 1305

89. Nardo di Cione, detail of Last Judgment, S. M. Novella, Florence

90. Florentine, ca. 1355, Last Judgment, Biblioteca Nazionale, Florence,
Magl. ii.i. 212, f. 64v

92. Barna, Crucifixion, Collegiata,
S. Gimignano

91. Giovanni del Biondo, Martyrdom of
St. Sebastian, Opera del Duomo,
Florence

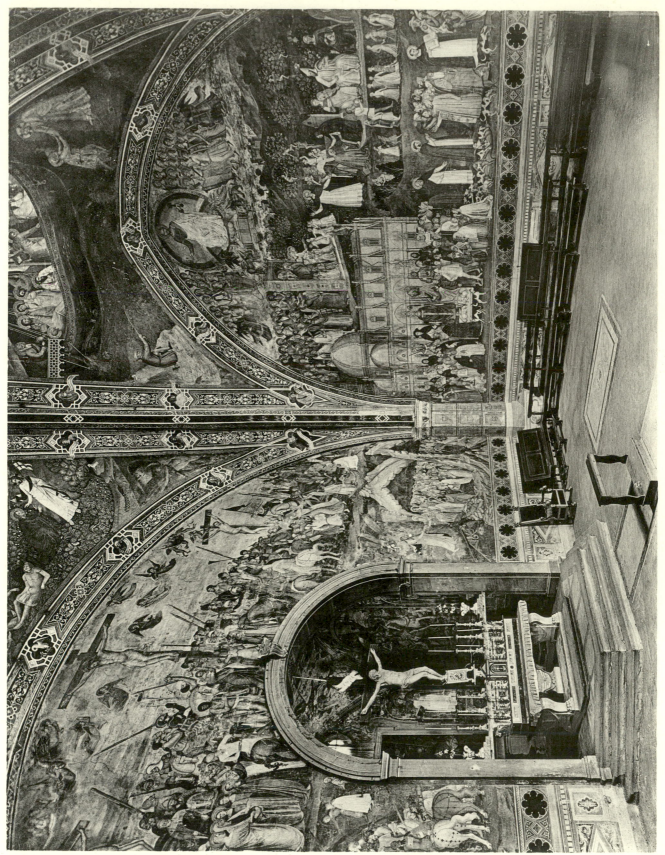

93. Interior of the Spanish Chapel, S. M. Novella, Florence. 1366-1368

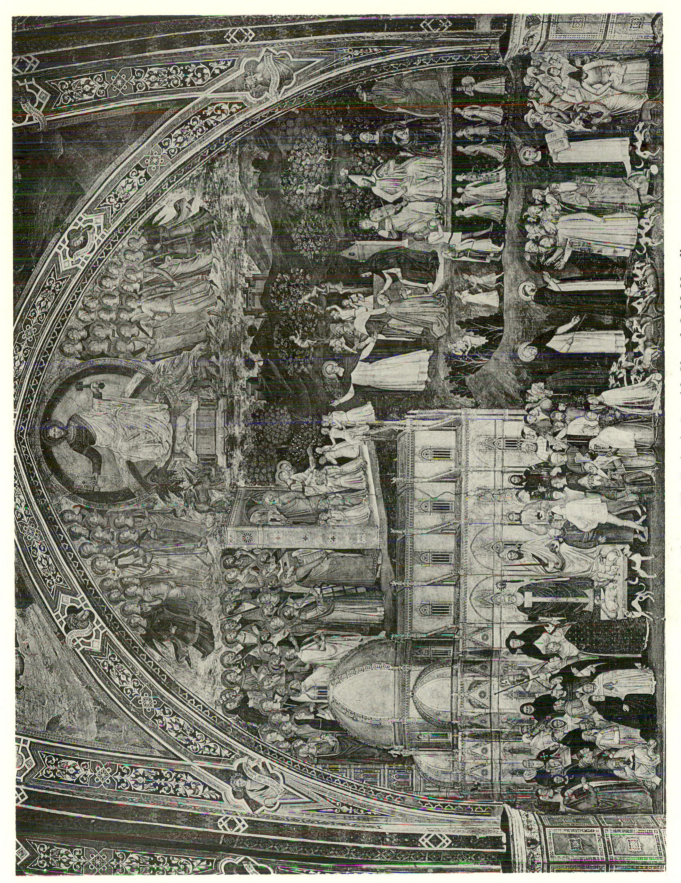

94. Andrea da Firenze, *Via Veritatis*, Spanish Chapel, S. M. Novella

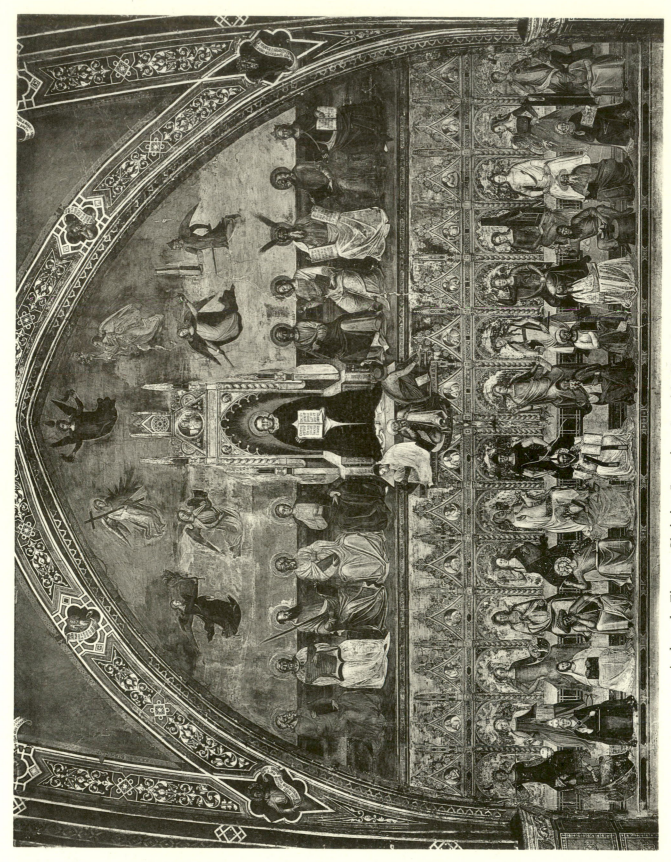

95. Andrea da Firenze, Christian Learning, Spanish Chapel, S. M. Novella, Florence

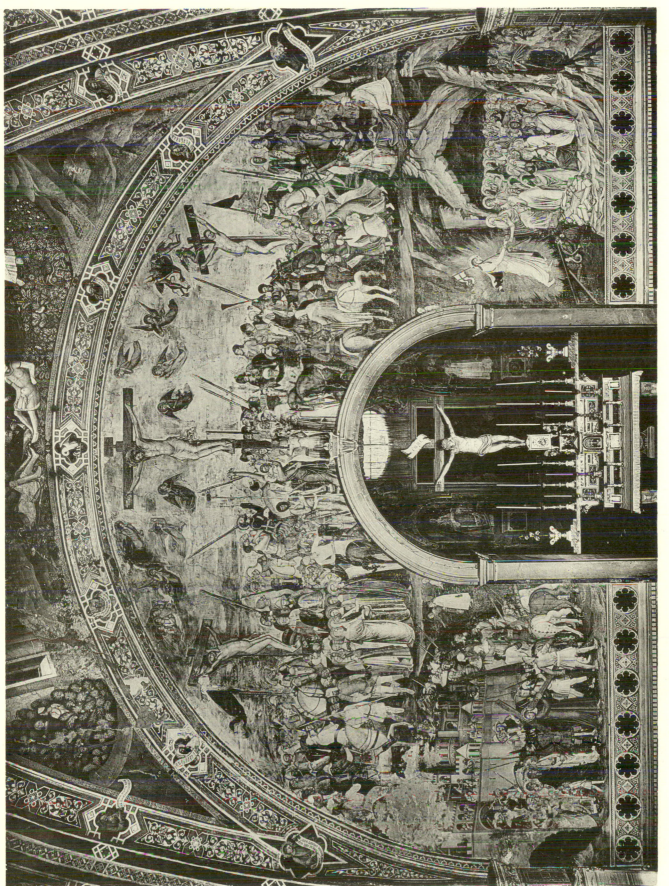

96. Andrea da Firenze, Crucifixion, Way to Calvary, and Limbo, S. M. Novella, Florence

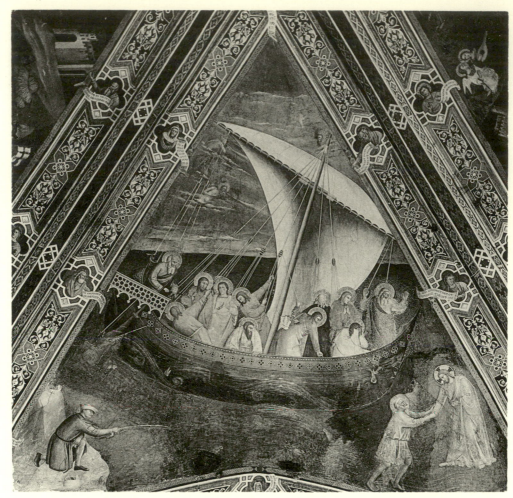

97. Andrea da Firenze, The Navicella, S. M. Novella, Florence

98. Andrea da Firenze, Limbo, Spanish Chapel, S. M. Novella

99. Florentine, Mystic Marriage of Christ and the Virgin, Museum of Fine Arts, Boston

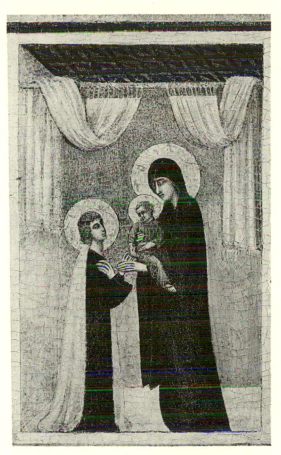

100. Follower of the St. Cecilia Master, Marriage of Catherine of Alexandria (detail of an altarpiece), W. R. Hearst collection

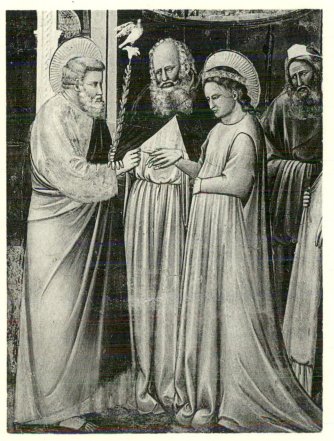

101. Giotto, Marriage of the Virgin, Arena Chapel, Padua

102. Follower of Giotto, Marriage of Francis to Poverty, S. Francesco, Assisi

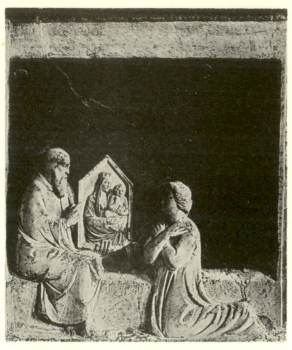

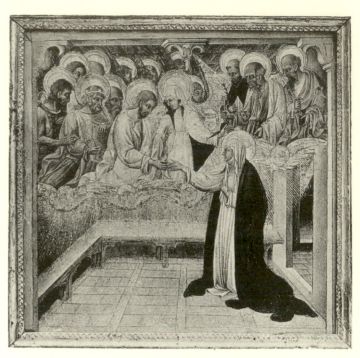

103. Pacio and Giovanni da Firenze, Catherine of Alexandria receiving an image of the Madonna, S. Chiara, Naples

104. Giovanni di Paolo, Marriage of Catherine of Siena, Stoclet collection, Brussels

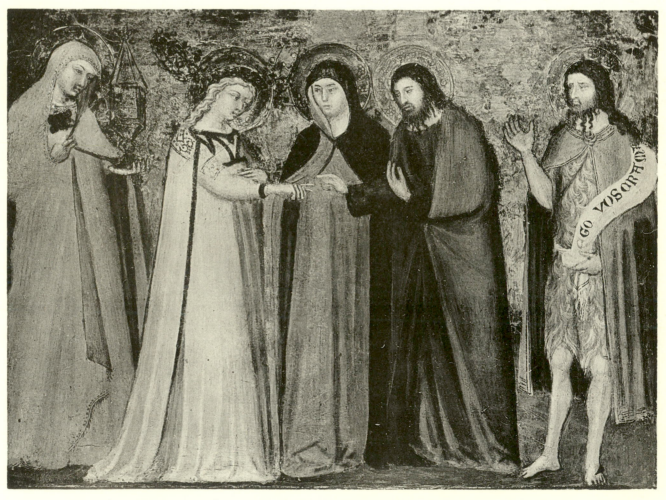

105. The Dijon Master, Marriage of Catherine of Alexandria, Ringling Museum, Sarasota, Florida

107. Associate of Barna, Marriage of Catherine of
Alexandria, Museum of Fine Arts, Boston

106. Giovanni del Biondo, Marriage of Catherine of
Alexandria, whereabouts unknown

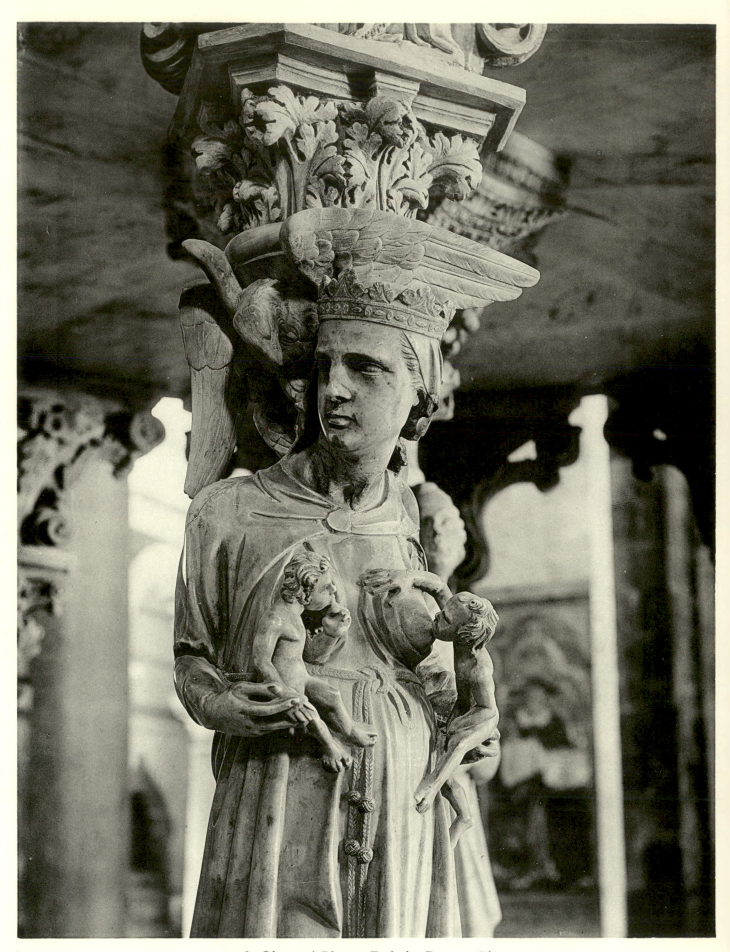

108. Giovanni Pisano, Ecclesia, Duomo, Pisa

109. Ambrogio Lorenzetti, Good Government with Caritas above, Palazzo Pubblico, Siena

110. Tino di Camaino, Caritas, Opera del Duomo, Florence

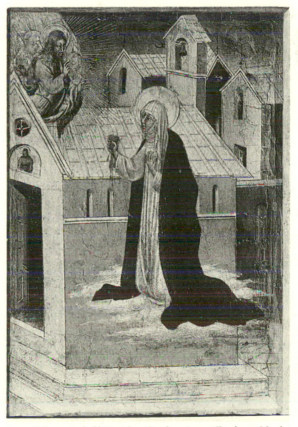

111. Pisan Master, Marriage of Catherine of Siena, Museo Civico, Pisa

112. Giovanni di Paolo, Catherine offering Christ her heart, Stoclet collection, Brussels

114. Florentine Painter, ca. 1250, Stigmatization of
St. Francis, Uffizi, Florence

113. Bonaventura Berlinghieri, Stigmatization of St. Francis,
S. Francesco, Pescia. 1235

116. Stigmatization of St. Francis, S. Francesco,
Assisi

115. School of Guido da Siena, Stigmatization of
St. Francis, Pinacoteca, Siena

117. Giovanni di Paolo, Stigmatization of St. Catherine of Siena, Robert Lehman collection, New York

118. Florentine, early fourteenth century, The Disrobing of Christ, private collection, New York

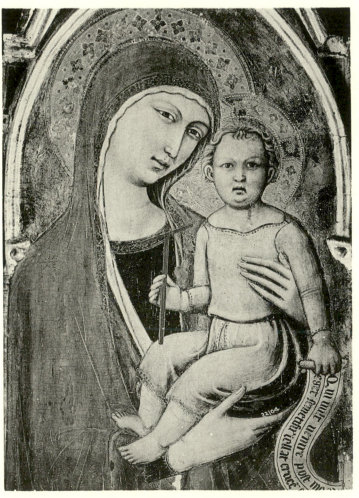

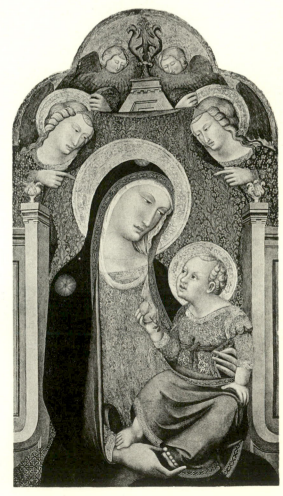

119. Luca di Tommè, Madonna, Pinacoteca, Siena

120. Niccolò di Ser Sozzo Tegliacci, Madonna, National Gallery, Washington

121. Follower of Orcagna, Man of Sorrows, Museo dell'Opera di S. Croce, Florence

122. Guido da Siena, Christ mounting the Cross,
Archiepiscopal Museum, Utrecht

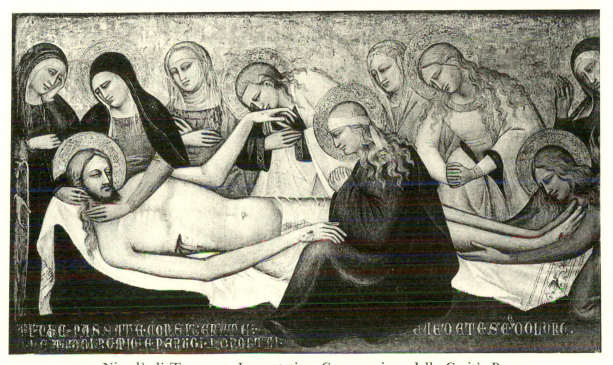

123. Niccolò di Tommaso, Lamentation, Congregazione della Carità, Parma

125. Niccolò di Tommaso, Man of Sorrows,
The Cloisters, New York

124. Follower of Niccolò di Buonaccorso, detail of
altarpiece, Pinacoteca, Siena

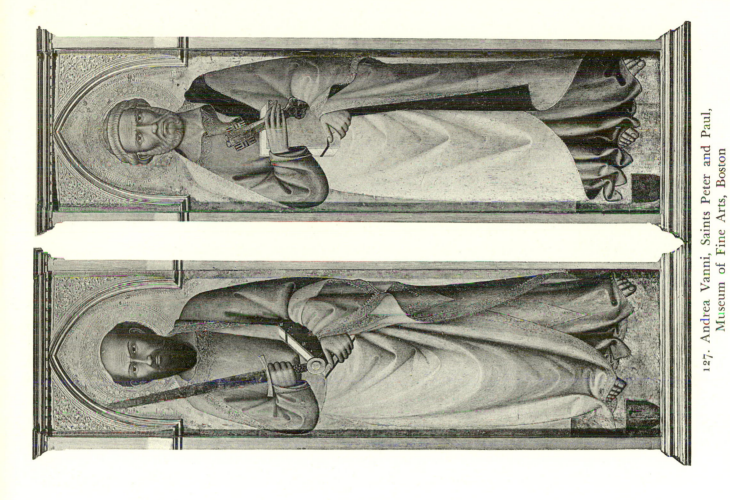

127. Andrea Vanni, Saints Peter and Paul,
Museum of Fine Arts, Boston

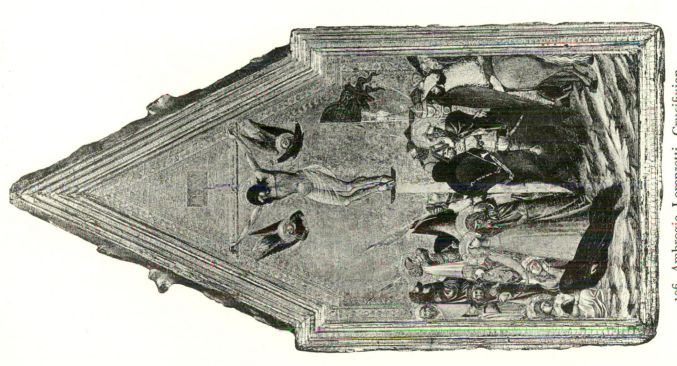

126. Ambrogio Lorenzetti, Crucifixion,
Fogg Museum, Cambridge, Mass.

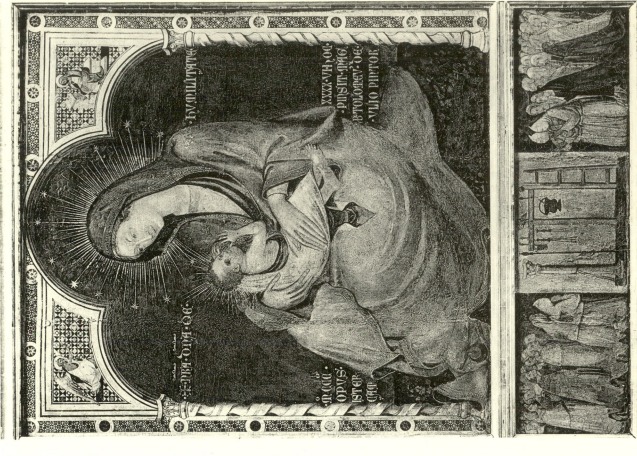

129. Bartolommeo da Camogli, Madonna of Humility,
Museo Nazionale, Palermo. 1346

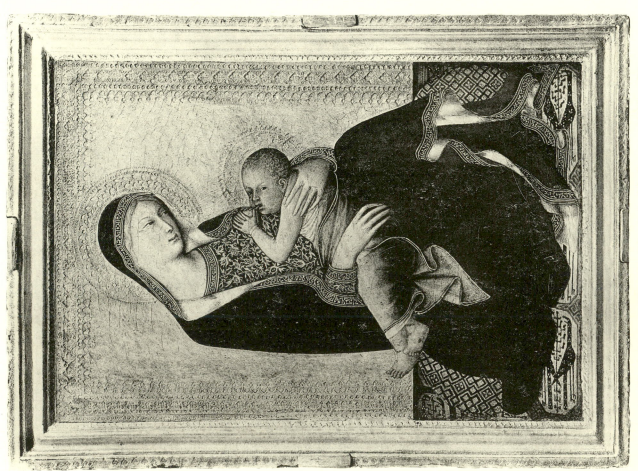

128. Workshop of Simone Martini, Madonna of Humility,
Kaiser-Friedrich Museum, Berlin

130. Simone Martini, Madonna of Humility, Notre-Dame-des-Doms, Avignon

131. Andrea di Bartolo, Madonna of Humility,
National Gallery, Washington

132. Giovanni di Niccolò, Madonna of
Humility, Ca d'Oro, Venice

133. Neapolitan Follower of Simone Martini, Madonna of Humility,
S. Domenico, Naples

134. Simone dei Crocefissi, Madonna of
Humility, private collection, Florence

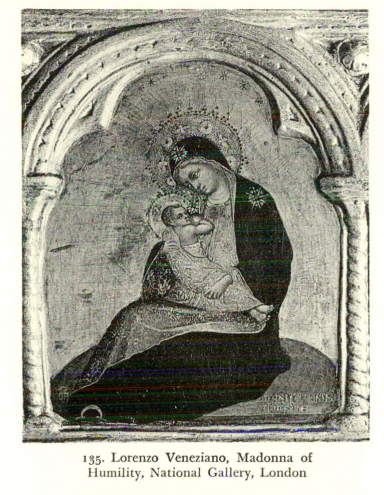

135. Lorenzo Veneziano, Madonna of
Humility, National Gallery, London

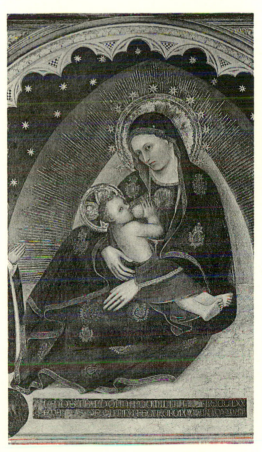

136. Fra Paolo da Modena, Madonna
of Humility, Gallery, Modena

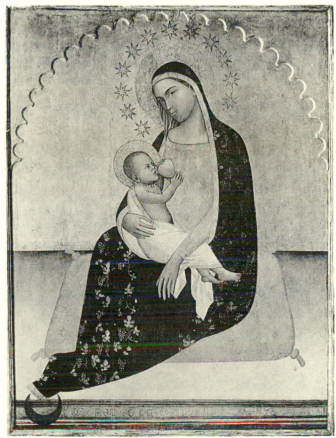

137. Allegretto Nuzi, Madonna of
Humility, Gallery, San Severino

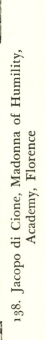

139. The Assistant of Daddi, Madonna of Humility,
Parry collection. 1348

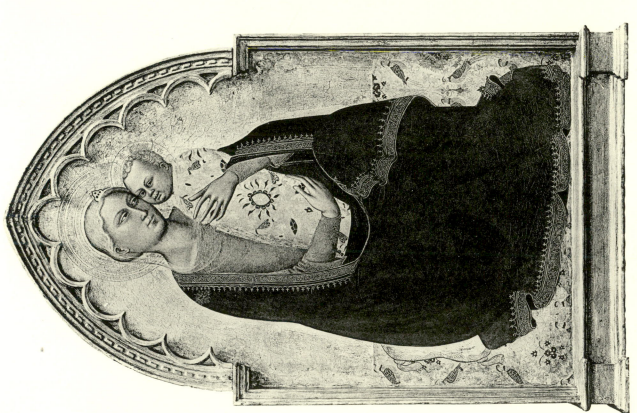

138. Jacopo di Cione, Madonna of Humility,
Academy, Florence

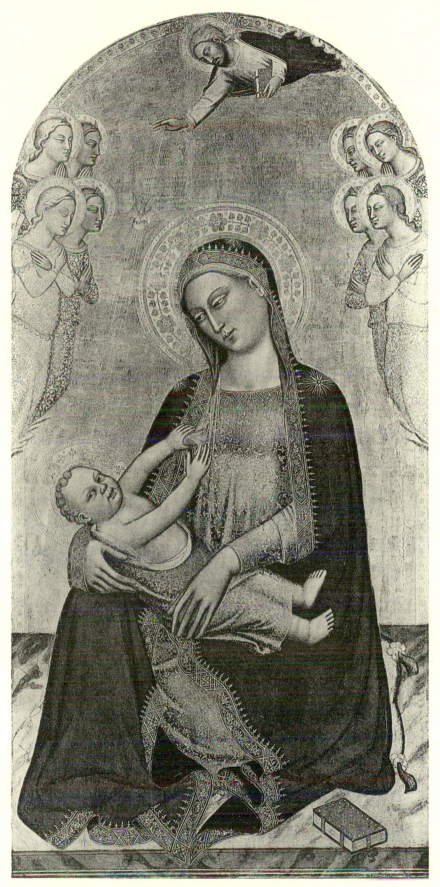

140. Orcagna and Jacopo di Cione, Madonna of Humility,
National Gallery, Washington

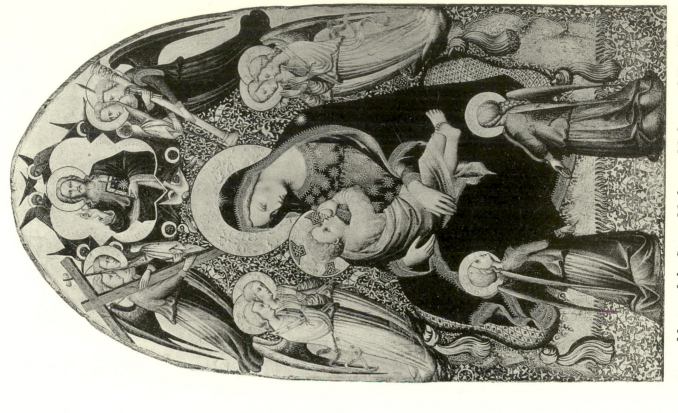

142. Master of the Straus Madonna, Madonna of Humility,
Kaiser-Friedrich Museum, Berlin

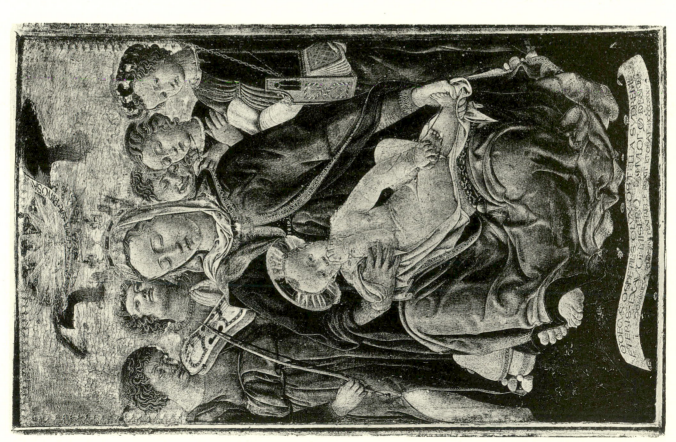

141. Domenico di Bartolo, Madonna of Humility,
Pinacoteca, Siena. 1433

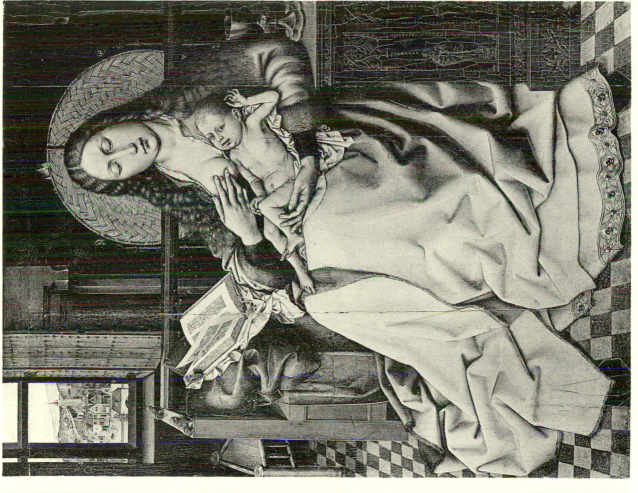

144. Master of Flémalle, Madonna of Humility, National Gallery, London

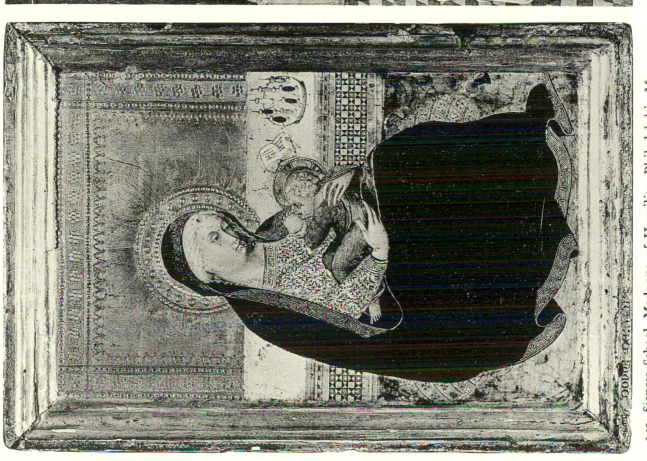

143. Sienese School, Madonna of Humility, Philadelphia Museum, Philadelphia

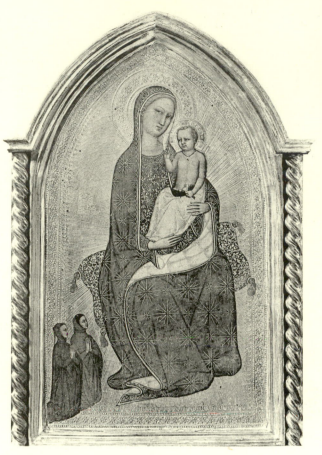

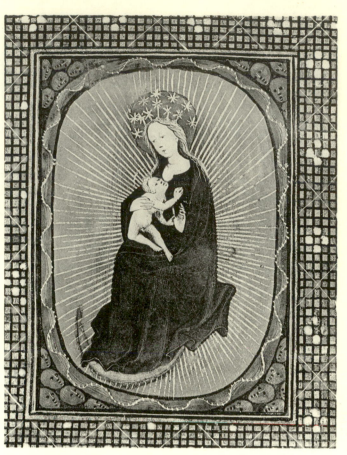

145. Follower of Nardo, Madonna,
Academy, Florence

146. Flemish, ca. 1430, Madonna of Humility,
Morgan Library, New York, MS 46, f. 85v

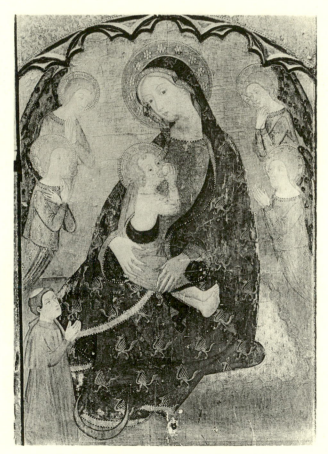

147. French, 1350-1370, Madonna of Humility,
Morgan Library, New York, MS 88; f. 151

148. Jaime Serra, Madonna of Humility,
Parish Church, Palau

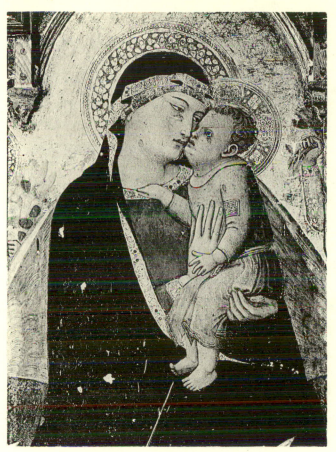

149. Ambrogio Lorenzetti, *Maestà*, detail,
Museo, Massa Marittima

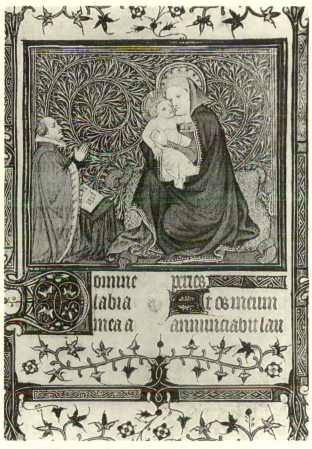

150. Follower of Jacquemart de Hesdin, Madonna of Humility, British Museum, London,
Yates Thompson, MS 37, f. 92

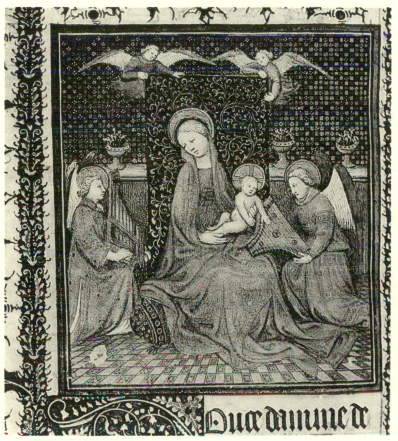

151. The Boucicaut Master, Madonna of Humility,
Bibliothèque Nationale, Paris, MS lat. 1161, f. 130v

152. Flemish, Madonna of Humility,
Mayer van den Bergh Museum,
Antwerp

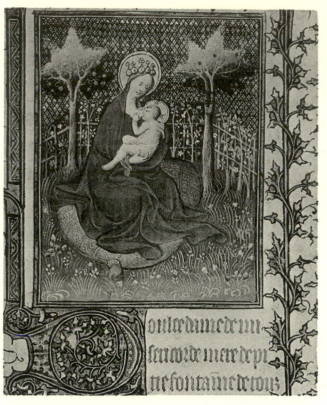

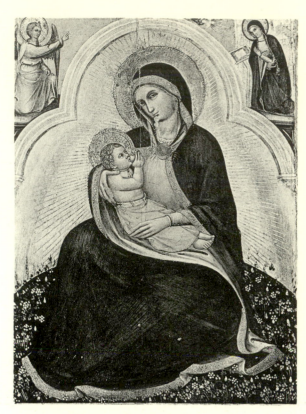

153. French, ca. 1410, Madonna of Humility,
Walters Art Gallery, Baltimore, MS 232

154. Giovanni da Bologna, Madonna of
Humility, Academy, Venice

155. Ambrogio Lorenzetti, Madonna,
S. Francesco, Siena

156. Second century, Madonna, Catacombs of
Priscilla, Rome

157. Amiens, late thirteenth century, Nativity,
Morgan Library, New York, MS 729, f. 246v

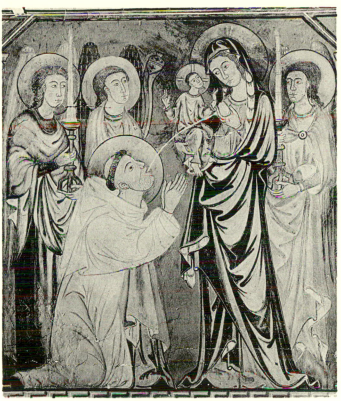

158. Majorcan, fourteenth century, Legend of
St. Bernard, Archaeological Museum, Palma

160. Liège, thirteenth century, Adam and Eve,
Morgan Library, New York, MS 183, f. 13

159. Taddeo Gaddi, Nativity, Kaiser-
Friedrich Museum, Berlin

161. French, ca. 1480, "Les Pauvres," Bibliothèque
Nationale, Paris, MS fr. 9608, f. 20

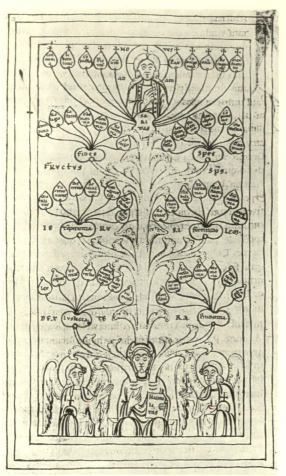

162. Twelfth century, Tree of Virtues,
Vatican Library, MS pal. lat. 565, f. 32

163. Simone dei Crocefissi, Vision of the
Virgin, Pinacoteca, Ferrara

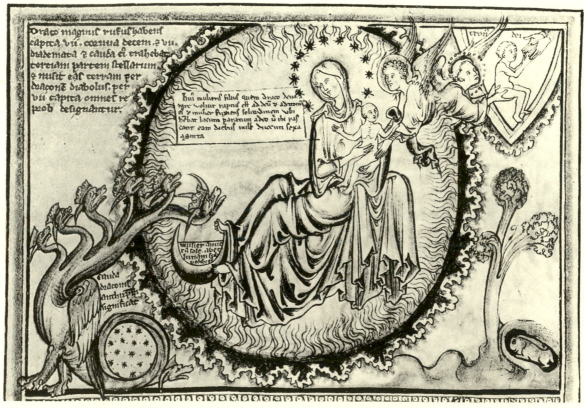

164. English, thirteenth century, illustration of Apocalypse XII, 1-4,
Morgan Library, New York, MS 524, f. 30v

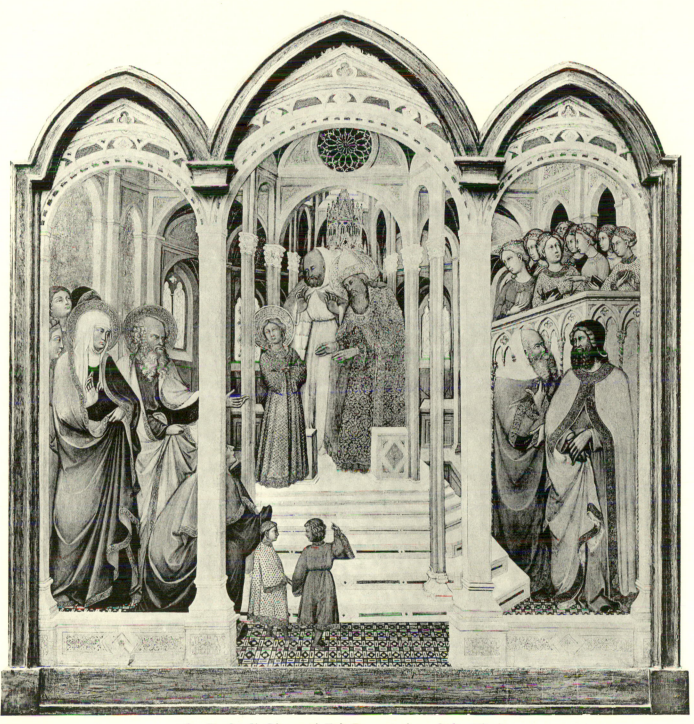

165. Paolo di Giovanni Fei, Presentation of the Virgin,
Wildenstein and Company, New York

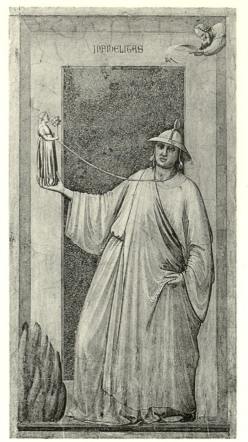

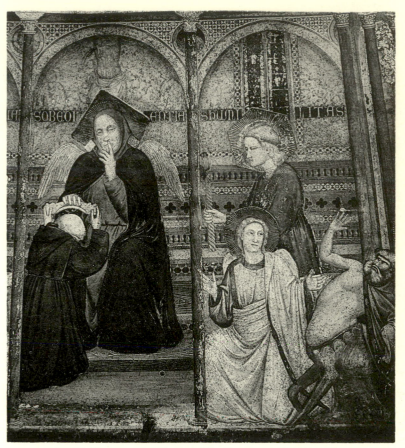

166. Giotto, Infidelity,
Arena Chapel, Padua

167. Follower of Giotto, Obedience and Humility,
S. Francesco, Assisi

168. Orcagna, St. Thomas celebrating mass, detail of the Strozzi Altarpiece,
S. M. Novella, Florence

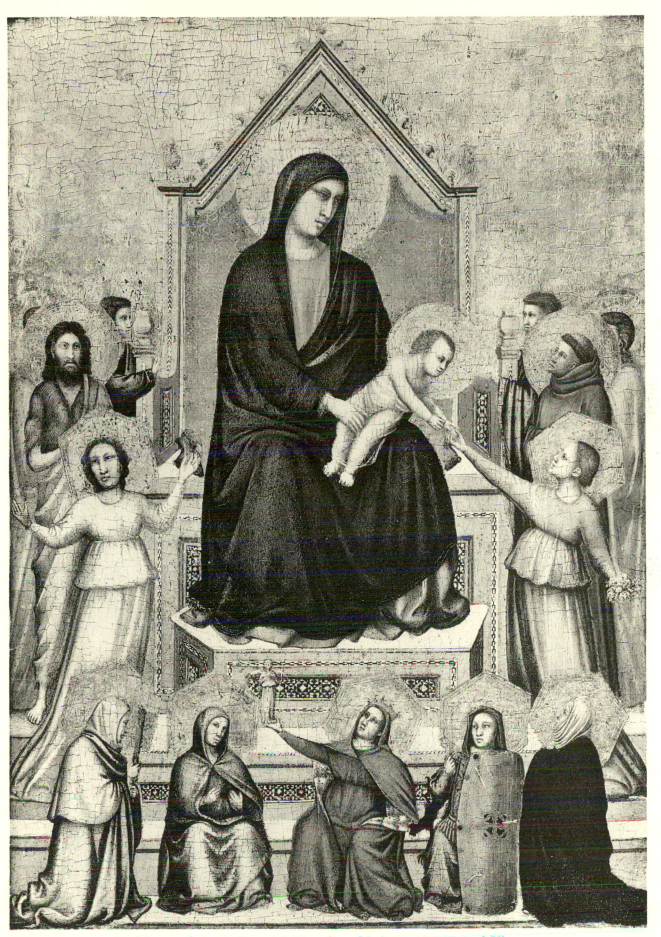

169. Master of the Stefaneschi Altarpiece, Madonna, Saints, and Virtues,
Wildenstein and Company, New York